'Loyn does a terrific job. His methodical, journalistic approach is perfect for grounding out a yarn that nobody would dare make up' *Time Out* – **Book of the Week**

'A gripping story, splashed with devil-may-care colour and scarcely credible tales of derring-do' *The Guardian*

'Girls, booze, physical hardship and flying bullets ... Loyn keeps his narrative rattling along nicely' *Daily Mail*

'Barnstorming non-fiction. Every page is full of the kind of chutzpah, grit and valour that makes your own nine-to-five seem gut-wrenchingly futile.' *Arena*

'You'll not find a more impressive set of boys'-own tales anywhere.' *FHM*

'Hugely entertaining ... the nearest thing to a Victorian adventure romp of empire against a background of fine marijuana, "Hotel California", and the wheep and chirrup of satellite technology' *Literary Review*

'You had to dodge a bit to get film for Frontline Television. Much can be forgiven this breed of men. Loyn thinks that they were born at the wrong time – not long before television became a respectable, organised part of the establishment, and so could succeed without such mavericks. Frontline's cameramen were, perhaps, the last of the pioneers.' **W. F. Deedes,** *New Statesman*

ABOUT THE AUTHOR

David Loyn is the author of the acclaimed *Butcher & Bolt: Two Hundred Years of Foreign Engagement in Afghanistan*. He is a foreign correspondent for the BBC, who has won major awards for both TV and radio reporting during thirty years in the field. He was the only foreign journalist with the Taliban when they took Kabul in 1996, and has travelled with them on assignment since 9/11.

FRONTLINE

This revised and updated edition published in 2011 by Summersdale Publishers Ltd.

First published by Michael Joseph 2005
Published in Penguin Books 2006

Summersdale Publishers Ltd
46 West Street
Chichester
West Sussex
PO19 1RP
UK

www.summersdale.com

Printed and bound in Great Britain

ISBN: 978-1-84953-141-2

Substantial discounts on bulk quantities of Summersdale books are available to corporations, professional associations and other organisations. For details telephone Summersdale Publishers on (+44-1243-771107), fax (+44-1243-786300) or email (nicky@summersdale.com).

DAVID LOYN

FRONTLINE

Reporting from the World's Deadliest Places

Foreword by John Simpson

summersdale

CONTENTS

LIST OF MAPS

FOREWORD BY JOHN SIMPSON

This book is the history of a moment in television news, which was brief enough, yet so bright that it will stay in the minds of everyone who experienced it, like staring into a torch-beam on a dark night.

Frontline still exists, as anyone knows if they have climbed up the steep stairs to the club-room above the Frontline restaurant in Paddington. Men and women recently back from somewhere terrifying and unpronounceable lounge around in the leather armchairs, or prop up the bar. *Objets trouvés*, bits of wrecked cameras, looted street signs and something which turns out to be Mo Amin's prosthetic arm gleam out from glass cases around the walls. Only Frontline, you feel, would put the false arm of a now-dead cameraman on display.

But time has passed, the world has changed, and those who choose to document its weirder and more dangerous aspects have to adapt to new ways of doing things. Television news is different from the way it was in the 1980s and 1990s, and wars – Frontline's greatest stock-in-trade – are different too. They have become even more dangerous for the adventurous freelance cameraman or camerawoman to cover, and the old sense of protection which you used to get from owning a

press-card and sticking the initials 'TV' in gaffer-tape on the windscreen of your car has long since evaporated. Cameramen no longer have the flimsy security of being regarded as neutral onlookers. Nowadays they, and the reporters who work with them, are treated as though they have taken sides. Wars have become primarily a matter for propaganda, for spin, for twisting the facts.

The glory days of Frontline, the days which David Loyn has chronicled so well and so affectionately in this book, now have a feeling almost of innocence about them: or, if innocence isn't exactly the word that springs to mind when you think of people like Peter Jouvenal, Rory Peck and Vaughan Smith, then there is unquestionably a feeling of straight-dealing, of honourable behaviour, of a long tradition of decent reporting. The American journalist Martha Gellhorn, who died in 1998 a few days short of her 90th birthday, used to love it when I told her stories about Frontline, and she said to me, 'They sound just like the kind of people I used to work with in the War.' It was an accolade to be relished; Martha, who worked alongside Capa and Ernie Pyle, and shamed her husband Ernest Hemingway into leaving his fishing in Cuba to come to Europe in time for D-Day, approved greatly of people like Peter and Vaughan and Rory: real journalists, she called them.

The group they formed in Peshawar during the Soviet occupation of Afghanistan had real glamour. They might be adventurers, but they were gentlemen and you could trust them. If a Frontline cameraman promised to go with you, he would stay with you whatever happened. If a Frontline cameraman sold you video, it would be precisely what he said it was. There was nothing questionable, nothing dodgy, about Frontline footage. The provenance alone was a sufficient guarantee of quality: and this in an area where so many spooks and crooks and weirdos

were operating. If you were good enough for Frontline to take you on, then you could be trusted.

Some of the best times of my professional life were spent working with people like Rory, Vaughan and Peter, and I suspect the same is true for David Loyn. To read about their lives and careers in this excellent, well-researched book is a considerable pleasure; and I am proud to be a bit-part player on one or two of the pages that follow. My guess is that, partly thanks to the fact that David has written the definitive account of them and of all the other brave and charming people who worked for the organization over the years, Frontline will be remembered as one of the high peaks of journalism. Martha Gellhorn certainly thought so, and she was a pretty good judge.

INTRODUCTION

In 1979, an ex-soldier, Peter Jouvenal, caught a bus at London's Victoria Station. He had enough money only for a one-way ticket across Asia to Afghanistan, which had just been invaded by the Russians. He planned to earn money taking pictures. For the next three decades he would spend more time in Afghanistan than any other Briton, ending up living there and marrying an Afghan woman.

In his early days he worked alone, but soon realised the virtue of combining with others, to deal with companies, fix rates, and do the accounts, which all journalists are very bad at. He had his own agency, VIP, in Pakistan, and later helped to set up Frontline. As a BBC reporter I came to value their military knowledge, ability and friendship over the years.

Quarter of a century after Peter took his first steps into Afghanistan it was all over. The Frontline Television News agency was wound up over lunch in Kuwait during a break in the war in Iraq in 2003. The adventure was coming to an end, and the two men with me knew it.

It was not the kind of place that any of us liked – bland, spiritless food was served with a mechanical charm. Five star comfort sure enough; but it could have been anywhere or

nowhere. We all ate the same thing: a sort of smoked salmon mountain, speared through with pieces of mango, served on a bed of rocket salad. Globalised comfort food, exotic but safe. And this being Kuwait it was all washed down with fresh fruit juice. Alcohol was strictly off limits.

My companions did not seem to mind. Both have spent more of their adult lives abroad than in England. Peter Jouvenal, an outwardly shy and taciturn man, is more at home in hostile environments than anyone I know. He could cope with a salmon and mango salad. The other man, Vaughan Smith, a resourceful ex-Guards officer, had been less successful at making a profit than he had been in shooting pictures. Over the years he became a sort of unofficial shop steward for the emerging industry of freelance cameramen, but that did not pay the rent. Outside the windows a mock wood sailing ship was moored against the jetty, neither rising nor falling with the tide, but sitting rock hard on its concrete base as the warm waters of the Persian Gulf lapped around it. The restaurant was a sanitised theme park, not the real thing at all.

'So it wasn't worth opening an office here for the war,' Peter said.

'No, and the Kuwaitis were more than usually bloody difficult with visas even if we had got the work to justify the cost,' said Vaughan, his bald head fringed by short blond hair already burnt by the high mountain sunshine in Iran, where we had just spent two weeks trying to cross into Iraq to cover the war for the BBC. It was a typically off-piste assignment for Vaughan. I would not have attempted it with anyone else.

'You know it's another year that we have not made a profit.' Vaughan speared a mango as if it were an accountant.

Frontline was costing Vaughan up to £20,000 a year to keep going. Not that that ever seemed to worry the others, who carried

news cameras as a passport to adventure but had never been able to make the sums add up. The maths were simple. In the early 1990s they could sell footage to a major network for £700 a minute, while selling into other markets too. The whole business depended on them retaining the copyright and being able to sell the same material more than once into different territories. But by 2003, the price had halved, and broadcasters expected far more for their money, including internet rights. The change made it virtually impossible to operate. With everything added up, the comparison in real terms was that Frontline pictures got only a fifth of the value they could have got a decade previously.

Vaughan always had a bigger vision than just providing news pictures. He had a driving passion to keep the company afloat for two reasons: firstly because he believed that at least *some* news images should be taken by people outside the big corporations, and secondly because he owed it to those who had died along the way. The walls of his tiny office in Southwick Mews in Paddington were lined with black and white photographs of his fallen comrades. Eight people who have had a close connection with Frontline have died violently. Vaughan takes seriously his responsibility of remembrance.

For almost a year then he had been in protracted arguments with several TV companies over pictures that had been taken by Roddy Scott, a Frontline cameraman who was killed by the Russians while trying to travel into Chechnya with a rebel group. Russian television distributed the pictures found on his body through the shared European network, where TV companies exchange pictures, and Frontline had been fighting some big agencies and broadcasters since for proper payment. By refusing payment, they seemed to be challenging the whole notion of professional freelance endeavour. It was getting harder and harder to make a living, even if you died doing it.

'We could still carry on doing your accounts, and support Robert...' Robert Adams, rather characteristically for an ex-Frontline member, was now living in Zimbabwe, although at the time he had given up news camera work. 'But I think the days of trying to make a go of it as a freelance business are over for the foreseeable future.'

Ironically their skills had been in more demand that year. America's response to the events of 9/11 had launched a whole new wave of uncertainty and conflict in places Frontline knew well – Afghanistan, Iraq, Iran, Sudan, Somalia.

In Afghanistan Peter had been the key to ensuring that John Simpson got the access he needed for his famous walk into Kabul as the Taliban retreated. John told me that positioning themselves so that they could move forward so quickly was 'solely Peter's achievement.' And as we toyed with the processed salad over lunch in Kuwait Peter was just heading into Iraq for a long filming project with the American military on their way into Baghdad. Vaughan was on his way into Iraq to work with me for the BBC, his former military experience enabling us to resist the BBC requirement to take along a safety officer as well. Again Frontline were at the sharp end, as they had been for a long time now, making a big impact over the years and wielding influence which far exceeded their size.

Remember the night shots of rockets in the first Gulf War, the first massacre victims in Kosovo, life under Serbian siege in Bosnia, the US bomb which was misdirected onto a bunker killing women and children in Baghdad, Mullah Omar wrapping himself in the cloak of the Prophet Mohammed and declaring holy war for the Taliban – the only time he was ever filmed? They were all Frontline pictures. Then there was the uncertain expression on the face of Ceauşescu when he realised that the game was up in Romania, US-supplied Stinger missiles on sale in the black markets

of Central Asia, Chechen rebels heading for battle, Zimbabwean troops in Congo, Afghan drugs smuggled through Iran, murderers from Liberia to Somalia. It was a great library, a tour through the darker side of the modern psyche. But Frontline was broke, and Vaughan could not continue to cover its losses.

So why had they carried on doing it? The money, it seemed, had never been the thing that really mattered – the news camera was first and foremost a ticket to travel, which they were very good at. They knew how to get things done, dealing easily with the drivers and porters and translators of the developing world; Peter never travels in Afghanistan without a small retinue of people, cultivating an almost Edwardian air. Behind these outward appearances their most important shared skill is to take pictures of the victims of war with compassion.

They have a strong sense that the audience should see more of the true horrors of war. Peter once told me that he often films things which he *knows* cannot be shown:

> If people are tied up and shot in the back of the head, then it is my duty to film it. It might be useful to an investigation later. But if you don't film it, then it's a form of censorship. It is as if the deaths never happened. It may not be *your* duty to broadcast it, but I feel it is *my* duty to film it. I do it all the time – like dogs eating people's faces in Liberia. If you don't do it then when you send the pictures back as cut stories to people in London, they start to think that war is not so bad. They need to be woken up occasionally. It is a message to these editors to wake up. This is a real war.

One of the sequences Peter shot in Liberia shows a soldier shooting a woman and the baby she is holding from point-blank range. The pictures are taken from a distance, but Peter then walks right

up to the soldier while his gun is still smoking, and the baby is twitching on the ground, lying next to the bible which her mother had hopelessly carried for protection. Peter speaks directly to the soldier: 'Why did you do that?' And the gunman is too shocked by the approach to shoot Peter as well, so he replies 'Well, they are… [and he names another tribe].' The small-minded tribal reason for the death is laid bare in this exchange, the true and petty nature of ethnic killing. It is rare and shocking footage.

The key Frontline men deal in war because they know about it. In Vaughan's case it is a family business – a fourth-generation army officer, he has the most military experience of all of those who worked at Frontline: eight years in the Guards. Another founder member, Nicholas della Casa, also had military experience, although not with the British Army. In the 1970s he had fought against black majority rule in what was then still called Rhodesia. (His mounted regiment, the Grey's Scouts, bore the unenviable nickname of 'the Donkey Wallopers'.) The last of the key founder members, Rory Peck, never got beyond initial training as an army officer at Sandhurst. He was far too exotic for the Army, like a piece of game meat that has been hung for slightly too long. He made up for any deficiency in technical knowledge with raw courage. All brought military analysis to bear on the complex and dangerous battlefields of the post-Cold War world, where civilians are far more likely to be the target of bullets than ever before. And they brought a military understanding of risk-taking to war. They could live with danger without being addicted to it, and they knew how to cope when nothing happened. As Rory once wrote, 'So much of one's time is spent waiting; waiting for an attack, waiting for an interview, waiting for wheels.'

The pioneer of this breed of public-school educated, ex-soldier cameramen was Lord Richard Cecil, who was killed in 1978

while filming the independence war that turned Rhodesia into Zimbabwe. He was a traditional English Tory with a strong dislike of authority and profound suspicion of the State. In other times he and the Frontline freelancers who came after him might have been cavaliers, buccaneers, explorers, frontiersmen, trappers or prospectors. In the eighteenth and nineteenth centuries these were the men at the leading edge of the Empire, searching for the source of the Nile, mapping the Pacific, conspiring across High Asia in the Great Game against the Russians. But they were born at the wrong time. By the closing decades of the twentieth century there was not a lot of call for these skills. Lord Richard's brother, the present Marquess of Salisbury, says, 'He was a simple man. He enjoyed danger and blondes.'

Like most of them, Vaughan's first taste of war as a cameraman was in Afghanistan. He says now that he knew instinctively that this was right for him. 'This was where I wanted to be. Being on the edge of conflict appealed to me.'

And despite their high attrition rate, they have a good appreciation of safety. I have travelled a lot for the BBC with several of them, and value their safety judgements. None would ever take risks unless it was for a good story, and they were to become instrumental in setting up some of the early safety courses for journalists. Peter is not superstitious in most senses of that word, but he can get very angry if you say something like, 'It's all going well', as if that would annoy some unnamed gods of the battlefield. When he was travelling with John Simpson in 1989, on an undercover mission to try to penetrate Kabul, they had a bad day, getting stuck all the time, making no progress. As they finally got clear of the mud and their jeep picked up speed Simpson said something like, 'We're getting somewhere now.' Peter had hardly even begun to form the words 'don't say that' before they were stuck in the snow again. He rounded furiously

on Simpson, barking at him, 'If only you hadn't said that, then we would have been okay.'

To Peter, war is a serious business. He has a quiet intensity, working it all out, weighing it up, although he is not an intellectual in the traditional sense, and indeed is dyslexic. Like many good cameramen I have come across, his brain seems to be wired in a unique way. He deals in images not words, and has only ever expressed appreciation for one book in my hearing – *Flashman* by George Macdonald Fraser, the fictional account of the Victorian anti-hero Harry Flashman, whose earliest military adventures, after he is expelled from Rugby, are in Afghanistan. What is there in the antics of this most reluctant warrior that appeals to war cameramen?

While they may have started as romantic adventurers, drawn by the lure of travel, with more knowledge of soldiering than television, they quickly learnt their trade and the power of the images they were taking. Like anybody confronted with the reality of human suffering, they were changed by it. They grew up in the field, looking inwardly at the same time as they collected images of inhumanity. Television journalism gave them a purpose, and into it they directed their energy, bloody-mindedness, hopes and disappointments, putting their inherited values and political beliefs to the test. They started out not knowing what they were doing, but they ended up making a useful contribution and at great cost. If they had a shared world view after all this, it was one which had allegiance neither to left nor right but rather was sceptical of all dogma, having seen the damage that war can do.

That first pioneer Lord Richard Cecil, not a Frontline cameraman, but an honorary member in memory, once stood for parliament as a Conservative. But none of them was overtly political in a partisan sense, sharing a small 'c' conservatism which was already out of date by the time Margaret Thatcher had taken hold of

the Conservative party. They are liberal, or perhaps libertarian is a better word, in the way that people who see the world can sometimes be. They tolerate a lot, showing loyalty to each other and people they like but a contempt for many of the ways of the modern world which can look like arrogance from outside. And while they were better than any at living rough, they always stayed and dined in the best hotels where they could. They had the manners if not always the money of the aristocrat. Plans for the next war would be put together over breakfast in Claridge's or in the bar at the Ritz.

War played havoc with their personal lives. Apart from the bereaved parents, widows and orphans which dead cameramen left behind, there were women abandoned across the globe. Vaughan's marriage to the Bosnian woman he brought out of Sarajevo foundered when he spent too long away covering the next Balkan war in Kosovo. And another of the Frontline cameramen, Richard Parry, told me of a long-term relationship he had with a woman who became quite a successful poet. After the relationship collapsed he picked up a new copy of her poems in a bookshop and read of a man who could not communicate, who was 'up to his neck in a bloody war in the Balkans'.

Richard should have known. He once went to Moscow to look up Peter Jouvenal, who was then living there. Peter's Russian girlfriend showed him a postcard which Peter had sent to her. It showed a faded picture of Afghanistan. He had not written any message, just her name and address. It was all that she had heard from him for the last nine months.

Rory Peck's first marriage collapsed, and his second wife Juliet always kept close to him, travelling to difficult places even when she had young babies. She seemed almost out of her time, like many who ended up in Frontline, mavericks to their own society perhaps, and yet at home anywhere. Juliet belonged in places like

Peshawar as did Peter, with his strangely Edwardian mannerisms, and the other men and women who ultimately make up the Frontline story. Their temperament gave them the impetus and the ability to live in some of the hardest places on the planet. The travel writer Peregrine Hodson spent some time with Peter in Afghanistan, and wrote of the unnerving nature of the experience:

> It was disturbingly unreal to be caught in the middle of a forgotten war. At times it was like being in the grip of a massive hallucination: living on nuts and berries in a cave, being bombed by Soviet jets. The outside world acquired another meaning.

In my search to find out what it was like, to look behind that other meaning, I carried out interviews for this book in some surprising places. Often in war there are long periods of time when nothing happens, and I took time then to gather the stories. I spoke to Vaughan at length during breaks in the war on Iraq. In the background of the recording there's the loud hum of the generator powering the tented desert headquarters of the Marine Unit we were embedded with. There's a generator too in the background of an interview with another of them, Tim Deagle, who I talked to in the ruins of Aceh after the tsunami. I talked to Peter in a bombed-out office block where he had set up the BBC, several miles ahead of all other journalists, just north of the Taliban front lines before Kabul fell, or Ker-BULL, as he pronounces it in the old fashioned way, his clipped and cautious English weighing every word with care, as if making a report to a senior officer. On the recording occasionally a shell falls nearby. But he is more relaxed here than anywhere, ignoring the shells or just commenting on their relative danger to us with classic sangfroid. (Why is this quintessentially English quality best expressed in a borrowed French word?)

Describing one particularly hair-raising episode, crossing enemy lines into Kabul, disguised as a Russian and pursued by the secret police, who were trying to shoot him, he said, 'It was good fun. And I suppose that even if we had been found, it is always good for a journalist to get arrested occasionally, especially for a little company like Frontline. You have to do something interesting with your life.' It connected him directly with a line of Victorian adventurers such as Sir Richard Burton, who wrote, 'The world was all before me and there was pleasant excitement in plunging single-handed into its chilling depths.'

I talked too to newspaper journalists and photographers who knew them, and the correspondents and producers who commissioned and depended on Frontline footage for many years. But too few in the broadcasting industry have really appreciated what the genuine freelance brings, despite what Frontline did to create something that had not existed before.

Until Frontline television news was finally broken on the wheel of accountancy, they made a difference for a quarter of a century, bringing some of the most memorable images of our times to the screen, often covering stories that would not otherwise have been covered, while travelling into what they call the 'ulu', a borrowed military term for the jungle, the interior, the other world beyond the frail curtain put up by 'civilisation'. They were the last survivors of an old way of doing journalism, before satellite phones and 24-hour news, doing television in a way news had been done since the Crimean war: going out into the ulu, finding out what was happening, and bringing it back – with a runner carrying pictures across the Hindu Kush as the most sophisticated method of communication. And they paid a high price: a horrifying number of them died doing it. This is their story.

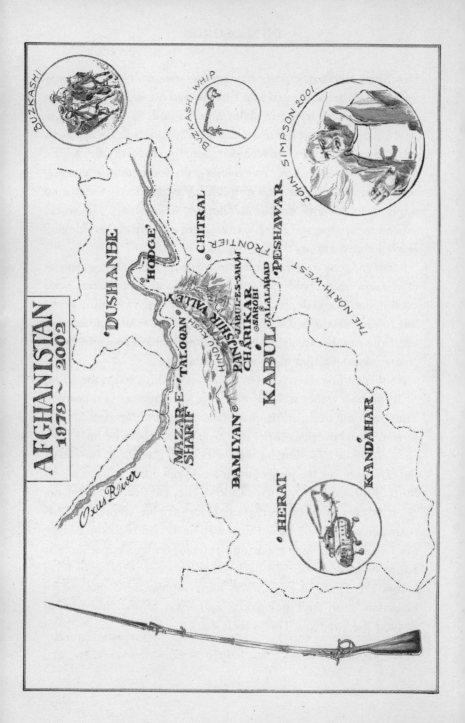

AFGHANISTAN
1979 ~ 2002

BUZKASHI

BUZKASHI WHIP

JOHN SIMPSON 2001

Oxus River

DUSHANBE

'HODGE'

CHITRAL

MAZAR-E-
SHARIF

TALOQAN

HINDU KUSH

PANJSHIR VALLEY

JABUL-ES-SARAJ

CHARIKAR

SAROBI

FRONTIER

PESHAWAR

KABUL

JALALABAD

BAMIYAN

THE NORTH-WEST

HERAT

KANDAHAR

I

A LITTLE KILLING

The mobs rule Kabul itself, each mob under its leader imagining that it alone has frightened the British off. They do a little looting, and a little raping, and a little killing.

George Macdonald Fraser, *Flashman*

Kabul, Afghanistan, March 1989

There are two really dangerous times in any war, as Peter knew only too well. The beginning and the end. The times when you do not know the front lines, or where the hazards are, and people around you are frightened, on edge, ready to shoot first before asking questions. This was one of those times, endgame for Russian influence in Kabul – and he was disguised as a Russian.

The sound of the leather soles of his brogues on the broken concrete of the empty, wide, dusty street was too loud, too defined and crisp, altogether too military. Peter knew that his Bond Street shoes would easily identify him as an Englishman if anyone bothered to look. But this was Afghanistan, where the fighters he would meet would probably not even be able to read, and would believe his story that he was a Russian. He hoped. Kabul was still in the hands of Russian-backed forces

for now, but the mujaheddin, who had guided him in, were at the city gates. He pulled the anonymous anorak closer around his face, against prying eyes and the thin, dry, always-cold, high mountain air.

Kabul sits at the centre of the strategic geography of high Asia, one of the highest capital cities in the world, the guardian both of the only route up to the sheer walls of the Hindu Kush to the north, and the eastern routes into the central Afghan plain. The mountains around are all bare rock in startling colours – one grey, one purple, another green. Peter had walked through most of the night, wondering at the history which gave this alien and unforgiving landscape its savage names. Hindu Kush itself means 'Hindu killer', and the last place they had stayed before their walk into Kabul was Sanglakh – literally 'the blood of a hundred thousand'.

They had driven all of the day before through snow, avoiding the main road where they could, going through the mountain passes which had seen the worst-ever British military catastrophe, when the Kabul garrison had been cut to pieces in 1842. More than 16,000 men, women and children were put to the sword during an ignominious retreat. The Afghans left just one man alive, an Army surgeon, Dr William Brydon, who rode from the carnage in Kabul through the dawn to Jalalabad. (In Peter's favourite novel, Flashman of course lived to tell the tale as well.)

Now Peter was coming through another dawn into enemy-controlled Kabul. But despite walking for much of the night they arrived too late to slip in unnoticed among the early morning commuters in the deceptive half-light of the early day. The sun was well up by the time they approached the city. They would have to take their chances alone, exposed in the too-quiet avenues.

At the other end of the street he saw what looked like a single guard, standing motionless and staring impassively towards him

as he walked. There was nothing for it now. If he ran, he would be shot. He had to continue going forwards along the broken concrete road, his brogues kicking up the fine lunar dust which covers everything in Afghanistan like freshly driven snow, getting into your hair, your eyes, your nose and the cracks in your skin, clogging up cameras and computers.

Not that he had a camera visible. His Hi8 was hidden under a sweater in a carrier bag which was part of his disguise. In garish letters a slogan on the bag proclaimed that Afghan-Soviet friendship would be eternal. The occupation ended far short of eternity. Just a decade after they had come in unbidden at Christmas 1979, while the west was otherwise occupied with turkey and cranberry sauce, the Russian troops had gone. The mujaheddin thought they were now poised to take the final prize, pushing out Russia's puppet regime.

'I think I should keep the beard,' Peter had protested, as they dressed him up for his walk. He had only grown it to blend in with the mujaheddin in the first place, and he was attached to it now. They had insisted. If he was to look like a Soviet technical adviser who was left over after the main forces had gone, he would have to be clean-shaven. The mujaheddin wanted the world to believe that they could operate in Kabul at will, and Peter was there to film it.

The only other figure trudging like him along the wide street was John Simpson, fifty yards or so behind Peter. The BBC's best-known foreign correspondent hunched his large frame, playing his part as another Russian adviser. He was dressed in a similar anonymous anorak, although the mujaheddin had insisted that he wear a rather loud Afghan scarf.

Peter checked himself as he came closer to the soldier he had seen from a distance standing at sentry duty. No wonder the man had been impassive. He was just a cut-out figure. Peter allowed

himself a small smile. But just ahead there was a checkpoint where the men and the guns would be real. He did not want to risk his limited Russian and he cut round the back along a side street, towards a taxi. In the front seat sat a guide who Peter recognised. A couple of minutes later, Simpson joined them, and Peter surreptitiously took the camera out of his Afghan-Soviet friendship bag.

There is a saying in Afghanistan that having the BBC with you is worth a brigade in military terms. The mujaheddin wanted to show that the city was theirs for the taking. Peter's pictures would show the extent of their penetration. But if they were caught they would probably be shot. They were risking death for a television piece.

They were nearly discovered as soon as they started. The driver took rather too eagerly to his task, breathing on the window next to him to steam it up and conceal his passengers but not looking in front of him. There was a crash as he knocked a cyclist off his bike, but they managed to get away without revealing their identity. Soon they saw the breathtaking control the mujaheddin had, allowing them to move around the city. The rebels had even penetrated the regime enough to have some of the secret police on their side. Proof came when they produced a grey Russian jeep bristling with aerials. It belonged to a commander of the Khad – the secret police who were nominally controlled by the Russians' stooge President Najibullah but had been infiltrated to a fatal extent by the mujaheddin. They drove in some style to the British embassy, where Peter filmed Simpson walking in the street outside.

Then the mujaheddin stunts became genuinely dangerous. They asked Peter to film them making a home-made rocket in a safe house, and drove to a piece of open ground near Khad headquarters to set it off. This went beyond what Peter had been expecting, exposing them to far greater risks. And apart from the

considerable danger of being arrested or shot, this episode strayed across ethical boundaries. At what point would their reporting contribute to loss of life? Fortunately for them, and indeed for the Khad people inside, the rockets missed the building. The mujaheddin were never very good at the mechanics of war.

But even a miss drew attention to them. Setting off rockets in an enemy-controlled city was not a safe thing to do, and now they had to get through the night. As they were making their way back to another safe house, guided all along by a mujaheddin commander who carried a concealed pistol, they were separated from their vehicle. They had to hail a taxi, and slumped into the back seats, grateful to be able to hide again. It was just beginning to get dark, but the taxi driver was prepared for this. He had wired his brake lights up to the interior lighting. He was proud of his beads and CDs hanging from the mirror and the sequinned upholstery covering the dashboard, and he wanted everyone to see it when he pulled up at traffic lights. Everyone could also see the two white faces in the back, in a city where nothing is a secret for long.

'They are destroying the city, these who call themselves mujaheddin, and now there is no food because of their constant bombardment.' The driver slammed his hand on the sequinned dashboard, keeping up a stream of insults against the mujaheddin for the benefit of the two 'Russians' in the back seat. He could not have known that his front-seat passenger, Peter's guide, was a mujaheddin commander. Peter could see the commander's hand move under his jacket onto the handle of his pistol, although he grunted noncommittedly as the tirade went on.

'I could never forgive them after they killed my brother.' So it was personal. The driver's hand moved reverentially to caress the green cloth binding the Koran resting on the dashboard, his hand flecked with dancing lights reflected from the CDs, which bounced as he braked again to avoid a pothole.

'How can they call themselves Afghan patriots? He was only a boy and he was not doing anything wrong, but they took him away and killed him because they said he was helping the Russians. When will it all end?'

The taxi went close by the Intercontinental Hotel. Both Peter and John Simpson had stayed there before, and they knew that there would be a few foreign journalists in the bar now, buying Afghan brandy to keep out the cold and the smell in the rooms in the badly built Soviet-era pile. The relative comfort appealed. It was tempting to go in and have a drink after the traumas of the day. But they knew it would be very messy to explain things, and they would almost certainly get their escorts killed.

The strange evening went from bad to worse as two drunken Afghan policemen stood in front of the taxi demanding to be picked up. One of them climbed in to the front, squeezing tightly against the mujaheddin commander. The other pushed Peter across in the back, and he groaned and pointed at his head, pretending he was ill. He shut his eyes although any pretence of sleep was impossible as the lights flashed on and off.

A loud Afghan argument began in the front about how the load was too heavy and would wreck the brakes of the taxi. The taxi driver may have been on the side of the government but that did not stop him berating the two drunk policemen, and the disguised mujaheddin commander came in on his side now. In a while they managed to persuade the policemen they were not going in their direction, and the taxi stopped to let them down. They lurched off into the night, still unaware that the other occupants of the taxi were a BBC crew and a mujaheddin commander who would have been a prize catch.

The next day they could not do any filming at all and were not allowed to leave the house. It emerged later that the Khad had known all along that they were in Kabul, and now suspected that

they were in there. It was hardly surprising that if the mujaheddin had penetrated the secret police, then the reverse must be true too. Their commander friend saw a Khad colonel in the street and shot him in the back of the head, just as he was about to order an assault on the house. It was time to leave. But although they left the house, they could not easily get out of the city in daylight. They stopped their vehicle at the side of the road with the bonnet open, to wait until nightfall. Despite Peter's protests, the mujaheddin even rested the axle on bricks and took off a wheel to make it look more authentic. They could not have got away quickly even if they had wanted to.

As they walked through the last ring of checkpoints the evening sky lit up with flares and tracer bullets as the government made a final effort to find them. But they got away with the pictures and their lives.

London, 1979

Peter Jouvenal did not seek out Afghanistan. It found him. When the Russians took advantage of the west's Christmas hangover and marched across the Amu Darya, the Oxus River, to take Afghanistan in 1979, he was twenty-one years old, living in London and waiting for a war. It just happened to be that one.

He had been one of those lucky teenagers who have a very clear idea of what they want to be when they grow up. He had known it ever since a master at school had shown him a book of photographs of the First World War. Peter did not focus like the other boys on the mud and the blood but thought instead of the man taking the pictures. That was where he wanted to be, in the trenches, not as a soldier but as a photographer.

He joined the army with the specific intention of learning military skills, and they taught him how to take pictures too, when he showed an interest. He even had his own dark room for

a while, and could order any equipment he wanted. He spent his last summer as a soldier hiding in an abandoned lingerie factory in Lurgan, taking pictures of IRA suspects with a long lens. When he left the army he bought a Pentax camera, because that is what they had trained him to use, and then the Russians invaded Afghanistan.

Peter took a series of buses across Europe and then into Asia, finally checking into the best hotel in town, the Pearl Continental in Peshawar, with his new Pentax because he thought that is what real journalists did, although he had no money for the room at the time. He lacked any professional experience, spoke none of the local languages, and was arrested by the Pakistani police on his first attempt to try to smuggle himself across the border into Afghanistan, travelling with some no-hope group of guerrilla fighters who no one ever heard from again. But none of that mattered. He has the only skills that really count as a foreign correspondent – the ability to live easily in difficult places, and enormous self-belief.

Within a few weeks he made his first successful trip into the war, travelling with an Italian reporter who put six of Peter's pictures on the front page of his newspaper and then lost the negatives. It was an uncomfortable baptism for Peter into the ways of the industry. Freelance photographers rely on owning their copyright; it is all they have for a pension. Peter lost control over those pictures and still sees them occasionally popping up in retrospective articles about the war, credited to some obscure Italian news agency and not to him. That experience was one of the spurs that would eventually lead to the foundation of Frontline.

Afghanistan, 1980

Peter did well at the war. As the mujaheddin fighters grouped into the factions that would ultimately drive the Russians out of the country, he made friends with young commanders who would

never forget him when they later became generals. He travelled with them on long goat trails through the hills, ate with them and slept with them under the stars. He once found himself trying patiently to explain to some fighters, as they looked up in the sky over the Hindu Kush, that Americans really had been to the moon. They did not believe it.

The Afghans made up in senseless courage what they lacked in strategic vision. It meant that many more of them died than necessary, but it also gave them an edge. The Russians quickly found themselves bogged down in an unwinnable war in hostile and remote terrain. Only 3 per cent of the land of Afghanistan can be farmed; the rest is mountains and desert. To this day high tracks in the hills are littered with the rusted debris left by the Russians. The Afghans have turned tank carcasses into walls around their fields, lined the edges of roads with shell casings and thrown the chassis of trucks across rivers as makeshift bridges.

Peter was once with some mujaheddin who were running away from Russian infantry across vine fields. The fields were divided by mud walls, and the Afghans would run over a couple of walls before taking up positions against the Russians running in pursuit, and then move on again under Russian fire. There was never much method in it, but then Peter jumped over another wall and saw an Afghan fighter who was not running and shooting in the chaotic way of the others. He was sitting, composed and ready, with a rocket-propelled grenade launcher on his shoulder, pointing through a hole that he had punched into the mud wall. He was watching and waiting as a Russian armoured personnel carrier moved slowly along the road. Peter spent the day alongside the young commander, whose name was Gul Haider, and made a friend for life.

Among the soldiers was a blond man with blue eyes who did not say much, wearing a Russian uniform. Gul Haider explained

that the blond was a Russian who had defected, and was now fighting for the mujaheddin. Peter took some pictures of him in action, winning a double-page spread in *Paris Match* for a photo feature. It earned him £800, a decent amount of money at the time.

A couple of years later Peter bumped into Gul Haider again.

'How's my Russian soldier?'

Gul Haider looked blank. 'What Russian, Mr Peter?'

'You know, Gul Haider, the one who changed sides.'

There was a moment's pause and then a deep warm laugh.

'He was never a Russian. He got that uniform from a dead man. He was more Afghan than me.'

It had all been a joke. The 'Russian' probably came from Nuristan in the north-east of Afghanistan, where people have strikingly fair skin and European features. The man was dead by the time Peter found out the deception, and *Paris Match* were never the wiser. But Gul Haider was now one of Peter's best contacts in Afghanistan, and it was a friendship that would pay huge dividends in getting access for the BBC during the American attacks in 2001.

Peter kept the friendship going through the years. 'Hello Mr Peter,' Gul Haider would say. 'That's a very nice jacket.' And Peter would give him his jacket and win access to another front line. Peter soon made friends with the mujaheddin commander Ahmed Shah Massud as well, giving him unique access until Massud was killed by an Arab disguised as a cameraman in September 2001, only days before the attacks of 9/11.

Peshawar, Pakistan, 1980

With his freelance career established, Peter moved to Dean's Hotel, which had a more shabby feel of forgotten glory than others in Peshawar and was known as a meeting place for spies. At the time

Peshawar had a heady allure. The local language, Pashtu, gave the word 'khaki' to the world, when the English turned from their red coats to camouflage after being picked off too often in their century-long war of attrition with the border tribesmen. And after Britain had finished provoking Russia across the high mountain passes in the years of the Great Game, America took over. The large American military buildings and the unusually long runway at Peshawar airport were built long before 9/11. They owe their origins to the earliest days of the Cold War, when America needed an Asian base to keep an eye on the Soviet Union. When Gary Powers was shot down flying over Russia in his U-2 spy plane in 1960, he took off from here.

It was hardly surprising that Peter should run into Dominique Vergos in Dean's. Vergos was a fashion photographer from Paris who left *Vogue* to become a spy for the CIA in Afghanistan, using war photography as a cover. Peter's first television job was assisting him on a shoot for the American news network NBC. Those were the high-rolling days of American television at its most profligate. They went into Afghanistan for a week with a budget of £50,000.

Peter never touched a stills camera again. He reasoned that people in television have no time but lots of money, and given that he had all the time in the world, he could use some of that money. He went back to London, and showed his stills portfolio to the TV-news agency Visnews, which was then partly owned by the BBC. They gave Peter a crash course on an old Arriflex film camera. At the time most broadcasters were moving from film to tape, but the early video technology was heavy, clunky and gave fuzzy pictures. Film pictures were still acceptable, especially from places like Afghanistan, and there were old film cameras lying around that broadcasters were getting rid of, so they were cheap to buy.

For a while Peter used 8mm film cassettes, which were a nightmare in the field. They lasted for only two and a half minutes, and once the film was exposed there was no rewind. The Afghan mujaheddin took their time in everything they did. So he found himself using half a cassette just for the time it took to load a mortar. But the cameras were light and easy to use.

He was learning a lot about the strange ways of US TV accounting as well. For two years he had a contract with the American network CBS. He would go across the border in the way that he likes to work – on his own. He tried to get them to pay him a lump sum for the job. But they insisted on a daily rate, and when he came back after a two-month trip they sent back his expense claim saying that it was not large enough. Apparently they were frightened that the tax authorities would ask how this crew could live on just $2,000 for 2 months, far less than any other. So Peter made up some receipts, adding $3,000 dollars, more than doubling the total claim to make them happy.

Soon Peter was living in the region for at least nine months of the year, and when he was not in Dean's Hotel he would stay in guest rooms at Afghan Aid, a British charity headed by the energetic Tory MP Viscount Cranborne, later to become the Marquess of Salisbury. He was the brother of Lord Richard Cecil, the cameraman shot in Rhodesia three years before. Cranborne knew and liked journalists and had an elegant use for them, apart from wanting to make money for his charity by letting the rooms. He wanted to have journalists around him to provide the latest gossip, the first rung of intelligence gathering. Like his namesake and ancestor who ran England under Elizabeth I, he had links with the intelligence community. He insists that Afghan Aid itself was not a front for British or American Intelligence, although everybody in Peshawar assumed that it was. It was certainly campaigning for

the same side. Cranborne knew that people like Peter Jouvenal had more first-hand knowledge of what was happening inside Afghanistan than anyone else. For him, journalists had a crucial role if the Russians were to be defeated.

Peter always knew how much money was around, seeing it at first hand when he went to pick up his then-girlfriend from a secret conference at a big house near Oxford. She was the representative of an aid organisation that had been invited, with a dozen or so others, to pitch for American cash to spend in Afghanistan. At that meeting the Swedish committee criticised Afghan Aid for bidding for cash for ridiculous projects. The Swedes backed out, choosing to seek funding elsewhere. But Afghan Aid were playing the game, knowing how much money was available without strings attached; once they had the money they could focus it on Afghan needs as they came up.

The Americans at the conference were obsessed with spending their allocated budgets. Peter remembers that when he arrived 'there were these chaps, wearing Barbour jackets and Timberland boots in the courtyard, standing out, as my old sergeant-major used to say, "like a bulldog's bollocks". I asked my girlfriend about them. "Who are they? They don't look very happy." She said, "No they're CIA. They turned up with a budget of 5 million dollars and they can't spend it. We've found projects worth only 3 million dollars!'

British agencies like Afghan Aid exploited another weakness of the American system. No agency receiving USAID money was allowed to send American citizens into Afghanistan. So there was money sloshing around for non-Americans that was not immediately accounted for. All the Americans had to do was to say that they had spent the money.

Given this context it was not surprising that there were some pretty unethical things going on in Afghanistan. It was a dirty war,

and many of the worst atrocities were carried out by the Pakistani intelligence organisation, the ISI. They took control of much of the American money, which provided them with a unique power base. They had been given a free hand in Afghanistan by the Pakistani military dictator General Zia, providing they did nothing against his government in Pakistan itself. In the circumstances the last thing the ISI wanted was free access for journalists to wander around on the other side of the border, seeing what was really going on. Incredibly as it may seem, they used some of the vast amounts of American military aid money to stage elaborate military exercises, with fighters who looked like Afghans. The fact that this was all happening on the *Pakistani* side of the North-West Frontier was not always made absolutely clear in some TV news reports. The pictures were so good. But it was a deceit that did not suit Robert Cranborne at all. He saw the war quite differently.

This Tory grandee had read his Chairman Mao, who said that a guerrilla fighter must 'swim like a fish' among his people in order to succeed. If more refugees fled in the increasingly bitter fighting, then it would make life much easier for the Russians in Afghanistan, by draining the 'water in which the fish swim.' The argument went on: Afghan rebels needed populated villages in order to move freely; those villages needed aid in order to stay alive; the aid effort would only come if there was lots of reporting from inside Afghanistan. So helping camera crews to get in was part of the war effort for Cranborne. At one point he even *advertised* for crews to go to Afghanistan. He was planning to equip them with satellite dishes mounted on mules to beam out the pictures. This was a serious plan, although many of the people who replied to his adverts were barmy. Through a friend who had retired from an intelligence research establishment he developed mobile satellite uplinks several years ahead of the rest of the broadcasting industry. It was a perfect project for the Tory

peer, a genuine business venture that might make him money at the same time as furthering his war against communist control of Afghanistan.

Peter Jouvenal was closely involved in the satellite development project and always maintained good contacts with the intelligence community, although he was never a spy. There were active attempts to recruit him by a number of services, including most farcically by the Chinese, who would come to Dean's Hotel in large delegations to try to try to buy his loyalty. His familiarity with Afghanistan and with detailed military affairs would have made him a good source. For example, he was one of the very few journalists there who could tell whether the mujaheddin he met were carrying Russian army rifles, the only really clear sign that they had won a victory over the Russians. The rifles were almost identical to the black-market guns that were otherwise available to the mujaheddin, but Peter could tell the difference. In Peshawar, a city awash with rumours and claims of victories, such knowledge was a valuable commodity.

Despite Cranborne's good friendship with General Zia, he never got the permission he needed to bring the dishes in. Pakistani intelligence officials, like spooks everywhere, were worried about the effects of unrestricted pictures of what was *really* going on inside Afghanistan being beamed up. They blocked the mobile dishes for years. Ironically the first time they would be allowed into Pakistan at all was for General Zia's funeral, after he was killed in a mysterious plane crash.

Through all those years Cranborne was part of a web of influence and intrigue which guaranteed that Afghanistan continued to play centre-stage in the foreign policy of the west and made the cause sexy in the British ruling establishment. There was a boycott of the Moscow Olympics as the rhetoric against Russia ratcheted up after Margaret Thatcher's soul-mate, Ronald Reagan, was elected

to the White House. The Afghan Aid house in Peshawar became an extension of Chelsea, and the London office filled with Sloane Rangers doing their bit against the evil empire.

That was where Rory Peck first encountered Afghanistan, bounding into the office one day, newly married and playing not very seriously at various short-lived careers. The first day he arrived he was wearing bright-yellow check trousers and a red sweater, looking a little like Rupert the Bear. His relationship with Afghan Aid lasted longer than his marriage, and when his marriage broke up, they sent him out to Afghanistan do their accounts, although this was obviously ludicrous folly to anyone who knew Rory. He had a rather shambolic antiquarian book business for a while, but he was not interested in book-keeping in the sense of making the sums add up.

Peter first met Rory at the Afghan Aid office in Peshawar and offered to take him into Afghanistan on a trip where he needed a soundman. He gave him half an hour's training, the only TV training that Rory ever had. They disguised themselves as mujaheddin, dressed in robes they bought in the market, and went into Afghanistan in the usual way, evading the Pakistani guards. Their reporter was an Italian who was later killed in Angola. Peter's camera had a fault and he pulled back from an attack since there was no point being killed for no reason. But Rory went ahead with the mujaheddin carrying a stills camera. A Russian jet dropped a bomb which fell only about ten yards away. If it had gone off then Rory would certainly have been killed during his first military operation. As it was the bomb lay where it fell, and Rory became completely hooked.

He was not a man who could tag along behind other people doing the sound, so the Afghan Aid accounts remained uncounted and he bought himself a video camera. His early pictures were wobbly and often out of focus. But somehow it never mattered,

because he had an ability to get into the middle of the action. He would never live in London again. His restless lifetime's search was over; this was the job for him. He brought a historian's eye to Afghanistan, and an inherited anti-communist stance, although, like the other Frontline cameramen, exposure to the real face of war questioned his conviction. He soon found that the distinction between right and wrong on the ground was a much more complex one than the black-and-white anti-communism he had brought with him from his native Ireland. Afghan Aid, with their strong political stance, brought him to Afghanistan. Television news would teach him to look at the world differently.

Rory's earlier commitment to the anti-communist cause in Afghanistan was inherited from his parents, a couple to whom the description eccentric does not really do justice. His mother Carola, an 'instinctive cold warrior' according to Viscount Cranborne, was from a rather grand American family, claiming descent from Myles Standish, the military leader on the *Mayflower*, himself. She turned the rescue of big old houses into a lifetime mission, remembering her own father restoring a house in New Orleans once owned by General Beauregard, the legendary Confederate war leader, saving it from conversion into a macaroni factory. (This was the ultimate indignity. She spat out the words in old age with the memory still fresh – *'a macaroni factory'*.)

When the Afghan cause came along the Peck family took it straight to their heart, holding a fund-raising event for Afghan Aid. At the lunch Viscount Cranborne was advised not to talk to one of the neighbours, 'because he is certainly a communist'. They ate scrambled egg washed down with Château Lafite, a claret that is virtually unaffordable now, but had obviously been laid down a generation before. Cranborne recalls the 'most delicious lunch I have ever had' in a rambling country house, the only heating coming from open fires as rain poured in through

the windows. There are Roman statues in the hall, a music room full of instruments in various states of disrepair, and a giant library, lined with leather-bound books in French and Russian, as well as English. The furniture has a baroque magnificence, with weapons and other military bits collected by Rory in various campaigns adding to the collections of porcelain and glassware. Among the canvases that line the staircase is a large oil painting of a man crouching among mujaheddin in a cornfield, carrying a camera alongside their guns. It is Rory, painted by his mother. She says that Rory got on with the mujaheddin 'because they were bone idle and they liked a joke. They liked him for the same reasons.'

The other key Frontline members share a background in the kind of British public schools where hardship was said to be character building, with a robust self-reliance drilled into them by that and the army. Rory's origins were far more unusual. He never really went to school at all. His parents feared that if he or his brother and sister went to school, then they might become communists. They were brought up in isolation in large rambling mansions in Ireland, in constant expectation of a Soviet invasion. Their father would read airmail copies of *Pravda* to keep in touch with the latest moves in the Kremlin, and insisted that all of his children learn Russian, giving them a head start in engaging with the new Europe that he was convinced would emerge.

Not going to school regularly did not mean that the Pecks were not educated. They were taught by a succession of more or less eccentric tutors who passed their parents' rigorous tests to sniff out communist sympathisers. Russian lessons came from a White Russian priest, which led to the consecration of an Orthodox chapel in the basement of the house. When Rory's sister brought home a boyfriend who tentatively said that he had once supported Amnesty International, he was not even allowed

to finish his dinner. He was driven instead to a local hotel since he was obviously left-wing and probably a communist.

Rory's childhood was spent first in the countryside near Dublin, before his parents moved north to the mansion in Londonderry. They were always travelling, spending their summers by a lake in Maine and part of the winter in an apartment in Monte Carlo, taking the retinue of tutors with them in the days when they could afford it. And occasionally they children would do a term in school in Monte Carlo or Maine.

The children were not taught only Russian. When Rory's father heard that NASA was making some scientists redundant after the Apollo moon programme was wound down, he wrote asking them to send one to teach science to his children, reasoning that this would be a reliable way of ensuring that he at least would not be a communist. NASA did send a scientist, although all that Rory remembered him teaching was how to maintain a car; not very well, since this was something Rory could never do. Finally the education authorities caught up with him and he did a couple of years at school, which he hated, but it gave him just enough conventional qualifications to go to a college in Florida to study oceanography, where he spent most of his time smoking dope.

After Florida he came home and went to university in Scotland. But he was restless, and dropped out to join Ian Smith's forces fighting against black rebels in Rhodesia. It was perhaps the most right-wing cause in the world, but even his conservative-minded parents thought he was mad. His brother, Colin, went with him to try to get him to change his mind, and with the aim of slowing him down. This became easier when they met a former family au pair who now worked for a modelling agency in Paris. A few evenings of champagne for the models at the Moulin Rouge ran through the money that Rory had planned to spend on an air

ticket to Rhodesia, so they took a train south, planning to go overland across Africa instead.

They moved to an ancient hotel in Egypt, where horse-drawn carriages outside the door were not there for the tourists; that was all the transport there was. It was like a place out of its time, suiting Rory and Colin exactly. The border to Sudan in the south was closed so they bought a dhow and earned a little taking passengers and cargo up and down the Red Sea for six months. Rory filled it with books arranged into a large library, and forgot about going off to become a mercenary. Having succeeded in stopping his brother going off to fight, Colin came back to Britain to arrange a university place. When he returned to the Red Sea to try to find his brother he was hailed by what looked like any other dhow captain on the wharf in Yemen one day. It was Rory, dressed as an Arab and sporting a huge beard. After swapping the dhow for air tickets home, Rory went to Sandhurst for a while to try to train as an officer in the Grenadier Guards, one of Britain's grandest regiments, but did not last the course. To them he seemed a Davy Crockett character, an untamed Irish-American. By then he was older than most of the officer recruits, and could never take the whole thing seriously. He never made it beyond Brigade Squad, the first rung on the ladder to becoming a Guards officer.

When his class graduated from Sandhurst, he went back to join them for a drunken lunch in Berkshire, and afterwards he suggested that they swim across the Thames. It was a risky dare, with genuine danger attached, since they had all drunk a lot, and there was a weir less than twenty feet away. Three of the others agreed to strip off and go in with him. One of them later went skiing with him in France, and told me that it was impossible to beat Rory coming down a mountain. Rory was not the most elegant skier, but he would cut all the safety margins on every

turn, making it a white-knuckle ride the whole way down. He used to have a lot of car accidents in those days, always going too close to the edge. Soon after he left the army, some of his friends who had become officers came to see him in the family home in Northern Ireland, although it was strictly out of bounds to serving British soldiers, unless posted there.

Rory's family were not troubled by the IRA, although when he drove his friends in a Cadillac through the Catholic districts of West Belfast and tried to get into the barracks to see his old colour sergeant, they tested the limits of the IRA's patience. The American car got stuck on a security hump on the way in to the barracks, and they had to be helped out by army engineers.

With this background, working as a freelance cameraman in an unstable guerrilla war in Afghanistan was more normal than anything he had done before. Asked to choose his perfect holiday, Rory would say, 'Dump me anywhere. I will survive.' Afghanistan suited him fine.

It was Rory who first suggested to Peter that they should set up a company together one night in Dean's Hotel. The rooms there were big and poorly furnished with solid, ugly, wooden furniture left over from the last days of the British Empire. An Afghan friend, Habib Kawyani, liked to gamble. During one of their card evenings, fuelled by locally distilled drink amid the haze of smoke, Habib and Rory dreamt up the idea of a company. Peter was sceptical. He was more established than the others, and although Rory's cavalier streak appealed, his cavalier approach to money was frightening. But Peter had a shoot coming up with a German TV company that clashed with a commission for the BBC. So the company was formed and he subcontracted the German story to his new partners. The original company, the forerunner of Frontline, was called 'VIP', although none of the survivors agree whether it stood for 'Video in Pakistan' or 'Video in Peshawar' or

'Video International Productions'. It was always just a convenient way of negotiating collectively.

Peter had learnt the hard way. At the beginning companies would say, 'You're just an amateur, here's $100 in cash.' If they worked together, then they could pool information. They knew which the big payers were and if they sold pictures to agencies they could keep track of the usage, so they knew how much they were owed. After all, they were risking their lives for the pictures. But none of them ever made serious money in Peshawar, and Rory had a habit of spending it on large parties when it came in.

They moved into No. 10 Canal Bank Road, close enough to a rather greasy canal, which Rory would throw people into if they offended him, or if they contravened the arcane rules of complicated ball games he devised. Sometimes Peter would arrive with a foreign TV crew, expecting to stay for a few days on their way in or out of Afghanistan, and they would have to sleep on the floor because the rooms were full of Rory's girls.

But behind the games and the jokes, there was always an eccentric correctness to what they did, a heightened sense of right and wrong, a feeling of what was and what wasn't 'done'. Despite Rory's willingness to sleep in a tent in Afghanistan for a month, he could get unreasonably impatient if he came back to find that someone had eaten the smoked salmon from a hamper he had brought in from Fortnum and Mason. Peter too knew how things should be 'done', surprising an Afghan who came to live in his house in Henley for the summer by his obsessive use of different polishes to clean the brass and the silver. He once turned up at a friend's wedding bearing a priceless antique teapot as a gift. The delicate porcelain survived although he was carrying it loosely in a plastic carrier bag. In the field he was always immaculately turned out, wearing the best foreign correspondent khaki in the front line, and well prepared. He was the living example of an

old British military saying that 'any fool can be uncomfortable'. When the travel writer Peregrine Hodson stumbled on him travelling with a friend in the Panjshir valley, he was startled by their supplies:

> Besides a large medicine chest, they had a mouthwatering selection of food: boxes of instant meals, including sausage and mash; beef in gravy; paella; curry; packets of soup and vitamin drinks; tins of steak and kidney pie and baked beans; porridge and honey and bars of chocolate... In addition they had a tent, sleeping bags, foam rubber mattresses and inflatable pillows.

Unfortunately a day or so after they met, they were cut off from this life-saving store house by a major Russian offensive. Peregrine Hodson counted thirty troop-carrying helicopters going overhead, which fired at the Englishmen hiding behind rocks on the ground. Their only route to safety lay through a minefield. They picked their way carefully across, hoping that the mines that they could see, thinly covered by sand, were the only ones that had been laid. Peter picked up one of the small, green, plastic anti-personnel mines that he said, with some authority, was inactive since it looked as if the firing pin had gone. He tossed it away to one side, where it exploded. He grinned sheepishly under his moustache at Hodson. 'That's lucky. I'd thought of lobbing at you for a joke.' They travelled together to safety in Pakistan, walking hundreds of miles across hostile terrain, with few supplies, all encountering sickness along the way. One night there was a loud burst of automatic gunfire while they were staying in a village where they believed that there might be robbers. Hodson recalls that Peter's head hardly lifted from the pillow at the sound.

Rory too valued courage above everything else. Although with his classical understated good manners he would never of course *claim* that he was brave himself. In one incident he narrowly escaped death after an attack by a Russian helicopter gunship. All of the mujaheddin he was travelling with were killed except for one, who was very badly injured. Rory put him on his back and carried him for a day. When he could go no further, he sharpened a Swiss army knife and laid out a makeshift operating theatre on a rock to try to get the bullets out. The young man died before he could begin to operate.

In those early days his pictures were never great. He was learning a new trade at the sharp end. The veteran BBC correspondent Brian Barron and his cameraman Eric Thirer were asked by the BBC to look him up, and met him in the back garden of Dean's Hotel one afternoon, drinking whisky out of teacups – a polite diplomatic fiction in an Islamic country to avoid getting the hotel into trouble. To Barron he seemed like a figure from another age, 'one of those gunpowder-stained Irish/British military stalwarts from the Hundred Years War.' The BBC crew looked at some of Rory's pictures, and found them frightening. In one sequence Rory was with mujaheddin forces who were taunting Russian soldiers, literally dancing among the rocks in front of them. Barron remembers his shock when he looked at the pictures, as the inevitable Russian assault began: 'In the sequence all you could hear was shrapnel bouncing off the rocks around him, but the pictures did not show anything at all – just swirling images and sky.' Most of the dancing mujaheddin were killed. Both Barron and Thirer had war experience going back to Vietnam and gave Rory some advice, particularly about measuring the balance between reward and risk. They were impressed with his ambition, but wondered whether he was getting into danger for no reason.

Rory stood out even in an industry where life-and-death calculations are made on a daily basis. He once told a friend that being shot at was 'like standing on a green at the golf course. There are lots of balls being fired at you, but none of them hits you.' No one spent more time in danger than Rory Peck, and people flocked like butterflies around him.

Peshawar was the front line in the Cold War, awash with money and guns as America paid for influence. There was lots of money too from TV companies, who were often paying for the same thing as the American spies – information about the war across the border. The city was full of glamorous, fit young men going into danger and coming out with their pockets full of cash. There were parties, but none as large or loud as Rory's parties, and there was gossip in this city where the last thing you came across was a fact, but there was no gossip as good as that heard in No. 10 Canal Bank Road.

Amid the journalists, aid workers, diplomats, spies and soldiers, they stood out: freelance adventurers, drawn to something deep in all of us, the same thing that draws people to fast cars, sky diving, Russian roulette and cocaine – the desire to explore the border between life and death. There have been cities before which had that allure, life on the edge of danger – Saigon in the 1970s, Beirut in the 1980s until the kidnapping started, Split in the 1990s. But not perhaps since Vienna in the years after the Second World War has there been a city like Peshawar.

Everybody pretended to be working for someone else, dealing in secrets in the large concrete villas that they all lived in. And among them American right-wing fanatics traded in the belts of dead Russians like scalps. The garden at Canal Bank Road filled with vintage motor bikes, and the sheds filled with antique rifles that Peter began to deal in. There were plenty about. Alongside the hi-tech weapons that the Americans gave the mujaheddin

fighting their proxy war against the Russians, there were many Afghans still using rifles that had been supplied by (or taken from) the British more than a hundred years before. Perhaps *Flashman* was still the best book to take in your luggage to the Hindu Kush.

And mixed into the strange cocktail of sex and espionage in the air in Peshawar was the presence of genuine danger. As well as the war itself going on in Afghanistan, there were private wars being fought in the back alleys of Peshawar on this side of the border. The Afghan Aid office was managed by Juliet Crawley, who was cast from some empire-building mould left over from another age. She married the French photographer and spy Dominique Vergos, the man who had first taken Peter into Afghanistan for television. His spymasters now told him he could no longer work for them because he was married. Soon they had a son, and Vergos began a project for the UN Refugee agency, mapping Afghanistan in preparation for refugee returns, if they should ever be able to go back.

But his past caught up with him. When her husband was shot dead outside their house one night, Juliet refused to believe that it was the chowkidar, the watchman, who had done it. There had been a curious warning from the French embassy a couple of weeks before that his life might be in danger.

The first that Juliet's boss, Viscount Cranborne, knew of it was when the phone rang in England on Boxing day. It was Juliet, his key asset in Peshawar, with news of the murder, which had happened only hours before. The words on the crackling phone line broke through the genteel rituals of his country Christmas.

Given his involvement in the region, it was not a matter of if but when something like this happened to someone on his staff. Cranborne himself knew the risks of living in Peshawar as well as anyone; he knew how close death could be even if you were not the target, as Juliet's husband Dominique clearly had been. After

he had put the phone down, his mind went back to the his own brush with death a few months before, when he went to meet an Afghan professor, a friend who managed to combine a liking for whisky with the faith of his nation with no problems. Cranborne was three-quarters of an hour late for the meeting, and arrived to find that his friend had been shot dead. He believes that if he had been on time he would have faced the same fate. He shares Juliet's belief that the Afghan secret police, the Khad, killed Dominique Vergos.

The police arrested the chowkidar – that was the easy bit – but Juliet could not see how he had jumped out of the window and shot Dominique in the back of the head before jumping back in again, which was the police version of events. She refused to have him prosecuted and instead called for a traditional meeting of elders to decide his fate. They decided he was guilty, and offered her the opportunity to shoot him or take blood money. Of course she did not shoot him, and they ended by slaughtering a sheep and having a feast. But she did not give up.

She pursued the case as far as the secret-police headquarters in Kabul, but found nothing of any value, arriving as the then conquering army was burning bale-loads of documents in front of her. For a while a key Pashtun leader, Abdul Haq, was helping her out. He was the Americans' first choice to take over Afghanistan after the Taliban, but they bungled his return and failed to protect him from the Taliban, so he was quickly killed. Juliet never found out what really happened to her first husband.

II
INTO THE ULU

*In my time every healthy young man preferred the ulu to the town,
not merely because he found the life more attractive in itself, but
also because it offered greater chances of promotion.*
['Ulu', Malay for 'head' or 'upper part', is British military slang
for bandit country, the jungle, or interior.]

R. H. Bruce Lockhart, *Return to Malaya* (1936)

The North-West Frontier, Pakistan, September 1989

After discovering John Gunston still asleep with a hangover at
11.30 in the morning, Rory Peck locked him in his room and
went out to lunch. Gunston never let anyone forget that he was
a direct descendant of the Duke of Wellington. He could not
have been further away from Waterloo now in Peshawar on the
North-West Frontier. The region still bore the 'frontier' name left
over from the time when this was the farthest reach of the British
Empire. Britain had tried and failed to subdue Afghanistan for
more than a century, but they never succeeded in pacifying the
Pashtuns, Kipling's 'wild and dissolute' people. Even today the
administration of Pakistan's 'frontier' territories remains outside
central government control – the beginning of the patchwork of

patronage of tribal leaders and warlords that extends west across to Afghanistan.

Peshawar was like a town at the centre of a permanent truce: not at war, but never quite at peace either. Guns, drugs, people, oil, televisions, fridges, bicycles, ideas – all flowed across the deserts and mountains that divided Afghanistan from Pakistan at the North-West Frontier, and they were traded in the tea shops in the dark alleys of the old town in Peshawar, as had always been done since Alexander the Great himself passed this way.

The Afghan border was a fiction drawn on a map by Sir Henry Mortimer Durand, a British colonial administrator in a hurry in the 1890s. It ran through areas that had been in the hands of powerful Pashtun clans for all recorded time. They knew what they controlled – to them the international border was a passing fancy, which they could cross at will. And now, in the decade since the Russian invasion, Peshawar had become surrounded by more than a million Afghan refugees: some rotting in tents in giant camps, but many filling the streets and alleys of the town itself, a constant reminder of the war across the border. A century after humbling the British Empire Afghanistan was the graveyard of Russian ambitions too. But defeating the Russians was only the beginning of Afghanistan's agony. It would be a while before the refugees could return home; after the Russians left, the mujaheddin fought among themselves over the spoils. A messy, complex guerrilla war ground on in the mountains, while the Russian-backed government clung stubbornly on in Kabul.

Rory strode into the wide yard in the front of No. 10 Canal Bank Road, picking up a dusty 50-year-old 'Matchless' motorcycle from the scrubby grass and kicking it into life. He felt the still-warm air of late summer on his thinning hair as the big single piston thudding up and down announced his progress along the track beside the dark waters of the canal, weaving through the

fruit sellers, and stray dogs and auto-rickshaws, kicking up the dust on his way to Dean's Hotel.

The sun was shining in Peshawar, but it would be getting cold up in the mountains now. His business partner, Peter Jouvenal, had already gone off into Afghanistan on a long trip. He had to get in too. There would be just time perhaps for one more long trip before the snows closed down serious campaigning for the winter. And if Massud got off the pot and did what he had been promising for months – taking on the government forces in Kunduz – then that would be a story. Rory calculated the possible earnings: CBS should be good for £5,000, and the Germans too. He probably would not get more than £1,500 from the BBC. Cheapskates! But if the French came in for the same, then that would total £13,500. Not bad for a month or so. He did not want to go away for longer, certainly not as long as the epic forty-seven days of his previous trip. His recent memories were too good: of a certain girl he had just met at her family's ancestral castle on the Borders, days spent at the Notting Hill Carnival and nights bedded down on the kitchen floor of his brother's tiny flat in Notting Hill, while his Afghan assistant Mohammed Gul, who travelled everywhere with him now, slept on the sofa.

He propped up his motorcycle just inside the worn gates in the once-grand entrance drive of Dean's, clapping the doorman on the shoulder and exchanging a word as he walked in. He had an unusual arrangement with him and with the doorman at the grander Pearl Continental up the road. Rory would give them a tip if they redirected likely-looking backpackers towards his rooms in Canal Bank Road rather than letting them check into the hotel. Likely-looking usually meant pretty and female.

Today though he had business and not pleasure on his mind, although with Rory the two were always closely linked. Anatol Lieven of *The Times* had some news.

'Well, Tony got in at last.'

'That's good,' said Rory. 'He deserved to succeed after the going-over he got last time he tried. The brutes! Police are the same the world over.'

It was a game. The Pakistani police had orders to stop western journalists crossing into Afghanistan. But they could not police the whole border and with just a little bit of luck, and the right guide, you could usually get through.

'Tony should not be that far ahead of us if we set out soon.'

Tony was Tony Davis, an imaginative and engaging Australian freelance reporter, who was then spending several months of every year in Afghanistan. His command of Dari, the Afghan dialect of Persian, was a really useful tool in the mountains. The other man at lunch, Steve Levine of *Newsweek*, was another serious player in Afghanistan. They had travelled with each other often, trusted each other and shared contacts and stories.

Going back in would certainly beat the last piece Rory had shot, a bizarre meeting between Native American Indians and Afghan leaders in one of the foetid, sprawling refugee camps housing a million people on the Pakistani side of the border. The Native Americans had come in full dress – feathers and all – to see how the Afghan 'tribal structure' had survived in exile. Rory filmed them sharing a pipe of peace, and noted on the shot list (the written description that went with the taped report) he sent to broadcasters, 'It was all very amicable and no doubt beneficial to Afghan–Indian relations.'

The day after the lunch he was in Chitral, still on the Pakistani side of the border, but geographically at least now in sight of the never-ending mystery of the mountains of the Hindu Kush, striding westwards across Afghanistan. Rory led the others on a walk up a mountain near the hotel, shaking out the cobwebs after a month of drinking and smoking too much in London. He wrote in his diary:

How I dislike London except for short bursts and benders, when one should go completely wild before disappearing back into the ulu. It is the extremes of civilisation and primitiveness which keep one on one's toes but of the two I prefer the wilderness. Somehow one never really feels lonely in the wilds, which is not true for cities. One can never really be at peace there. But when one is surrounded by mountains, ruins, trees and the odd passing goat, one can achieve complete happiness.

Rory reached the top of the hill first, of course. He had a sportsman's instinct to compete to win. The family photograph albums, from his childhood in the backwoods of Ireland and Maine, are full of pictures of him doing things like breaking the ice in the winter to go for a swim. The rule in Maine was that you were not allowed to bring any food in when you went to stay. All you ate you had to catch or shoot. It was an upbringing that encouraged self-reliance. As a teenager Rory would play a game called 'cuckoo', which involved standing in a totally dark room and calling 'cuckoo', then staying still while his brother, Colin, tried to shoot him with an air pistol – perfect preparation for Afghanistan.

Afghanistan, September 1989

At nightfall they slipped past the Pakistani sentries, accompanied by guides who did not mind whether their customers were carrying opium or hashish, or Korans, or guns or cameras and notebooks, as long as they paid. They walked for sixteen hours across two high mountain passes – one at more than 14,000 feet, a height that makes the uninitiated light-headed and short of breath. Rory recorded the heights on a Swiss altimeter that he always wore. Their guides pushed on, although the pace was too great for an

Afghan translator, who Rory immediately sent back. He did not suffer the weak or foolish, and he knew something about what he was doing now; this was his thirty-fourth trip into the ulu.

The next evening they settled into a *chaikhanna*, literally 'tea shop', a great Afghan institution. About twenty mujaheddin fighters lounged around on the high, carpeted platforms, being served greasy goat and rice by boys who walked along the narrow passages between the platforms. The raised areas, made of hollow clay, were kept warm by hot air currents flowing from a fire that burned at the end of the of the corridor. There was no other furniture. While they ate they talked of a recent attack that had left three of their men dead. Rory had a habit of distilling sophisticated analysis down into simple truths. In his world view, the Jamiat-i-Islami, who he was travelling with, were 'good chaps' and the Hezb-i-Islami, the rival mujaheddin who had attacked them, were 'bad chaps'. The 'good chaps' had taken a bad hit a couple of months previously too, and they retold the tales now, over green tea, of how thirty of their key commanders had been killed by the Hezbi on their way back from a conference of war, which had been designed to form an alliance of all the mujaheddin to rid the country of the communists. The 'bad chaps' had gouged the eyes out of one, cut the nose off another and the ears and lips from a third, before shooting them all. The war had removed all limits of civilised behaviour. And these men were supposed to be allies.

Rory had his own reasons to be fearful of the Hezbi. While he was working with Afghan Aid, before he became a cameraman, he would often go into mujaheddin-held territory as a courier, bringing in very large amounts of money for the cause. On one occasion he was held by Hezbi guerrillas ('bad chaps') when he was carrying three-quarters of a million dollars in packs on the back of a mule. He was lucky to be rescued before they found

the money. And only a few months before going on this trip Rory had faced his most dangerous ordeal in Afghanistan. Again he had been travelling with Anatol Lieven, along with another TV cameraman from an American network. By now there were a large number of Arab fighters in the field, since defeating the Russians in Afghanistan had become a jihad, a holy war. The Americans were happy to sponsor the mujaheddin, whose name means 'holy warrior', in an act of epic short-sightedness that would come back and hit the American homeland on 9/11. Even back then, in 1989, the Arab fighters could be hostile to foreign journalists, particularly cameramen.

When Rory bumped into the Arabs that summer they were particularly edgy, because they had taken a lot of casualties and believed that TV coverage of the war was giving away too much information to the enemy. Rory found himself separated from the other two journalists, away from any of the more friendly mujaheddin he had been travelling with, and facing a hostile Arab – a short man who shouted at him for several minutes, close enough to shower him with spittle. After haranguing Rory he fired his Kalashnikov at him from very close range. Rory thought that it must have been a blank, since he felt just a light peppering from the blast on his arm, but it might have been a live round that missed. It was time to respond if he was to save his life. Rory grabbed another of the Arabs by the throat and shouted at him. But it did not subdue them; they had the guns. The situation began to spiral out of control as the short Arab ordered one of his friends to mount a machine gun on a packing case, pointing directly at Rory's chest, and then shouted at Rory again, telling him that he would be shot if he did not renounce Christianity and embrace Islam. The short Arab stood inches away from his face, bellowing 'Say it: *La illaha il Allah, wa Muhammed rasul Allah* [There is no God but God and Mohammed is His prophet].' Rory

knew that in the mind of a Muslim he had only to say this three times to become a convert to the faith.

About a hundred yards away there was another group of mujaheddin who he did know, and he calculated that what he was facing was just mental torture. Surely they would not actually shoot him. He tried to ignore the shouting, got up slowly and said in English, 'Enough is enough.' Then he walked slowly away, wondering all the way if he had called it right or whether they would carry out their threat. That hundred yards was the longest walk of his life. But he made it, reaching the comparative safety of the other group. He was ordered to leave, but warned that if he ever came back to Nangahar province, then he would be handed over to the Arabs.

When Anatol Lieven reported the incident in *The Times*, it sounded as if Rory had done what he had been ordered to do, and recited the key Koranic verses. Rory wrote a letter to the paper, indignantly denying it: 'having been brought up in the Church of Ireland I intend to continue in the Protestant faith.' Now a few short months later, he was back in Afghanistan, and not far from Nangahar, the very place where he had received the specific threat to his life.

After eating cross-legged with the mujaheddin in the *chaikhanna*, Rory pulled out his sleeping bag and slept on the same raised platform, kept warm and dry by the underfloor heating. He was back among his people.

The following day they bumped into Ahmed Shah Massud by chance. The mujaheddin commander had built a legendary reputation for keeping the Russians out of the Panjshir valley. Seven times their armoured divisions had entered the long steep-sided valley, guarded by a very high mountain pass in the north, and a narrow twisting entrance in the south, where even tanks and other armoured vehicles were at the mercy of Afghan defenders

firing down from the crags above, since the Russian tank guns were unable to elevate to engage the Afghans. Every time the Russians came in they retreated in disorder after losing hundreds of men, leaving the valley floor littered with damaged vehicles. The Massud legend was built up particularly by the French press; he spoke French, but very little English. Rory was not a Massud groupie but did admire the short wiry Tajik, and thought him to be the only really decent Mujaheddin commander. Over breakfast of cold chicken, sweet biscuits, and hot milk, a rare luxury, Massud said that the long-planned assault on Kunduz was only days away. They had come at the right time. Leaving Massud, Rory went ahead to Taloqan, the regional headquarters of the Mujaheddin, where the assault would be led from.

The days there quickly became routine. In the mornings he would try to get the latest intelligence guess on when the assault would start; in the afternoons he would go fishing or play football with the Afghans. In those far-off days, before the total destruction of Afghanistan in later fighting between the mujaheddin, there were other pleasures to be had as well even in wartime. While waiting for the offensive, Rory went for a bath, stooping to enter through the low wooden door of the communal bath house, built that way so that the heat did not escape. As he entered he was immediately struck by a blast of hot, humid air. Leaving his boots in the pile by the door, he strode into the changing room. He was surrounded by Afghan men covering themselves in towels while they wriggled out of their clothes, careful not to expose any more of themselves than was necessary. By the time Rory was in the hot room itself, his body was streaked with lines of sweat, coursing through the entrenched grime. He lowered himself into a hot tin trough, sloshing the dirty soapy water onto his skin. Then came the most invigorating sensation – a shower with cold water. And all the more pleasurable for the rugged demands made on them

most of the time. After a haircut, he had a massage, one of the greatest pleasures for cameramen, who always suffer from bad backs. His mind went back to better massages, in better places: *the Afghans seem to consider the cracking of every bone in one's body sufficient, while the Turks excel at it. The Swiss are scientific. But the Thais cannot distinguish between eroticism and massage – it is a very fine line indeed in the East.* Melons and sweet black tea followed – small luxuries went a long way in the Hindu Kush.

The area they were in had only recently been taken over from the communists, and the market stalls were still full of flowery knee-length dresses left over from those days. But no women were buying these now. Rory witnessed the first appearance of the burqa in the north, the coverall sack of clothing with just a grill for the eyes, which was later to be seen in the west as a symbol of oppression when the Taliban imposed it. One morning he filmed seven criminals being paraded through town with small items, radios and a bag, hanging round their necks. The Police chief told him that they were on their way to having their hands cut off. These visible signs of a new, more conservative and hard-line Islamic rule under the mujaheddin challenged his role as a journalist. This was years before the Taliban, who were easy to demonise because they took things to extremes.

The western press were broadly sympathetic to the mujaheddin in the 1980s. But if western help, egged on by the considerable exposure that the war was getting on television, was going to result in a worse society for Afghans, then questions had to be asked. Pictures of people having their hands cut off reflected badly on Massud. Rory knew that as a journalist he had an ethical responsibility *not* to filter out things that happened to be inconvenient for people he liked. He went ahead and filmed the material, apprehensive that things were changing for the worst. One night the mujaheddin brought in a generator to run

a projector for a film show. They put on an Arabic film about the persecution of early Muslims. The believers were staked out in the sand and defiantly recited, *'La illaha il Allah, wa Muhammed rasul Allah'*, while they were speared to death in gory detail by heathens. It brought back memories for Rory of his own brush with the fundamentalists chanting those same words just a few months before. The film was in Arabic but the message was clear to the Afghan mujaheddin. They were being hardened up for martyrdom.

While filming in the bazaar one afternoon Rory bumped into Tony Davis, the Australian freelancer. Looking like just another bearded Afghan, dressed in the local dress, Tony called out in the local language, and it took Rory a moment to recognise him. Over dinner of nuts, raisins and kebabs, they plotted a trip up to the north to the Oxus River, the border with Soviet-controlled territory. Ever since he was a boy Tony had dreamed of swimming across the Oxus. He had nearly made it as a student, travelling in that forgotten Afghanistan in the days before the Russian invasion, but a policeman had stopped him. Even then, when a king ruled Afghanistan, the river was off-limits. Now, in the lull before Massud's expected big push, they planned a trip north to have a picnic on the banks of the Oxus. It would be the opportunity that Rory had been waiting for to drink the bottle of Californian Chardonnay he had kept at the bottom of his rucksack since the start of the trip, and there was journalism to be done too. Pictures of the Russian border posts on the other side of the river would be valuable.

There had been an unstated agreement on both sides of the river for a few years then that fighting across it would be counter-productive. In places, as the Russians withdrew, they arranged local deals with the mujaheddin, even giving them weapons to patrol on their side of the river. The consequence was that even

though the mujaheddin and Russians could often see each other clearly, they would rarely engage each other. On the couple of occasions that the mujaheddin had used rockets or other weapons to attack Soviet positions the retaliation had been so big and so destructive that it had the desired effect of preventing other attacks.

But that did not stop the mujaheddin from trying to influence events north of the river. When Rory and Tony got up there, they discovered another far more serious reason than a picnic to go to the river. There had been stories around for a while about Islamic anti-communist propaganda being printed in Afghan refugee camps in Pakistan, then smuggled across Afghanistan and ferried north across the river to convert the neighbouring Soviet republics, Tajikistan and Uzbekistan. Rory was fascinated by the tale, drawn to the drama of the ideological confrontation, the insertion of an ancient creed from here into the soft underbelly of the Soviet Empire. A commander on one stretch of riverbank later told Tony that in good years they successfully sent 3,000 books a year across, along with audio tapes. He said that the clear aim was to foment Islamic revolution. 'Once the people there are prepared for sacrifices against the Russians, I can freely give them military assistance.' Few then foresaw the damaging effect that a narrow and violent view of Islam would have on history. The books were short propaganda texts, printed in Russian, with titles like *Islam – Opinion of the People*'. And with them were copies of the Koran printed in Russian.

At the river bank they hid behind some reeds, filming a Soviet border post on the other bank about 100 yards away. Sometimes soldiers were visible, but mostly they walked protected behind reinforced concrete, just in case any mujaheddin across the river were to break the unwritten terms of the non-firing pact. There was a substantial military presence, with armoured vehicles

moving about. The Soviet military machine can hardly have predicted after their invasion of Afghanistan that there would be hostile Afghan fighters on the border of the Soviet Union itself ten years later.

Disappointingly there were no Soviet flags flying, which Rory knew would reduce the value of the material. The authenticity of TV pictures from Afghanistan was now more important than ever, since some dreadful examples of fakery had recently emerged on American networks. It made the material shot by the genuine free spirits like Rory even more valuable, but it meant that they had to be more careful to provide convincing evidence that it was real. Since they often travelled on their own, they were open to charges that they had faked it.

On the way back from their first trip to the river a pheasant flew across the road and landed in a wheat field nearby. It did not know that it was about to become part of a British country ritual, as Rory borrowed a Kalashnikov and recruited Afghan gunmen to beat the field to bring it over him. The cry of 'Hi Cock! Hi Cock! Up, up, up, up!' was heard in those parts for the first time, and he had a shot at it. But unfortunately the assault rifle was not built for the job like the shotguns of his youth, and there was no pheasant for dinner.

On the day of the book-smuggling operation, Rory and Tony Davis first headed up to the river bank for their picnic. There was a little discussion since the day they chose was Friday the 13th – superstition plays some part in the complex matrix of factors that make up risk-taking in a war zone. They decided to go, in spite of their concern, slipping away from the mujaheddin when they arrived, and enjoying the exquisite pleasure of a swim in the cold waters of the Oxus, just out of sight of a Soviet post on the other side. They went about half way across, feeling rocks underfoot; it was not very deep. Then they sat back in some reeds, hidden

from the mujaheddin and drank half of Rory's wine, which they had decanted into a water bottle. The effect was magical after the protracted absence of alcohol. They were in a carefree mood; home felt a million miles away. Suitably relaxed, Rory suggested that the banks would be full of gold, and he spent an hour or so sieving the mud, gathering a few specks of gold and shouting, 'I am rich.' They could not easily discard the empty wine bottle anywhere on shore without being found out, so they put a little message in it, which read:

> So Ivan you failed,
> To conquer these Afghans,
> We came to your river,
> Swam in its waters –
> Drank of them,
> Took of your gold
> And lifted our fingers.
> We will come again
> When your Empire crumbles.

They threw the bottle far out towards the middle of the river, following its progress for several minutes as it disappeared in the dark slow-moving waters, making its way towards the Aral Sea.

Later that day the book-smugglers were ready to go. Their boat would have been familiar to their Stone Age ancestors crossing the same river – six inflated cow-skins bound together under a framework of saplings, which made a flat and quite stable platform. Seven of the mujaheddin were planning to cross: four to hand over the books to their contacts, who were supposed to come out of a small wooded area that they could see on the other side, and three others to row the boat with makeshift paddles. The operation went wrong almost as soon as it had begun.

On the first crossing they dropped their boxes of books, and then rowed their ungainly craft back across to Afghanistan. Rory went on the second crossing to film, but as soon as he landed on Soviet soil, there was a shout from the other bank: 'There's a foot patrol of three soldiers coming down the road.'

The watcher, another journalist, had been scanning the Soviet side with binoculars. The mujaheddin and the books disappeared into the woods. The boatmen seemed to be at a loss as to what to do. Rory ordered them to head back to the Afghan side, aborting his plan to follow the books into Soviet territory. He reached the Afghan bank, and lay concealed under long grass with the others, waiting for shots. Tony took a pair of binoculars from the Afghan soldier lying next to him, who was murmuring 'Allah, Allah, Allah!' under his breath, and tightening his grip on his rifle. It was almost evening, but in the fading light Tony saw around fifteen soldiers climbing out of the back of a truck, which the first patrol had called in as reinforcements.

Even if anyone had missed the first patrol arriving, the dark cloud of dust kicked up by the truck announced the Soviets' arrival. And they came with an unhurried sense of professional purpose, dividing into two groups. While one group sealed off the rear of the strip of trees concealing the exact location of the book gang, the others scrambled down the bank into the river, splashing out into the water to hold a narrow strip of sand that formed a beach between the river and the undergrowth. The commanders began to call their troops back, clearly concerned in case one of them should open fire and provoke a firefight. Rory and Tony could only watch in horror as the four Afghan fighters were led away.

They did not speak much that night, since they were guilty about their own role in the debacle. Tony Davis said only, 'It was a festival of military incompetence. There were no spotters up

or down the road, no abort plans, no controls.' There was also a question over the timing of the raid. The smuggling was usually carried out under the cover of darkness, but the mujaheddin had decided to do it in daylight, since they knew it would look better on camera, although Rory and Tony had never asked them to change their schedule. They all knew the fearsome reputation of the Russians for their cruelty to captives, and they feared for the worst, although, as Rory noted in his diary, they hoped for the best 'as men do, even against all odds.'

They discovered years later that the book smugglers had got away with their lives, although they were beaten up and jailed for a while. A couple of days later, back in their main base at Taloqan, the cloud lifted only when Rory procured a bottle of vodka from a shopkeeper he had chatted up weeks before. The man was taking a big risk, since in the new climate of Islamic austerity owning alcohol was about as bad a crime as there was. Now that he was compromised, Rory decided to ask him if he could bring in a prostitute, but she never materialised. A New Zealander, Terence White, nicknamed Cold-Steel White, had now joined them. He was later to become famous for recovering from the most appalling wounds after being blown up and returning to work in Afghanistan, such was the magnetic appeal of the country, its people and the story. (The day he was injured was another Friday the 13th. Tony Davis, remembering his own bad luck on the river, told him that he had been crazy to go out that day.)

Within a few days there were eleven journalists in town, all waiting for the promised offensive, and mutual suspicions and enmities began to intrude into the air of general trust among friends that had existed up to now. It was a large gathering; most were old Afghan hands, drawn like Tony and Rory to the military romanticism of the story and the ways of the people. But some were young hopefuls, interviewing every Afghan in town.

Christophe de Ponfily, one of the French journalists who had done most to create the legend of Massud, arrived in some style with a personal assistant, guiding a Swedish TV crew around the intricacies of the story.

Nothing much has changed in the way journalists from rival news organisations behave since the days of William Boot, the accidental hero of *Scoop,* Evelyn Waugh's comic novel about the 1937 Abyssinian campaign. Every private soldier may carry a Field Marshall's baton in his pack, as every classical ballet dancer has a secret ambition to be Fred Astaire, but for foreign correspondents there is only one piece of essential luggage, and that is *Scoop.* The absurd good fortune of the hapless correspondent Boot, plucked from obscurity on his 'Lush Places' nature column and sent to the front line, seems to strike a chord. He gets the scoop because he does not know the rules of the game, and when the more experienced journalists move off together as a herd, each needing to keep tabs on the others, he stays in town and is the sole witness to the coup mounted in the capital.

Now as then the herd is good for comfort, gossip and sharing drinks in an alien land, but it is also there for job security. Of course it is great to have an exclusive, a scoop, a distinctive story. But the chronic fear that wakes journalists up in the night is not the fear of missing the scoop but the fear of *not* having the same story as everyone else, *not* matching the opposition. Rory had always been generous about sharing what he knew, and had high expectations of similar honourable behaviour on the part of other journalists, which were constantly disappointed. Once the number of journalists reached a critical mass in Taloqan, with little news to report, reality began to drift and events occurred that were manufactured for some press facility or other. Rory now had a bird's-eye view, since he and some of the others had moved into rooms in a makeshift mujaheddin press centre, where there

was a balcony, so they could sit outside without being pestered all day by small boys crying, 'Hello, Meester! What ees yourrr name? How arrre you? Dollars, baksheesh.'

There were troop movements, but no one knew whether they had been staged for the cameras or were for real. One day, in an incident straight from *Scoop,* Rory filmed the movements of some armoured vehicles that turned out to have been laid on for an unclubbable American journalist, who had been trying to work outside the pack. In the event, the American was not even there to take the pictures himself, and was furious when he found out that Rory had taken *his* pictures, complaining to Massud about bad practice. It would have been funny if it had not been in the middle of a war.

The staged manoeuvres were all they had to film; the real war seemed to have stalled for now. Tony Davis suggested a press meeting every morning to iron out any more disagreements over access, and the American, all wounded innocence, agreed. One night they drew lots for the exact time and place of the offensive, with a prize of $100 at the bar of the American club in Peshawar to the winner. But it began to become obvious that there would not be serious action before the winter. Rory had been on the road for more than a month; the illusory offensive was looking less attractive than the certain pleasures of Notting Hill. By now he had reread Graham Greene's *A Burnt-Out Case*, and was on to *War and Peace*, a sure sign that it was time to leave. The book played to his patrician sensibilities, and he wrote down Tolstoy's thoughts on the different characteristics of European nations, reordering the original, of course, to put the English at the top:

An Englishman is conceited on the grounds of being a citizen of the best-constituted state in the world, and also because he as an Englishman always knows what is the

correct thing to do, and knows that everything that he does is indisputably the correct thing. The Frenchman is conceited from supposing himself mentally and physically to be inordinately fascinating both to men and to women. An Italian is conceited from being excitable and easily forgetting himself and other people. A Russian is conceited precisely because he knows nothing and cares to know nothing, since he does not believe it possible to know anything fully. A conceited German is the worst of them all, for he imagines that he possesses the truth in a science of his own invention, which is to him absolute truth.

He filmed a military parade by the mujaheddin. The pictures show men marching in a curious style, 'LEFT, RIGHT, LEFT,' then a long dragging 'CLANG' with the right foot. It looked as if they would be running out of right boots first at this rate, although there was no sign that they were doing much drill; they were just going through the motions of becoming a proper army as they made the difficult transition from guerrilla force. They could clearly take ground now for the first time, but were not strong enough to hold it, if the communists cared to hit them back. It would be some time before they could take and hold the northeast, let alone move on to Kabul.

To break up the monotony he and Tony Davis had their pictures taken by one of the roadside photographers who used a technology unchanged since the early days of photography. They had simple wooden boxes mounted on makeshift tripods with a small hole through a piece of glass at the front, covered by a cardboard disc. The one chosen by Rory was rather more ambitious than most, in that he took his portraits indoors, with an ancient, spluttering generator providing intermittent power for a light. As they posed, the photographer lifted the cardboard disc for less than a second

to expose a piece of chemically treated paper, but it took several attempts to make a long enough exposure. In the picture, Rory is wearing a cotton shirt under braces and a hat of the sort that no one has worn since the 1950s, except in *Raiders of the Lost Ark* – the sort of hat he might have picked off a peg in the family's rambling Irish mansion before setting out for Afghanistan. He is looking out from under the brim with an enigmatic smile peeping through a fortnight's stubble, while Davis looks every inch the mujaheddin commander next to him, wearing an Afghan *pakhool* woollen hat, and a big cotton black-and-white check Afghan scarf. Rory wrote a little story on the back of the print, about 'an isolated post in Turkestan commanded by Tony (Beau) Davis which was attacked by hordes of Turkomen. In the finest PC Wren tradition Davis props his dead men up as dummies, and the relief force arrived too late. I was the ace reporter from the *Chicago Daily Star* whose record of the defence was the basis of the legend. There were no survivors.'

After having the pictures taken, Rory decided to go into a neighbouring town held by the Hezb-i-Islami, 'the bad chaps'. He and Tony argued their way across several checkpoints to get there. The town was much less stable than the area under Massud's direct control, with a feeling that the Russians could be back any time. The Hezbi were smuggling books across the river as well, and Rory went back up north to a sector they controlled, but never joined them on an operation; the whole place seemed to be much more threatening. The Hezbi told them that when the Russians withdrew, they sold off Afghan soldiers who had supported them to mujaheddin along the way. The price was 5,000 afghanis (£7) for an officer and 1,000 afghanis (£1.40) for a soldier – not much for a life. The Russians took hashish if the mujaheddin did not have money.

But they were running out of things to film; it was time to go home. They told Massud that they were off, and he did nothing

to dissuade them; his promised attack seemed to be as far away as ever. Getting back out was even more hazardous than getting in, since the Pakistani police had by now been promised a bonus for stopping journalists. Rory and Tony decided to do it as lightly as possible, travelling at speed, getting their horsemen up before dawn and virtually jogging across the passes. Tony had a personal rule that he had to be out of Afghanistan by 31 October, since after that time the northern passes could be closed by snow. They made it across the border on the night of the 31st, despite Rory suffering from a recurrence of malaria, 'minnows through a tuna net' in Tony's words.

At the end of his thirty-fourth trip into the ulu Rory Peck went straight to the American club in Peshawar with John Gunston and got very, very drunk.

III

WAITING FOR THE MUJAHEDDIN

The British public has no interest in a war which drags on indecisively. A few sharp victories, some conspicuous acts of personal bravery on the Patriot side and a colourful entry into the capital. That is The Beast *Policy for the war.'*

Lord Copper's advice to the new war correspondent
William Boot in Evelyn Waugh's *Scoop* (1938)

Henley, England, 1989

'Come over to my house in Henley,' Peter said. 'There's someone I would like you to meet who has a plan for getting the pictures out.'

Eamonn Matthews was a producer for *Panorama* – young, innovative, hungry and planning a film about Afghanistan, which no one then knew would take most of the next year, and almost cost them their lives. When he went to Peter Jouvenal's house on a Sunday afternoon he met Vaughan Smith, who was standing next to a new microlight in Peter's garden. Vaughan put on a salesman's patter.

'It's a wonderful thing. Completely robust. You will have trouble

getting your pictures out quickly because there's no satellite. This is the answer. It's what you need. I'm your man.'

Vaughan and Peter went up for a demonstration flight, but Eamonn shook his head as he looked at the slow craft circling low over Henley. This was a non-starter. Anyone would be able to shoot it down with ease.

As they landed, the microlight hit a bump in the grass, bounced and crash-landed with its nose stuck into the Jouvenal ancestral lawn.

Eamonn ran forwards, rather concerned, thinking he would be calling an ambulance.

But Vaughan scrambled out, flipped the plane upright, and after replacing the propeller, said,

'No serious damage done. The thing about microlights is that they are very robust. That just proves it. Your turn!'

And Eamonn strapped himself in for a spin over the Thames, although he had firmly decided that *Panorama* would not be using microlights. It was his first taste of the founders of Frontline, and his first impressions were very good. 'They were completely unconventional, and really pushing and looking for new ways to do things. Where other people would have rejected the idea of a microlight in a war zone out of hand, they thought they might as well check it out and have a bit of fun along the way.' He was perhaps lucky that it was a hot day, and he didn't go inside the house. Peter kept a skull under a chair in the living room, which he would occasionally produce for effect. He called the skull Henrietta.

Vaughan had only recently left the army after eight years in the Grenadier Guards. His first job as a civilian had been as a test-pilot for microlights, working for the father of an old army friend who was trying to market them for military use. But Vaughan was not the best demo pilot to secure sales. On his first demo flight,

from a heliport in Thailand, he fell off the edge. He had seven crashes in all, including once being stranded high in the branches of a tree in Germany. Not only could he not climb down, but also had to hang there, powerless, as he watched the horizon fill with a fleet of ambulances and fire engines heading towards him across the fields. They had been summoned after a British officer out shooting in the woods called for help. Somewhere along the line, the key word 'microlight' had been left out; the emergency services thought since they were responding to the crash of a '*Flugzeug*', an *aircraft*. The German authorities sent Vaughan a bill for £2,000.

He had met Peter in the North-West Frontier after the last microlight ended up like all the rest – good only for scrap. He had been demonstrating for the Pakistani military and Vaughan blamed the crash on an over-enthusiastic Pakistani major he had taken up for a ride. The major tried to take over in the air and Vaughan only regained control by whacking him in the stomach, but he could not save the plane. They sent to London for spare parts, the bolts to hold the propeller on, and even paid for an air ticket for the sister of a Guards officer friend to bring it across. But true to a kind of ditzy Sloane style, she arrived in Peshawar without the right part and the plane remained unmended.

Vaughan's test-pilot days were over, but the pursuit that was to dominate the rest of his life was about to begin. Peter Jouvenal heard that he was in town, and had developed a typically romantic notion that microlights might be the answer for evading the Pakistani border guards who lined the North-West Frontier. Perhaps they could even be used to transport in the satellite dishes that Viscount Cranborne was still promoting. Like so much that Peter did, the idea had a certain mad English style, although this one was perhaps more Austin Powers than James Bond. Nobody ever tried it, but it brought Vaughan Smith onto the Canal Bank

Road radar screen. At the time Peter had more pressing needs. He was about to go into Afghanistan with John Simpson and needed a soundman. He recruited Vaughan in the same way that he had Rory, a half-hour lesson in the basics, and off they went.

By 1989, Peter had become preoccupied with what would happen to Afghanistan once the Russians left. By now he had lived in the region for the best part of a decade, and wanted to chronicle what would happen next. The departure of the last Soviet tanks, rumbling across the Friendship Bridge into Uzbekistan in February 1989, was a piece of historical theatre. The expectation was that the mujaheddin would rise up behind them and sweep their puppet government from power, but the promised next act in the play took years to happen.

Peter sought serious journalistic backing for a documentary report, and some weeks before the pull-out he went first to Thames Television. A hard-headed executive asked him what would happen next and he replied rather honestly that he did not know. That did not get him too far. He was shown the door. So he put together a proposal based on what had happened to the Americans in Vietnam, with lurid descriptions of mobs sacking the Russian embassy in Kabul as Massud's hordes swept down from the Panjshir Valley to claim their prize. The BBC were impressed by the detail and agreed to go ahead with a programme for *Panorama*, with John Simpson as the correspondent and Eamonn Matthews as producer. At Peter's first meeting he admitted to Eamonn that he had made up the whole idea, based on fitting a Vietnam matrix onto the Afghan map. He had no idea what would happen, he just thought that they ought to be there to find out.

They started again with a clean sheet of paper, and mapped out the options, although they did not include the possibility that

a year from then the Russian-backed government would still be in power in Kabul. The programme was commissioned on the generally received wisdom that the communists in Kabul would collapse quickly without Russian control. But received wisdom is rarely right about Afghanistan. There were to be no quick victories of the sort liked as much by modern broadcast editors as by the newspaper proprietors lampooned by Evelyn Waugh.

Afghanistan, March 1989

It was another freelancer, the legendary Mo Amin, who got them into Afghanistan. Mo, whose pictures of the Ethiopian famine in 1984 were the single most influential images in the history of television news, had made friends with a major in the British Secret Service in the North-West Frontier. The spy gave the BBC team his car to make the journey, so that they were not hassled by the Pakistani authorities. Peter Jouvenal, John Simpson, Eamonn Matthews, and another documentary cameraman Chris Hooke, slipped across the border. It was 1 March, Eamonn's birthday. He nearly did not live to see another one.

Soon after they switched to a vehicle inside Afghanistan, it got stuck in the mud, so they had to walk and sleep in a shed in a village. During that first night their tripods were stolen, which was a relief in a way, since tripods are a heavy piece of kit, and none of them knew how much they were going to have to walk in the days to come. Eamonn had never been to Afghanistan before, and he remembers the ruined landscape: 'It felt like being in a cross between a medieval kingdom and the Wild West, or maybe that weird bar in *Star Wars,* full of freaks from across the galaxy. People would step out in front of you and open fire just to check their weapons.'

They walked initially for two weeks, travelling with a supply convoy for protection. There were government garrisons

everywhere, and they would creep past them in tracks sunk down behind high banks by long use. It was an unsettling experience. The government forces would know that they were there, but would not usually risk taking on a large group of men and mules. So they would move past unmolested, although occasional bursts from heavy machine guns or anti-aircraft guns would thud into the banks over their heads.

One night they stopped in a hut and Peter recognised a camera tripod on an ox cart outside; he had a trainspotter's ability to identify almost anything on the battlefield. Not only did he recognise from its shape that it was a tripod hidden under a piece of tarpaulin but when he uncovered it he knew whose it was. It belonged to a friend, Ken Guest, a former Royal Marine and one of those who had answered Viscount Cranborne's call to come and work as a cameraman in Afghanistan. They went inside the hut and what looked like a pile of sacks in the corner began to move. Ken Guest got up to greet them, and alongside him was Rory's old friend John Gunston. They spent an evening together, a rather charming chance meeting in the dangerous surroundings of the area east of Kabul. The next day John Simpson and Peter headed off to meet the mujaheddin who said that they might be able to get them to Kabul, while Eamonn and the others headed north for the Panjshir Valley.

It was an epic journey. They took almost a month covering ground that could normally be covered in a morning by car, going on a roundabout mountain route, trying to avoid the war. But there was precious little fighting. Eamonn found himself reliving the same unnerving experience he had when he walked in – a landscape where the war itself was invisible, but omnipresent. Afghans have always avoided 'battles' in the normally understood sense of the word. Government forces were static in their positions while the mujaheddin manoeuvred around them, with

neither side engaging the other much. Occasionally Scud or other missiles would screech over their heads, ripping the air with an unforgettable AAARGH – then OOOH as they passed. But despite the mujaheddin's long experience against the Russians they did not seem to have learned much in a tactical sense. The *Panorama* film revealed clearly why they were failing to take any more of the country. One morning the soldiers travelling with Eamonn and the others were planning to attack a convoy. Eamonn had no military training, but you did not need any to see that this was a suicide mission. He said to the mujaheddin, 'If you ambush them from here you will die.'

And they said *'Ins'allah* [as God wills it]'. They always had a strong vein of fatalism running through them, which meant that they lost far more men than necessary in the war.

The camera team managed to talk them out of the ambush and move on to their main prize, which was to meet Ahmed Shah Massud in his lair, the Panjshir Valley. There were no satellite phones then and they were completely out of touch, living in total isolation with the mujaheddin in the extreme cold, eating their food and even dressing like them, or rather, dressing like Russian soldiers after the mujaheddin raided a Russian uniform store.

Every day was a surprise. They never had any idea of what was going to happen next. One day they filmed a *buzkashi* game. There was no warning of the match. It seemed to emerge out of the dust of the Hindu Kush: men on horseback, fighting with each other for possession of the carcass of a calf – the most macho sport in the world, polo without rules and great television.

Finally they came close to Massud, who was by then receiving money from Britain, and they guessed that the SAS were nearby, if only because the helicopters Massud had seized from the Russians had had all of their sensitive equipment expertly removed. The advanced avionics systems were useless to the Afghans, but a gold

mine for British agents. After doing the interview they had come for Eamonn and Ken Guest started the long walk back, while the other two, John Gunston and Chris Hooke, who both had riding experience, joined the cavalry. After the *buzkashi* match the Uzbek horsemen set off at a charge into the night, with the BBC's cameras and the 'rushes', the tapes they had shot, strapped to their saddles.

The next twenty-four hours seemed to be filled with murderous intent for Eamonn and Ken. While they were walking up a precipitous mountain pass somebody started to shoot at them from close range. They dived to the ground, although there was very little cover. Two Afghan guides who were with them had already gone about fifty yards ahead and managed to escape. Eamonn had prepared a phrase in Arabic that was supposed to make Muslim gunmen think twice before shooting. He shouted it out again and again, while standing up with his arms in the air. It did not do much good, and things began to look very bad when they were asked to take their clothes off.

Ken knew that it was the Afghan practice to strip people before shooting them, and Eamonn guessed it quickly enough. The mujaheddin all went behind a rock, and Ken hissed, 'We're going to have to make a run for it.' But before they could decide which way to go the mujaheddin commander came back wearing Eamonn's clothes, and gave him his own pile of stinking garments to put on. Ken too was given another set of clothes. The gunmen had just liked the look of their clothes, although after more than a month travelling what Eamonn and Ken had been wearing was in a bad state. The soldiers even gave them back their passports before releasing them.

Now wearing the rank clothes they had been given by the mujaheddin, they met up with their two guides further on and set out again. But they had not gone far before they ran into a

government patrol. The patrol might not have attacked them if they had had more numbers. But they had set out without waiting for the supply convoys they usually travelled with, and they were paying the consequences.

With grenades exploding all around them, Eamonn hid in an orchard. Ken ran past, shouting, 'Move on. Don't stay.' He ran on again and they found refuge in a cave with their two guides. Ken had been hit by shrapnel from a rocket-propelled grenade, but luckily the old Soviet jacket he had been left with in the enforced clothes-change earlier in the day had absorbed much of it. He cut out the shrapnel with a knife and dressed the wound himself.

'You were bloody lucky there, Eamonn, mate. As you were running out of the orchard I could see the bullets kicking up the dust behind your feet. Just like in the movies.'

'I don't feel lucky. I feel stupid. We shouldn't have gone on without waiting for a supply convoy. We broke one of Peter's main rules. We were too cocksure.'

Their two mujaheddin guides said that they were hungry and they were going to go *back* along the path for lunch. They could not be persuaded to stay. Eamonn and Ken heard a huge burst of bullets and grenades, and to this day they do not know whether the guides made it. It was not exactly suicide, but it was at least a different view of life and death to the one that we know in the west. That fatalism again determined so much. The men shooting were fellow Afghans who just happened to be in the other party for the moment. Was lunch worth dying for?

Eamonn and Ken waited in their cave until a supply convoy finally came by on foot, and they went up the mountain pass with them. At the top of the mountain, at the end of this strange long day, they heard a baby cry. He had just been born in a hut, and his father doled out milky yoghurt so that the supply convoy and the two Britons could toast his health. It was an emotional moment.

As night fell, they entered the outer suburbs of Kabul. The city remained under government control, and this supply route, one of the mujaheddin smugglers' trails, showed signs of being constantly shelled. Eamonn was reminded of images of the First World War. Dead pack animals lined either side of the road, their rotting bodies swelling and decaying where they had fallen. Exhausted, they took refuge in a cellar, ignoring the shells and rockets going over their head. The next day they headed for the place where they had arranged to meet the men who had gone ahead on horseback.

As they arrived, suddenly Eamonn noticed tanks in the valley pointing in their direction. He shouted to the mujaheddin who were there to spread out and seek cover. They just laughed and ignored him. He ran anyway, and jumped into a shell hole. Moments later a tank shell fell among the mujaheddin where he had been standing and killed many of them. He started to talk to the man who was in the shell hole with him. Bizarrely, he turned out to be the fixer who had taken John Simpson and Peter Jouvenal into Kabul. It was the first news that Eamonn had had of his colleagues for a month. He started to deluge the man with questions. In quite a relaxed way the fixer said that yes, they had got in, and more importantly they had got out. He supposed that 'Mr John' was back in England by now. Eamonn caught up with his rushes, and walked for another week or so to get back to a vehicle that could take him to the border. He had his pictures. Now he wanted to see Peter's.

Kandahar, Afghanistan, May 1989

It had been an tough couple of months. But now that the original expectation of the country falling quickly was proved wrong Eamonn Matthews, as producer of the film, needed to find out what was really going on. They had been to the north to see

Massud, and Peter and John Simpson had been into Kabul in an act of bravado. They had also made a separate trip to Kabul, with government permission, to interview the Russian-backed President Najibullah, who was clinging on against all the odds and looking rather confident while he was doing it. Now they needed to find out what was happening elsewhere. Eamonn set out with Peter for Kandahar, the major city in the south and the spiritual capital of the Pashtun people, who make up 40 per cent of the population. This was to be Vaughan Smith's first trip into Afghanistan with Peter. He was dropped off outside the city to take pictures while they went forward.

Like most of the major cities of the country, Kandahar was still under the control of the Russian-backed government but was surrounded by mujaheddin. Through Peter's contacts they hung around with a mujaheddin commander near the city, who did a frank interview for them, suggesting that the communists should be forgiven and that Afghanistan could be united without recriminations. He was poisoned soon afterwards for such moderate opinions, but not before he had found a way for the BBC to cross the lines into Kandahar. It was close to a major Muslim festival and there was a bizarre ceasefire. Mujaheddin soldiers were even checking in their guns at government holding stations in order to come in and join the festivities before collecting them again on their way out to rejoin the war. The friendly commander succeeded in getting Peter and Eamonn delivered to the Governor's palace in the back of a truck. They climbed out and literally knocked at the door, saying, 'Hello, BBC here.'

The people inside were puzzled, and their reaction was strange and unsettling. One of the guards said, 'You're early.' Then they locked up Peter and Eamonn for several hours in a side room. Eamonn was apprehensive but Peter seemed reasonably calm, despite the threat. They were waiting for the Governor; locking

them up was only one level above keeping them waiting in an outside room. It could be seen as Afghan good manners. When they were let out the adjoining room was full of journalists, who had been invited down from Kabul for a press conference. Among them was Lyse Ducet, then the BBC's Kabul correspondent, a good friend of Peter's. The surprise was mutual.

But with the press conference over, it began to become really dangerous. Being locked up in a side room had only been the beginning of a series of events that spiralled downwards. The visiting journalists had provided some protection. But it was illusory, like the cover given by a crowd in a Hitchcock film. Once they were gone, Peter and Eamonn were suddenly vulnerable – alone in a hostile town. And the mujaheddin who had brought them in identified their vulnerability. It was ironic; the town was full of rival mujaheddin groups who were enjoying an amnesty. About the only people in town facing danger were Peter and Eamonn. This was not paranoia. Peter overheard their guides plotting to murder them. Not only did they have to avoid the government forces but suddenly leaving their escorts became a very high priority too. Peter told Eamonn what he had heard and said, 'Get your stuff together quickly.'

They ran out into the street and Peter flagged down a passing vehicle. It was a coach, already full of people. They climbed on top but there was nothing to hold onto. Eamonn shouted across the luggage that was lashed to the top, 'I can't keep a grip. I am going to fall off this thing.'

Peter shouted back, 'It doesn't matter how much it hurts, or how hard you have to cling on. It doesn't matter. It doesn't matter. We've just got to get out of here.'

Only an hour before they had been taking tea with the Governor. Now they were fugitives, trying to get back into mujaheddin territory, while being pursued by the mujaheddin who had

brought them in. They were surrounded by constant death in a dysfunctional society. Nothing was as it seemed.

Later during the making of that programme they filmed an old man who was badly injured. He was brought rather roughly into hospital. Peter's pictures of his son weeping in the corridor were a sudden, stark reminder of what this was all about. Eamonn came out the hospital, saying, in the way of a tyro producer in search of a story, 'Oh, that was a really good sequence', and Peter pulled him up with a terse phrase, as he could: 'Well his father's just died, actually.' It is very hard to retain your humanity at the same time as aggressively pursuing a film. After many years in Afghanistan Peter managed that balance, as he managed the ability to cross front lines safely.

While Eamonn and Peter had been preparing their trip to Kandahar, in No. 10 Canal Bank Road Rory was contemptuous.

'I don't agree with the take that you guys have,' he said laconically. 'I have people telling me other things.' And he promptly went to Jalalabad.

His intelligence had been better. He filmed the mujaheddin in a full frontal assault on the eastern city with a bravery and lyricism that won him a rare specific credit on the *Panorama* film, for 'additional Jalalabad combat photography'. Other people in television news did not shoot like that in those days. The pictures took the viewer right into the battle, showing just what it was like to be there. Rory's reputation in the industry depended on one thing: an ability to get himself in and out of difficult and dangerous places, with pictures of a unique, visceral brilliance. He carried on filming at Jalalabad despite being wounded in the neck by a tank shell, which burst directly in front of him.

The authenticity of this kind of material was the main asset that Peter and his colleagues had. He was now the best-known

journalist in Afghanistan, and during a trip to London he was called up by ITN. 'We have some incredible pictures which look as if the mujaheddin are attacking power lines near Sarobi, and we would like you to come in and talk about them.' Sarobi is a key strategic gateway to Kabul in the East. If the mujaheddin could act there at will, then that was a good story. But Peter was reluctant to provide the commentary; the pictures had been shot by an American freelancer, and he did not know the precise circumstances. When he saw the pictures go out that night he felt even more uneasy; there was something wrong with them that he could not put his finger on. They were compelling images of a battle sure enough, but they looked *too* good. When he started to investigate the doubts built up. He discovered that the cameraman had gone across into Afghanistan and met a man who had just defected from the communist side with his men. His job had been defending the Sarobi road and the power lines. The defector was already known by the nickname Dr Death. The American freelancer had persuaded him to blow up the power lines while half of his troops pretended to defend them. The whole thing was a set-up.

In another incident the same cameraman organised a staged attack on a village, with bombs detonated by remote control as the cameras ran around at will. Chinese-made F7 jets were cut in to the film to make it look as if they have dropped the bombs. Peter recognised the shots of the warplanes; they had actually been taken by his colleague Habib in a refugee camp. If you watch the images on freeze frame, the *Pakistani* markings can clearly be seen on the wings. The Pakistani air force were certainly not bombing Afghanistan at that time. At one point the cameraman was even filmed running across through the smoke in the heat of the battle, while Afghan government armoured personnel carriers drove out of a base in a way they never did in real life.

It was real Hollywood stuff, which won awards and was impossible to compete with. And there was a more pernicious side to it as well. The crew claimed to have discovered a booby-trapped toy doll. As they poked it, it exploded. The clear motivation of the image was to paint the Russians in as bad a light as possible. But the problem was that there were no proved sightings of such dolls. Peter does not think that they ever existed, despite repeated rumours. He thinks that people were confusing them with 'butterfly' mines – which are nasty things certainly, since they are dropped from one canister and spread across a wide area from their original drop site. They are designed to make areas like airfields hard to operate and are on the edge of legality. They can look enticing to a child, but are not the same as actually planting booby-trapped dolls.

He remembers a heated discussion with a right-wing American in Dean's Hotel after he questioned the footage. She was ranting on about 'Russians killing babies'. Peter said, rather reasonably, 'Well, I wouldn't be surprised. But you have no proof. Where's the evidence.'

And she said, 'We don't need evidence. It just makes them look bad.'

That was the name of the propaganda game, and some of the huge sums of money available went into the pockets of journalists who were *paying* Afghans to blaze away with Kalashnikovs and race around in the dust in armoured vehicles. None of the people filming this kind of thing of course turned up for the genuinely dangerous encounters, like the fall of Jalalabad, the battle where Rory first really made his name.

Eamonn Matthews went on to become the pre-eminent commissioner of footage for British television from difficult places for the independent company Mentorn. He says that his experience working on that *Panorama* has informed everything else he has

ever done. It was revolutionary. At the time there was a different culture among most cameramen. Some of course were brilliant, but for many the name of the game in covering conflict was to keep your head down and make a fortune on expenses. Crews came off a taxi rank, covering the Old Bailey one day, the Hindu Kush the next. But Peter, Rory, Vaughan and those who followed them were different. They were *specialists*. Eamonn recognised the difference:

> What had arrived was a bunch of people who were changing the way that television news was done. This huge clanking lumbering machine was about to change. What they had done was to convert John Simpson to their way of thinking – and he was going to become increasingly powerful in the BBC – and they had converted me. Increasingly there was a whole generation of producers who recognised them. It made the BBC much leaner and hungrier and sharper. What I began to realise was that when you watched their rushes, they were incredibly vivid. They might not have been conventionally framed, but they had great content.

Vaughan crossed into Afghanistan another half a dozen times, although never in a microlight. He was not yet formally connected to the company VIP, which lurched from one financial crisis to another. By now the Soviet Empire was not forced out only from Afghanistan; it was imploding elsewhere too. The Peck family nightmare of Russian boots marching through Dublin was clearly not to be realised as the Berlin Wall came down, Poland fell without a shot, there was little violence in East Germany and the Czechs saw their velvet revolution. But in Romania it looked as if things might be different. At Christmas, exactly ten years after the Russian invasion of Afghanistan, it was clear that the communists in Bucharest were not going to give up quietly.

IV

THE END OF HISTORY

Nothing is so exhilarating in life as to be shot at with no result.

Winston Churchill

Romania, December 1989

In the days when the BBC still had space for characters, the Foreign Editor was one of them. He was a remarkable man called John Mahoney. He spoke very quietly, in a rather mannered and polite way, with one of those unplaceable British accents – a Celt in Ealing. He had a very good feel for foreign news and the people who would deliver it for him, and was one of the key early supporters of maverick freelancers like Rory and Peter. Rory was always an exotic figure when he came into Television Centre in those days, wearing one of his ridiculous pork pie hats, 'to confuse the natives'. He once brought Mahoney as a gift an Afghan rug that smelt so much that it remained in the boot of the car for weeks since Mahoney's wife refused to let it into the house.

As Foreign Editor, he would often go on his instincts, commissioning crews to travel thousands of miles on a hunch that something was about to happen, and usually it did. By Christmas 1989 you did not need intuition to know that something was

about to happen in Romania. A new freelance producer, Tira Shubart, was going in for the BBC, and in his usual diffident way he said to her, 'You might look out for Rory Peck. He's going to be there, and frankly I think he might do some useful things for us.' By now Rory's record was well known among the discerning, and John Mahoney was the most discerning.

It was Tira's first war. She drove in from Budapest, with John Simpson and an amiable and able BBC cameraman, Bob Prabhu, on what she remembers as 'an insane improbable trip', across a countryside already in flames. Many people were already celebrating the downfall of the dictator Nicolae Ceauşescu. But when they got to the capital, Bucharest, it was very clear that the fighting was by no means over. A French TV journalist had been killed the night before, and there seemed to be very few other journalists around.

While John Simpson and his cameraman went off in separate directions, Tira drove towards the Intercontinental Hotel through what seemed to be steadily increasing gunfire. Occasionally she would stop and crouch behind the vehicle, although it gave her no protection, and there were echoes of bullets everywhere. The city streets filled with real and imagined threats but she ploughed on regardless. Parking the car at the Intercon, she ran in, crouching. Before she had caught her breath a tall and rather polite man came across and said in a louche and laid-back drawl, 'I wonder if you could help me, please. I am looking for a battery for my camera.' Even without him introducing himself she guessed who this was, and if she had known him better, she would have known that arriving without the right kit was an infuriating hallmark of Rory Peck in those days. He was always in the right place at the right time, but usually not fully equipped. He would count on somebody like Tira Shubart waltzing into the hotel lobby so he could say, 'Do you have a camera battery?'

She said 'Maybe I do. Are you Rory Peck?'

'How did you know that?'

'Never mind how I know. But there is a lot of stuff in the boot of that car. Have a look for yourself.'

Outside there were still people crouching down and taking cover. But Rory said, 'All right,' and walked out completely upright as if he was taking a stroll. Tira knew that Rory was experienced at war coverage by now, so she thought he knew what he was doing, and followed him out, trying not to look concerned. Rory rummaged around and found what he was looking for, while Tira lugged some other bags into the lobby.

It turned out to be the heaviest day of fighting. Later she was to do some exhaustive research on the events of those days, making a pretty persuasive case in a BBC film for the theory that this was not a popular revolution at all but rather a sort of palace coup, a shuffle of top cards with only the dictator replaced. Whatever the big picture, on the day the effect was the same. There were tanks on the streets where Europe's most feared secret police, the Securitate, were fighting a losing battle for control.

While Rory went off to film the chaos, equipped with his new battery, Tira did what producers need to do, conjuring up a news operation in the middle of nowhere, setting up an office and finding a local 'fixer' – the key element in any successful assignment. Having a good local who speaks your language and knows the town is the only thing that really matters. Tapes came back by strange means. Bob Prabhu gave one to a passer-by, just someone he met in the street, who found his way through the shooting to the hotel. But then she had to feed the material to London. Some of the heaviest fighting was going on around the TV station. She made a courageous dash across 100 yards of open ground to find Rory already there, standing rather laconically, with his camera connected somehow along some bare wires to an international

satellite circuit. Perhaps his unorthodox education at the hands of a NASA space scientist was not wasted after all. They were not sending a finished report, just pictures, which would be put together in London with a voice track sent down a phone line by John Simpson. It was compelling and exclusive material. Now they had to get out of the TV station. Tira turned to Rory and said, 'You are an experienced war cameraman.'

'Yes...'

'Well, it was a bit tricky getting in.'

'Of course. Don't worry.'

And he walked out through the gunfire quite nonchalantly, with Tira alongside. She was thinking all along that he must know what he was doing, he must be able to work out what was dangerous and what was not, although at the back of her mind the suspicion grew that he was just walking through it because he calculated that he would *probably* not be shot. At one point, as they strolled towards the centre of town a tank started firing just alongside them, and everybody on the street flattened themselves to the ground. But Rory carried on walking.

They crossed the road, and Rory moved rather naturally behind Tira to walk alongside her on the outside as a gentleman might do in London. He even opened a discussion on manners while a tank crossed the road in front of them, crushing cars and firing over their heads

'I don't quite know the etiquette of walking with a lady in a war zone. Do you realise that in the eighteenth century men always walked on the outside because of carriages splashing people, then in the nineteenth century they walked on the inside because brigands might jump out of the bushes.'

If you wanted a definition of the stiff upper lip then this was it. Tira is an American who lives by choice in London, and she wondered not for the first time about the nature of her adopted

people. Rory put out his thumb to try to hitch a lift towards the action in the centre. They were picked up by a man who turned out to be a fleeing Securitate agent. He never threatened them, although only the day before they would have been seen as enemies of the state. He was only doing what any sensible person would, trying to get away from the random and worsening shooting. But that was not the direction they wanted to go in. They soon realised that he was driving out of town. So they stopped the car to get out and walk again. And then they happened to pass the residence of the British Ambassador. Looking at his watch Rory said, 'It's teatime', and he rang the doorbell. Of course there was no answer, but he rang again.

'I think that's a bloody bad show.'

Tira said tentatively, 'Perhaps they are doing something else right now.'

'Tira, when we get back to London I am buying you tea in Claridge's to make up. They've really let us down.'

As they walked on, Tira started to talk about safety again, asking for guidelines about how to tell what was going on around them. At first Rory was noncommittal, telling her that she was doing fine. But when she pressed him, he said, 'It's very simple: unless you can hear the bullet whizzing, it's not coming towards you.'

'Gosh, that makes it really simple.'

By now they were on a side road leading into Central Committee Square, and they could not go any further because there was so much shooting going on. Rory got to the end of the street and pointed his camera round the corner to see what was going on, because even he was not going to put his head into the square. By now Tira was so tired that she leaned against the wall with her head resting on a shop window.

'KERACK...' Everything she was leaning on shattered and she fell down. A bullet had hit the window. At that moment she

realised that Rory had not been entirely telling the truth about what was dangerous and what was not. She left him to work, and made her way back to the hotel, crouching down with normal human caution as soon as she was out of his sight and running when she could. Rory went on to get some legendary footage of the library burning and gun battles for control of the square. The pictures are quite extraordinary. The streets are full of tanks and grey-uniformed men running across the front of the over-large mock-classical buildings that were much loved by communist dictators. In the grey light of a lowering Bucharest day hundreds of bullets criss-cross the pictures and you can hear them hitting buildings and the road and the sides of tanks.

Rory was in the middle of all this, and so was John Simpson. He found Rory in circumstances that would seem unlikely to anyone else, but ordinary for Rory. In the thick of the fighting, Simpson came across a man who looked like a brigand from a comic book, with a red scarf round his head, festooned with bandoliers of bullets, and carrying an axe on his shoulder. The man turned out to speak English.

'Oh, you speak English do you?' Simpson made conversation as the bullets flew around.

'Yes, I am working with Rory Peck.'

'Actually I am looking for him,' said Simpson. 'Where is he?'

And the brigand pointed towards a government building that was burning fiercely on the other side of the road. But there was no sign of Rory.

'You mean he's round the other side?'

'No, no, he's inside,' said the brigand, quite casually.

And at that point Rory emerged from the inside of the inferno, wearing a fireman's asbestos suit that he had borrowed to film an extraordinary sequence of the main staircase of the building collapsing in flames in front of him – vivid, wild, real, *original* images.

Peter Jouvenal and Vaughan Smith turned up the next day after a similar hair-raising journey through the snow from the border. At the time Vaughan had not yet fully committed himself to television. He had the idea of setting up a holiday company that specialised in taking people to difficult and dangerous places; Bucharest appealed. They met for an unusual Christmas dinner in a grand, art deco, pre-revolutionary hotel with all of the faded splendour of a forgotten Europe. It was full of black-marketeers and spies, mingling with the journalists. The food stores that had been hoarded by the Securitate were suddenly open and the waiters rose to the occasion, bringing piles of food on old silver-plate trays whose silver had rubbed off. John Simpson says that it was the 'noisiest and smokiest lunch I have ever been at'.

Wild boar was the main course, and with his usual style, Peter had brought mince pies and a Christmas pudding all the way from London. While the Romanian chef worked out how to cook the pudding, the plan for Frontline emerged from the conversation in the smoke and noise and chaos of Christmas dinner in the vortex of a revolution. They were all looking for new options now that the Russians had pulled out of Afghanistan. Rory was optimistic, having just made £30,000 in two days in Bucharest, selling the same footage to several companies in various countries.

Already they had a small reputation among those in the know in the industry for innovation, pioneering the use of small, flexible, consumer video-8 cameras for news. The company was founded over the Christmas pudding with one comment of Rory's: 'If I had someone behind me selling the pictures I could have made more money.'

It was Vaughan who turned that aspiration into something. Within weeks he was selling tapes, going round London on his bicycle, before it was stolen and he had to take the bus. It was all done on a shoestring. Another ex-soldier, Tim Weaver, a good

friend of Rory's, joined them early on. He was an ex-newspaper reporter, who had been standing alongside Rory during the assault on Jalalabad, and realised that he was taking the same risks for far less reward. After the usual five minutes training from Rory he became a cameraman, and was in London when they set up the company. They were making it up as they went along, investing in one of the early mobile phones after Peter missed a contract because he could not get hold of Vaughan to book him a soundman. The phone was the size of a briefcase – rather cumbersome on a bicycle.

Rory, always the romantic adventurer, wanted a TV company with a profile similar to that of the famous Magnum agency for stills photographers. He was even ambitious enough to want to compete directly with the big agencies like Reuters and APTN, who offer pictures to broadcasters who subscribe to their service. That was always an unrealistic goal. It was not called Frontline at first; they called it 'Hard News', before realising that there was already a TV programme of that name, and they tried out 'Newsnet', before finally settling on Frontline. Vaughan was not yet fully a cameraman but ran the office and tried to make the figures add up. It was a hard task, made harder by the occupational inability of his colleagues to keep receipts in order. Their turnover in that first year was only £50,000, not keeping up with Rory's earning power in the Romanian revolution.

In August 1990 Saddam Hussein's invasion of Kuwait changed the world, although it did not quickly change their fortunes. At the time Peter was back in Peshawar and wrote to Vaughan asking for money. Vaughan replied with an anguished fax outlining their cash problems:

I am concerned on the financial front. You have asked me to give Mohammed Gul £100 and £500 to Habib. Where

is this money supposed to come from? I have an overdraft of £5,750 as we have had no business since the beginning of the Gulf crisis! I still have not had anything from ABC. There would not be a problem if the expenses for ABC had been sorted out. They have complained that many of the receipts are missing and that they like their expenses sorted in a particular way. Until you are available to help make head or tail of it they won't pay us a penny. You indicated that you would rather buy the V900 [a camera] than rent it. Are you able to send me any money for it?

Vaughan was ambitious. He took on television news as he had taken on signals, and vehicle maintenance, and drill, and shooting, and all of the other things he had to do in the army – with methodical professionalism, married in his case to a maverick anti-authoritarian streak. He had spent much longer in the army than any of the other Frontline members, leaving only when a business he ran on the side backfired. During his last years in the Guards he was stationed in Germany, but had a girlfriend who was a ballet dancer in London. In order to go and see her, he bought a minibus and filled it with private soldiers every weekend that he could, charging them only for the price of a ferry ticket. He filled the vehicle with cheap Becks and Grolsch lager, then largely unknown in Britain, and sold it, duty-free, to a dealer in London. It never made him much money, but he did it as much to irritate the system as for profit. By now, conforming as a Guardsman was becoming tiresome. For every man he carried he could take 50 litres of beer, and even though some of it was drunk along the way by thirsty Guardsmen going on leave, it enabled him to pay for weekends at home with his ballerina. It all fell apart when he left one weekend without one passenger, so he was carrying too much booze when he arrived in Dover – not a serious criminal offence,

but it was enough for his superiors to reach a mutual agreement with him that perhaps a long-term future in the Guards was not a good idea.

Vaughan had never quite fitted into the officers' mess. He learnt a number of vital skills there, such as how to open a bottle of champagne with the swish of a sword. But he had always got on better drinking in the sergeants' mess, or chatting to private soldiers, than with officers; a talent that he turned to his advantage in later years on the road: he knew how to get on with fighting men, whether in Bosnia, Kosovo, or Afghanistan.

He was an unconventional officer. Once, when he was in charge of the guard at Buckingham Palace, he set off for his evening round and found himself facing a crisis. One of the guards was not in his sentry box. The soldier in the adjoining box did not know, or would not say, where he was. This was a serious offence. The months that Guardsmen engage in ceremonial duties are something of a perk for officers, who dine in rather splendid surroundings in St James's Palace, surrounded by mementoes from earlier campaigns, including ashtrays made out of the hooves of Napoleon's horse. The job involves swaggering out with a sword to make a bit of a show every couple of hours, to make sure that the guards are awake and alert. A Guardsman could be severely reprimanded just for having a button out of place. Not being there at all looked very bad.

Vaughan began to search the surrounding area, starting with the local pubs (where the sight of an officer in full dress uniform carrying a sword did not cause any surprise). Finally he set off across Green Park, where his first sight of the missing soldier was his buttocks shining in the light of the moon as he lay on the grass on top of a girl. The girl saw Vaughan first, her eyes widening at the sight of him bearing down on them with his sword raised. Vaughan smacked the soldier across the buttocks

with the side of the sword, and he leapt up, pulling his trousers up and running off into the night, back into his box. But Vaughan did not report him.

One of the key skills that Vaughan refined in the army was shooting, eventually becoming an instructor, which later gave him added confidence in war zones as a journalist. He *knew* the capacity of the weapons he was facing in a way that few other journalists did, and he understood how soldiers thought, and the business of military tactics. Even by the time he joined the army he had already shot for the British under-21 rifle team. He went on to captain the Grenadier Guards shooting team for several years, and one year even captained the British Army shooting team. Again though his maverick streak got him into trouble. While still in the army he once had his car towed away from a yellow line in London. When he went to the car pound to collect it he found himself in a long queue and an argument going on at the front. He could see his car parked not far away and quietly walking into the pound, he took the spare key, which was kept in a magnetic clip under the wheel arch, and drove out behind another car that had permission to leave. A little later in the day he had a phone call from his father, who was then retired from the army.

'Vaughan, I hear there is a problem with your car.'

'No problem,' he said. 'I have liberated it.'

'That's not the problem. I have had a call from the anti-terrorist branch. It seems there was some ammunition in it.'

Vaughan had just come back from a shooting competition, and there must have been some spare rounds loose in the car. There was a major alert, with police looking for him and his rather indifferent brown Austin Allegro across London. It took a while to sort that out, and of course he had to pay the fine for being towed away.

Peter was now trying to get another business off the ground as well, dealing in old hardware from the battlefield. Among the shot-lists and tapes that came and went through Vaughan's tiny Chelsea flat there were lists of Russian military clothing and weapons. He had an eye for historical stories too. He tried to sell an idea for a documentary based on the centenary of the 'Durand line', the hastily drawn border between Afghanistan and Pakistan, which divided the Pashtun people. But no one was putting money into Afghanistan now. It slipped from view, and slipped from the attention of foreign ministries too. They thought the problem was sorted. In truth the full horror for Afghanistan and its significance for world history had not yet begun.

Peshawar, 1990

Rory would still go through Peshawar occasionally, and when he did he would meet up with Juliet Crawley for a drink or a game of backgammon. He had tried and failed to get her to join him in Tiananmen Square during the student demonstrations: hardly a romantic date, but that was Rory. To him the threat to communist order anywhere was fascinating and he was disappointed when the rebellion failed. Newly widowed and with a young child, Juliet was completing the monitoring work in Afghanistan for the UN that had been started by her husband, Dominique Vergos, before he was shot. Sometimes Rory would help out if he could combine her research with a filming trip. Afghanistan still remained in a wretched state of limbo, with the Russians gone, but no stable government to replace them. Juliet's work was aimed at finding out if Afghanistan was safe for refugees. In the event it would be another decade before many could return.

In December 1990 Juliet combined a trip to a friend's wedding in Scotland with sitting foreign-office exams. The diplomatic

life appealed. Rory tracked her down and they spent some time together. A few days later at a party the host asked if the relationship was serious and, fortified by wine, he misunderstood her answer. He thought they were getting engaged. Suddenly champagne appeared and there were celebrations all round. Juliet was embarrassed but thought they could undo it all in the sober, cold light of day, although she remembered something her first husband had told her once in Peshawar: 'If anything happens to me, you watch that Irishman. He'll be on to you!'

Later at their hotel, in rather an unromantic way, Rory said, 'Well perhaps it's not a bad idea; we should get married.' For him that was it. Juliet was still non-committal, hoping it would all blow over, until they met in a pub in Whitehall the next day, in the lunch-break of her diplomatic-service exams. Rory had brought a ring with him and was not to be fobbed off. She went back to Pakistan without telling anybody, not really wanting to get married again so soon after the death of her first husband. As soon as she arrived Rory was on the phone saying, 'We're to get married in Moscow.'

She got herself a visa and flew to Moscow to get married with a feeling of inevitability. Rory had instructed Bruce Clark, an old friend from Northern Ireland who was now the *Times* correspondent in Moscow, to find somewhere for the wedding, but, hardly surprisingly, it had not been easy to arrange in a hurry amid the collapse of the Soviet Union. They went to a Georgian Orthodox church where Juliet chatted up the most drunken-looking priest, thinking that he would be the easiest to persuade to marry them. But she found Rory talking in his fluent Russian to the most upright priest in the church. The priest made his opposition very clear, saying, 'It would be easier for me to get in a rocket and fly to the moon than to marry you.' Rory offered to convert to the Georgian Orthodox faith, but that failed too.

He thought hard that winter about the possible threat to his life. He wanted to get to Iraq, now under threat of a US-led attack after the invasion of Kuwait, and he knew it would be dangerous. He wrote in his diary: 'Always when going into this sort of situation there is a question mark with the grim reaper propped against it. I have seen enough deaths around the world to look at it in the face and accept its inevitability; however, I have no wish to die. Years of not really caring have slipped past.' He always knew the risk. When he asked friends to act as godparents for his children, he would add, 'Think about it for a while. Don't give me an answer straight away. You know I have a dangerous job, and that carries its own implications.' Juliet told him that she was not worried about him being wounded since she could push him around in a wheelchair. Rory said, 'I suppose you see me as a potential lame duck.'

Juliet said 'Certainly not. I think of you as a particularly vicious gander.' She flew back to Peshawar from Moscow and it was there, only 3 weeks after their 'engagement' in London, that they were married. The Anglican church wanted to be bribed to conduct the service because Rory was divorced. So they were married in the courts, with a service in a Catholic church, where Juliet knew a sympathetic priest. She had been there to pray from time to time. Other than the priest, nobody knew that they were to be married until the wedding. They invited six friends to tea and took them to church with them. They even had some hymns, played on the church's wheezy organ by Bruce Wannell, another English leftover born in the wrong century. He speaks beautiful Persian and ultimately converted to Islam. During the refugee years in Peshawar he would hold musical evenings and debates to keep Afghan scholarship alive among the refugees. The Catholic priest gave them chocolate cake, and then they all went home and drank far too much whisky.

Soon afterwards Juliet was badly hurt while out horse-riding and flew home to the UK. Leaving her in hospital, Rory went to Baghdad, and would not come back for four months.

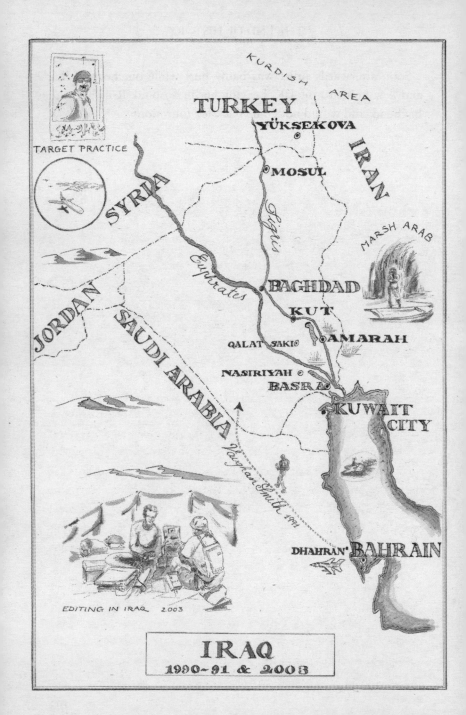

TARGET PRACTICE

KURDISH AREA

TURKEY

YÜKSEKOVA

MOSUL

SYRIA

IRAN

Tigris

MARSH ARAB

Euphrates

BAGHDAD

KUT

AMARAH

JORDAN

QALAT SAKIO

NASIRIYAH

BASRA

SAUDI ARABIA

KUWAIT CITY

Vaughan Smith 1991

DHAHRAN

BAHRAIN

EDITING IN IRAQ 2003

IRAQ
1990-91 & 2003

V

A PLACE OF DEATH

It is a desert peopled only with echoes – a place of death for what little there is to die in it... Nature, scalped, flayed, discovered all her skeleton to the gazing eye.

Sir Richard Burton, *Pilgrimage to Mecca and Medinah* (1853)

Bahrain, December 1990

Vaughan Smith sat in Bahrain for two months wondering how to bluff his way into the Gulf War. And while he waited, staying temporarily with a friend, whose bookshelves he explored, he searched for inspiration in books that charted the exploits of the prisoners-of-war who had escaped from German camps in the Second World War: tales of false identity papers; disguises; repeated ingenious attempts to get out of Colditz, including building a glider; the Wooden Horse and the Great Escape from Stalag Luft III.

The difference was that while the POWs in the Second World War were trying to break *out*, he wanted to break *in* to a country that was nominally a British ally, but where Britons are not welcome unless they work for oil or defence. His aim was simple but would be difficult to carry out. He decided that the most likely

way to get himself to the Gulf War front line would be to pose as a British soldier. For too long Vaughan had been going around London by bus hawking pictures taken by his colleagues: it was his turn in the front line.

There was no device like a wooden horse to make the crossing along the 14-mile narrow causeway from the friendly island of Bahrain into one of the most closed and secretive police states in the world. Saudi Arabia is the watchful guardian of the holiest sites in Islam, for a millennium a secretive and empty place to all but believers. The Victorian explorer Sir Richard Burton had to disguise himself as an itinerant healer in order to travel there, a hundred years before Vaughan's attempts. After the sea, the next line of defence, the desert, is just as hazardous. Saudi Arabia would have remained unimportant to all but pilgrims were it not for the discovery of oil. Under that wilderness lies a quarter of the known oil reserves in the world. The regime's particularly severe reading of the Koran motivates its security. Oil gives the Sheikhs the ability to pay for the best military defences that money can buy from the most sophisticated arms dealers in history – Britain, France and America.

And now the sheikhs needed more than their own defences. Saddam Hussein had seized Kuwait, and Britain and America were spearheading the largest task force seen in the world since the Korean War in an attempt to push the Iraqis back.

Vaughan was broke. If this plan did not work he knew that he could not continue to run Frontline; he would have to get a 'proper job'. Overdrawn on every account, and up to the limit on his last credit card replacing cameras that the customs officers had taken off him on arrival (in these paranoid times any westerner with a camera was suspect), Vaughan realised he was truly on his own, with no back-up in London, let alone in Bahrain. When his cameras were taken by customs, he phoned up a Kensington

video shop who sent a package by courier, which did arrive intact this time. He was nominally there for a German ZDF TV crew in Bahrain. They had the right to first use of his pictures, but they gave him no help in replacing the cameras lost at customs. Even his one-way plane ticket to the Gulf (which ZDF paid for) was booked only after Rory used his influence. He suffered from the usual discrimination against freelancers: because the ZDF crew on the ground had not commissioned him, they saw him as competition.

In his desperation Vaughan began looking in sports-goods shops for giant flippers, thinking he would swim across the Gulf, until someone told him about underwater surveillance and mines – not to mention the barracudas. Meanwhile his German 'colleagues' had the lavish resources of a large network, even hiring a speedboat for themselves, which sat for day after day on the quay, clocking up bills, to evacuate the crew if Bahrain became unstable. That moment never came since Bahrain was a long way from the war, but the speedboat made them feel secure. As the ZDF crew sat in their five-star hotel, trying to justify their expenses, the presence of an English freelancer was an unnecessary distraction.

Vaughan lost a stone in weight while he waited for almost two months in Bahrain, since all he could afford to eat were the bread and nuts he bought in the market. He spent his nights in the bars that make Bahrain a popular resting place for Europeans in the Gulf, where you can have a drink without being flogged – a place to chill out. This was where he got the confidence to carry out his bold plan.

An ex-SAS friend who had been with him at the beginning had pulled out already, considering the plan to be a non-starter. But during Vaughan's two months in Bahrain's bars he had blended in among British soldiers on their way up and down from the front. He mingled with them easily. No one was in uniform. Like

him they were in what he knew was called 'scruff order', normal civilian clothes. Being an ex-Grenadier Guards officer, he spoke their language and understood how they thought, and decided he would try to give the impression that he was still a serving soldier who was normally based in Germany, who had come to Bahrain because he 'didn't want to miss the party', It was a motivation they would understand. The British Army had not been to war for eight years, so many of the soldiers who had joined up after the Falklands would never have seen a shot fired in anger, and would find his enthusiasm entirely plausible. Besides, Vaughan had personal motivation too: he had been to a party in London a few weeks before, for a friend still serving in the Grenadier Guards who was heading for the Gulf, and Vaughan had promised that he would 'see him in Baghdad'. He wanted to make good the promise.

One night he met an Engineers officer he thought he could trust, and he told him the whole story, about how he was really a civilian cameraman who wanted to find his way to the front disguised as a soldier. He had a certain amount of kit with him, including his real uniform and dog tags, left over from his days in the army. But he did not have an identity card. The Engineer was amused by the plan, and although he could not and would not officially help, one night he 'lost' his wallet in the bar. It contained his ID card, and the next day Vaughan went to the only Apple Mac dealer in Bahrain and scanned in the card, before returning the wallet to his friend. Now he had a computer scan on a disc, but it was not something he could show to sentries so he went to a greetings-card shop, the kind where they made up special certificates for coming-of-age parties, school swimming contests and so on. He described the particular pink card with a pink wavy line that was used by the army for ID cards, and they found something close enough. Then he went back to the Apple dealer

and printed his details onto the pink card, matching the typeface of the card he had copied. He produced half a dozen cards with different names, though he planned to travel under his real name, unless he got into trouble. He was more likely to remember the truth and respond appropriately if challenged.

To make an authentic photograph for the ID, he constructed a wooden board with little hooks on it bent from a wire coat hanger and bought plastic numbers from a shop where they made notice boards for offices. He was stretching the office goods quarter of Bahrain to its limit. In a photo booth, he wore a green T-shirt, similar to an army T-shirt, and changed the numbers on the board six times for six different identities, holding it front of him for each photo, as soldiers would for a real ID card.

The last process needed for an authentic look was lamination and now, unwittingly, the British Embassy helped him out. By this time Vaughan was living in a flat owned by someone else he had befriended, who was a member of the British Embassy Tennis club. The friend persuaded the club to give him temporary membership, making up a story that Vaughan was an ace tennis-player, and would be an asset to the club. He went in with another photograph, this time without the green shirt or military identification board, and joined the club. While his application was being processed he managed to distract the woman who was pushing the tennis-club card through the lamination machine, and he slipped his six false military cards through. By the time the woman turned her head back to see what was happening the newly laminated cards were sitting securely, still warm, in his pocket.

He had succeeded in making up an identity for himself. But he was still a long way from the war. Now his Engineer friend helped him out again, inviting Vaughan onto the base to film his unit. For a morning he worked officially for the only time in the Gulf as what he really was, a civilian freelance TV cameraman, using one

of those little Hi8 holiday cameras, which were still the mainstay of Frontline coverage in those days.

The Engineers did not mind that Vaughan came with such a small camera, although they might have expected him to carry one of the big industry-standard professional Betacam kits. Although the army depends on the Engineers, they are not a glamorous regiment and consequently have never enjoyed much media coverage, so they were happy to go through their manoeuvres for Vaughan and for the folks back home.

When he had taken his pictures, Vaughan hung around the base, learning the geography. If he was going to come in here dressed as a soldier he knew that he would have to be able to find his way around. The whole business of deception is looking the part. He found out one critical piece of information: every Monday morning at 0700 a Land Rover crossed the causeway into Saudi Arabia. It was as regular as a bus service: all he had to do was get himself a ticket.

So he printed himself one.

The former Guards officer wrote a movement order in standard Ministry of Defence jargon, festooned with false numbers, ordering himself to go from his unit in Osnabruck in Germany to join 4 Brigade in Saudi Arabia as a press-liaison officer. Knowing the language was more than just being able to chat to soldiers in bars. The movement order needed to have just the right amount of credibility.

He had only his green camouflage uniform designed for northern Europe rather than the desert, but that shouldn't be a problem since not everyone had desert kit yet this far back from the front line. And being a press-liaison officer would be the perfect cover. The fictitious job justified his slightly chaotic appearance and the fact that his arrival had not been signalled beforehand. It was just the kind of job you could be fished out of Germany for at the

last minute. Some inconsistencies or strange behaviour would be discounted.

He never felt any guilt about the deception. The army had only themselves to blame because they had sewn up access to the war. He had tried to get a visa and accreditation, but as a freelancer it was impossible. Even established newspapers and TV networks had not got access for everyone they wanted to take to the Gulf. This was not to be a freelancer's war. The Americans led the way on making the rules for the press, blaming tight restrictions on the sensitivities of Saudi Arabia. It was a convenient cloak for an operation that imposed the toughest restrictions on war reporting seen anywhere in modern times. And the British went happily along with them, basking in the US admiration of their handling of the press during the Falklands War in 1982.

The Americans had carried out their own analysis of the Falklands, and they wanted to apply the lessons learned in a naval battle to their war in the desert, an environment which was as inhospitable as the ocean and potentially as easy to control. Their analysis had a simple conclusion, with pretty chilling implications for free speech, which certainly made life hard for freelancers: the best way to deal with the media was to 'control access to the fighting, invoke censorship, and rally aid in the form of patriotism at home and in the battle zone'. The template for US manipulation of war reporting was set for the next generation. There was no space for freelance initiative of the kind promoted by Frontline Television News.

The relationship between soldiers and reporters has never been easy. Ever since William Howard Russell, 'the first war correspondent', exposed the shortcomings of the British Army in the Crimean War there have been attempts to curtail the activities of journalists in the front line. The conflict between the two professions is unsurprising. For soldiers, secrecy is quite literally

crucial for survival. For journalists disclosure is all. And the American military was now led by a generation of officers whose souls had been seared by Vietnam. They *believed* that the press had lost them that war, and they weren't going to let it happen again. In Vietnam almost anybody could go to Saigon, set up as a correspondent, and be taxied around the war in American military helicopters. But now things would change.

Using techniques that they practised in two little local wars, Panama and Grenada, the Americans, with the enthusiastic support of Whitehall, developed the 'pool' system to the point where it virtually strangled independent initiative. The idea was simple on the face of it. The military believed that it would be dangerous, both for individuals and for the security of the operation, for journalists to wander around the front line on their own. Since the armed forces simply did not have the manpower to help the several hundred journalists who wanted to do just this, they agreed to take groups of them in 'pools'. Those who had been on the pool trip would make their despatches available to others in their own branch of the media – TV-tape to TV companies, newspaper stories to newspapers and so on.

And the beauty of the pool was that the fierce competition to get in encouraged correspondents to toe the line if they were among the favoured few. A few journalists who had visas and accreditation to Saudi Arabia did stay out of the pool, and there was enormous hostility against them from those who were working in the confines of the system, sometimes with ludicrous consequences. When Robert Fisk from the *Independent*, travelling on his own, was spotted up-country by an American TV crew in the pool he was reported to the US Marines. Fisk says that the NBC correspondent said, 'You asshole, you'll prevent us from working. You're not allowed here. Get out. Go back to Dhahran.' Since the place they were in, a Saudi town, Khafji, was still in

the hands of the Iraqis several hours *after* the British government had reported that it had been taken by the coalition forces, this petty response rather missed the point. Amid gunfire, journalists were arguing about their respective right to be there, and those wanting to report the events first-hand outside the pool were always denied access.

A few weeks before the bombing campaign began in January the Americans, taking their lead from the British in the Falklands conflict, actually imposed censorship in the field for the first time since the Korean War almost forty years before. In a country where free speech is a constitutional right this should have been the cue for a huge storm of protest, but spin at the highest level from the White House and the Pentagon to editors in Washington delayed and smoothed over any complaints. They claimed that nothing would be censored 'for its potential to express criticism or cause embarrassment'.

In reality of course the censors lost and trampled on things they did not like. They stopped a story about US pilots watching pornographic videos to wind themselves up before a mission, they cut the swear words from the reported speech of military personnel and they seized TV pictures of the fighting in Khafji from a French crew who were outside the pool. Despite protests from, among others, Walter Cronkite (the most trusted American journalist alive), who compared the Gulf censorship unfavourably with his experience in the Second World War, the rules stuck. Those on the ground were too busy fighting each other for access to complain.

So this was the environment for the media in the Gulf War: the tightest restrictions ever imposed by democratic countries on free speech, with access limited to pools, which were useless to freelance buccaneers like the men from Frontline, whose lifeblood depended on getting out with pictures of action that they could *sell*, not *give away* to everyone else.

Bahrain, 9 February 1991

At 0630, wearing his old uniform and dog tags, and carrying a pocketful of ID cards printed on Bahraini wedding-invitation card and laminated at the British Embassy tennis club, Vaughan walked up to the gates of the base in Bahrain fully expecting to be rumbled immediately. He had a cover story prepared, which he thought a sentry would understand, about why he was walking up at this hour. He had come from Germany late, and spent his last night on the town before going into a dry country. After the most cursory check he was in. He couldn't believe it, but as the gates swung open for him he walked purposefully towards the office, which he had recced the week before.

'Morning, Sarn't-Major.'

'Sir!'

Vaughan knew that his biggest asset in carrying out the deception was the eccentric reputation of Guards officers, who are curiously tolerated by the rest of the army because that's just the way it is. They are all considered rather weird by other soldiers anyway, if only because they spend a third of their lives marching up and down the Mall guarding the Queen, and the illusion of a body of soldiers set apart is one they like to foster. It adds to their mystique and thus to their military power. Being in the Guards was still a bit different, even in the meritocratic new army of the 1990s, and he was going to play to a role, exploiting the arrogance of centuries of eccentric Guards officers who had gone before him. Added to his general weirdness, his role as a press-liaison officer would justify any other inconsistencies in his story.

'I need to get on the transport leaving for Dhahran, Sarn't-Major.'

He knew that this was the defining moment. If he could get behind the wire and into the army, then no one would question him this closely again. Unfortunately, the discerning sergeant

major did not seem likely to be fooled by the blustering Grenadier act. He was not satisfied with the story, and asked far more questions than Vaughan was prepared for.

'What the hell are you doing here, sir? I don't know anything about this, sir.'

Everything was punctuated by 'sir' but the questions were to the point. The man was doing a good job and Vaughan knew that it would take only a little digging to expose him as a sham.

Then the phone rang.

While the sergeant major was distracted, Vaughan walked out to the Land Rover that he knew was now waiting outside and put his pack into the back.

The sergeant major came out.

'Sir, I don't want you to get on that vehicle quite yet. I want to sort this out first. Sir!'

Then the phone rang again. By now it was 7 o'clock, the time the Land Rover was scheduled to leave. While the sergeant major was inside Vaughan jumped into the passenger seat, put on his best arrogant Guards officer voice, slapped his palm on the dashboard as if on the neck of a horse and ordered the driver to set off. The driver had not heard the sergeant major asking him to wait, so off he went.

As they drove across the causeway, the sun was already up and shining brightly behind them, lighting up the narrow concrete bridge built over the sea ahead. In the distance he could see Tornadoes flying towards Iraq. He was heading for the war at last.

But the journey along the narrow causeway seemed to last for ever. And for every second of the drive he was wracked with doubt. If he had been a real officer, he would have waited while the sergeant major sorted it out. Surely the man would phone ahead. He had a picture in his mind's eye of the sergeant major coming out and saying, 'Right. Where's that fucking vehicle gone?' and

ringing Dharan. He convinced himself that he would be arrested on arrival. Why not just ask the driver to stop on the causeway so he could get out and walk away from the whole thing? The plan was mad and hopeless. But he did not want to fail. As the Land Rover steadily advanced he tested his story with other soldiers in the vehicle, who did not seem to regard him as a fraud. Vaughan gained confidence. Perhaps he could get away with it after all. The low barracks at the base, and the city beyond, came into view. The Land Rover slowed and came to a halt outside a nondescript building. If he was going to be exposed then this was surely the most dangerous moment.

Saudi Arabia, February 1991

The army is like a city, particularly in a war when there are all sorts of people coming and going. Vaughan looked the part; he fitted in and was welcomed cheerily on arrival by officers who were all part of the same community even if they did not recognise his face.

But he did not want to hang around. He was on his way to the front.

The constant scream of warplanes overhead was a reminder that the aerial bombardment of Iraq was reaching a climax, that the ground war could not be long delayed, and he wanted to film it. Besides, he began to think that the suspicious sergeant major must have phoned from Bahrain – so he needed to move on fast, before someone tracked him down. But he needed to upgrade his kit first.

The men and women who run army stores have their own inherited traits and prejudices just as Guards officers do. They have their stock catalogued and stored efficiently on the shelves, and they usually believe that that is where it should stay. Even with the right paperwork it can be hard to get the kit out. Vaughan

blustered in. He did not even need his Bahraini wedding-invitation ID card now, he just needed his manner. He was going to bully the kit out of them. He knew that his act was not just about using the right word. The whole tone and approach had to be right to lower suspicions. He could speak Guards officer 'puff' as well as anyone.

'You haven't got any paperwork? My god, how bloody inefficient. Right, get me that phone. Oh you are going to give me some are you? Right, get on with it. Look, there's a war on now, you know!' And so it continued until he had everything in the shop, the whole desert kit, better gear than most of the other people this far back from the front line. He even got himself a holster, since he knew that in a war every soldier had to carry a weapon. And to complete the picture he was given a lanyard, which he sewed into the top of the holster as if there was a revolver inside.

He changed in the lavatory and walked towards the movement control room looking businesslike. He was in Saudi Arabia and going to war: no one was going to stop him now. He began to ask questions *expecting* an affirmative answer.

'I need to go forward.'

'Yes, sir. We have a Land Rover leaving in half an hour. It is heading up to the Life Guards. Is that close enough to where you are going, sir?'

'Perfect. Got a brew on have you? Shall I wait on this side?'

The Land Rover took him to a desert plain filled with Challenger main battle tanks, the most potent armoured punch in the British Army , designed to deter the Soviet Union from storming across Germany, now repainted in desert camouflage and pointing purposefully towards Iraq.

Vaughan gradually refined his story until it became quite a sophisticated lie, almost a half-truth. He chatted his way into a tank and spent a couple of days trundling forward with them.

He used his real name and rank, telling them he was an ex-Guards officer who still had a commitment to the Reserves and that he'd been called up and asked to help with press liaison and take a few pictures. It added up. There were Territorials around and this was the sort of job they would be called up to do. His rank helped the illusion, since as a captain he was senior enough to be able to order most people around. And he calculated that majors (his immediate seniors) would be far too busy to worry about this extra captain wandering about. In the comparatively closed world of the army his name would have been half familiar. Other officers might not even know that he had ever left the army.

However, he knew that some would be suspicious, because however plausible he was, there was something not quite right about him. So he prepared another cover story to use to deflect questions. He wanted to give the impression that what he was covering up was not as bad as it seemed, so he dropped a few hints – that he was really a British officer based in Germany who had missed the boat but had managed to get out to the Gulf to join the action. It was the right kind of story – the desire of a soldier not to miss the Big Push, and he knew it would appeal to anyone not fully convinced by his first cover story. His audacity would be admired and therefore he would not be turned in. The worst suspicion soldiers might have was that he was a serving officer from the BAOR, the British Army On the Rhine, who should have been On the Rhine; he was less likely to be reported for that. With any luck, none would suspect that he was a civilian freelance cameraman.

As they rolled north the friendly crew of the tank he was in suggested that for the best pictures he should go to an artillery position, where British rocket launchers were sending salvoes out into Iraqi positions day and night. They dropped him off at a base

on the way so that he was able to zigzag in and out of the front line until he got to an MLRS position – Multi Launch Rocket Systems – armed and pointing towards Iraq.

A week after first arriving in Saudi Arabia he took his first saleable pictures, shots of rockets streaking into the desert sky, rare footage of rocket-launchers in action.

But the next day the atmosphere changed markedly. Vaughan was convinced that the Major in command of the MLRS unit did not believe his story. The whole tone of their line of questioning changed. He always tried to sleep apart from the others in the desert, to give him a chance to slip away if he heard people coming to look for him. But that night he was even more wary He woke at 4 o'clock determined to leave, but in the dark he could not find the command post. Then as the first light of dawn turned the desert to a soupy grey colour, he found a telephone cable, and followed it until he came to his means of escape. At the command post, a small tent at the edge of the camp, a Land Rover sat with its engine running and the driver snoozing at the wheel.

Without pausing to think of the effect on the war effort, Vaughan jumped in and woke the driver with a cheery shout.

'Right! We're off.'

The driver, a 19-year-old Lancastrian, obeyed the order, while Vaughan looked in the mirror, fully expecting an outraged officer to emerge from the tent and shout after them. But he was not discovered.

His plan all along had been to try to meet up with his old Guards company and go into action with them. They would look after him and not reveal his real identity. But he had to get the timing right. Too early and he might meet other journalists who would see him as a threat and obstruct him in any way they could. Too late and he would miss the start of the ground war. The intensity of firing at the rocket site, and what people said there, confirmed

that the ground war was only a few days away, so now he wanted to head for his old unit, if only to make good his drunken promise to his friend to 'see you in Baghdad'.

But where were they? He searched the back of the vehicle, which was full of maps, about thirty of them, but the sand did not have any distinguishing features. The maps were identical apart from the grid numbers; they might as well have been at sea. He made a guess as to where 4 Brigade might be and, using a compass, they continued driving doggedly in a north-westerly direction, parallel with the Kuwaiti border, with his driver thinking that all officers are wankers and this one was the worst.

The hours passed in the featureless waste. There was no road, but they drove on the desert floor: not the soft sand of Hollywood's imagination but a hard dirty crust, warm outside but not baking, a few isolated shrubs the only signs of life. They drove on and on, seeing nobody at all, until suddenly they came upon a British communications truck.

The truck was a 'Ptarmigan', part of a honeycomb of communications strung across the desert. The aim is that the system will survive even if some of the 'nodes' are knocked out or break down. The two signallers inside were pleased to see them, having been left alone for several days. This was several miles back from the army's forward positions, but the signallers were under such tight security that even they did not know where they were, a safeguard in the event of their capture by enemy forces. However much he bullied or charmed them, they could not or would not tell Vaughan anything useful. Perhaps they thought this was an exercise to test their nerve. They claimed not to be able to say even which direction they had come from. But Vaughan had one big advantage. From this point in the desert he could be connected up to anyone in the British Army, and he knew the language. He had worked as a Regimental Signals officer.

'Right! Get me 4 Brigade HQ!'

'Sir!'

Once they were connected up the captain at the other end of the phone was incredibly suspicious.

'Look, I'm lost. I'm here at node 21 of Ptarmigan. Any chance of giving me a grid so I can get back to you. I have been sent from the MLRS battle group.'

'No, sorry. Not allowed to give you a grid.'

'Right! If you can't tell me where I am or where you are perhaps you can give me a magnetic bearing, the course to follow to go to get you. That's just a direction. It would not compromise security.'

After more negotiation, and a garbled explanation of why he needed to get across to 4 Brigade, Vaughan got the information he needed, and his long-suffering driver set off on the course he had been given. He drove for six hours through the empty desert night with the Guards officer who he seemed to accept despite, or perhaps because of, the fact that he appeared so clueless.

As the sun rose over the desert the next day, Vaughan came on the sight he had been waiting for since he left London more than two months before. They topped a low ridge, and there in the desert before him were the Warrior Armoured Fighting Vehicles of the Queen's Company of the Grenadier Guards. It was as if he had never left. Nothing much had changed in the five years he had been out of the army. They were spread out across about half a mile, deployed defensively to minimise damage if they were attacked. The vehicles were pointing outwards and sentries armed with automatic rifles were entrenched along the perimeter. The vehicles were stretched out as far as the eye could see, about twenty Warriors in all – 10 million pounds' worth of armour.

Baghdad Radio reported that morning that Tariq Aziz had returned from Moscow with a new Soviet peace proposal; President Bush said it fell 'well short' of what was needed to

end war. An Iranian newspaper reported that 20,000 Iraqis had already died; it was the second day of American bombing of Iraqi targets in Kuwait. An Iraqi oil slick of 60 million gallons oozed down the Gulf; the acrid smoke from burning oil wells was carried towards them on hot desert winds. But the Queen's Company of the Grenadier Guards were not going to war that day. Inside the position there was a relaxed atmosphere. People were moving about in the early morning. Vaughan recognised a lot of them, and sitting on top of the nearest Warrior, shaving, was the friend who he had promised to 'see in Baghdad'.

When his friend had recovered from the shock sufficiently to give Vaughan the best breakfast he had eaten since leaving England, it quickly became clear that that was all he was going to get. Any illusions of filming the war from a Guards Regiment Warrior were quickly shattered. They would not turn him in; surely no one would bubble a former comrade, even the lower ranks. He had always looked after them, and what he had done showed a certain style that they might think was pretty cool. But the rules were clear. They had even had a special briefing: journalists were seen as the enemy just as much as the Iraqis. The only difference was that journalists were not to be shot, they were to be handed in. He would be risking the career of his friends if he insisted on staying and it made little difference that they trusted him in a way that they did not trust any other journalist. The friend he first met had had a newspaper journalist riding with him for a few days and he had not liked what was written. The piece had made light of what they were doing, poking fun at men who were going to war. Vaughan was different, but he knew he would have to move on since any pictures he took would automatically identify the men who helped him.

A cooperative captain was heading to Brigade headquarters and agreed to take Vaughan with him, while his friends looked after

the driver he had hijacked, absorbing him in their ranks until he could get back to his own unit.

That night at Brigade Headquarters Vaughan slipped into the back of a briefing. It was the final orders for the ground war, now only a few days away. He had only just made it to the front line in time. The briefing outlined the whole of the plan of battle, section by section, the so-called 'Orders Group'. And he laughed with the rest of them as the briefing officer finished with a reminder that they should look out for journalists.

'There's even a chap called Smith who is dressed as an officer running round somewhere. Be particularly wary of him.'

Where he was sitting nobody recognised him so he laughed with the rest of them, but he slipped out as quickly as he could at the end, going some way off in the cold night air of the desert to grab a few hours' sleep. Somebody must have reported him. He knew that it would not have been his old colleagues in Queen's Company. Perhaps it was the sergeant major from right back at the beginning. He knew now that there was no way of going to war with the British.

Before dawn the next day he made contact again with the Captain who had given him a lift to Brigade Headquarters. He was heading that day to a British base close to an American position and he agreed to take Vaughan with him. He would try his luck with the Americans.

A couple of hours later, Vaughan was snoozing as they drove through the flat, empty anonymity of the Arabian desert. He woke to find that the officer had stopped his Land Rover in the middle of nowhere and was clutching the wheel, staring forwards.

'I'm sorry, but you'll have to get out. I don't know what I thought I was doing. I must have been crazy. I am putting my whole career at risk for you and I hardly even know you.'

There was no arguing with this. The driver had heard the briefing the night before and had been thinking as he drove through the desert.

'I quite understand. Thank you for bringing me this far. Do you know where we are exactly?'

'I don't know. We must be about halfway to the next British position. I'll try to bring you some water on my way back.'

Backwards or forwards, it was several days' walk in either direction in the empty desert towards the only places where he knew there was life. Vaughan got out with half a bottle of water in the middle of nowhere. He had no food. Picking up rations involved risk, since he was not on any lists and was always vulnerable to questions he could not answer.

He sat against the reinforced bank of an abandoned tank 'berm', watching the sand thrown up by the wheels of the Land Rover as it went slowly but certainly out of sight.

The berm, a hollowed-out position to give a tank some protection, gave no shelter from the sun, and the day was the hottest since he had arrived in the war zone.

It was the lowest day of the trip. He had made a fool of himself and all for nothing. The game was up. Every British soldier was looking for an impostor called Smith. He was bound to get caught and if caught he expected to be handed over to the Saudi authorities and forgotten about. If you are sneaky and get away with it then people think you are cool, but if you are caught no one has any sympathy: the whole adventure would just look stupid. He wondered if he should just pull out, leaving the desert to try and sell the rocket-launcher pictures. They would be as good as anything filmed of the war. No one else would have got better. His lucky streak was over. If he stayed, it was only a matter of time before he ran into other journalists, and then it would all be wasted. They would just hand him over as soon as they saw him.

But although he could not go forward, he could not easily get back either. He was stranded.

As the sun set on the upturned saucer of the featureless western horizon there was still a glow of burning oil wells to the north. But he was not going to be able to go north. Or anywhere, in fact. He drank the last of the water in his bottle.

VI

ISN'T THAT AGAINST THE RULES?

The coming battle will be the mother of all battles. This battle has been ordained by God.
<div align="right">Saddam Hussein</div>

Saudi Arabia, February 1991

Ever since the first jeep was sold as army surplus more than half a century ago, civilian vehicle-designers appear to have been locked in competition with the military for bigger, more muscular ways of driving off-road. Once the civilian world had superseded jeeps with giant sports utility vehicles with enough traction to climb a mountain, the military had to raise the stakes, equipping itself with the Humvee, a bigger, meaner vehicle than ever that hardly fits on a European motorway. Rescued from the desert, Vaughan found himself in the back of one of these leviathans, racing at high speed towards the war. The vision had emerged out of nowhere. If it wasn't for the loud country music playing from giant speakers buried somewhere deep beneath him, he might have been in heaven.

The Humvee was crammed full of women, but they managed to squeeze Vaughan in somehow. He could hardly believe his luck.

The uniforms they seemed to be only just wearing identified them as a forward field hospital for US Army battlefield casualties, a CASH unit. Feeling as though he'd walked onto the set of a Hollywood movie, Vaughan found that his English accent turned out to be an irresistible asset. He was back in the war, in style.

The driver who had left him in the tank berm had stopped off on his way back to the British base, leaving him a litre of water. Vaughan knew that he would die in the desert if he did not move. As soon as the fiercest sun in the middle of the day had abated he started walking in a straight line in what he knew to be the general direction of the MSR – the Main Supply Route. After about ten miles' walking with his pack on his back he found it, an artificially rolled surface across the sand, the main road into the war. The first few vehicles he saw did not stop for him, and then the Humvee appeared like a mirage through the murk of the desert dusk.

While he was talking to the CASH medical team a US military police Humvee drew up. Vaughan tried out a story he had put together as he risked sunburn during the long daylight hours. He told them he had had a crash on the road and did not want to miss the push, so he had continued on foot to the front, hoping for a lift, to carry out his duty as a liaison officer. The biggest concern of the military police was that he did not have a weapon, which Vaughan knew was the least authentic part of his appearance. Every soldier on a battlefield carries a weapon, and losing it is a major offence. He would be in trouble either way – arrested as a soldier who has lost his weapon, or as a fraud. He had packed away the holster with its fake lanyard sewn onto a fictitious pistol because it got in the way. He tried the arrogant Guardsman act again.

'Well I'm a bit pissed off actually. It was your fault. One of your 5-ton trucks pushed us off the road. Do you teach your people to

drive or what? My driver has been towed back to Dhahran with the vehicle. It's a write-off. The Americans have put me out of the war. Now you have to help me.'

The two Humvees were side by side on the road – the military police facing one way, and the CASH girls the other.

The military policeman leaned out from the window.

'So? Where's your rifle?'

'That's another thing. It got bent in the crash. It's no bloody use now. A bent barrel might be some use shooting around corners but it is no damn good in the desert.'

He needed a little humour. Most of all he needed them to leave so that he could charm his way into the back of the CASH Humvee, which looked much more inviting.

'I'm out of the war without even firing a shot at the enemy.'

The police eventually left but did not 'replace' his weapon. For that he had to wait until the next day, when he persuaded someone from the CASH unit to give him a lift to the US Brigade Headquarters, another tent in the desert. By now the Americans were apologising for his accident and loving his accent everywhere he went. He became a bit of a mascot. He quickly tore up his original plan of going into battle with the British Army. This was much better. With Americans he was anonymous but acknowledged, and any abnormal behaviour, such as his desire to film things occasionally, was accepted as a harmless eccentricity as long as he did it in a soldierly way. The US soldiers were all taking snaps of everything anyway. He was just another enthusiastic amateur photographer. He was given a black ArmaLite rifle with a couple of magazines of bullets and an attachment to launch grenades. His disguise was complete. For a day he travelled around in the back of an open Humvee, occasionally sheltering under the tarpaulin when it rained, catching up on sleep until he met the key figure in that sector of the army – a two-star general

who could have been cast as Patton himself. He was turned out very neatly with grey hair, a neck like a turtle, and a gravel voice. Vaughan was highly amused by the gung-ho language around the Commander.

'We're going for it... we're going to whip their ass... Yessir!! Those I-RAQIS won't know what hit 'em.'

That was the general standard of strategic thinking. It was not the language he was used to in the British Army. They found him pretty funny too.

'Hello sir. I am a British liaison officer separated from my unit. I was wondering whether I could be of some assistance since I have ended up here. I would like very much to see what is going on. I am sure that there is much that we can learn from you.'

The turtle neck swivelled to take in Vaughan with his accent and his unfamiliar British uniform, topped with a US Army ArmaLite.

'Yeah...? Where you from, son?'

'London.'

And the gravel voice spoke slowly.

'I've been to London.'

And that was it. That was him saying yes. Vaughan was in and only just in time.

After more than a month of aerial bombardment tonight was the night the land war would start. He filmed jets going overhead, and the small artillery unit attached to the Headquarters staff – the last shells to be fired after months of 'softening up' before the beginning of the biggest assault by armoured vehicles since the Second World War. But something was not right. The camera kept jamming. It made a ripping, whirring sound when he tried to record and one of those little symbols came up in the viewfinder, superimposed over the picture. The symbol seemed to be saying, 'You're in trouble', without giving any tips on how to fix it. He must have got sand in the works. Sitting in the back

of a Bradley Fighting Vehicle, thundering through the desert, he stripped it down with a penknife, trying to keep all of the tiny screws together, but it was rather difficult to put back together again. After that the little flashing symbol never went away, and he found that it would only record without chewing up the tape if he pressed the side in a certain way. He wasn't able to rewind or replay. After coming all this way he couldn't tell if his camera was filming anything. He was filming blind with no back-up camera, heading into the front line with a camera designed for holiday movies, with a flashing Japanese symbol telling him that things were not going well.

The US plan for the Iraqi Army as outlined by Colin Powell was simple – 'We're going to cut it off and then we're going to kill it.' Beach landings and a frontal assault on Kuwait were staged as deception. They were never the main event. A giant lobster claw coming directly into Iraq from Saudi Arabia in the west was the punch. At the front of that was a line of tanks and about a kilometre behind them were the Bradleys full of infantrymen.

The endorsement of the general got Vaughan into the point company – the front row of the American armoured assault on Iraq. The Americans and British had done everything they could to keep independent journalists out of the front line. But in the front Bradley in the American assault, in his army disguise, Vaughan popped his head out of the top occasionally to take the pictures they had tried to stop.

It was lucky for him that he had his head inside when the next-door vehicle was destroyed in a direct hit from an Iraqi tank shell early in the assault. Not all of the Iraqis opposing them had been 'softened up' then. He filmed the Bradley burning through a murky porthole window, holding a pair of borrowed US night goggles over the lens to improve the definition of the picture, and still pressing in the side of the camera so that he did not

scrunch up too much tape. They were not ideal conditions for great camerawork. But he knew that these would probably be the only pictures of the Americans taking casualties – if he was recording any pictures at all. The camera continued to make its whirring, grinding sound.

As the attack advanced he moved from vehicle to another, and got to know the soldiers travelling with him. They were mostly black or of Hispanic origin. He identified their fighting role as exactly that which he had been trained to do himself, but they did not have the same outlook as British soldiers. In those days before 9/11 a spectre still hung over the American armed forces that had haunted them since Vietnam. They did not want to lose a single man, and did everything they could to avoid the sight of body bags covered with US flags. The soldiers certainly did not seem to be very keen to get out with fixed bayonets. It was considered too dangerous to let them get out at all. The US political obsession with casualties had created a military doctrine that involved destroying everything ahead of them, so that they were never required to get out of their vehicles and do any real fighting. An officer told him on the eve of the attack that 'we're not here to lose anybody'.

Why were there so many of them then? Only half of the soldiers with him were needed to keep the vehicles moving forwards and operate their weapons. The others were just sitting ducks. He concluded that this was an army that was good at maintaining itself, supplying itself and moving, but no one seemed to have joined the army to fight at close quarters. Despite the hit on the vehicle next door Vaughan was too high on the adrenalin of his success to be frightened. He thought back to his black day sitting on the tank berm, when he had wondered what he'd got himself into. He had arrived in the Gulf with the rather simple notion that free speech was a right, that restrictions on access were wrong and he was right to get to the front. Previously, he had mostly

been preoccupied with running Frontline, while the others went to war. He had never spent that much time with real journalists. But his unconventional approach and military understanding had taken him far ahead of the field. As they barrelled on through the desert, covering a lot of Iraqi ground at a fair speed, he still had no idea of the value of his pictures, or even whether he had any pictures at all.

The only thing preying on his mind was the possibility of chemical attack. He was not up to date on training for chemical warfare. He had not had any of the right preventative injections and the likelihood of Saddam Hussein using chemical weapons seemed rather high. He knew that the vehicle itself should protect them and would filter out the poison but beyond that he calculated that he would be more vulnerable than any of the others. He had procured an American protective suit along the way, but other than that he had only his old army gas mask, which was really just for show and well past its shelf life. Getting kit was always the hard part of his permanent pretence. People who issued kit asked questions. In the end he was lucky. There were no chemical attacks.

The formation did not stop much, at one point progressing in a configuration that Vaughan suggested and the lieutenant with him accepted, being junior in rank to him. Although his role was not to be a soldier, the military thinking came naturally to him. It was what he was trained for. Vaughan's position was completely absurd. At the front end of the American army, a tactical decision, albeit minor, was being made by a freelance British cameraman.

Occasionally they would fire anti-tank missiles, but most of the firing came from the main battle tanks up ahead, screening the ground and clearing the way in front of them. On the second morning he was sitting up in the cockpit looking out as they crossed a ridge and saw a line of Iraqi tanks ahead. As he focussed

with his battered camera on one of them it was destroyed by an American tank-round fired from long range. Another great picture – if it was recorded. A piece of the tank flew high into the air over his head. They moved on but then, to everyone's surprise, the entire military machine ground to a halt. Powell and Schwarzkopf had ordered the assault to stop.

Vaughan's company, at the front of the claw, was by then well into Iraq and only about half a day's drive from what they guessed to be their main objective, engaging Saddam Hussein's Republican Guard north of Basra. The men at the front did not know why they had stopped. There were rumours that they were short of fuel. But this well-supplied army did not have that kind of problem. Later it would emerge that the order to halt came exactly 100 hours after the ground assault began. The generals had an eye on the history books; they liked the clean sound of a 100-hour war. There were less-clean reasons too: the first pictures were coming out of what became known as the 'turkey shoot' – the slaughter of retreating Iraqis on the Mutla Ridge. The Americans and their allies had done what they came for. Enough was enough.

Now Vaughan had to get back with his pictures more quickly than he had got in. He knew that their value would diminish with every hour.

Saudi Arabia, 28 February 1991

Once more, the Americans could not have been more helpful with travel arrangements. Vaughan chatted up some engineers who were heading back to Headquarters. Their job was to check Iraqi vehicles along the way for booby traps. Regardless of the perceived danger of what the Iraqis may have left behind, there were already American soldiers looting souvenirs from among the battlefield debris. It was shockingly overt: Vaughan filmed one man trying to blowtorch a bit off a tank while others were carrying anything

they could, including guns. It was not the kind of behaviour he had ever encountered in the British Army.

When he arrived at the American Brigade HQ still no one asked him what he was doing there. He asked if they had any helicopters going towards British force and they suggested that he 'indent' for one. So he filled out a form, rather optimistically requesting a helicopter to Dhahran Air Base. The following morning he was picked up in a Blackhawk with a few others who were heading south as well. The pilots were high on the war, flying stunts, almost upside down at times. On one low swoop, as Vaughan hung from his seat belt and looked through the canopy towards the ground, he spotted some men waving at them from below. It was a trenchful of Iraqis, who were trying to surrender.

Vaughan was the 'senior officer' and still had the ArmaLite grenade-launcher they'd given him a few days previously. He ordered the helicopter pilot to land, as much for the safety of the Iraqis below as anything else; they were alone in a desert with no food or water. When the helicopter landed the other passengers suggested that Vaughan should take the prisoners. As he approached the Iraqis he realised they were expecting to be shot. The Americans behind him started sniffing around the trench for souvenirs; they were not interested in the prisoners at all, but were only there for plunder.

Then the situation became even more surreal as the Americans grabbed the Iraqis' weapons and fired them off into the desert, throwing their hand grenades around as well. Again Vaughan felt as if he was in a movie, *Apocalypse Now* perhaps, although there was an element of *Bilko* in the scene. The shooting only stopped when he pulled rank and ordered the soldiers back into the helicopter, but not before he had tried out the grenade launcher he had been carrying around for a week. The grenade exploded against a sand dune, just where he had aimed it. For the former

army marksman there was a quiet moment of satisfaction. None of this was captured on film – Vaughan's camera had completely packed up by this point.

The Iraqis must have thought they were in a madhouse: Vaughan remained in command of the whole operation, arranging the prisoners on their knees with their hands behind their backs on the helicopter. He was completely credible now, even to the British soldiers at the temporary prison camp where he handed over the Iraqis.

The helicopter did not go all the way to Dhahran but dropped him near the CASH field hospital where he had left some kit including a stills camera. He had picked up other kit along the way as well, including an American camp bed. He walked off into the desert overloaded like a Christmas tree, needing a little time alone to perform one key task – he had to get rid of the ArmaLite, his key accessory, which had given him authenticity as a soldier but which would be a liability in the civilian world that he was hoping to rejoin as quickly as possible. He buried the rifle deep in the Arabian sand.

Walking was becoming painful. His last pair of stolen US army socks had worn through at the heels and his feet were bleeding. After walking for about three miles he bumped into a group of Americans with long hair and irregular uniforms. They were a US Special Forces unit, who had been training Saudi forces and now wanted to get out as fast as him. They had no suspicion of him and they gave him a lift to Dhahran in the fastest vehicles in the desert, their open-topped *Mad Max*-style buggies.

Bahrain, 1 March 1991

Vaughan still had to reach Europe with his pictures, to see what value they had to the German TV station who had commissioned him in the first place. He had an uncle who did business in Saudi

Arabia, and he phoned him from Dhahran. Uncle Peter was driving across the causeway to Bahrain the next day and, in the way of British businessmen in Saudi Arabia, he picked Vaughan up in a huge white Cadillac. Vaughan stuck his feet out of the window to reduce the smell as they drove across the 14-mile causeway out of the war. Inevitably, every civilian flight out of Bahrain was booked solid, so Uncle Peter took his own flight and left him the keys to the car. He had a bag full of tape cassettes, and spent a night in the back of the Cadillac throwing away pocketfuls of damaged tape, trying to join up the other bits with sellotape and a pen knife – not exactly stylish editing.

The following morning he left the Cadillac on the civilian side of Bahrain airport and went over to the military side: if he could not fly as a civilian, perhaps he should try as a soldier. It had worked so far. He was very sure of himself. His home-made identity card should still work if anyone even bothered to look at it. His sweaty uniform marked him out as someone who had been in the thick of it. No one could catch him now. But although the British flight movements office did not suspect him they would not fly him anywhere.

'Show me your movement order. You know we need a movement order, sir!'

'I am in a hurry, dammit! You must have something going to Germany.'

They humoured him – he was a Guards officer after all – but they were not going to fly him.

'OK, then. Well if you are not going to be helpful, I'll go to the Americans.'

The Americans did not bat an eyelid at him. Once again they could not have been more helpful.

'Sir! There's a Galaxy leaving for Europe in one hour. But it is not going to Germany. It's going to Sigonella in Sicily.'

'That will do. I can get something from there.'

He was on top of the world and he had a reason to be. Once on the European mainland he could take his precious pictures to ZDF in Frankfurt and cash in. He might even get the Americans to fly him on from Sicily if his luck held.

He sat in the tiny passenger cockpit above the cavernous hold of the Galaxy, sleeping for much of the long slow flight in the giant transport plane back to Europe.

Sicily, 2 March 1991

When he arrived in Sicily the atmosphere changed markedly. He quickly put any thought of being flown to Germany out of his mind. There were planes going to US bases in Germany all the time, regular as clockwork, night and day. But he was not going to be on one. He had to argue hard to stay out of jail. He was suddenly out of the comparatively casual environment of the battlefield, where no one doubts the unexpected because they are all making it up as they go along.

As soon as he arrived he was grilled by the master sergeant on duty. A strange British soldier had arrived out of nowhere, requesting to fly on with no orders that the sergeant recognised. Far from being *easier* as things had been in the Gulf the fighting had made it *harder* here since they were on a heightened state of alert. They were trained to be suspicious for anything out of the routine, and Vaughan was very much out of the routine.

The only people who ever caused him any trouble or even really suspected him at all were the British sergeant major on the first morning when he had tried to take the Land Rover across the causeway, and now his American equivalent as Vaughan was trying to leave.

He was regretting his over-confidence in Bahrain – the Cadillac had gone to his head. There must have been another way out of the Gulf.

The Sergeant took his ID card.

'I'll hold onto this, sir, and I'll make some inquiries. Where are you based in Germany?' Vaughan gave him what he knew to be real locations but made up names for his unit and his commanding officer. He knew that it would take only one inquiry to prove him a fraud and he certainly did not want the Americans to have a photocopy of his ID card.

He put on the stroppy Guardsman act for one last time. 'Well if you are not prepared to help, I'll make my own way. Don't know why we bothered to help you fight your war really.' And he grabbed his ID card back from the Sergeant. There was a line of civilian taxis waiting outside the barracks. Vaughan threw his kit into the back of one and told the driver to take him away. It was less than 100 yards to the gate of the base and as they drove he was on tenterhooks expecting to be called back by the suspicious sergeant. But the sergeant just stood there, weighing up the situation, and never quite had enough confidence in his own judgement to stop Vaughan from leaving.

Vaughan still had to get to Germany. He needed to know if he had recorded anything at all that he could sell. But he did not want to fly because he was afraid that the sergeant had written down his name and would send out an order to find him. The taxi took him to a hire-car firm, where he spent a long time negotiating the right to take the car all the way. Although it was an international rental company, it was in Sicily – a place run by its own rules, which are determined by the mafia. It was hard enough to get the right insurance to take the car off the island, let alone half way across the continent. He was not going to get the permission that day. The two women in the car-hire firm were having a party that night and they invited him over. Still in his uniform, he ended up sleeping on their sofa. But his pictures were another day older.

The following morning he got the permission he needed to take the car, and as he drove through Sicily he realised that his feet were really in no shape to get all the way to Germany. He stopped near a beach and walked into the sea leaving his car in sight, about 100 yards away. As he felt the first healing salt water painfully swirling around his bleeding feet he heard breaking glass, and turned to see men taking his bag from the back of his car through a broken side window. He ran faster than he had ever run since he played rugby in the army, the hot sand making each step painful for his lacerated feet. But he could not make it in time. He did not even see the number plate of the car as they drove away.

He sat with his head in his hands.

The robbers had not taken his rucksack from the boot, with its valueless collection of dirty clothes, or his looted US army camp bed. Instead they had gone for the bag on the back seat containing his useless broken camera, and his other camera, which he had reclaimed from the Bahraini customs, as well as all of his tapes of the Gulf War.

He walked into the police station, shirtless, wearing only his army trousers and leaving a trail of bloody footprints. One woman spoke a little English. They were very sympathetic and suggested that he offer a reward. He was now so overdrawn that it was difficult to contemplate spending any more money on the operation. But reluctantly he agreed to the reward, and the police spent the afternoon taking him around rubbish dumps in case his bag had been abandoned there. They found nothing. He bought a white shirt and went to the cheapest hotel he could find.

It was all over. The idea of being a cameraman had come to nothing. He was going to have to get a real job just to pay back the debts.

The next morning at about 9 o'clock the phone rang. He was called to the police station, where there were two photographers

at the entrance. The police had obviously realised the publicity value in getting back the tapes, which were worthless to anyone other than him. It took all day, but he got the tapes back, all except for the one he had been viewing in his new camera. They asked for a reward of 10,000 dollars, and after a little negotiation accepted 8,000. He was photographed shaking hands with the police chief, thanking him for his fine work, though he knew that the police must have shared the reward with the robbers. This was Sicily after all, as they had continually been reminding him since he reported the theft.

He had told them the whole story of how he had disguised himself to get to the front line, and now it was going to be in the paper the next day. He was past caring if the sergeant at the US base saw it or not. He went back to his hotel to sleep for a few hours, leaving early the next morning for Frankfurt. To keep out the breeze blowing through the broken car window, he wrapped himself in the Afghan blanket that he always carried. On his way to Germany he paused only for brief breaks, to sleep in the car.

When he arrived at the cool, orderly, air-conditioned sanctum of the German TV station he was an unwelcome intruder, limping, in combat trousers, with a flannel wrapped around his bleeding feet. The Gulf War had been over for almost a week. The only name he knew in the building was the producer he had met in Bahrain, part of the crew who had kept a speedboat on hand at all times but never went anywhere near the war. It was a Friday night and they were busy, trying to finish things off before the weekend in a tidy German way. They were sorry. They might have been able to make something of his pictures earlier. There was not much interest now.

'Have a look at what I have got, will you? I've come a long way,' he said.

The appeal worked, and he was directed, rather reluctantly, to the office of a weekly news programme called *Ausland Journal*. He

was not given a proper producer but a student on an internship. She knew even less about television than he did. But somehow they managed to put together a piece that just made it to air on time. Vaughan wrote the script for them, using his rough-and-ready army-taught German. It was hardly polished television. Afterwards he and the intern went out, promptly got drunk and slept together.

Since then those pictures have grossed around £150,000, and they are still earning money for Frontline in reuse fees by documentary makers. The Bradley filmed by Vaughan turned out to be one of only five to be hit by the Iraqis, although twenty-seven other US armoured vehicles and tanks were destroyed by their own side in 'friendly fire' incidents. The pictures are the most valuable asset in Frontline's archives. They have been used by networks on every continent because they are what Vaughan hoped they would be – the only real combat footage of the Gulf War taken by a journalist. After a couple of years of earning nothing he had something to prove. While his network 'colleagues' were clocking up bills in the Bahrain Hilton he was wearing through his socks walking to the front line. It was make or break for him and he had made it.

Only a few journalists came close to accomplishing what Vaughan had. Bob Simon of CBS broke the pool, crossed the border into Kuwait and was arrested by the Iraqis and held in Baghdad for two months. Richard Dowden of the *Independent* lived in the desert on his own for a while and started a bit of a trend among journalists by picking up some stray Iraqis who wanted to give themselves up. Suddenly, for a few days, everybody wanted to find POWs, and they set off from Dhahran for the border in their Land Rovers and Pajeros hoping to find them. The only person who did anything similar to Vaughan was Chris Hedges of *The New York Times*, who was accredited and had a

visa, but was never part of the pool system. He painted upside-down chevrons on his Land Rover to make it look like part of Desert Storm, and he wore combat clothing, which got better as he picked up bits of kit from friendly soldiers he met. He ended up with a helmet, a knife and some little gaiters that marked him out as a US marine. He would put his helmet down low and drive through the checkpoints until he was stopped. And he managed to keep his accreditation, despite constant harassment and arrests, while he ran up and down the desert tracks from Dharan, finding the war. But he never got to the front line during the fighting. Nobody got any pictures of fighting in the ground war apart from Vaughan, especially not a group of French freelancers who made a high-profile and completely ineffective protest by calling themselves the 'FUCK THE POOL' pool.

Throughout the conflict the main threat for journalists outside the pool was having guns pulled on them by allied soldiers; the American and British military were more of an obstacle to free reporting than any threat from the Iraqis. The pool itself did not provide much of value. An ITN crew were on board Kuwaiti armoured vehicles as they stormed into Kuwait at the start of the short ground war. But they did not encounter much resistance. And Martin Bell of the BBC went deep into Iraq, but the soldiers he was with did not see much action. The pool failed to deliver any pictures of the attack. Apart from one British local-newspaper reporter who saw infantrymen from his home town in a brief and bloody skirmish with Iraqi soldiers, nobody saw anything. As the *Washington Post* put it: 'The war had the largest armoured movement in history and essentially no one saw it.' Vaughan had scooped the pool.

When he came back, he came clean. The *Daily Express* had reported his exploits with the headline 'Bogus captain led Gulf troops into tank battle'. Vaughan knew that there is nothing the

military dislike more than being made fools of. But he also knew the mentality. After he made contact with the MOD, they took him to the Headquarters of Military Intelligence at Ashford in Kent, where they filmed an interview in return for not taking any disciplinary action against him. One consequence was better identity cards, but Vaughan never found out whose Land Rover he had hijacked when he left the rocket-launching site in a hurry: the only action he took that might in any way have affected the war effort.

There was a curious postscript to Vaughan's Gulf War. At a Guards dining-club evening six months later he was introduced to the Queen by a brother officer who probably did not think much of him. The officer gave the Queen a rather brief and garbled introduction, not giving her much background but only saying, 'This is Vaughan Smith, who left the Army and then pretended to be a British Officer in the Gulf.' The Queen furrowed her brow, and then said in a rather perplexed way, 'Oh! Isn't that against the rules?'

VII

CLUB NUKO

In the practical art of war, the best thing of all is to take the enemy's country whole and intact; to shatter and destroy it is not so good.

Sun Tzu, *The Art of War* (*c.* 400 BC),
translated from the Chinese by Lionel Giles (1910)

Amman, Jordan, January 1991

When the phone rang in Nicholas della Casa's hotel room at 3 o'clock in the morning in Jordan, he was about to go into another chorus of an old Ella Fitzgerald song, accompanied by his friend Jeff Harmon on trumpet. They had run out of the Portuguese songs that Nick remembered from his childhood in Brazil, and which had come in useful when he had been held hostage in Portuguese-speaking Mozambique. Now they returned to the jazz classics.

> Here I go again
> I hear those trumpets blow again
> All aglow again
> Taking a chance on love

Nick's complex character – independent, fearless, adventurous, and precise, although self-effacing – made him a natural freelancer, cast

Peter Jouvenal's portrait taken by an Afghan street cameraman with a simple pinhole camera made from a small wooden box – the image looks as if it comes from another age.

Peter had the full Northern Alliance battle plan several days before their attack on Kabul after 9/11, from contacts he had built up during more then twenty years' travelling in Afghanistan.

While reporting on Afghanistan's new wars he traded weapons from the country's old conflicts.

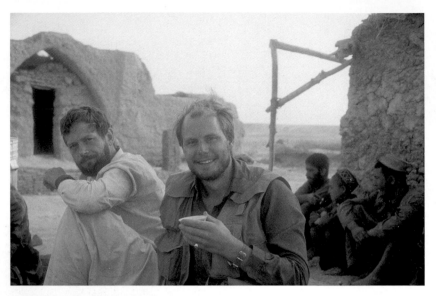

Peter Jouvenal (*left*) with Vaughan Smith on the Kandahar front line in 1989...

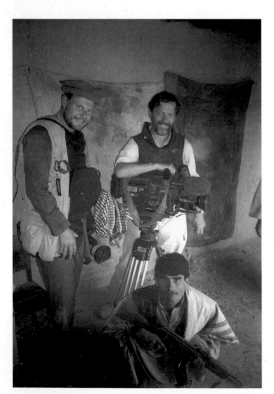

... and together again on the
Kabul front line in 2001
(Peter *right*).

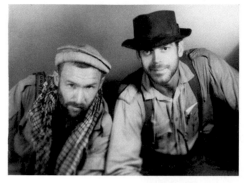

Rory Peck (*right*) with Tony Davis at 'an isolated post in Turkestan commanded by Tony (Beau) Davis, which was attacked by hordes of Turkomen... I was the ace reporter from the *Chicago Daily Star* whose record of the defence was the basis of the legend. There were no survivors.' Another picture taken with a simple pinhole camera.

Rory observed by the legendary mujaheddin commander Ahmed Shah Massud, in 1989. (Massud was later killed by a bomb hidden in a TV camera.)

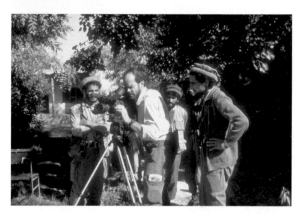

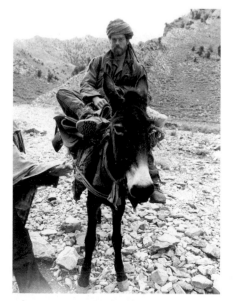

There was often no alternative but to ride when moving around in the Hindu Kush, evading the Russians in the 1980s. Rory was almost too tall for this mule.

Rory filming Koran-smugglers crossing the Oxus River from Afghanistan to the Soviet Union on a raft made from inflated cow skins; the picture was taken shortly before Russian soldiers intercepted them. Rory escaped just in time.

The Peck family on holiday at their home in Maine (*from left*: Jamie, Juliet, Fynn, Rory, Alexander and Lettice).

Vaughan Smith in the Kurdish mountains in April 1991, in the same region where Nick della Casa had led his team into Iraq two weeks earlier.

Colin Peck in Afghanistan in 1987, surrounded by weapons carried by the mujaheddin he was travelling with, which included a sophisticated British-made Blowpipe surface-to-air missile-launcher. His photos of Blowpipes were the first firm evidence that Britain was supplying them, and led to questions in Parliament.

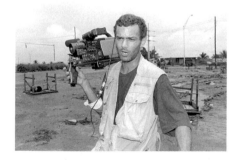

Tim Weaver in Liberia in 1990.

Vaughan with Richard Parry in Bosnia in 1993. Hitching a ride in the belly of a transport plane was often the only way in and out of Sarajevo during the siege.

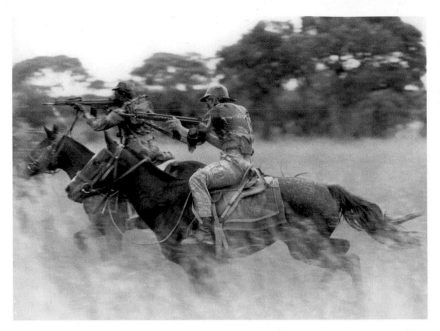

Nick della Casa's regiment in Rhodesia, the Grey's Scouts, the last regular cavalry regiment in action in the world.

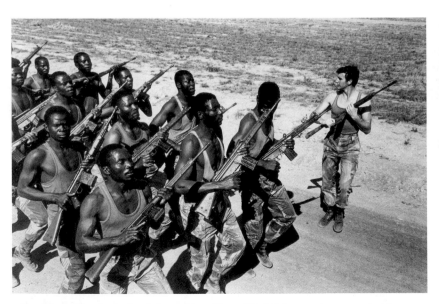

President Mugabe insisted that white officers like Nick stayed on to train his new army after he won Zimbabwe's first election.

Nick della Casa, after he swapped his gun for a TV camera.

A fax sent back to the company (then called Newsnet) by Nick, who was ahead of the others on the trail of Kurdish refugees in 1991.

Rosanna della Casa.

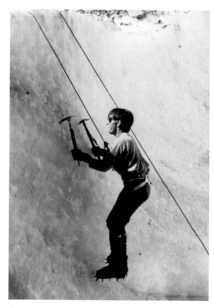

Charlie Maxwell, climbing an ice wall in the Alps.

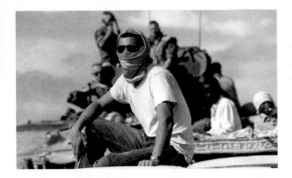

Carlos Mavroleon, in characteristic dress, sitting on a tank in Somalia in 1993.

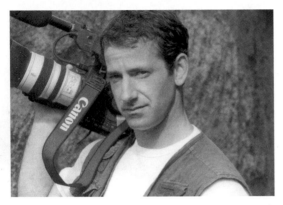

James Miller – 'He made a connection that took him past the camera' [award citation].

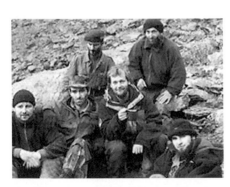

Roddy Scott with Chechen guerrillas, three days before they crossed the border to try to retake their country. This picture clearly shows that he was not wearing military clothing, as the Russians claimed.

Richard Wild – 'easily the most interesting' young freelancer commissioned by Vaughan.

from the Frontline mould. English-born, with an English mother and an Italian father, he was brought up in Brazil and Argentina before going to a conventional English public school and then briefly to Sandhurst. After that there was little conventional in anything he did. He ran away to Rhodesia, as it then was, to fight against black rebels, a lost cause perhaps, but a moment of history that fascinated him. He successfully completed the journey that Rory Peck had only begun a few years previously – Rory ending up sailing a dhow in the Red Sea instead. Nick's regiment, the Grey's Scouts, were one of the last active regular cavalry regiments in the world. When the rebels finally became the government, they insisted that Nick should stay on to train their forces. Learning how to fire a rifle while riding hard through the bush on horseback was excellent training for a cameraman. Nick was to become the fourth key founder of Frontline Television News.

After he was allowed to leave the newly formed army of Zimbabwe he picked up a camera, basing himself initially in South Africa. He helped CBS to an Emmy award with his coverage of rioting in Soweto. But he first really came to prominence in 1987, when he was kidnapped by Renamo guerrillas who were fighting against a Marxist take-over of Mozambique. They were an unlovable group of men, condemned by both sides in Mozambique's miserable war. The Americans backed them at first but then said that they were as 'bad as the Khmer Rouge', while the Russians and Cubans called them 'bandits and murderers'. Nick made contact with their leadership before leaving London, hoping to do an interview, but the message did not seem to have got through to the gang who arrested him. They thought he was Portuguese or Russian, or at best an American mercenary. He wrote in his diary:

They search my gear. Get bad vibes. Things not going well. V. worried. Junked-up commander dressed in white,

gets excited, jabs bayonet, screams orders to tie me up –
v. painfully at elbows. Try to explain I am English, it's all
right. Smoky eyes have me worried.

He was to spend 18 months in their hands before they released
him for Christmas, providing that he returned to film them later.
His diary-keeping was meticulous; there was nothing much else to
do to fill the time. He wrote of days in which 'I pace a circle, write,
sleep, shit, await tea.' But he was not bored and clearly had the
strength of character to overcome his ordeal, discovering, among
other things, that elephant dung made a good insect repellent.
One night under the African sky he wrote:

Lovely bright full moon in a clear sky. Writing outside my
tent, near stream bed. What a strange and wonderful thing
is tea, surely a very powerful drug. No matter how low and
dispirited, even ill, one feels, just the thought of a cup, and
I feel stronger than Lysander.

In London, his brother, Andrew, sister Alex, and other family
members made efforts to secure his release, contacting Renamo
officials in Lisbon, although they were never sure what influence
they had over the men in the bush. They also had some indirect
contact with Nick himself, through an American Evangelical outfit,
ironically called the 'Frontline Fellowship'. The breakthrough to
secure his release came when they were told that someone called
Bob could help out. They finally met the elusive man, who turned
out to be an ex-soldier, now mercenary. He looked the part, tall
with a well-worked body cased in a sober suit topped by dark
glasses as if advertising his calling as a spy, while his future
wife, Sybil, who he brought with him to the meeting was quite
different. She was incongruously short standing next to Bob, with

something of the look of a librarian, which unaccountably gave Alex a fit of the giggles. Sybil turned out to be the daughter of someone very high up in the CIA, and this unlikely couple finally succeeded in helping to negotiate Nick's release.

Bob was later killed and eaten by cannibals while protecting diamond assets in Sierra Leone. But that is another story.

Nick would give Frontline a toehold in Africa, where they had no other presence. His unsought fame as a kidnap victim in Mozambique attracted Vaughan and the others, especially with mentions like this, in the *Sunday Telegraph*:

> Nicholas has many of the qualities of a John Buchan hero…
> qualities which are useful – not to say essential – for the life
> he leads: a blithe indifference to discomfort, and a serene
> lack of concern for his own safety.

He was once held for three months or so in Zimbabwe, while investigating smugglers of ivory and rhino horn. His experience as an officer in the Rhodesian, later Zimbabwean, army helped him out: he organised the other prisoners, and by the time he was released, he was responsible for locking them in at night.

On another occasion Nick was held in Kenya, after trying to walk 400 miles from the Somali border in an attempt to check the romantic notion of a friend that an ancient tribe of elephant-smugglers still lived there. He was pretending to be just a tourist, but an officer recognised his name and said, 'Della Casa? Are you by any chance related to the journalist who was kidnapped in Mozambique? We studied his case in my political science course in London.' And Nick, who was at the time tied to a tree, stammered a little, claiming that he was the *brother* of the man held in Mozambique. 'Well, what a coincidence.' At the end of that investigation he was at least only deported, still carrying the

pink straw hat that he had managed to keep with him through his trials in the bush. He knew the difference between work and play, with an appetite for champagne and girlfriends that was second to none. He could sometimes be seen between wars walking barefoot down the King's Road, wearing kurta pyjamas or an Arab long shirt, with a girl or two on his arm.

Here I slide again
About to take that ride again
Starry eyed again…

In the Amman hotel room the sound of the phone broke through as they started the song again, fuelled by whisky.

'So who could that be? Yes… yes. Oh, too loud? TOO LOUD? The whole region is about to go up in flames and you are complaining about the noise.' Nick was belligerent and contemptuous.

Music was like letting the air out of a pressure cooker for Nick's friend Jeff Harmon. And this harmless hobby gave him a disguise too. He would carry his trumpet in and out of Iraq in the months before the bombing, and the Iraqi officials never checked the case. It was perfect for carrying messages in and tapes out. Harmon had taken to doing an impromptu cabaret in the hotel in the evenings, putting dirty lyrics to old jazz classics, but now it was the middle of the night.

A weary voice at the other end, the night desk at the Intercontinental Hotel, said that it wasn't his fault, he had to phone as some of the guests were complaining. Harmon grabbed the phone and tried to disguise his American accent with an appalling impression of Nick's upper-class English tones.

'Don't you realise I am celebrating my honeymoon? How dare you talk to me that way. I'll make as much damn noise as I want. What do you mean by this? It's an outrage!' Nick's new

wife, Rosanna, who was tall and blonde, had certainly made an impression during a previous trip to the hotel.

With an night-time curfew keeping them in, and a well-stocked bar, the Intercon became a journalistic legend – 'the year of living comfortably' they called it. Amman was the gateway to Baghdad and, surrounded by Iraqi spies everywhere, most journalists tried to keep a low profile while hanging around waiting to get into the war. Nick lived differently, thriving on danger, appearing to *enjoy* trouble. He would walk barefoot into the bar of the hotel. It might be fine for Chelsea, but it was seen as too casual by far, even an insult, by the Iraqi and Jordanian spies. Amman at the time was in many ways a more unsettling place to be than Baghdad, the focal point of Arabic opposition to British and American war plans.

Hatred of the west was raw, visceral, and growing. British and American flags were routinely burnt, and journalists faced abuse or attack in the streets. Jeff Harmon says that Nick was happier there than most people, taking in the frontier atmosphere with its heady mix of public street demonstrations and spies from America and Iraq working in the shadows. Nick had done his time in Peshawar, going in and out of Afghanistan, on one occasion walking with his camera to the Afghan border with China. In Amman he found another border town, another place on the edge, the jumping-off point for another war.

There were frequent demonstrations. During one, an American radio reporter, Jacki Lyden, found herself crushed under the weight of a crowd storming out of a football stadium. Passing through her mind was the idea that she might become a story herself, a footnote at the end of the news – '*journalist crushed to death in demo in Jordan... And now the sport...*' Suddenly she heard a call from above. It was Nick, who was filming from a place he had found on the wall above before the demo started. Surprised at his

strength, she found herself pulled up out of danger. He saved her life.

Anti-war protestors from around the world flocked in, among them an American conceptual artist, Art Nuko, who specialised in huge canvases of well-known cities against a backdrop of nuclear explosions. His name inspired Harmon to invite a small group of like-minded journalists to join him every night for drinks. They called themselves the Club Nuko, drawing in another aristocratic cameraman, Alex Lyndsay, and a reporter with *The Times*, Adam Kelliher, a giant of a man from New Zealand. The last member of the Club Nuko was Peter Jouvenal. They all shared the same maverick iconoclastic temperament, and all of them would be connected to Frontline, directly or indirectly, over the years. In the Club Nuko, they gave each other silly nicknames, all ending in '-o'. Peter's terse speech and military bearing earned him the name 'Wingco.' He had come into Jordan with an American TV company, aiming to go onto Baghdad, although he feared that he was going to get stuck in Jordan. To his crew, crossing the desert looked dangerous.

The fear of what US bombing would do to Baghdad rippled through the western press in Jordan. Unlike the men in Club Nuko, who were lone wolves, most journalists hunt as a pack, and the pack did not like what it was hearing. The story was that this would be quite different to anything anyone had seen before. 'Smart' bombs were to be used on a large scale for the first time, and there were a lot of myths swirling around among journalists about what happens to you if you are near a 1,000 lb bomb exploding. There were quite a few journalists around who had experience of being bombed by the Americans. It was only a few years since US warplanes had taken off from Britain to bomb Colonel Gaddafi in Tripoli. But that was said to be nothing compared to what was to happen in Baghdad.

The stories were sourced to the few grizzled veterans of Vietnam still on the road – men and women who had experienced the scale of bombing about to be unleashed on Iraq. The word was if a big bomb falls close by, you lose your hearing, all your equipment breaks down and – the best one – the fillings fall out of your teeth. The reporter Peter was with listened to too many of the stories. She slowed the trip down, settling into Amman to make features instead of heading off for Baghdad. She definitely did not want to lose any of her expensively maintained teeth.

Nick della Casa went in and out of Baghdad for a while for the American channel CBS, who took themselves and their mission very seriously, like all American journalists. This was in the days before mobile phones, and they kept in touch via two-way radios. One evening in Amman, in the bar where Club Nuko met, Nick's radio was squawking away with the usual self-important chatter of producers who believed that they mattered. Having learnt enough of the names, one of the other club members picked up the radio, sowing confusion, pretending to be another CBS employee, and started piling on vulgar and abusive insults against random people in the loop. All rather childish of course, but nobody at CBS saw the funny side. Nick was given one last chance to toe the line, and threatened with the sack.

Baghdad, January 1991

He went back to Baghdad. Saddam Hussein was keen to let journalists into the country while he was under attack, providing they were strictly under his control. It was a remarkable policy, which was to be refined over the years. Saddam was a sophisticated man who calculated that he could use the media, and television in particular, for his own ends, showing civilian victims of bombing or evidence that the devastated 'chemical weapons factory' actually made baby milk.

But only days after arriving in Baghdad Nick was ordered to pull out by CBS. The bombing was now imminent, and the Pentagon had given a specific warning that the safety of the Rashid hotel, where all journalists had to stay, could not be guaranteed. The fear of the bombing had a powerful effect on most, but not on Nick. He immediately terminated his contract with CBS and hung around the lobby of the hotel to see what would happen next. He soon bumped into Eamonn Matthews, the producer who had made the Afghan *Panorama* with Peter and Rory the previous year. He had come in to think big thoughts for *Newsnight*, and suddenly found himself heading the main BBC news operation, since most of the news team pulled out. Amid the chaos of journalists packing their bags, with truckloads of equipment being ferried out, he hired Nick on the spot.

On his way out from England to Baghdad Eamonn had made his will in a solicitor's office in Chiswick High Street. From his Afghan experience he knew that he might not come back, and only a few months before he had been badly shaken up after being arrested in Baghdad and forced to leave without his rushes. He could have lost more than the pictures. It was not so long since Saddam had hanged the Iranian-born *Observer* journalist Farzad Barzoft. When Eamonn went back, he knew what he was going into. As the story spread that the Rashid hotel was not safe, and that America was now threatening to bomb Iraq 'into the Stone Age', even those journalists who had come to report the war began to bail out. For most BBC staff in Baghdad, the issue seemed a simple one. They had been ordered out by the Head of News himself, Tony Hall. The intervention from above was unprecedented and hard to ignore. At one point during the discussions John Simpson threatened to resign from the staff; staying mattered that much. The radio correspondent Bob Simpson (no relation) decided to stay too, alongside Eamonn.

After hiring Nick, Eamonn took on another cameraman who had been ditched by his company, and set about working out how to cover the war with his group of mavericks. Anthony Wood was another of the freelancers attached to Frontline. Eamonn's Afghan experience gave him the ability to separate himself from the hysteria sweeping the hotel. And working with the Frontline men, he was reminded of the best days in Afghanistan as well. To him, the way Nick spoke about how they would hide cameras and evade the guards who would want to lock them into shelters was an echo of Peter Jouvenal. With the bombing only hours away, John Simpson recalls Nick looking up at the sky and saying, 'Won't be long now', clearly pleased by the prospect.

On the early nights of the bombing raids the footage consisted only of green flashes on the horizon. But they were hugely significant at the time – objective reporting from *inside* the capital city of a country being bombed by American and British planes. And the few cameramen in town did not shoot only flashes on the horizon, but also cruise missiles, flying quite low, literally map-reading their way around the city streets, before exploding on their targets. One cruise missile, which had been damaged by Iraqi gunfire, ended up in the Rashid hotel swimming pool, which was a shame because that was where the BBC team were washing.

That first trip did not last long before they were escorted out of the country, but it was hugely influential. Back at Club Nuko, Nick was asked about the bombing.

'Not that impressive,' he said.

Peter was getting frustrated sitting in Amman through all this. Iraq's policy over access changed daily and some journalists were still getting in. All of the Frontline team were anxious to get into the war. Rory had a BBC contract, and shouldered his way in through the mob of journalists at the border, ruffling the feathers

of an American TV crew who were supposed to be going with the BBC but could not get their huge baggage train of equipment ready in time. There were two drivers to choose from, and Rory chose the one called Jesus, saying, 'That should bring us a bit of luck.'

But as Rory disappeared, and hotel car parks filled with petrol bowsers, satellite trucks and container-loads of camping kit, Peter's reporter showed no signs of wanting to get on the road to Baghdad. He called his old partner, Habib Kawyani, in from Afghanistan to take over his contract in Jordan, so he could detach himself from his crew and go into Baghdad on his own. But he was too late. The border closed with Peter stranded on the wrong side.

A few days later the Iraqis agreed to let in an approved list of journalists. Peter was not on it but he joined it anyway under the wing of a French friend, Patrick de Saint-Exupéry, the grandson of the author of *The Little Prince*. In the desert the convoy stopped and the Iraqi minders read out a list of names, counting them all off. Peter signalled to a journalist friend to charm the minders into agreeing that the list was right without a formal head count. The subterfuge worked, and the Iraqis did not know that there was anyone extra in the convoy until they arrived in Baghdad. None of the minders wanted to take responsibility for the cock-up; mistakes could be fatal. So they had to tolerate Peter for a while. With his lightweight cameras, he always managed to work just outside the pack. His shots of cruise missiles navigating their way around the streets of Baghdad, among the best taken, made the trip worthwhile on their own.

The bombing did not make your teeth fall out, but it killed thousands and along the way destroyed Baghdad's infrastructure, knocking out power, water and sewage works as well as the bridges over the Tigris. To combat the smell from the drains Peter

began to smoke cigars, a habit that stayed with him for years, until he married an Afghan woman who disapproved.

When Peter arrived in Baghdad Rory was already there in the Rashid hotel, where the face of President Bush had been added to the foyer entrance, tastefully picked out in tiles, so that you couldn't walk in without stepping on it.

Life had a surreal air. The restaurant had no power or water, and the only guests now were journalists. The food was disgusting, but a pianist still kept up appearances, playing the standard medley of songs from the shows in the semi-darkness. Jeff Harmon was not there now to spice them up. In the lobby a trader put his carpets down, and set up a coffee pot to serve customers. Rory bought a leather jacket for one of his sons.

All travel was very severely restricted. Permission to travel out of Baghdad was granted only for the purpose of showing the effect of the bombing on civilian life. In a hospital in Basra Rory filmed hundreds of civilian casualties, but nearly had his camera broken by a minder who started to scream at him when he tried to film a wounded soldier. In the coach on the way down he noticed that the roads were full of soldiers who were trying to hitch lifts north, but no one stopped. Strategic road bridges were swathed in smoke from the fires made of piles of tires soaked in oil to give the American and British planes the impression that they had been hit. But he could not film any of this. Nor were they allowed to stop in Babylon, the cradle of civilisation, which had been rebuilt in epic style by Saddam with his name inscribed on every brick.

Saddam's assumption was that there would be bombs that did not hit military targets. On 13 February the allies obliged him with a direct hit on the Amariyah shelter. Their intelligence told them that it was a communication headquarters. But on the night they hit it several hundred women and children were sheltering inside. Rory filmed their charred remains, lined up on

the pavement outside. He meticulously noted down the names of one family whose bodies he had filmed. They were Hamid el Beyat, a lawyer, and his wife Fowzeza, mother Wafiqa, his son and daughter Martham and Shaima, daughter-in-law Nada, and grandson Henger. It was a horrific scene, with details that could not be reported on television, like the pools of water in the ruins with a layer of melted human fat floating on them. The rescuers carried charred bodies and body parts out for three days, praying all the time, a mesmerising soundtrack to Rory's pictures.

In a terrible case of the media blaming the messenger for bad news, some tabloid newspapers were outraged that the BBC broadcast the pictures, seeing it as somehow unpatriotic. They did not like the BBC being in Baghdad, on the 'enemy side', while 'our boys' were at war. One even carried the front page headline 'BBC in Baghdad bunker blunder', as if it were a camera crew who had dropped the bombs and not the US-led forces. From their vantage point in offices overlooking the Thames, newspaper reporters even questioned the truth of the incident itself, claiming that it had been staged by the Iraqis. They were suspicious of the English-speaking doctors, so conveniently on hand to talk on television about the tragedy. Given the strength of this poisonous attack from the press, Rory's integrity counted for a lot. He had been woken at 4 a.m. by the blast, had filmed the pictures since dawn, had noted the names of the dead and was an honest witness to the atrocity. That is the point of having an independent media.

London, 1991

The Gulf War put the company formally onto the map. The name Frontline was first used after that, and Vaughan was keen to make the whole business more professional. When he came back from Germany to try to sell his pictures, he met a producer at TV Asahi, Anna Roberts, who became his girlfriend, and within a couple

of months was Frontline's first full-time staff member, although like many people who worked in the office in those years, she did not work for much money. At the beginning the cameramen had started as a partnership, putting in £1,000 each. But now Vaughan bought out the founders, and tried to build a business model as a freelance TV news agency, although he knew there was no template to work from.

The key was not to employ cameramen – he did not want to found a crewing agency – but to allow the others to pursue their own journalism, while he set up a system to sell it. He would provide not the authority of a manager, but perhaps at least the glue to draw them together, and attract like-minded people to their world. It was always a full-time job, so there were long nights on the phone when he was travelling himself to keep it going. And it meant he had to sacrifice some opportunities to shoot his own pictures. But he knew that Frontline had to be bigger than the sum of its parts.

He moved to a one-bedroomed flat in South Kensington, where they set up TV-editing equipment on an antique table in the living room. Carlos Mavroleon, the most eccentric of them all, would drop in occasionally, wearing his trousers tucked into big Russian boots, taking a swig from a brandy bottle as he discussed plans. A half-Greek, half-Mexican heir to a shipping fortune, he drifted into television news after dropping out of Eton, converting to Islam, and fighting in Afghanistan. It did not feel like a normal office, but amid this they were selling pictures all the time. If Anna took a phone call in the middle of the night from Australia, and was asked to pass the call onto the accounts department, that meant passing the phone to the other side of the bed.

After the Iraqi army was driven from Kuwait a huge new movement of Kurdish refugees in the north drew the eyes of the world. Nick della Casa went to see his Club Nuko drinking

partner Jeff Harmon in his London flat to ask him to help with a proposal. Harmon took time off from editing a Gulf War film for Channel 4 to spend the evening with Nick, helping him to turn his ideas into something that broadcasters would back. Rosanna was determined to accompany Nick on this assignment and, knowing the crudeness and isolation of Kurdistan, Jeff tried to persuade Nick not to take his wife. But they had made up their minds. After meeting Harmon, Nick went to the BBC foreign-news desk the next day with his two-page proposal, and the BBC agreed that they would take a look at the pictures he came up with.

It was enough. A couple of nights later, Club Nuko gathered again, this time at Alex Lyndsay's flat in London for a farewell party. Nick was on his way to Kurdistan.

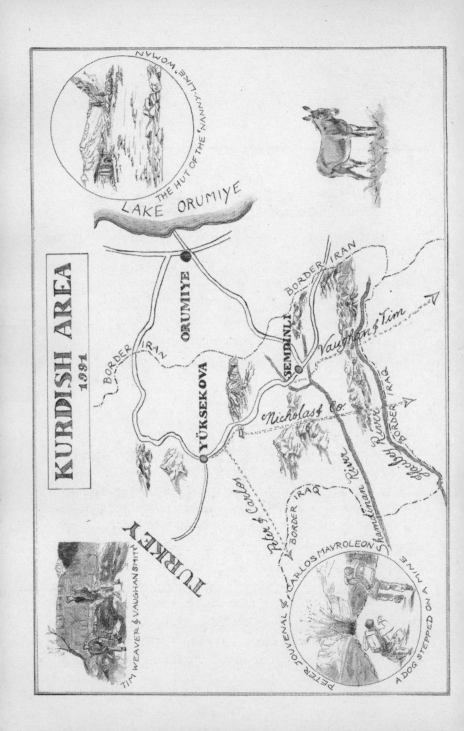

THE HUT OF THE 'NANNY-LIKE WOMAN'

LAKE ORUMIYE

KURDISH AREA 1991

BORDER IRAN

ORUMIYE

BORDER IRAN

YÜKSEKOVA

ŞEMDINLI

Vaughan & Tim

Nicholas & Co.

Peter & Carlos

BORDER IRAQ

CARLOS MAVROLEON

Shamdinan River

BORDER IRAQ

Haji River

TURKEY

TIM WEAVER & VAUGHAN SMITH

PETER JOUVENAL & CARLOS MAVROLEON

A DOG STEPPED ON A MINE

VIII

SEVEN DAYS IN MARCH

When peace is won and we're home again,
All I will ask of my country then
Is that the Grey's Scouts give to me
My wartime companion in Squadron C.
[The 'companion' was a horse.]

Nicholas della Casa

Kurdistan, March 1991

Rosanna had to make one important stop on her way to the airport. She needed to buy new walking boots. Her husband, Nick, had advised her that her old ones were too much like climbing boots for the task they were planning, crossing the Turkish border to meet the Kurdish forces who had taken on Saddam Hussein. She stopped in Kensington High Street to buy the boots and a reporter's notebook, which she kept as a diary. Nick della Casa was going to do the TV pictures and she planned to sell still photos alongside the footage, which she had not done before: new husband, new career, new boots. It was not an unusual arrangement – there are several other husband-and-wife teams in the field – although Rosanna's height and striking blonde hair would make her stand out in an

area where women are very much second-class citizens. On the first page of the notebook she wrote a list of camera agencies who might take her material – Rex, Reuters, Camera Press, Central News, Alfa, Gamma, Sipa – and the home number of a rather famous French woman photographer. Rosanna was aiming for the top. Although a novice photojournalist, she had travelled to difficult places before, including the wilder parts of Turkey. She prepared well for the trip, even procuring drugs to protect them against the threat of Saddam's chemical weapons.

Nick had gone on ahead to make arrangements to get in, flying to Diyarbakir, the biggest town in south-east Turkey. They knew that it was not going to be easy. Turkish security forces had long experience at keeping down the Kurds fighting for autonomy in southern Turkey, and kept tight controls over the borders into Iraq to the south and Iran to the east. Unwilling to be drawn into the Gulf War, the Turkish government wanted to keep this unwelcome front line as far away as possible. But Nick also knew that the border was an ill-defined line across a series of mountain passes, folding one into another, and that the Kurds on all sides kept supply lines open; getting in was just a question of finding the right guide.

Once Iraqi forces had been pushed out of Kuwait in 1991 it was clear that the next story would be in the north. The careless suggestion by the first President Bush that the Kurds should rise up against Saddam Hussein led to widespread persecution by Saddam's forces as soon as it became clear that the Americans were not going to back up their words with any material support. Tens of thousands of Kurds fled north to the mountains ahead of Saddam's tanks, bulldozers destroying their villages behind them.

The obstacles for television reporting were formidable. This region is one of the most inhospitable in the world. To the north of the desert plain that takes up most of Iraq lie mountains that seem

to go on for ever. Four countries, Syria, Iraq, Iran, and Turkey, meet in the mountains, and the Kurdish nation live across these borders without a country to call their own, facing persecution at every turn.

Nick wanted to go to the eastern edge of the Kurdish area. He prepared himself well, going to Paris to meet the Kurdish leadership in exile before he set out. His plan was to find the leader of one of the main Kurdish parties, Massoud Barzani, to do an interview, and then stay on to report on the refugee crisis. Kurds would regularly cross the border along secret routes in the high mountain passes.

The night before Rosanna was due to fly out to join him Nick's sister, Alex, rang her to see if she had heard any news. Alex was very close to her brother. While she was talking her husband, Charlie Maxwell, grabbed the phone and said 'Has he rung, has he? Has he left a number?' Once he had the number Charlie rang Nick straight away, although it was already late at night in Diyarbakir. 'Would I be useful? Shall I come and take out the first pictures?'

Charlie had occasionally travelled with Nick on journalistic trips before, taking time off from his own career as a barrister. As a young man he had travelled to the Kurdish region, had never forgotten its harsh beauty and had always been wanting to return. He had done his time in the army too, serving as an officer in the Black Watch; he could look after himself. He told Nick that he would come just for a few days and take out the first pictures, knowing that the idea would appeal. Once they had met up with the Kurdish leader Barzani, Nick would be keen to get the interview out to the BBC, while still continuing to report the refugee story. The decision was taken on the spur of the moment. Charlie was by then working as an in-house lawyer for a pharmaceutical company and was able to take time off. If Alex

had not rung Rosanna that night, then perhaps Charlie would never have gone. As it was, she found herself packing his bag the next day. 'Throw in lots of warm things,' he said, as he ran out of the door to pick up the air tickets and meet Rosanna.

They took a late-night flight to Istanbul, and the following morning they flew to Diyarbakir, where Nick outlined the details of what Rosanna called their 'secret squirrels plan'. Nick was restless and frustrated that he had not got very far. He had already been in Turkey for several days and had not yet found a guide or a route across the border. He was aiming to go east across the border to Iran, where he believed that he would meet the Kurdish leader Barzani in the town of Orumyie, providing they could evade the guards, or if that did not work, they would go directly south across the mountains into Iraq. He faxed Vaughan and Peter, who were planning to follow him. He finished the hand-written note with some advice:

I MUST STRESS – KEEP LOW! LOCAL GOONS EVERYWHERE, WILL DEFINITELY STOP YOU IF THEY KNOW YOUR PLANS. AVOID CARAVANSERAI HOTEL HERE – FULL OF HACKS AND GOONS. BRING WARM CLOTHES. GOOD LUCK AND SEE YOU IN ORUMYIE. INSH'ALLAH.

Nick, Charlie and Rosanna drove overnight east towards the town of Yüksekova. Apart from wanting to make good progress, driving at night meant that they kept a low profile on the road; the fewer people who saw them the better. On the way they passed one of the most spectacular sights in the region, the seventeenth-century fortress at Hosaab. But in the darkness they could see only the shadow of a stony outcrop hanging menacingly over the road. And then Yüksekova itself emerged in the strange green light

of a new day, the third since Rosanna had bought her new boots in Kensington High Street.

It was a bandit town at the best of times. Now the whole place seemed on edge. It smelt of smugglers; its narrow streets were full of Mercedes cars with no licence plates and there seemed to be no legal economy to support them. The first of the Kurdish refugees fleeing from Saddam's retribution shuffled along in the mud, trying to find a way to survive in this unforgiving land. While Nick and Charlie stayed in town to try to organise things Rosanna drove to the border to see if they could cross legally into Iran. It was a hopeless quest. It was a holiday in Iran so there was no way of getting a visa. As she returned in the evening empty-handed it began to rain. Another day had passed with no result. They met other journalists, who had been around for some time without getting anywhere. And then on Saturday, Rosanna found something upbeat to put in her diary: 'New hope! A new found promise to take us on our way. He's v. young and sweet looking.'

The young and sweet-looking one was Hasheem Cifti, who was hanging around the small four-room hotel where they were staying. They had been driven from Diyarbakir by a fixer called Ilker Catalbas, who was well-known to western journalists. He spoke some English, but neither Hasheem nor Obeid, his cousin, who was to come with them, spoke any English at all. Hasheem persuaded them that he knew the smugglers' routes in and out of Iraq. Ilker, translating all the time, says now that he was wary of this route. Many journalists were going east towards Iran, where the worst thing that could happen was a jail-term if things went wrong. The south looked much more dangerous, and he tried to persuade Nick not to take his party that way. But Hasheem looked plausible enough and they arranged to set out the next night.

Two other Frontline teams were now following closely behind. This was the first time that Frontline would field several crews to cover the same story. Nick was ahead of the rest, and was keeping them in touch with plans and contacts, calling Anna Roberts, who was coordinating the information, in London every day. They travelled in pairs for safety and support, so that one could always ferry out pictures if necessary. Peter Jouvenal was with Carlos Mavroleon, a man with useful connections. Early in the Gulf War he had offered Peter a ride into Saudi Arabia on a plane owned by his uncle, who was said to be a prince. Peter went as far as Munich to meet the plane, but the flight never materialised. Frontline acted as an agent for Carlos for several months, in places as varied as Somalia and Yemen, but he was not with them for the long term. He liked to carry a pistol, which the Frontline founders all felt very strongly was not what cameramen were supposed to do. From their time in the army they knew as much as anyone about guns. But to them, carrying a camera required courage of quite a different order. Carlos was clearly a serious player – an adventurer of the old school. But the pistol made him look like just one of those Walter Mitty characters who hung around the freelance fringe.

Vaughan and Tim Weaver drove through the night with Peter and Carlos to Yüksekova, and then the two pairs split up for long treks south across the mountains into Kurdish Iraq. It was a hair-raising trip. At one point Peter found himself drawing the unwelcome attentions of a dog attracted to the food in his rucksack. As he pushed it away it blew itself up on a mine. Vaughan and Tim had to cross minefields too, and after crossing one they found that they could not avoid a Turkish checkpoint. They chatted up the officer in charge, playing chess with him and winning his confidence so that he let his guard down, and they slipped away into Iraq before dawn. They could see that

they would have to move quickly. The way ahead was littered with clothing and possessions abandoned by Kurdish refugees fleeing from Saddam's soldiers. The story was happening on the other side of the mountains. They would need to move if they wanted to get material they could sell in time. Despite the hostile conditions, the hardest they had known, they filmed some useful material, including a patrol of Kurdish *peshmerga* rebels, which Vaughan carried out and sold to the BBC, while Tim headed off to try to cross into Iran, where he was promptly arrested and held for eleven days before being pushed back across the Turkish border. The transcript of one of his interviews in a refugee camp is evocative of the pain and loss of the Kurdish people:

> You could say that we are lucky because we are not yet dead. When the winter comes we will stay here under this collapsed concrete roof where we have cleared a space. We don't know if we can last all the winter, but we have nowhere else to go.

Nick spoke to his sister, Alex, on the phone on Sunday. He was impatient and obviously exasperated by slow progress. He could see that if they did not move quickly, they would not get the story. Charlie was supposed to be returning to work on the following Tuesday, but they had still hardly started. Nick told Alex to cover up for Charlie by phoning his office. 'Tell them anything you like, but there is no way he will be back until Wednesday at the earliest. I'll need him to come back then to get the pictures out.' Nick believed that from the border it would be only one day's walk to the *peshmerga* rebels. Alex reminded him that Easter was coming up. Her family was planning to spend it at Charlie's family home in Ireland. Nick said, 'If he doesn't come, just go ahead and fly to Ireland for Easter and he'll join you later.' Charlie did not come

to the phone, and so she could not tell him the news that she had confirmed since they had set out: she was pregnant with their second child. She was pleased not to tell him; the news could wait. Charlie clearly had enough on his mind.

After dark that evening Ilker Catalbas drove them south and dropped them a little way before Semdinli, the last town before the border, since there were Turkish army checkpoints on the road before Semdinli. Nick was in a confident mood, happy to be on the move at last. He told Ilker that nothing would stop them: 'Even if the mountains turn into a lake, then we will swim across.' Ilker dropped them on the road in driving rain, and they disappeared, walking into the darkness. Their aim was to scramble up the mountains to avoid the checkpoints and then meet taxis to take them along the roads in between. The walking was hard from the start. The road cuts through a series of mountain passes, the highest at around 7,000 feet. Rosanna was amused that their guides carried an umbrella, noting in her diary: 'It looked v. funny, both walking along a mountain and in this situation, but as the whole walk alternated snow and rain, rather sensible.'

The climbs seemed endless, along sheer-sided snow-filled tracks in the dark. In places there were no tracks, so they had to make their way through deep virgin snow. Every step was a trial as the snow went up to their thighs. Rosanna tried to keep control by promising herself that she could stop for a brief rest only after every fifty paces. But each time she started to count again seemed harder than the last:

First thing was to scramble up bank and lie behind rock for convoy to pass – already breathing hard! All clear, crossed road, and started slithering, tripping, stumbling and trying to keep balance up hill. Walked across screes horizontal to slope so v. hard. Pack made life hard and

I nearly gave up, being worried I'd hold everyone up – wouldn't be able to run, would lengthen journey by slow walking. Told N I shouldn't come. I really thought at this point that I wouldn't make it. One of the guides came back and took my pack – relief, I can now move and keep my balance and it's easier to climb out of holes my legs sink into. In some parts the slope was a bit frighteningly steep and I tried not to look down. Our guides seemed to go faster the more we weighed them down with our packs, bags, cameras etc. For a while we could see the lights of the CP [checkpoint] just below and heard dogs barking, but reckoned that we were too far up the mountain for them to chase. I walked behind C and kept seeing him disappearing knee and thigh deep in the snow which was soft and slushy. N got bad cramp and I thought he'd rolled off down the mountain at one point.

Finally they reached a road but there was no taxi waiting, as had been promised, so they had to set off up the road at a fast pace, plunging off it at the sound of a car. The two Kurdish guides made it across a stream when the car approached but Rosanna just crashed into the water, pulling herself up onto the far bank. The sight of a dry animal shed was never so welcome to anyone as to her that night. And then, no sooner had they pushed the sheep, goats and cows up to one end to make space for themselves than a 'bandit-looking man' appeared with a Kalashnikov and invited them up to a nearby cottage.

After the hours walking in tough conditions removing their boots in front of a dry stove was a luxury. The house was simple, with quilts around the edge of the rooms, large rugs in the middle, and no other furniture. It was the standard hospitality of Asia. Rosanna was given a pair of trousers belonging to one of the sons

of the family to replace her wet things, causing laughter all round because they reached only halfway down her legs.

After a while a taxi appeared, but they decided that it was too late at night to make a new start, so they stayed there through the following day, sticking to their plan to travel only at night. In the morning Rosanna was offered soap by her new friend, a 'hospitable and nanny-like woman', who delighted in combing out her long blonde hair for her. The second night of walking was easier since it did not snow, but Rosanna still wrote of 'hellish exhaustion' as they made their way up and along a jagged ridge. After about five hours of walking they drove ten kilometres in a taxi, although they were still north of the Turkish border at this point. They slept in a dry shed, and did not go out at all on the Monday, except when Rosanna slipped out briefly to take some pictures in the 'monochrome, brownish landscape'. But tensions were growing. Hasheem Cifti became impatient at their slow progress. It was not only Rosanna who was too slow for him. Nick and Charlie were finding the snow hard going too. They had a mule carrying all their packs that night, but that did not make them much quicker. On 25 March, the seventh day after she left London, Rosanna wrote in her diary:

It's frightening and dangerous and I'm worried about how I'll get out... The Kurds not only walk fast, but wear galoshes – & they seem to be able to keep them on in deep snow & mud with only shirt & jacket... Up, up and literally *over* the mountains.'

When Charlie did not appear in London by Wednesday Alex flew to Ireland to stay with his family, but already had a premonition that something serious was wrong. She made an unscheduled return home in the middle of the Easter weekend and settled into

the empty fireplace of the drawing room on the first floor of her home in Fulham with the phone by her side for several days and nights, doing nothing but contacting everyone she could think of who might be helpful. Looking back, she has no memory of what she did with her small child during that time; she was focussed only on finding out what had happened to her brother and her husband, as well as her sister-in-law. It was before the days of small lightweight satphones. Vaughan, Rory, and Peter consoled themselves with the knowledge that Nick was very resourceful. Surely he would turn up, as he had once turned up three weeks late from a trip to Somalia. On that occasion he emerged, looking neatly pressed, into the camp of an English couple who ran fishing holidays on an island off the coast of Kenya. 'I'm *terribly* sorry to disturb you, but is there an airstrip near here?' He had just walked 250 miles across hostile territory in Somalia, sleeping for part of the time wedged upright into the crook of an acacia tree, since the land around was flooded. Smugglers had ferried him out of the country in a dhow.

But Alex *knew* that something had gone wrong. She phoned the KDP, the Kurdish party who Nick had been trying to contact, and they were polite but exhausting to deal with. Every time that she phoned them she had to start the story all over again. And she phoned every journalist she knew who might know anything. But the 'secret squirrels' had left few tracks. The way that Nick moved independently now worked against him. There had been other journalists around at the time, but none seemed to know exactly how or why he had hired Hasheem or which direction they had taken.

After a while the BBC's Foreign Editor, John Mahoney, went out to Turkey with a producer who spoke all of the right languages to try to find out what had happened. There was still snow on the ground, and evidence of that long and hard winter for the

Kurdish people was all around. Tens of thousands had died. The Kurdish authorities were not initially interested in the fate of three westerners. The BBC producer, Annie King-Underwood, made what contacts she could while Mahoney questioned other journalists who passed through, including an American TV crew who knew Nick, but no one had seen him or Charlie or Rosanna.

The first breakthrough was made by King-Underwood. On previous trips she had used Ilker Catalbas, the fixer who had introduced them to their guides. Hasheem himself had disappeared, but through Ilker, she met Hasheem's family. The father was silent, frightened, suspicious. The mother was in tears, and although her husband told her to keep quiet, she told King-Underwood that her son had gone south towards Iraq, not east towards Iran.

Nick's brother, Andrew, went out to the region as well, following various leads as they emerged. They were a close family and by now he had considerable experience of trying to find Nick when he got into trouble because of some story he was covering. Andrew, a banker and an experienced traveller himself, always marvelled at how his brother went for the harder stories. Seeing other, more obvious things to follow, which would be easier to sell, he would ask, 'Why not do that one? It's a dead cert,' but admired Nick for pursuing the stories that he believed needed to be told. Charlie's brother Ronnie travelled with them, and they hitched rides on helicopters, moving around southern Turkey and northern Iraq, talking to anyone they thought could help.

A diviner who had found hostages before offered assistance to the BBC and pored over maps, swinging weights, and, more conventionally, the BBC printed leaflets with photographs and requests for information, which were dropped around the region by British and American forces, now there in strength. Since information had a value, there were many rumours and leads, some cruelly raising false hopes, others telling of bodies. Some

badly decomposed bodies were flown to Britain; but they turned out not to be the missing journalists.

'Sweet-looking' Hasheem was arrested by the Turks on a charge of smuggling, under one of his assumed names, but escaped by bribing a guard before any connection could be made with the della Casa case. But then in August, five months after they disappeared, he was arrested again, this time by the Kurdish authorities, who had latterly been making more effort to try to find out what had happened to the journalists, who, they could see, had come to reveal their plight to the outside world. They picked up Hasheem in the Kurdish area of Iran and brought him back across the border. Initially he denied having anything to do with any deaths, and he changed the story so often that no one could ever piece together what happened with any assurance.

The first real breakthrough came when another Kurd, who was trying to escape from the region and claim asylum in the west, found two bodies. He took his information first to the Americans, and then to the British. Andrew della Casa had a phone call: 'There's a guy here who tells us that he has found bodies in an area your party could have gone through. What shall we do with him?'

'Hold him, please. We're on our way.'

Andrew and Charlie's brother Ronnie headed out to Iraq, and it was not a wasted journey. Two British helicopters flew across the awesome mountain range separating Turkey from Kurdish Iraq to the spot that had been identified. One helicopter landed and, after securing the area, Royal Marines found the site of a camp fire and human remains in the undergrowth. The bodies had been disturbed by wild animals and moved around as the snow melted. During the search the marines saw a bear with two cubs. By now, in high summer, the area where Nick, Charlie and Rosanna had trudged through thigh-deep snow was all green.

Andrew and Ronnie were in the second helicopter, but tantalisingly had to remain in the air, watching the drama unfold on the ground and listening to the radio traffic reporting the finds, since, they were told, their helicopter had too little fuel to be able to land safely and get out again. Charlie's watch was found on its own, in a pool of water under a boulder. It had stopped on 31 March, a week after Rosanna's last diary entry. Remnants of an unidentifiable British passport were found in the grass, with an intact Canadian entry stamp. All of this information was relayed back to Alex in Fulham. Yes, she and Charlie had spent their honeymoon in Canada; it could be his passport. The key find was Rosanna's diary itself, which had been concealed in a waterproof bag, wrapped in some underwear, along with camera films, buried under the remains of their camp-fire, and had escaped detection by robbers. This soldier's hiding place was typical of Nick.

The two brothers flew back to a British military base in northern Iraq, and confronted Hasheem, who was being held nearby by the KDP. Andrew says that his eyes were expressionless: 'Not dead, but expressionless. We asked him why he had done it, and he shrugged and said, "Because I did." He did not try to give a reason.' The Kurds asked what should be done with Hasheem, expecting them to say that he should be shot. But instead, the bereaved families said that he should be put on trial. By now, though it was pretty clear that one of the bodies was Charlie, the identity of the other was unknown. Nothing identified it even as male or female, and the assumption was that it was Rosanna, since it was more likely that Nick had gone on alone. Alex knew that she had lost her husband but she clung to the hope that somehow, all these months later her brother might still be alive. It was not to be. The police back in England carried out detailed forensic tests, and visited Alex late one night to break the news. They were convinced that they had the bodies of the two men.

Further confirmation that Nick was not still alive came when his watch and stills camera were found with Obeid, the second of the two guides, who was never charged with any offence. There was great sorrow of course, but relief for Nick and Charlie's families that they could bury their dead.

For Rosanna's family the uncertainty went on. Her mother, Marigold Curling, a doctor, had made her own inquiries, pursuing every lead. She made five visits to the region, advertising in local papers for information. At one point there was a suggestion that Rosanna might have been seen alive in the Iraqi Kurd town Kirkuk. But the woman they found there, although a westerner, had dark hair. It was a heartbreaking time, the chance of a reward opened several false leads. The possibility that her daughter may have survived, whatever happened to the two men, kept Dr Curling going. She is a woman of inexhaustible will and something of a traveller herself. She paid a ransom to one Kurdish gang who said they had taken Rosanna hostage, and travelled to France to meet the Kurd who had first reported Nick and Charlie's bodies.

Hasheem never gave a clear narrative of the day he killed the two men but he was always adamant on one thing, that he had not killed Rosanna. He had been carrying a gun in order to shoot animals to eat and to protect them. He claimed that the gun belonged to Charlie. Alex is sure that this was not true. She knew that her husband never trusted himself with guns, because he had a condition that meant that his hands shook. Even when he was an officer in the Black Watch, he would never put any ammunition in his weapon, if he had to carry one. And as a journalist, Nick never carried guns either.

During one interrogation Hasheem said twice that he 'hated' Nick. Even when he was given a chance to apologise he repeated himself. He gave a lot of details about the days *after* Rosanna's

last diary entry, and the Metropolitan Police investigators were able to corroborate much of it by talking to local villagers.

At the time of her last entry, on 25 March, they were still not inside Iraq, so the frustration with their slow rate of progress must have been building up on both sides. Hasheem admitted to the police that he did not know the best route to take, and on 27 March, after walking all night, he left Nick, Rosanna and Charlie in hiding under a bridge close to a village and went on ahead on his own to fetch help. He paid a guide, who joined them for a day, and it was now, Hasheem said, that they insisted that he should buy a gun. Once they had crossed the border they travelled by daylight, since they did not have to evade Turkish guards.

On Saturday, 30 March, the day that Alex left Ireland to return home because she *knew* that something was wrong, Hasheem went forward on his own to check out a village that was thought to be deserted but where there could be mines and even Iraqi forces. When he returned he found that the two men were cooking a quail they had trapped. Rosanna was sitting on one side on her own. While they ate the quail Nick took out a notebook, waving it in Hasheem's face to show that he had been paid to get them out of Turkey, but they were only a few miles across the border after walking for days. Hasheem claimed that he had not received any money, their original fixer Ilker had taken it and not paid it to him. Ilker has always denied this, saying that he only made the introduction. Hasheem said that Nick became angry: 'He began to count in the book. He was telling me I had had enough money. I pointed out that I had bought the gun, mule and food. They said they had given Ilker the money for me.' And then, according to Hasheem, the only survivor, an argument developed, using signs, since they had no common language.

'He threw the book in my face. I threw it back at him. When he threw the book again he hit me in the face, and I hit him back.

The other man grabbed my wrist to stop me. He slapped me in the face, twice. I pulled my hands from him. I decided I was not going any further with them. I said I was taking the gun. I took hold of it and the younger man said, "No", and grabbed the other end. We fought and somehow the gun went off. I don't know whose hands pulled the trigger to shoot.'

Hasheem says that Charlie was holding a knife. 'He began to attack me. I shouted at his face not to come. I shouted in Kurdish, "Don't come or I'll kill." When he attacked me I began to shoot. It was two, maybe three bullets. Rosanna fled behind a boulder. I turned to her and when our eyes met I was not able to pull the trigger. I could not. I liked her like a mother. I was too shy to look into her face.'

He said that he left the scene, and when he came back later he saw her tracks leading off in the snow.

The Royal Marines who found the bodies and the cache under the camp fire did not have time to search any further, but in a later search Metropolitan Police officers investigating the murders walked several miles around the area where the bodies were found. They found a hair grip, a sock, and one of Rosanna's boots, identified by the shop in High Street, Kensington as being one of the pair bought there on 19 March.

Finally Rosanna's mother asked a private investigator to help out. He talked to Kurds who said that they had come across Rosanna's body and had put it in the river months before to dispose of it. The investigator went into the river where they pointed, and dug out her money belt, still containing money and credit cards. It had lodged against a rock, but in the fast-moving river there was no sign of her body, and her family believe that it must have been washed away.

The biggest unanswered question is how the three of them ended up in that area, still very close to Turkey itself. It was directly west

of where they are believed to have crossed the border. Either they had indeed crossed that far west, and made very little progress, or they were going round in circles. Perhaps their guides just could not find a way across the inhospitable terrain. Rosanna's diary reveals that they were certainly making much slower progress than any had hoped. It is also possible that the presence of Turkish troops in the area may have hindered their advance. Marigold Curling certainly believes that the Turks know more about the incident than they have ever revealed.

She wrote to everybody she could think of. Saddam Hussein replied to her letter saying that his troops could not have been involved because they were not in that region at that time, they had never got so far to the north. The British Prime Minister at the time, John Major, himself became involved, writing letters to seek help from the Turkish government.

Hasheem Cifti's trial was dramatic. The whole court, including the judge, and three presiding magistrates, trekked into the hills, where Hasheem re-enacted what had happened. Rosanna's mother, Dr Marigold Curling, was there with her surviving daughter, Davina, and son, Richard. They had been there before and had even met some of the people who were the last to see the three alive, including the 'hospitable and nanny-like woman' who had brushed out Rosanna's hair. Whatever Hasheem said about the money, Marigold Curling believes that the real reason for the argument might have been the route. With their military training, Nick and Charlie would have known that the guides were not taking them in the right direction, across the river, into the area where they could have met the Kurdish rebels.

Whenever a journalist dies, everyone else is wise after the event, and sometimes cruelly critical of the decisions made by the dead. Contempt about these deaths was particularly strong, because two of the victims were not 'professional journalists'. Hindsight is

a really corrosive thing in the news industry. Frontline journalists, who operate outside the pack, have always had their reputations trashed after their deaths, usually by journalists who do not put their lives on the line for their craft.

After Nicholas della Casa died, questions were even asked about whether he was really kidnapped in Mozambique. But his own personal diary of that ordeal, and the painstaking negotiations with his captors undertaken throughout by his family, make clear that he was genuinely held against his will, and often in very hazardous circumstances, where only his quick wits and strength of character saved his life. Those who question his judgement in allowing his blonde wife and brother-in-law to accompany him into Kurdistan should know they all went in with their eyes open.

But they were certainly unlucky meeting Hasheem Cifti. He turned out to have a life story straight out of *Midnight Express*. He had once been put in a Turkish jail for drug smuggling, but escaped in a coffin, pretending to be dead. Although Hasheem was clearly a crook, that might not necessarily have ruled him out for the job. Crooks often make the best guides. This was a smuggler's frontier: it would be hard to find a guide who was *not* a crook. But whether he was the best choice for this trip remains a real question. His expertise, such as it was, lay in drug-running across the mountains from Iran directly to the east, not in the trails further south where they wanted to go. Perhaps their real enemy had been the weather. Moving around was even more difficult than usual; melting snow slowed everything down and swelled the waters of deep rivers which cut their way through the region.

Jeff Harmon wrote Nick's obituary in the *Daily Telegraph*. He could not take any money for it, but asked them to send him the equivalent in Krug champagne. Club Nuko was re-formed one more time to remember Nick in style. Harmon said later, 'I couldn't conceive of Nick getting killed. There was something

about him that was almost magical. You could see him getting thrown in jail, getting taken hostage, getting in a firefight, but not dying.'

The Kurds put up a memorial stone to Nicholas, Charlie, and Rosanna in the mountains, and more practically, Rosanna's mother raised money for a hospital for the Kurds to stand in her memory.

Pictures of the three went up on the wall at Frontline Television News in London.

Hasheem Cifti escaped from jail when the doors were opened during fighting in Irbil in 1997. He has not been re-arrested.

IX

NIGHTS AND DAYS

'Tis all a chequer-board of Nights and Days
Where Destiny with Men for Pieces plays:
Hither and thither moves, and mates, and slays,
And one by one back in the Closet lays.

> The Rubáiyát of Omar Khayyám (c. 1100),
> translated by Edward FitzGerald (1859)

Baghdad, February 1991

During the bombing of Baghdad, journalists in the Rashid hotel were sometime herded into the basement. There was no power, and for a while there was no water so they had only red wine to drink. Rory Peck talked through long nights with a Russian journalist, Vladimir Snegirev, who he had bumped into at the border and given a lift across the desert. Vladimir was a star correspondent for *Pravda*, Russia's most prestigious newspaper, but he could not begin to afford the 1,000-dollar taxi fare to Baghdad.

It was a favour which was to change Rory's life. Vladimir came from a different universe but they became close friends. In those days he would certainly never have been invited as a dinner guest at Rory's eccentric Irish home, still the bastion of Cold War anti-communist attitudes. Vladimir was a lifelong, loyal Communist

Party member who had been on the first skiing expedition to the North Pole, and improbably had once trained as a cosmonaut, although he never actually went into space. They were mirror images of each other. Vladimir speaks of the relationship in the poetic tone of the true Russian: 'He was anti-communist, I was anti-capitalist, we were like water and stone, or black and white.' But as they swapped stories over the red wine during the American air raids in Baghdad, Rory needling Vladimir in his usual combative way, they discovered that they had much in common. After all, *Pravda* had always been required reading for Rory during his unusual upbringing.

Vladimir had spent as much time in Afghanistan as Rory had, and they swapped battle memories – Jalalabad, Kandahar, Herat. Both men had been in all those places, Vladimir accredited to Russian forces and then with Afghan forces loyal to Moscow after the Russians left, Rory with the mujaheddin guerrillas on the other side. There was even one occasion when each was looking for the other unknowingly. Rory's mujaheddin desperately wanted to capture or kill the Russian 'adviser' they knew was among the Afghans on the other side, while Vladimir's Afghans had caught fleeting glimpses of a distinctive, tall, balding man on the other side who they suspected of being a CIA spy. These were difficult times for a loyal Communist Party writer; the brutal side of the war led to gradual disillusionment with the cause. Doubts as to Russia's right to invade Afghanistan began to build up in Vladimir's mind as he reported on 'the seamy side of the war. It was cruel, bloody, dirty.'

Later, when they met in Moscow, Vladimir looked at Rory's pictures of the siege of Jalalabad and identified exactly the places where he had been under fire from the guerrillas who were with Rory. Vladimir had gone to Jalalabad initially just for three hours. He had to stay for three days, under constant rocket attack from the mujaheddin. When a fleet of helicopters finally managed to

take off again to return to Kabul, two of them were shot down, and Vladimir's was full of bullet holes. Rory was on the ground filming with the gunmen who shot at the helicopters.

Moscow, August 1991

You could not make luck like Rory's. He went to Moscow only to meet up with Vladimir again in the summer and found himself in the middle of the most dramatic event in the city in modern times – the fall of communist order. While President Gorbachev was on holiday in the Crimea, the levers of power were seized in a fast-moving chain of events that ended up when Boris Yeltsin replaced him. When it began Rory went to the offices of *Pravda* and grabbed Vladimir out of his chair, saying, 'You're coming with me.' Vladimir never went back to work for *Pravda* again. Rory was like a large planet with a strong gravitational pull, which inspired and drew in people. For three days he and Vladimir hardly slept as they chronicled the collapse of communism. For one man it had been the creed by which he had lived his life, for the other it had been the devil, and now they shared its death throes.

There were tanks in the streets, while Yeltsin was holed up in the 'White House', the Russian Parliament, waiting for the best moment to make his move. Crowds swirled everywhere like lava from a volcano, bolder as it became clear that troops would not shoot at them. Nowhere were the crowds deeper than in Dzerzhinsky Square, in front of an anonymous yellow-painted building. It had originally housed an insurance company, back in tsarist days before the 1917 revolution, but it was now known only as the Lubyanka, the headquarters of the communist secret police, the KGB. For all of the lives of everybody in the square the KGB had wielded the power of life or death. And in the centre stood a statue of the lean figure of Dzerzhinsky himself, the first head of the secret police after the Russian revolution.

Rory could not have been happier. Communism – the thing he had been taught to hate above all else – was falling and he was there at the heart of it, filming the moment which became the symbol of the collapse, the crowd pulling down Dzerzhinsky's statue.

He quickly met up with John Simpson, who never missed the big moment, and in those days after the old power dissolved, before the new order emerged, they took every opportunity offered to get the camera into forbidden places. A brief power vacuum is full of hidden danger, since no one knows who to trust. But it can be the best of times for a journalist, when the impossible becomes possible, if only you know who to ask. Vladimir's biggest coup was to get them into the Lubyanka. Simpson asked if it could be done, so Vladimir phoned a KGB General.

'I would like to come in just to look around and see everything is safe.' It was not an unreasonable request. Vladimir was a decorated hero of the Soviet Union, and a trusted correspondent of *Pravda*.

'Why not? Come tomorrow.'

'I want to bring some friends. They are British. Journalists.' He spun out the words, knowing that even a day before it would have been an absurd request.

There was a long pause at the other end of the phone. And then the general spoke again

'I see. Bring me some whisky and I see no reason now why that should not be possible.'

So for a bottle of whisky Rory and John Simpson secured the first television access inside the KGB. They even succeeded in entering the office of the director itself, where death sentences had been handed down to literally tens of millions of people. The eyes of the guard looking at Rory's lens as they walked in told their own story, surprised, suspicious and a little frightened at the turn

of events. Looking *out* through the windows of the Lubyanka, the empty plinth where Dzerzhinsky's statue had stood looked even more forlorn. Simpson wrote in his script: 'The world as seen from the Lubyanka has changed in the last week.'

As soon as they were inside Rory was on the lookout. 'There must be some great souvenirs in here.' But they never got so much as an ashtray as they were moved quickly around by men who were wary of them. In his usual chaotic way, Rory did not have the right plug for his equipment. He was setting up his lights while Simpson was sniffing around the glass cabinets, trying to decipher the labels on photographs of British spies from another era. Rory's drawl disturbed his researches.

'I say, John. Don't suppose you have such a thing as a screwdriver?'

Simpson was impatient. 'You're the cameraman. You're supposed to bring a screwdriver. Get yourself together. Do I ask you for a pen?'

And Rory defused the potential row rather laconically, smiling up from the floor. 'Well, as a matter of fact, about half an hour ago you did.'

He ended up improvising, stripping off the wires and sticking them into the socket with matchsticks in order to light up the rooms, while Simpson took in what he could. Who was the fifth man alongside Burgess, Maclean, Philby and Blunt? They never found out, as they were bundled along by their guides.

It was a great scoop which picked up awards worldwide. The KGB, and then its successor agency the FSB, soon re-established order, and did not allow any further filming inside their secret sanctum, which gave the added value of exclusivity to the pictures.

Vladimir even got them into Gorbachev's private apartment in the Central Committee building too. It really did feel like a revolution. Rory was in his element, using the opportunity to

buy up old Soviet realist art, which now had no value in the Soviet Union. He took Simpson to the house of an art dealer in an immense nineteenth-century flat close to the old centre of the town, the Arbat. Rory inevitably bought the largest, a giant canvas showing the assault on the Winter Palace in 1917. The idea of owning such communist excesses appealed. On the wall of the Metropol hotel, near Red Square, there was an enormous bronze relief of the barricades from the first Russian Revolution in 1905. Rory began negotiations to have it removed from the wall, although the sheer weight alone would have put anyone else off. His most audacious bid was for a building which he discovered had once been the Moscow 'English Club'. After the communists took over in 1917 it became the Lenin museum. Rory wanted to return it to its original use and he walked in and offered half a million dollars for it, serious money at the time. The curators were attracted. The communists had gone and nobody knew if there was going to be any value for the museum in the future. Rory made plans, looking around at exhibits like Lenin's overcoat and his Rolls-Royce.

'We'll want to hold onto some of that. But you will need to store most of the stuff somewhere else.'

The negotiations went on for a few days, and then stalled, initially because they could not find storage for the material that Rory did not want for his club. And then as normality returned the waters closed again over the moment of opportunity. A residual feeling of responsibility returned and doubts began to creep in among the building's managers as to whether they could really take the money. Rory's bid to refound Moscow's English Club failed.

Once the coup was over Rory could talk in detail about the original reason for his trip. Over the red wine in the Rashid hotel in Baghdad in February Vladimir had asked for his help in trying

to find Russian prisoners who were still being held in mujaheddin jails in Afghanistan, two years after Russian forces had pulled out. Now Rory had come as a peace envoy to Moscow. His Frontline partner Peter Jouvenal had been asked by his friends in the mujaheddin to see if he could negotiate the release of their prisoners who were still being held by pro-Russian Afghan forces. The Russian-backed administration in Kabul, led by President Najibullah, was hanging by a thread. Both sides wanted their prisoners back before the fighting started again. The friendship forged on the road to Baghdad opened channels between Moscow and the mujaheddin.

The lengths which Peter and Rory were prepared to go to for the release of prisoners went far beyond the journalistic value of the story, although clearly that was on their minds too. They always understood the humanity of the people whose predicaments they were reporting. In Kabul Peter was known for his generous gestures. He would take uneaten kebabs from lunch and give them to the soldiers at the next checkpoint. Now he was engaged in a far bigger and more complex act of charity. The fate of mujaheddin soldiers who were missing in action was a major concern for Afghan society. If there was no proof of death, then their widows could not remarry until eight years had passed. In such a traditional society, where there was no role for a single woman, this could make the difference between life and death. The mujaheddin leader Ahmed Shah Massud did not trust the Red Cross, and feared that if he just gave his enemies a list of names of the missing, then they would kill those they were holding, because they knew they had a value. He wanted an independent witness to go into the communist jails and tell him who was there before he asked for them. To the mujaheddin leadership Peter was the perfect person for that job. Prompted by Massud on the one side and the Russian government on the other, through Vladimir, Peter

began to register women whose husbands were missing, collecting photographs and names, while trying to negotiate access to the communist jail.

Afghanistan, December 1991

By the end of the year they were ready to move on their plan. To start things off Massud needed to be persuaded to release any Russians at all, so Vladimir set off on a hazardous journey to convince him of Russia's goodwill. Although the Soviet Union was crumbling, Russia still controlled security between the southern republic Tajikistan and Afghanistan, as it does to this day. But no Russian citizens were allowed to cross. Vladimir needed a personal order signed by President Gorbachev, who was still nominally in control in Moscow, in order to be allowed to make the trip.

Their arrival by helicopter at the last Russian border post on their side of the frontier shocked another Frontline cameraman, Tim Deagle, who had been crawling along the mudbank on the Afghan side of the border since early morning in order to get pictures of Russian military movements on the other side. He was more than a little surprised to find himself filming Peter, Rory and Vladimir getting out of a helicopter. It was the first helicopter Tim had seen for months so he supposed the passenger to be a general reviewing Russia's front line, although he did wonder at the exotic furred headgear of one of the new 'guard', who he later identified in his pictures as Rory.

Tim had been in Afghanistan on the usual trawl for images, this time crossing in the north-east, meeting some exotic traders who had crossed the jaw-dropping passes linking Afghanistan to China. To him they looked like Marco Polo. They said, 'We always know that it is time to come when the apricots blossom.' Back in Canal Bank Road after that trip Tim received a worse injury than anything he sustained covering conflict in Afghanistan, falling

down the stairs, after one two many joints, or bottles of whisky, or both, on the night of his return. The Red Cross doctors who stapled up his chin had little sympathy.

Once in Afghanistan Vladimir had to pose as a Finnish journalist, since he would certainly have been killed if the mujaheddin had known he was a Russian. Hiring horses and guides, they travelled through the snow in the Pamir mountains in order to reach the hideout where Peter knew he would find the mujaheddin commander Massud. Here Vladimir threw off his Finnish disguise to try to negotiate for the Russian prisoners. He was the first Russian Massud had met who was not a prisoner. The guerrilla commander had always been suspicious of Russians, thinking that he would be the target of assassination. Peter's presence was enough assurance for him to be able to trust Vladimir.

They met six Russian and Ukrainian prisoners, and Massud agreed to release them while Rory and Vladimir returned to put pressure on the Russian government for the release of mujaheddin prisoners in return.

On the way back out of Afghanistan, crossing the Oxus river on a frail flat raft, they were fired on by Russian border guards who took them for Afghan spies. When they arrived back in Moscow after their epic journey a Russian general, who had once been the commander of the Kabul garrison, came to meet them at the steps of the plane. He congratulated them on their trip, saying that Vladimir deserved the highest honour from his country. But then he said mournfully, 'There are no more Soviet awards to be had. The country was officially dissolved three days ago.'

All of this was costing Peter money, which neither the Russians nor the mujaheddin had. He ended up going to a most unusual source. While he was in Moscow trying to find someone to fund his work, a Russian colonel told him of an American group in

town who were looking for the bodies of American servicemen missing in action. The leader of the group, rather improbably, was a location finder for *Star Wars,* and between movies, even more improbably, he held a senior office in the 'Knights of Malta', the oldest order of chivalry in existence, which all rather fitted Peter's general style.

'Sir John', as he called himself, was very grateful for Russian help in tracing American bodies in Siberia and Vietnam, and in return he decided to help Peter in his quest to help the Russians. With the easy generosity of a man with big bucks behind him, 'Sir John' offered $100,000 if Peter brought back the bodies of two Russian servicemen. Peter planned to use that money to continue his programme with Afghan war widows who wanted the deaths of their husbands registered so they could get on with their lives.

He knew where there was one grave in the Panjshir valley. Sandy Gall had reported its existence for ITN in 1982. Afghan friends told him of another one close by. He did his own recce mission, and then brought in 'Sir John'. When they arrived in the village, one of the party sat on a small grassy mound thinking it was a seat, which greatly amused the Afghans since this was where the Russian was buried. Peter had brought an archaeologist with him and filmed him exhuming the body. The Afghans were fascinated by the care and attention, and then one said, 'What are you doing with our Russian?'

Peter said 'We are taking him away. He has to go home.'

'But he's *our* dead Russian. You should pay us.'

It was a low moment. Anyone could see that the Americans had large amounts of money and Peter thought that if he started to negotiate then it could cost them hundreds of dollars. He decided to try a joke instead:

'If I gave you 20 Afghanis [about half a penny] for a dead Russian, that would still be too much.' It lightened the atmosphere.

Everyone laughed, and they got away with the skeleton without payment, exhuming the second one as well, which was buried nearby.

It would be almost a decade before the bodies could return home.

Peter put them in a metal box, of the sort which Afghan families keep under the bed containing all of their worldly goods. At the time he had a house in Kabul, and the skeletons were there for a while, before being moved to the office of the American news agency AP, along with other possessions of Peter's. Vladimir was trying to find out exactly who they were, so that they could be repatriated, but at this moment the Afghan regime changed; the communists fell and all of the prisoners were released, so his incentive to raise money had gone. But Peter was still left with the skeletons. They turned out to be Ukrainians, which made the Russians less interested in securing their repatriation. So the years passed.

By the time the Taliban took Kabul in 1996 Peter's skeletons were with six other boxes containing his equipment in the German Club, which for a long time was the only place to stay in the centre of town. The tennis courts and swimming pool there were a reminder of calmer, more peaceful times. Peter's boxes ended up in storage in the bowling alley. Each of the metal boxes was locked and all of the keys were kept in one Russian safe box. Peter knew that someone must have broken in when he got an anguished phone call asking him to take his boxes away. But he was not able to get to them for another five years until after 9/11 and the fall of the Taliban. At the club no one would admit that they had opened them. Colin Peck, Rory's brother, was with him when he went to retrieve them, and got chatting to a German.

'Have you been in the bowling alley?'

The German said, 'No they won't let us. Apparently there are these dead Russians buried there.'

At this point Peter's boxes were being carried past and Colin said, 'I think it's all right to go in there now.'

But the Ukrainian bodies were still not at rest. Peter moved them to Pakistan, in the hope that the Russian embassy might take them, and Vladimir came with him to help to negotiate. They were stored for a while in a church, until that was hit in a grenade attack; then they went with Peter's other boxes to the BBC house for a while, although nobody there knew what was in them. Finally Vladimir's negotiations paid off and the Russians agreed to fly them back to Ukraine for burial. One was a lieutenant; the other a private soldier.

Afghanistan, March 1992

Vladimir's ability to work the system got Rory onto one of the last Russian transport planes to fly into Kabul in the last days of the communist regime. By now, with no Russian military forces on the ground any longer, it was clear that the city was going to fall into the hands of the mujaheddin. The last act of the Russian invasion was to be played out *three years* after Peter had made his epic *Panorama* film, which was based on the fact that it would be quick.

The Russian government wanted to get as many of its diplomats and as much equipment out as possible. Rory and Vladimir flew in over the Hindu Kush in the cavernous hold of an empty Antonov, which would carry out the last essential items that Russia could not leave behind in the embassy. As soon as they arrived Vladimir performed another patriotic duty. He crossed the front line and went to meet Massud again, who was now camped less than a day's drive from the city. Vladimir secured a guarantee of safety for the Russians who were left behind in the embassy. Massud promised that they would not be hurt.

As Kabul came under the most ferocious assault it had yet faced from the mujaheddin the electricity went off. That was always

a sign that control was going to change hands. The city's power supply was one of the things that survived virtually intact through all of the years of chaos in Kabul. The Kabul River powered a series of hydroelectric turbines as its water gushed down ravines off the high central Afghan plain down to the lower valleys in the east. Although it was always in working order, the power station was far enough outside the city to be vulnerable to being taken in battle. The power could easily be switched off. During the fighting somebody flicked the switch, and the BBC was unable to broadcast until Vladimir went to the Russian embassy and 'secured' a generator. He would not accept any payment since the BBC had helped him to get to Baghdad a year before. Thus was the favour repaid.

X

ENDLESS WAR

For what can war, but endless war still breed,
Till Truth, and Right from Violence be freed...
 John Milton, 'On the Lord General Fairfax at the siege of Colchester'
 (1648)

Kabul, Afghanistan April 1992

There is no airline in the world like the Afghan carrier Ariana. Its twice-weekly round trip from Kabul to Delhi, using ancient just-airworthy Russian-made airliners has run at times that no sane person would want to fly in and out of the Afghan capital. For many years, even after 9/11, you would buy a ticket from the same man in the cavernous, wood-panelled office in the centre of Kabul who had been there since the 1980s. People in Afghan government offices do not change with the regimes; they only change their appearance. Depending on who was in power the man at Ariana has worn a suit, or local dress, or grown a beard to keep in favour with the government. He writes down your name in a large book and does not insist on much of a bribe in order to guarantee a seat. It is all rather haphazard. You would carry your own luggage onto the plane.

In April 1992, three years after the Russians had pulled out, the journalists who flew into Kabul from Delhi hoped that they

194

had called the situation right. In journalism everything is down to good timing. Nobody wants to sit around doing nothing, but equally you do not want to miss the story. With its hold laden with thousands of kilos of television equipment, it spiralled down into the city in steep curves, deploying tactical flying techniques to avoid anti-aircraft fire. The rumour was that the last act of the Najibullah government was about to be played out, and the mujaheddin would finally take the capital. They already held most of the rest of the country. Peter Jouvenal was on that plane, as was Rory Peck with his wife, Juliet, who had an ulterior motive for joining him on this trip. She was looking for evidence of who had shot her first husband.

There was a tense atmosphere on the flight. For many on the plane, it would be their first trip into Kabul. During the long years of the Afghan wars, before the Taliban, most journalists would focus on the mujaheddin side, keeping out of government-held areas. Rory in particular would travel only on that side, because he was backing the mujaheddin against the communists. He was a cameraman with a cause; for him this was a war of liberation. And he was not alone; the lure of the mujaheddin both in Peshawar and in the mountains of Afghanistan drew people in.

Some even went as far as seeing journalists who went onto the other side as 'traitors'. It was a ridiculous charge. The admirable BBC reporter Lyse Ducet, who can speak for longer, with more fluency and fewer fluffs, anchoring news shows on cold hotel roofs, than anyone else in television, learnt her trade in Kabul. She and the equally admirable John Burns from *The New York Times* were once vilified and given a mock trial in the American club in Peshawar by pro-mujaheddin journalists. Their 'crime' was to have spent time in Kabul under the communist government. Peter was exceptional in crossing over at ease, seemingly without making enemies on either side. He never believed that

any Afghans, even the pro-Soviet leader Najibullah, were really communists. To them it was just a badge of convenience, and they would change sides for a better offer. He reasoned that since many families were divided in their wartime loyalties, brother against brother, village against village, then journalists should not be too precious about reporting from only one side or another. As the plane made its final tight approach in, he knew that at last, years later than predicted, the Russian-backed Najibullah government would lose power. The Russians and Americans had stopped their arms supplies. Afghanistan was on its own.

Soon after they arrived Najibullah was put under house arrest by General Dostam, an amiable thug from northern Afghanistan, who has been a key power-broker in the country for a generation. The seizure of Najibullah marked the final end of Russian influence in Afghanistan. Kabul now lay open to the mujaheddin. Peter led a BBC *Newsnight* crew out of the city, across the front line towards Jabul-es-Saraj, half a day's drive away at the top end of the fertile plain north of Kabul.

It was spring and the complex terraces and trenches in the sand-coloured landscape were covered in green as the first leaves grew on the vines. They found their way blocked by a checkpoint and this is where Peter's decade-long experience in Afghanistan came into play. The other members of the crew were impatient, driven by all of the imperatives of daily news. But knowing how things worked, Peter advised them to take their time and pay tribute to the local commander by doing a TV interview with him, even though they knew that they would not use it. He was playing in the same way that Englishmen played in Afghanistan during the days of the Great Game against the Russians a century before. He knew that pleading and making demands would not work. They would have to put in the hours with their boots off, sitting on a cold mud floor, drinking endless glasses of sweet green tea, and

eating sugared almonds. After a day of this the commander signed the piece of paper they needed, a laissez-passer through his lines, and sure enough, the next day it got them through the checkpoint.

They were just in time. They arrived at Ahmed Shah Massud's field headquarters to find him on the flat mud roof of a farmhouse ordering the attack itself. Pitched battles were rare in the Afghan campaign. More often commanders would switch sides, and Massud's obvious strength had persuaded the commander of the garrison controlling the plain north of Kabul to come over to his side, making dozens more armoured vehicles available to the mujaheddin forces.

At the top of the Shomali plain, the solid wall of the Hindu Kush rises out of the ground. Peter filmed a stream of armoured vehicles snaking down from tracks in the mountains to come together on the plain. Clouds of fine khaki-coloured dust billowed through the air as the deep growl of the big diesel engines pushed their way into formation. Commander Massud went among them like Caesar reviewing his troops, raising a huge cheer. As so often in Afghanistan, there would not need to be much of a battle. More and more defectors joined the conquering forces, and, out of nowhere, seventeen Russian-made Mil helicopters appeared. The entire transport division of the Afghan Air Force was now with Massud. And these were exclusive pictures. Thanks to Peter's guile in finding their way across the front line, they were the only journalists there to witness Massud's forces massing.

Airborne soldiers piled into the helicopters and Peter joined them, while the rest of the BBC crew went by road into Kabul with Massud. That evening the city fell into their hands.

The next day Peter brought a piece of news to his correspondent, the *Newsnight* defence expert Mark Urban, that he thought hugely funny. Urban had been one of the few journalists who had always reported from the government side in Afghanistan, never

travelling with the mujaheddin. Now the mujaheddin controlled the country.

'You'll never guess who I've just seen coming through the lobby. It's Abdul Haq. And he's been made Kabul police chief.' Peter knew that the famous mujaheddin commander had issued a death threat against Urban, believing that he had once called him an American spy in a story about how MI6 and the CIA paid for the war.

'So what should I do?'

'I am sure he will be OK about it now,' Peter said. 'I know he has a sense of humour.'

A former army officer himself, Urban had once been arrested in London with Peter in a bizarre incident. He was then writing a book about Afghanistan and, like many people, he regarded Peter's expertise highly. As they walked out of a restaurant in Covent Garden they found themselves grabbed and spreadeagled against a wall by plain clothes police officers from Special Branch, who demanded to know who they were. Their conversation, littered with references to Stinger and Blowpipe missiles, heroin trails and stashes of Kalashnikovs, had attracted the notice of a police officer who happened to be having lunch on a neighbouring table. During the lunch Urban had laid out some pictures of Blowpipe missiles for Peter to identify. The pictures had been taken by Colin Peck.

The two of them were held for a while as computer checks were run on them. Throughout Peter kept up a tone of indignant outrage, talking about getting his MP involved, although he had never voted, and muttering, 'This is the sort of thing I would expect to happen in Peshawar not in London'.

Among the journalists who were clever enough and lucky enough to have made the right call and got to Kabul in time for the change of regime, was a hugely tall, rangy and very engaging

man, Robert Adams, who was then writing for the *Daily Telegraph* and was soon to become a Frontline cameraman. It was not a common career switch. But he had never had any ambition other than adventure. As soon as he grew too tall to be a fighter pilot, his childhood dream, he travelled, cycling through Tibet and hanging around in Pakistan. Then on the strength of a three-month diploma in journalism he approached the *Telegraph* to see if he could 'string' for them from Pakistan, where his girlfriend happened to be living after they left university. He was presentable enough, and had a plausible air. Being a stringer, paid by the piece, he had no support or commitment from the newspaper. In his first three months he earned £70 for the only story they took, which did not even appear in the main paper, but was syndicated to affiliates abroad.

It got better, and a year or so later, he was doing stories across South Asia, filing from places where the *Telegraph* staff correspondents did not go, especially, as Robert says, 'the noisy and amusing places'. He went to Kashmir, where conflict was simmering, and took a motorbike into the Tamil Tiger areas in Sri Lanka. His then-girlfriend, now wife, Nicky, came with him on that one, and he remembers pointing out the finer details of a helicopter hovering overhead, such as the heavy machine gun mounted at an open door. POW, POW, POW... They had to roll off the bike into a ditch as the helicopter gunship let off a few rounds over their heads. One night he took the train from Delhi north to Amritsar, travelling third class among frightened Hindus at a time when Sikh militants often attacked the night train.

And now he was in Kabul, witnessing history. As the mujaheddin took the city there were maybe 30,000 people there with guns. When night fell flares arced up into the sky, sinking slowly on parachutes. It seemed that all of the guns in the city were firing up at the flares at once, the most extraordinary firework display.

Robert remembers sitting there as if 'inside a wigwam of tracer'.

And then the bartering over the spoils of victory began. Riven by political and tribal divisions, and bloated by the large payments they had received from the Americans over the years, the mujaheddin were not going to share power easily. For a few days there was no fighting, and journalists whiled away their time, trying to drink the bar dry at the Intercontinental hotel, enthusiastically assisted by the barman, who expected that once order was restored, the mujaheddin would close the bar down. (What they did not finish then was walled up in a secret cellar until it was discovered by the Taliban when they took the city four years later. The Taliban took the bottles of wine and Afghan brandy and several thousand cans of beer onto some open ground and crushed it all under the tracks of a tank.)

As the drink flowed the journalists at the bar ran a sweepstake on how soon they thought the fighting between the mujaheddin would break out. The man who gave peace the shortest odds, the worst of the Cassandras prophesying doom, was Tony Davis, Rory's old travelling companion and one of the few people who knows the country as well as Peter Jouvenal. He speaks the local language Dari well, and has never missed any of the big stories. He fidgeted restlessly with a beer glass, and as they ordered yet another round at the Intercon, there was a huge explosion across town.

Davis was on his feet immediately. 'There you are, it's started; I told you it was going to happen.' They bundled into taxis and Robert Adams found himself sitting next to Rory Peck, who he did not know well then. They raced into the centre of town and found a carpet museum in flames. Robert quickly established that the cause of the fire was an exploding fuel tank; it had nothing to do with the war at all. He looked around to see where Rory was, but he had vanished. And then as the firemen were going

into the building, he saw Rory walking *out* through the blackened doorway, beams crashing down behind him as a raging inferno with the intensity of a crematorium took hold. He had soot on his face and sparks in his hair, and his clothes were singed. But there was a smile in his eyes. 'Fantastic pictures. Amazing. It's great in there.' Robert told him that it was not a story. And Rory said, 'It doesn't matter. What a place.'

Everyone knew that the uneasy peace in Kabul could not last. The different factions who had fought the war had no agreed plan as to what to do next, and they were in a country awash with guns. As the *Newsnight* crew drove through the city one night two armed groups literally faced each other across the street. They stopped to ask them why they had not opened fire. The answer was, 'We are just waiting for the order.'

The Russian-backed government may have gone but the war was not over. Not by a long way.

Those ten days in Afghanistan sealed the fate of the modern world. If America had stayed focussed when it mattered, then the rise of the Taliban, and 9/11 itself, may never have happened. But Afghanistan was abandoned as a basket case once the Russians had gone. American involvement was only ever about drawing as much Soviet blood as they could. The profligacy of their spending meant that there were still unused arsenals of brand new weapons stored in hillsides across the country. And even as the dollars dried up there were others only too willing to fill the gap. Vaughan shot a report which turned out to be loaded with prophetic importance about hard-line Islamic fundamentalists now coming in to pay for the mujaheddin as the American money-tap was closed off. Over the next few years, the warlords who had grown rich on corruption, the way the Americans did business, continued their private wars, doing more damage to the country than had ever happened during the fighting against the Russians. It was

Afghanistan's darkest time, and it directly provoked the rise of the Taliban, who emerged in a conservative backlash against the corruption and despoliation of their country.

It had been a very dirty war, where drug-smuggling was tolerated and arms siphoned off by the Pakistani intelligence service, the ISI, to make trouble for India, first in Punjab and then in Kashmir. And the final legacy of this wasteful and shortsighted American policy was the attack on the World Trade Center, carried out by mostly Saudi Muslims, inspired by the very distortion of faith which America had promoted in Afghanistan.

The most cynical piece of America's policy was their promotion of Gulbuddin Hekmatyar, the most rabid of the Islamic fundamentalist leaders. Hekmatyar was a brutal and sadistic man who once told a western woman correspondent that he hoped she 'died of breast cancer' and abruptly stopped an interview with another because he could see her ankle. He began as a student leader, encouraging his supporters to throw acid in the faces of women who did not cover up. During the years after the Soviet invasion he terrorised refugees who had fled into Pakistan, murdering hundreds of intellectuals and members of the Afghan middle class, and imprisoning thousands more. He is suspected of being behind the death of a BBC reporter, Mirwais Jalil, who had previously worked often with the Frontline cameramen, particularly Peter Jouvenal. Partly at the bidding of Pakistani Intelligence, western agencies, including the CIA and MI6, saw Hekmatyar as the man to do business with, giving him money and guns. Now he sat glowering in the mountains south of Kabul, angry that Massud had got there first.

Robert Adams was one of a small group of journalists invited to a Hekmatyar press conference. He set out on a bone-crunching eight-hour car journey into the mountains, sitting in the back of an open pick-up. They were bombed by Massud's air force on the

way, and moved on from several locations, until finally a fleet of identical white Toyota Hilux vehicles appeared and screeched to a halt in the dust. All of the doors opened at once, and then Robert saw an inner door opening in one of the vehicles as Hekmatyar emerged from a sealed bullet-proof cabin inside. He was dressed immaculately, with a white turban and combed beard. He stood the journalists in a line about fifteen feet away, presumably fearing assassination if they got any closer, and harangued them for an hour about how his victory had been snatched from him, threatening to fight to regain power. And then after taking a couple of questions he raced away again. The BBC were not there, but Robert was already contemplating a move to television, and had persuaded them to give him a hand-held Hi8 camera. Robert's first TV pictures were useless as it happens, because he was not allowed to get near Hekmatyar to put a microphone on to the warlord. Robert returned to Kabul just in time to witness the beginning of the fighting that would reduce the city to rubble over the next two years.

In the event it was not Hekmatyar but the Hazara army who started the shooting, and everybody then joined in. In the ethnic mosaic of Afghanistan the Hazaras stand out. Their distinctive Asiatic features, almond eyes and olive-wood skin are said to mark them as the direct descendants of Genghis Khan's Mongol hordes, who settled in central Afghanistan. That history and their Shia faith have made them subject to persecution. The Hazaras say they opened fire only to defend their people from Massud's Tajiks.

In the power vacuum in Kabul after the fall of Najibullah the Hazaras had set up their tanks on the hill in the south-east of the city, defying an ultimatum from Massud to withdraw them. Rory filmed a salvo of rockets coming from inside the city which hit a hill nearby. The report that used the pictures put these words

to them: 'East of Kabul the Afghan army fires on mujaheddin positions. There are sporadic exchanges like this every day on the defensive perimeter which surrounds the city.' Rory expressed concern about the definitive nature of this conclusion. 'For all I know,' he said, 'they may well just have been squeezing off a few rounds onto the side of a hill.' It was not unlikely. The Afghans had a cavalier disregard about where their bullets fell. For a man who depended on selling the most compelling battle footage Rory was very cautious about making claims for things unless he was sure that they were true.

He had a complex relationship with other journalists and camera crews, standing apart from the herd. There were always rumblings about all of the Frontline cameramen. They were outside the career loop of staff crews, and were 'taking jobs away from them'. And there were dark murmurs that they behaved dangerously and acted unethically, although nothing stuck; no one ever mounted a successful ethical challenge to any Frontline pictures.

Ever since doubts were raised over Robert Capa's 'moment of death' photograph, which appears to show a soldier as he is hit by a bullet in the Spanish Civil War, war photography has been under scrutiny. The evidence for Capa's picture being exactly what it looks like is strong, but doubts remain. It is easier to sit in a bar and retell rumour and suspicion than it is to go out and put your life on the line to take real combat pictures.

Nobody can say what pictures show except the person who took them; interpretation comes down to trust. The Frontline cameramen have always been scrupulous about what they shoot. In Kabul that week Rory took some remarkable pictures of Uzbek gunmen jumping out from behind a building, firing a burst from a gun and jumping back. Who is to say, except him, the cameraman who was there, whether they were actually firing at a target or just

jumping in and out for effect? The TV audience relies a lot on the integrity of the people shooting the pictures.

There was certainly enough real action to film in Kabul. Some of the reports which were broadcast using Rory's pictures that week have hardly any words at all but just pictures of Afghans blazing away at each other – images from a lost nation that was falling off the edge of the world. In the hospital Rory filmed a searing sequence of a stretcher being carried in at speed and a French aid doctor with a grey face, weary of the war, lifting the head of the man for a few seconds, before diagnosing that there was nothing he could do. On the tape Rory's voice can be heard:

Rory: 'What chance has he got?
Shake of the head.
Rory: 'None at all?'
French doctor: 'No. He is dying in a few minutes.'

And the doctor waved the man out of his operating theatre so that he could get onto a case he could save. It was a visceral, telling exchange from a desperate and dangerous time. Helicopter gunships were being used to back up street fighting, and Robert Adams remembers General Dostam's Uzbek militia doing infantry assaults armed with sabres looted from the Kabul museum glinting in the sunshine, 'howling like wolves as they went up the hill to the old fort at Bala Hisar'.

As it became increasingly dangerous, the BBC came to an unusual arrangement with their main domestic competition, ITN, to use their satellite dish, since it meant that they could avoid a long and hazardous drive to the TV station. It was sometimes hard in those circumstances for Frontline to make the money it deserved. Vaughan was on the receiving end in London and sent a worried fax:

We could have made you much more money if you had been able to feed anything on Friday or Saturday. We are also having difficulty in separating your material from Visnews's and other BBC stuff... nobody knows whether anything on today's feed is yours and none of it has been released for us to sell. I am sure it is chaotic at your end.

When he first arrived in Kabul Rory had initially worked in the way he liked, going out and getting his own pictures and bringing them in, but as things became more dangerous he actually took over from a staff BBC crew to work directly with the correspondent. Even then he stayed out of the news machine, not socialising much with other camera crews, preferring to keep his distance. And he never spent time watching the pictures being put together in edit suites to be turned into the final TV story.

Mark Urban compares the Frontline cameramen to masters of cuisine. 'They would appear in the edit suite with the manner of a great chef as the client tastes the food in a restaurant. Once they had detected the ripple of satisfaction at the material they had brought in, they would retreat very quickly.'

XI

QUICK SPIRIT

I am not gamesome; I do lack some part
Of that quick spirit that is in Antony.

William Shakespeare, *Julius Caesar* (1599)

Buckingham Palace Road, London, 1992

Afghanistan's long ordeal intensified in 1992. But for the most part the world averted its gaze for a few years as the unending squabbles between rival mujaheddin played themselves out, finally provoking the rise of the Taliban. Frontline never forgot the country even if other TV companies did, although they made fewer sales of their material. Peter would come and go from his house in Kabul for years. But by now Frontline was not known only for its Afghan work. They were great days for the agency. Their archive is thickest for the early years of the 1990s. At the end of 1992 John Simpson wrote a glowing piece in the *Spectator* magazine: 'The biggest and the most successful of the British freelance companies is Frontline.'

They were researching and shooting their own stories – original material about the real world which filled a distinctive gap alongside the public policy and issue-based agenda of much TV

news coverage. This was the time that Vaughan tried his hardest to put the company on the map, and he knew that they would succeed only if they successfully extended their reach beyond war reports.

Vaughan had always been keen to make the whole business more professional, and took on Peter Allegretti, an American who had done just about every job in broadcasting from working as a reporter and newsreader to, on the other side of the lens, shooting and editing pictures. Peter Jouvenal had met Allegretti during his time in Jordan. The two Peters became friends, and Allegretti remembers Jouvenal walking around Amman with a paperback by Nietzsche sticking out of his pocket – a step up from *Flashman*. Allegretti had been working as an editor with a TV offshoot of the American *Christian Science Monitor* newspaper, but the company did not last long. When it folded at the end of the Gulf War he was left with a payoff big enough to risk working with Frontline. Tira Shubart, who knew Frontline from Romania and elsewhere, had also been working for Monitor TV in Amman, and now she came over to Frontline too.

At the time nobody knew whether there was any real potential for freelance TV news. The few freelance cameramen around tended to be frozen out by staff crews, who still worked in a very regulated way. In the unique conditions of Afghanistan Peter had created a market. Now they needed to see if it could be extended elsewhere. Anna Roberts learnt television production while marketing the features, and now Jenn Feray, a picture editor who had also been shaken out when Monitor TV crashed, came on board. But there were no models for the kind of business that they were developing so they had to make it up as they went along.

Stills photographers had worked in agencies for many years, but that business was different in one key respect: the cost of equipment was so much less for stills than for television. The

relative sophistication of television in those days, and the size of the crews that it needed, meant that it was always a corporate business, which was hard to break into.

Peter Allegretti had ambitious plans to make longer features. He wanted to attract TV companies to subscribe to a monthly half-hour programme made of Frontline items, so that they could guarantee an income alongside their other work, which was up to then sold on an ad hoc basis. They all knew that the 'bang, bang' footage, as it was sometimes inelegantly known, was never going to provide the basis for a long-term, sustainable business. Besides, the appetite of TV newsrooms to broadcast wars was limited – there was only so much 'bang, bang' that the audience could stand. It would always be the recognised key for the Frontline 'brand', but they needed more in order to make money, and they were already making reports about things not connected to conflict.

Anna Roberts had identified a market and worked hard to sell the material, encouraged by a story that Vaughan shot while they were travelling on the Trans-Siberian Express. It had a different, natural, human quality unlike the more pasteurised pictures usually served up on TV news, and they recognised that there were ways of making the business work without being shot at. The Trans-Siberian story changed their attitude to what was possible. Anna made several trips into the field as well as marketing the material in London.

They were bursting out of the flat which Vaughan and Anna shared in South Kensington, and taking advantage of cheap property prices in a recession, they moved to an office in a basement in Buckingham Palace Road.

To make progress they knew that they had to develop their craft skills. Tira Shubart and Jenn Feray devised a workshop, which most of the crews, including Peter Jouvenal, attended. After all his years in the Hindu Kush he happily hopped onto a No. 11 bus

to Fleet Street to make a little tourist feature, getting back to the basics of story-telling in pictures. And after years of using small holiday cameras the key people in Frontline were now equipping themselves with industry standard Betacam-format cameras: a substantial investment, costing tens of thousands of pounds. A new breed of literate adventurers was drawn to the company. Tira remembers Frank Gardner, later to achieve prominence as the BBC's Security correspondent, talking on his mobile phone in dark glasses as he rollerbladed down Buckingham Palace Road on his way to a class. Everybody smoked ferociously, particularly Susannah Nicol, who ultimately took over from Anna. Cameramen would appear into the low fug of smoke in the basement office, often dishevelled and unshaven, back from another war, trying to sell their pictures.

Peter invited his fellow Club Nuko drinking partner Adam Kelliher to watch the Henley regatta from his garden by the Thames, and over the Pimm's he suggested that if he really wanted to make money he should move into TV news. Peter was a good recruiter, always generous to young freelancers, and he knew that Adam was fascinated by the same things as him, especially conflict. He explained how you could remain your own boss, while getting paid well. Adam took him up on it, and went on a freelance trip around Central Asia, coming back with only a few hundred pounds and a few column inches in the *Sunday Times* to show for the reporting side, while the TV pictures earned him a huge wad of Deutschmarks from a German TV company. He never looked back to newspapers.

But the recession meant that there was less money to go around. The Gulf War had cost the broadcasters a fortune and Frontline needed to work hard to keep growing. Peter Allegretti began to think that they would never make the sums add up, and he left. Looking back on it later Vaughan regretted that he had not

established the company as a not-for-profit undertaking in the first place. As it was, he decided that the only way it would work was if the agency took as little as possible. He was now bringing in as much as any of the others as a cameraman, as well as running the business. The hope was that with the expansion of TV into 24-hour news channels, there would be an increase in demand. But it was going to be tough. Frontline footage was always a marginal cost; it could easily be cut out by the more hard-headed bean counters who began to dominate newsdesks. One friend in a French TV newsroom faxed them with this message:

> It's total chaos at the moment in the newsroom. Nobody seems to be in charge of anything at the moment... This weekend's new boss in Paris is a man named xxx. He's a real asshole so be firm on prices if you try to sell anything to him. He's what I'd call a 'carpet seller' trying to get a discount on anything.

Vaughan went to the former Soviet Union with the Christian human-rights campaigner Baroness Cox for a story about healthy orphans being locked up in psychiatric hospitals. He made another trip with the baroness to Nagorno-Karabakh, the Armenian enclave in Azerbaijan, and they shot a report in Poland about criminal gangs manufacturing amphetamines.

But the bread and butter of Frontline remained compelling war footage. Vaughan was always on the lookout for new recruits, bringing in Tim Deagle when he realised that he was being ripped off working on his own. Tim had been a freelance newspaper reporter, who started to shoot TV pictures along the way. He had the shortest military career of any of the Frontline cameramen, lasting less than a month in the Royal Marines, before he realised that he did not want to kill anybody. After three months on a journalism course he

was offered a job on *Trucking*. He actually did one story for them, on a Volvo plant in Stratford-on-Avon (Volvo gave him a copy of the complete works of Shakespeare). But *Trucking* was no place for someone who had wanted to join the marines for adventure ever since he could remember, so he headed for Peshawar on his own. He first went into Afghanistan with a rug-dealer who saw it as his Afghan duty to encourage people to leave the country before they were bombed out by the Russians.

One morning, after the rug-dealer had failed to persuade the people of one village to leave, Tim walked up a steep hill in the snow nearby, enjoying the clear, clear blue skies above the Hindu Kush, and dreaming of Kipling. He remembers he was still young enough to get a frisson from lighting a cigarette, absurdly thinking that school prefects might be around. He was high enough up the hill to be at eyeball level with the pilots of two Sukhoi bombers, blunt, squat things with short wings, which came out of nowhere. They dropped high explosive on the village he had just left.

Tim ran down the hill to a scene of carnage – the braying of wounded mules adding to the horror. His guide had survived and the remaining villagers said, 'Okay. Which way is Pakistan?' Tim walked with them for more than a week, carrying one toddler, while another child held his hand all the way. When he got back to the Galaxy hotel he rang the *Telegraph*, because that is the newspaper his parents read, and they took a half-page feature with his pictures, paying him £400. He had become a foreign correspondent, and he soon bumped into Peter Jouvenal, as anyone did who spent time in Peshawar, though more time would pass before he picked up a TV camera.

When the Kurdish story became big news at the end of the Gulf war Tim went to Damascus in Syria, crossing the border into Kurdish northern Iraq just as Saddam's Republican Guard turned on the north. He fled towards the Turkish border with the refugees.

He got to the hills and seeing blue berets ahead, he thought, *Oh good, it's the UN*. But unfortunately Turkish paratroops had the same colour berets. Thousands of refugees were trying to cross into Turkey; the soldiers fired over their heads and then into the crowd. By now there was a small group of journalists present, and the Turks flew them out, more to get them away from the appalling scenes than to help them. The soldiers asked Tim for his pictures and he said, 'No, no. Your colonel asked me to hand them over directly to him. Didn't he tell you?' Remarkably they believed this fiction and he got his tapes safely out to Turkey, where CNN flew them back to London unknowingly; they went in a bag that CNN thought contained only their TV tapes. Tim phoned *The Times*, and they said 'Write', while they phoned his parents, asking for a picture. His mother burst into tears because she thought he had been shot, but they said, 'No, no, it's for a picture byline. He has the whole front page.'

Tim had left his passport in a safe in a hotel in Syria when he had left in a hurry, so he had to make the difficult journey back to collect it. While he was there, he went to the Iranian embassy to try to get a visa, expecting an automatic rejection. Remarkably, they gave him a visa over the counter, so he went to Iran to report on the first refugee camps as Iraqis fled Saddam's reprisals after the Gulf War. The Iranians did not like him wandering around freely, so they deported him back to Syria, where by coincidence an American hostage had just been released from Beirut – another story at the end of a string of good hits.

He got back to London to find that his pictures of the Kurdish exodus had been 'lost' by Sky. He had signed a contract handing over copyright to them. Through a photographer friend, he met Vaughan again, who he had first encountered on the North-West Frontier. Through what he now calls 'stupidity, youth, intelligence and luck' he had got some remarkable pictures, risking his life

along the way, for only a single payment from Sky. Vaughan said, 'Next time, come and talk to us.'

The Times phoned Tim up and asked him where he wanted to go, and he said 'Ethiopia', where the Mengistu dictatorship was about to fall. He chartered a private plane from Wilson airport in Nairobi, phoning the AP news agency in Addis Ababa before he left to offer to put pictures on the plane as it made the return journey. It was a wise precaution. AP went to the airport to ensure that nobody tried to shoot down his plane. The next civilian flight that tried to make it in was shot at as it landed, injuring the passengers.

Tim reported the fall of Mengistu, the man responsible for the famine that drew the sympathy of the world with Band Aid, the dictator who had himself killed the last king, the Emperor Haile Selassie, with a pillow before stealing the ring of the 'Lion of Judah' and putting it on his own finger. Tim met another Frontline cameraman, Carlos Mavroleon, in the palace, where they filmed a white board on wheels with arrows marking the last defence of the city. It was classic copy, and he had the TV pictures that went with it. It would be the last time that he would file directly to Sky News. When Vaughan heard that Tim's next trip would be to Somalia he made sure that Tim was signed up by Frontline.

Somalia, 1992

Tim Deagle spent the next eighteen months in Somalia, which he says was 'quite simply the most dangerous place I have ever been to'. One of his shot lists is hard news at its hardest. It includes this:

> 0:18:49 Technical [pickup truck with machine gun mounted on it] waiting to move to front line. Sound of explosion and shrapnel narrowly missing cameraman's head.

It was a freelancer's war. Tim was one of only three foreigners living in Mogadishu. Most Fridays he would go round to the villa owned by Mohammed Aideed, later America's 'Most Wanted', and join him as he chewed *qat,* the hallucinogenic drug of choice in Somalia. For part of the time Carlos Mavroleon came to live with Tim, always cooking for the pair of them, with a certain bravura that Tim remembered from Carlos's flat off the King's Road. He would chop garlic with an AK47 bayonet in London in the same way as he did in a beach 'resort' in Somalia, surrounded by thousands of dying people. Somalis never ate shellfish, so Tim felt no guilt when Carlos appeared out of the dust one day with two live lobsters and proceeded to boil them.

One of Tim's reports from Somalia actually made a difference, as well as making him some money. He came back to Britain in quite a state after months of watching people die, and Vaughan met him at Heathrow. One of Frontline's key supporters, Sue Inglish, the Foreign Editor of *Channel 4 News*, met them at the door of the studio and took them straight into an edit suite, where a producer burst into tears as soon as the pictures were put on. The material was sold to *Channel 4 News* for £700 a minute, and they ran it for most of the first quarter of the programme. Now nobody could say that they never knew. Vaughan had retained non-British rights on the pictures, and sold the report to NBC as well, who ran it at length. Both John Major and Bill Clinton said, 'We cannot stand by and watch images coming in and do nothing.' They intervened, with disastrous consequences as it turned out, when hundreds of Somalis were shot dead by US forces who were trying to get out after losing some of their own men (the 'Blackhawk Down' incident). But that was not the point. The issue had been brought to the world's attention. Nobody could ask for more from a TV cameraman.

Peter Jouvenal went to Somalia too, with the producer Edward Girardet. It was very early days in America's ill-fated involvement.

An offer of material to the American TV company NBC received the answer that they weren't interested unless it profiled an American:

> Most could be living comfortably back in the good ol' USA, but here they are in this shithole called Somalia: a country 90% of Americans could not locate on a map.

Bangkok, 18 May 1992

From Somalia Tim Deagle went to Bangkok for *Channel 4 News*. It looked like a routine assignment. He planned to follow a refugee family back into Cambodia now that the worst killer of the 1980s, Pol Pot, had gone. He checked into the Royal Hotel with a brand new camera, paid for with his Somalia earnings. Vaughan had delivered it to him at the airport, and it still had polystyrene bits stuck to it from the packaging. He was just checking the instruction manual when the phone rang. It was the newsdesk at ITN.

'Tim, where are you?'

'In the Royal Hotel. Just going to bed actually.'

'That's convenient. We've heard that there might be a bit of a demo there. Probably won't come to much. But might be worth squirting off a few shots.'

One of the brand-new batteries for his brand-new camera must be charged by now, Tim thought. So he set out. He would come closer to death in the next three days in the tourist district of Bangkok than he had ever been in eighteen months in Somalia.

The first pictures were not complex, a stand-off between student protestors and police just outside his hotel, although the fact that the students were wearing gas masks might have told him what to expect. He fed the evening's pictures, and the following morning set out again with his new camera. A young man, a boy really,

attached himself to Tim, English-speaking, enthusiastic: 'I show you where...' Tim had seen his sort before. He wanted to be shown where.

He found himself in the middle of a wide street, ducking down behind a line of small motorbikes parked at right angles to the kerb when the shooting started. He knew enough by now to know that the bikes would not protect him from bullets, which pinged all around him, bouncing off the thin chrome tubing and puncturing the plastic fairings. The road ahead was completely clear. He looked up to the roofs of the buildings flanking it to see lines of Thai soldiers, their rifles pointing downwards. He gestured to the boy to get over high railings that marked the boundary of a solid-looking bank building on their side of the road. The boy went first. Adrenalin took Tim to the top of the railings, where he felt a hammer blow to the back of his head. He passed out, toppling down into the narrow drainage trench on the other side. When he came to he found himself lying on top of the boy, who was dead, shot in the back. Covered in blood, and believing that the hammer blow had been a bullet grazing his own skull, perhaps a ricochet, Tim looked up again at the soldiers. They seemed to be reloading – or perhaps taking new orders. He moved on his belly along the trench, still carrying his new camera. At the end of the railings there was a corner, where he turned to take cover from the mayhem behind him. He later learned that in that killing zone several dozen died; in a police state nobody did a final count. Behind him he saw a line of Thai soldiers, on the ground now, moving methodically along the street. He thought that they would have no hesitation shooting him if he remained where he was. But ahead of him was an open street. And they would see him as he ran across the road junction.

An abandoned dried-fish cart lay in the middle of the otherwise empty road. Wiping the blood from his brow, Tim looked at the

dried fish suspended behind glass inside, garishly lit by artificial pink light pumped from a paraffin lamp. He had no choice but to run for it. As he passed the fish cart it exploded in a hail of sparks, as the soldiers fired from the street behind him. But emerging from his cover had given him the element of surprise. Remembering days in the English countryside, he thought, *it's always the first partridge which gets away, the second that gets hit. Keep running.*

On the next corner was a normal Thai shopping street, thronged with tourists and locals. Tim stood among them like someone in the wrong movie, covered in blood now and breathing heavily. The killing zone seemed predetermined by the army. He had crossed an invisible frontier into normality. A well-meaning Thai couple, with a small child, who had come out to see what the fuss was about, offered him a lift to a hospital. Tim calculated that he was not *that* badly hurt and he asked them to take him instead to the TV feed point, on the other side of town. They must have thought him mad, but they did what he asked, and he apologised as he dripped blood onto the plastic-covered seats of their Mitsubishi as they drove. *Now I know why they keep the plastic on the seats.* At the TV station, the AP Bureau Chief was waiting for Tim. He said laconically, 'Got the pictures?'

Tim's T-shirt was so covered with blood now that only his armpits were white – as if he were a photographic negative.

'Yeah,' was all he said.

'Are you OK?'

'Yeah.'

Tim calculated that if he went to a hospital he would not be seen for hours, such was the intensity of the shooting, so he checked into another hotel because since he could not get back to his own. He could go out to film the next morning only after Brian Barron from the BBC gave him a shirt. The head wound did not trouble

him until many years later when, for no good reason, it started to itch.

Tony Smith, like so many of the Frontline cameramen, was recruited in the North-West Frontier. Peter Jouvenal met him there and told him that he should meet Vaughan, who was at that time lost in Afghanistan. The days passed and nobody seemed to be very concerned that Vaughan had not shown up, so Tony went back to London, meeting Vaughan when he finally emerged from the ulu a few weeks later. He successfully extended their range in the way that Vaughan wanted, into human-interest stories, winning the Amnesty International award for a piece from Kashmir. But his first piece had been in the aftermath of a war, when he was swept up from a hotel foyer in Tehran in 1991 by Baroness Emma Nicholson. She was just beginning what became a long-term concern for her, raising money for the Marsh Arabs of southern Iraq, who suffered terribly from Saddam Hussein. Another TV crew she had been hoping to meet had failed to get visas to Iran, and seeing Tony's camera, she persuaded him to come on a trip to the south with her. They slipped across the border into southern Iraq in boats, and Tony shot rare footage of villages that had been devastated by Saddam.

Tony's most profitable trip was in another war, in Haiti. Quite a large press corps arrived after the fall of the Aristide regime, but nearly all of them went off together, in the best traditions of journalism, like the herd in *Scoop*, when news came of a major refugee flight from Cuba nearby. Shortly after they left the US government imposed a total blockade on Haiti and Tony was stranded, but he was one of the only cameramen in the middle of a story that the world suddenly wanted. He went around on a motorbike, working for several TV companies at once, interviewing people who were concerned about the possibility of

a US invasion. When US Marines did finally storm up the beach they brought their own press with them. But by then Tony had earned more than he usually earned in six months. He went on to make documentaries with another freelancer from Frontline, Tim Exton.

One piece of genuine journalistic investigation from those days was Robert Adams's trip to the east of Iran made to investigate drug-smugglers. He had heard that dozens of Iranian soldiers were dying in fighting with Afghan drug-smugglers and he secured unique access to the area. The report was seen in more than thirty countries. In those days there was even a Frontline team permanently based in Asia, Marc Laban and Heather Kelly. Their profile of a Rambo-like figure who was looking for Americans missing in action years after the end of the Vietnam war had American networks queuing up to bid for the pictures. The man turned out to be a fantasist and conman, bogusly claiming to be a former Special Forces soldier. He was exposed and arrested while they were filming, so they were able to make a lot of money with the only pictures of him with his boxes of human bones, which could have been the remains of American soldiers.

Richard Parry went to Kosovo, years before anybody else had really heard of the place. He was arrested and imprisoned for a while but still got his pictures out, including an interview with a Kosovar politician who said that what would happen there 'would not just be a war between two nations or two states. It would be a Balkan war.' That was six years before the war there broke out. Frontline did something from Kosovo during each of those years. Selling the material, particularly off-piste material like this, was very hard. It was turned down out of hand by one big American outlet who wrote back that the report did not 'fit current plans and with our budget year near end we have very little money in buying pieces'. There were only so many forgotten wars or untold

famines that the world wanted to know about at once. Robert Adams made one unforgettable trip into Nagorno-Karabakh. His script included this haunting scene:

> As darkness falls villagers and soldiers gather for dinner around a wood fire, listening to the music of the Armenian flute. Our film ends as it began, back on the front line, as Armenian armoured vehicles move into position in the dark and fire cannon and automatic weapons at the Azeri troops below.

He hardly made any sales for that report at all. Nobody cared. But there was one war from which the world could not avert its gaze, however much it may not have wanted to know what went on. Frontline crews were already getting into place as television news editors dusted off history books about the Balkans and got out the atlas to look up Bosnia-Herzegovina.

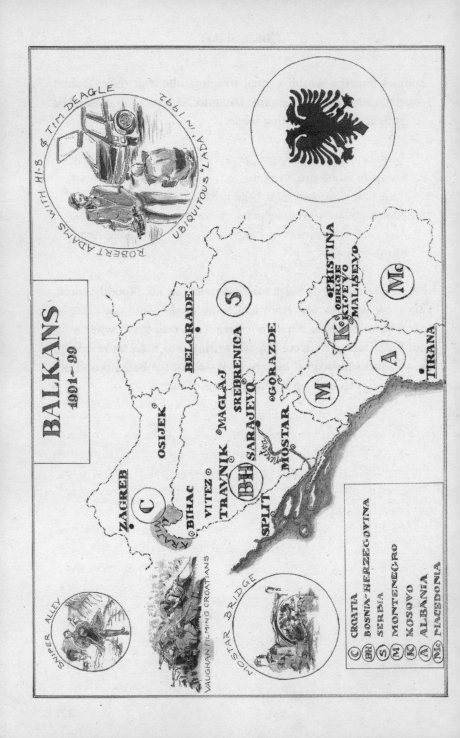

BALKANS
1991~99

ROBERT ADAMS WITH HI-8 & TIM DEAGLE
UBIQUITOUS 'LADA' IN 1992.

ZAGREB

C

OSIJEK

KRAJINA

BIHAC

VITEZ

TRAVNIK

MAGLAJ

BELGRADE

S

SREBRENICA

GORAZDE

BH

SARAJEVO

SPLIT

MOSTAR

M

A

K

PRISTINA

OBILIC

KOSOVO POLJE

MALISEVO

Mc

TIRANA

SNIPER ALLEY

VAUGHAN FILMING CROATIANS

MOSTAR BRIDGE

C CROATIA
BH BOSNIA~HERZEGOVINA
S SERBIA
M MONTENEGRO
K KOSOVO
A ALBANIA
Mc MACEDONIA

BRAND NEW MATERIAL

I wanted to write poems like newspaper reports,
so heartless, so cold
that I could forget them

> Goran Simic, 'Sprinting from the Graveyard' (1993)

Sarajevo, Bosnia, 1993

It was not a hard story to do, the one about Sarajevo corruption.
You did not even need to get shot at, as you did for any other story
in the city. You could just look out of the back of the Holiday Inn
and watch as locals queued up with anything – money, televisions,
video-recorders – which they exchanged with the UN soldiers for
food and fuel.

The Ukrainian soldiers were the most venal. There were times
when they could not go out on patrol because they didn't have
any fuel; they had sold it all to the locals. But French soldiers were
in on the game too. At the Holiday Inn crab, champagne and fine
cheeses were often available, even when there was no running
water. It all came from the black market. Outside in the gloom
a civilised, developed city, which had once hosted the winter
Olympic games, was starving and dying, its trees and furniture cut

up for fuel, every window broken by the relentless Serbian siege. But if you had enough dollars, or, even better, Deutschmarks, then you could get anything. All of the initial defences of the city had been managed by criminal gangs, since they were the only people with guns. Now they ran the front lines and, with the help of UN soldiers, the black market prospered.

No journalists touched the story until Frontline did it. They filmed the Ukrainians bartering their fuel, and they got assistance from the BBC journalist Allan Little, who said in their report:

> The ethics of foreign journalists have been questioned. They are living in the one place where normal life continues. In the relative comfort of the Holiday Inn, the foreign press cover the story of Sarajevo for the world. With enough hard currency, food can be bought on the black market or smuggled through Bosnian Serb lines. The Holiday Inn can afford daily water deliveries unlike the hospital which often has to do without.

This was not a coded attack. It was an unusual full-frontal gloves-off assault on the media industry where by tradition 'dog does not eat dog'. Just to ram the point home they filmed another hotel, the Europa, on the other side of town, where in contrast to the conditions at the Holiday Inn, 200 or so Bosnian refugees were struggling to keep warm, let alone eat.

Making the report they were literally biting the hand that fed them. Another Frontline cameraman, Richard Parry, worked on it with Vaughan. He was clever and streetwise, not from the same public-school/army background as most of them, but a gifted and intuitive journalist who complemented Vaughan's skills well. After the corruption report, voiced by John Simpson, went out on *Newsnight* Richard found himself eating with some French

journalists in the Holiday Inn who did not know that he had been the cameraman. The French are the most tribal of journalists. They take the business very seriously, living as if on the Left Bank, dressing in uniform black denim, sticking together when they can with a constant resentment that they lost the battle for the world language, smoking ferociously, drinking whatever is available, maddeningly drawing in the most beautiful local women and taking over whole floors of hotels, where they cover the walls with melancholy poetry about the hopelessness of it all. The group who Richard sat with that night were very very unhappy because until now they had been eating in the French officers' mess. All that stopped overnight.

'Fucking irresponsible journalist. Fuck him. You know him? I will cut him if I see him.' And the Frenchman waved around a table knife rather ineffectually. Richard did not own up. He had only been a journalist for a few months by then. But he did not think that 'irresponsible' was quite the right description for exposure of an international peacekeeping force on the take.

Richard and Vaughan lived together in Sarajevo throughout the summer, and for both men it was one of the happiest times of their lives, certainly the most profitable. Richard was the more experienced film-maker, while Vaughan had more military expertise. They made a perfect team. There was always much that was insane about Sarajevo, a city besieged by Serbs where many Serbs still lived and foreigners could fly in and out. When Vaughan arrived for the first time on the UN transport plane, running the gauntlet of gunfire from the Serb front line next to the airport, he instantly felt at home. Some journalists never even survived this journey. Vaughan arrived at the hotel to find a bullet in his car. And as he looked out of the window a woman was shot dead in front of him. The many layers of the conflict there fascinated him, and his military training made him better able to cope with

the hardship and constant sniper fire than others who had come to the city. He knew that he could not only manage it, but would thrive on it. Going through his mind was a thrill of recognition: *I can do this, and I can take pictures which will make a difference. I understand what is going on. I understand where these bullets are coming from. I understand where to take cover. I understand more than most of the people here about the environment we are in. I can live with barely any water. I don't mind shitting in a lavatory that doesn't flush.*

He was also lucky. He still has the fleece with a bullet hole in the sleeve as a souvenir of Sarajevo. The bullet only grazed his arm.

It was an incredibly dangerous place to live. Some foreign camera crews, and who can blame them, would never leave the safety of armoured vehicles. Richard and Vaughan were fit, free agents, and with very few other independent crews around they cleaned up. Access to Sarajevo was unpredictable, the Serbs opening and closing the city at will, which meant that the big broadcasters were often left uncovered. Cameramen like Richard and Vaughan, who were willing to remain for a long time, found themselves at an advantage.

There is a tradition that freelance crews charge for a whole day even if they work for only a couple of hours. Companies across the world phoned them all the time to do interviews or sequences and they were charged a day each, turning each Sarajevo day into about three days' salary during the periods when the airport was closed and no one could get in or out. Soon Richard and Vaughan found girlfriends and set up a flat for the four of them. This was a young man's war, a war you could reach in a small car on the same day from pretty well any city on mainland Europe, and plenty of people less experienced than Vaughan made their way there. Forty-seven journalists died in the Croatian and Bosnian campaigns.

In order to minimise the danger, the BBC veteran Martin Bell negotiated a unique deal over pictures, which gave any company with a crew in the city access to whatever anyone shot. It was a sensible-sounding arrangement for a company man. It meant that crews were not competing with each other for the same images, as they usually did, thus minimising the risks. It was not a risk-free compromise; somebody still had to go out and shoot the material, but not everybody did. Life became very complicated for Frontline, because the assumption across Europe now was that anything which came out of feed points in Sarajevo was 'pool' and could therefore be used for free. Frontline found it very hard to monitor usage of their material. There was a danger of them being squeezed out of the market for the sequences that they were best at shooting, and channelled into working only for other people or shooting whole documentaries.

Richard left the commercial details to Vaughan. He wanted to make documentaries and had been introduced to Frontline by Anna Roberts, their producer in London. He bought himself a video camera and found his way in through Croatia. He was a natural film-maker, who had shot 16mm horror films in his back garden since he was fourteen. Now he wanted to experience a war. He was always willing to commit more time to a story than anyone else, getting alongside people, living as they did. And it showed in the distinctive material which he shot.

On his first trip in he took a train to Osijek, one of the last major towns in Croatia, close to the border with Serbia. There was an air raid on the way, but that did not stop the train, and initially he was not too concerned. Then, as the train wound its way across Croatia, people got off at every stop until finally Richard was the only passenger on board. It never even made it as far as Osijek but stopped in open countryside. He hitched a lift into town on a farm cart. For the next month he lived in a cellar with a family

he met, learning their language and keeping them supplied with cigarettes. Then he moved in with the local pathologist and filmed the whole investigation of a massacre. He was spending time in a way that the full-time staff of news organisations never could; that is how Frontline made a difference to the way the world was reported.

His material included this interview with a 24-year-old Croat:

> The jailer said he was a specialist in eating ears and taking out eyes. I was numb. At last a policeman who knew us rescued us and told the *Cetnik* [Serb soldier] to leave us. When I came back our house had been badly burned and they had stolen everything... the video, clothes, furs and everything else of value. My father said: 'Well at least we are alive.' On the following Wednesday we could smell smoke and hear shooting nearby. At ten to one in the morning, Dad told us to go into the small room while he waited in the living room. There was a loud bang as someone threw a smoke grenade into the house. The police then forced us out of the house and into a van, all of us except dad. Then we heard a shot, and Mum and I knew what it was. My father was lying on the floor and his brain was all over the wall. I covered him with a blanket so that the kids would not see.'

In Sarajevo Richard and Vaughan started work on a documentary idea that would not be completed until fifteen years later. The project began with a desire they had to film journalists at work, warts and all. They could not find anyone to cooperate with them, least of all the big broadcasters, who they suspected did not want to be exposed. Finally they met a photographer, Robert King, who was a total novice at his trade. He was learning it all as he went along – a character from the pages of *Scoop*

dropped into Sarajevo. He admitted to being an idealist, 'put on this world as a messenger, to convey a message about human suffering.' Vaughan was filmed mercilessly quizzing him on the names of the key politicians in Bosnia, a test he failed. On one of the first occasions that they accompanied him into the field, they had to cross a patch of open ground under fire. After the journalists and their Bosnian military escort had made it across – running and crouching one by one as bullets cracked around them – a photographer turned and sneered at King for his white T-shirt, asking him what he was. 'I am not sure you have the aura that war photographers have.'

While Richard was travelling with King near Kiseljak, in Bosnia's Croat heartland, he came closer to death than at any time in the Balkan wars. They were driving down a road when they suddenly had an awareness that things were not as they should be. They were not in an area where they had been expecting to see fighting, but Bosnia was unpredictable, the front lines were always very fluid. There was no one on the streets, and they came upon a checkpoint manned by a Muslim soldier where they were least expecting it. He let them go on, but soon afterwards they were turned back by a Croat checkpoint and when they returned to the Muslim position, there was a mine across the road, so they could not cross. Suddenly there was firing all around, and bullets were going through the car. They ran into a ditch for safety but soldiers there said that they could not stay, so in a lull in the firing they ran back to the car and found a way round the mine on the road. Richard drove off at high speed, bullets hitting the car all the way. The photographer Robert King shouted out, 'I've been hit. I'm hurt.'

Richard called back, 'Where?'

And King groaned, 'In the arse.'

They made their way to a hospital, running in and shouting, 'Journalist hurt, journalist hurt', in Serbo-Croat, which Richard

now spoke. A doctor arrived, but when King took down his trousers nobody, including him, could see much of a mark to show where he had been hit, and they all burst out laughing. When they returned to the car, they found the bullet that he had felt lodged into the seat where he was sitting. It had been too close a call. When he examined his own camera, Richard found a bullet lodged in the viewfinder.

There is an uncomplicated existential young man's pleasure in his description of their life in Sarajevo.

> They were great days. We were going nuts, shooting pictures in the morning, sex in the afternoon, bombs coming in, drinking and smoking. It was a visceral, sensual, absolutely sensual, brilliant life. Nothing else mattered, not the future nor the past. We were all living for that moment.

When it came to his birthday he believed that they should celebrate it in style. He and Vaughan hired a room at the Holiday Inn and got all the equipment he needed smuggled across the front lines, as well as enough booze for the night. They risked their lives crossing the front line for beer. That was crucial. The only beer that could be bought locally in bulk was made from rice and it did not go down well at parties. The evening was a disaster. None of the journalists wanted to party but came and drunk the booze, and then the mafia came in and stole the rest of it. The two men were left dancing with their girlfriends to Richard's cutting-edge music, alone on the dance floor.

Richard was to suffer when he came back to London. Life there did not feel real. Reality was that heightened life on the edge that he had left behind in Sarajevo. He found that he needed to use a lot of drugs to compensate for the loss.

TV companies liked to pay them in cheques abroad, but when cash arrived they spent it on smuggled food. They would bribe their way across the front line beyond the airport to buy food from the Serbs for their girlfriends' families stranded in Sarajevo. The siege was a ridiculous, immoral affront to good sense, but money would break through it. They might come back with only a dozen eggs but they were shot at all the same. There are different ways of dealing with checkpoints – the Serbs were the most threatening, the Croats the nastiest and the Muslims the most irritating. Vaughan usually tried unquenchable good humour, swapping jokes and cigarettes and juggling balls in the air, however grim it looked, sometimes pretending to be an idiotic foreigner who was completely lost and incompetent. It was a mad way to live.

Croatia, 1991

Vaughan's own experience of the Balkans had begun two years before in Croatia. He hired a car in Venice with Tim Weaver, who he often travelled with in those days. As they drove from Italy across Slovenia, it all looked rather Austrian; the streets were full of flowers. Lucky Slovenia had cast itself adrift from Milosevic's Yugoslavia after a comic opera revolution, lasting only a few days. Apart from one damaged Renault 4 at a checkpoint, there was nothing much to film. How different it would be for the other former Yugoslav republics. Vaughan's crude German was useful across the region, since many Yugoslav workers had worked in Germany as *Gastarbeiter*, servicing the bottom end of the German economic miracle. But he knew that he would need a better translator if he was to operate effectively. He came across Ivo Standeker, a legendary fixer in the early years, who was later to die at Sarajevo Airport.

Ivo worked for a remarkable newspaper, *Mladina*, which was partly responsible for the break-up of Yugoslavia. It was staffed

by very young people, with post-punk fashions and progressive ideas about how their society should move on from the stagnant gloom transmitted by Milosevic in Belgrade. Many of the best fixers and guides for journalists all through those long wars, from Croatia and Bosnia to Kosovo, were often still in their teens. If you were lucky enough, you could tap into a very young, very articulate, English-speaking subculture of people who would not put up with the prejudice and barbarities inflicted on them by the war, and nowhere more so than in Slovenia, where youth culture, mobilised by *Mladina*, led the way. They all listened to the same music, and developed the same sense of black humour, as the countryside burnt around them. It was a genuine underground movement and it was very influential, since so many of the observations and perceptions of foreign journalists were filtered through the eyes and minds of these bright, brave, young fixers.

On his first trip Vaughan travelled with Ivo towards the Croat border and frankly admits that his inexperience nearly cost him his life, and for no good reason. His Gulf footage had put him on the map. He was learning more about camerawork all the time, and coming to terms with his own motivation a little as well. But he was still not an experienced journalist. When they got to the town of Osijek he found himself running around in the open under relentless bombardment, with shells exploding all around him. One fell quite close and shook him up. He stopped taking pictures, sat down in the middle of the barrage, and literally gave himself a talking to. He said to himself, *This isn't the way you want to do this job. You have to teach yourself that actually this is absolutely what you don't believe in. You are just chasing shells. This is unprofessional.* After all the running around he hardly had a usable frame of footage he could sell. He learned a valuable lesson about risk, and especially about not taking risks without a good reward, unless there is a story at the end of it. In those early

trips he shot footage in a series of little towns that achieved an unwanted world fame: Osijek, Ocucani and finally Vukovar, the place where the Serbian killing machine first really got into gear.

Bosnia, 1992

Robert Adams and Tim Deagle were the first Frontline cameraman into Bosnia itself, filming Croat ethnic cleansing at the very moment that the 'peace negotiator' Lord Owen was on television saying that it was not happening. During the insanity of those wars, there was a constant mismatch between what was said by politicians, particularly British politicians, and the grim realities on the ground. But it always needed people to tell the stories, witnesses to the madness, in order to make a difference.

After the fall of Kabul Robert had come back to London to get married. Tim's wedding present to him was a flak jacket and two bottles of very good wine. These rather curious trophies sat among the toasters and casseroles at the end of the trestle tables in a marquee on the lawn at Robert's very conventional English wedding in Somerset. The two had first met in Peshawar. Robert was a guest at a rather incongruous European-style dinner party held by an aid worker when Tim burst through the door after six weeks in Afghanistan, unshaven, smelly and looking for somewhere to sleep. They got on from the start. Bosnia was clearly the next big foreign story but the Balkan wars had been going for a year already, beginning in Slovenia and Croatia, and newspapers already had their own people in place.

Driving a hired Russian-made Lada, hardly a safe car in a war zone, but the usual transport for freelancers who could not call on armoured vehicles, they drove across the ruined landscape from Split Airport. The idea was that Robert would produce while Tim taught him how to shoot pictures. Bosnia was the only state in continental Europe with a significant Muslim population, and their

plight had attracted the attention of thousands of fundamentalists from across the world, who saw this as the next jihad or holy war. Using Afghan contacts, Robert was hoping to film a story about the Islamic militants, mercenaries for Allah, who were now flooding in. It was this movement that would ultimately develop into al-Qaeda. Robert faxed the office in London:

> There's a difference of opinion between the volunteers (who come from Afghanistan, Pakistan, Yemen, Sudan, Saudi, etc.) and the Bosnian Muslims about what it means to be a Muslim. This leads to entertaining arguments about whether the post-battle priority should be beer or prayer mats and whether Allah minds young men holding hands with young women in the street... Apparently Sky had a piece about this last week, but also apparently it was crap. This is good in that it means it can be done, and better in that it has been done badly.

But before they even got anywhere, on their first day driving into central Bosnia, Robert and Tim literally drove into the middle of a story completely by chance, which was to be the best they would get. They had not been expecting major trouble. Croats and Muslims were united in this region against the Serb onslaught. They were even carrying a letter of introduction from the press spokesman in the Croatian government to the Muslim commander defending the central region. They did not get to him. The alliance had broken down overnight. As they entered a town on the main road they suddenly found themselves in a scene that looked like the set of a movie about the Second World War. There were dead bodies in the street, houses burning everywhere and men wearing swastika armbands ordering people on to coaches. They stopped to film without any real idea what was going on. Nobody shot at

them, although there was a lot of shooting going on. In Robert's words they were 'lucky followed by more lucky followed by more lucky'. They parked the car and Tim ran round a corner to get to cover. Robert did not arrive, and the seconds turned into a minute, a very long time when there is shooting going on. Then Robert finally came round the corner, running with his big ugly loping gait. 'God, what kept you? I was beginning to think you were in trouble.'

'I had to lock the car,' said Robert, realising, as he paused for breath, that this should not perhaps have been the highest priority.

Tim said only, 'You've been in London too long.'

As the shooting died down, they filmed some drunken Croats on a victory parade, incongruously carrying big multi-coloured umbrellas with frilled edges, looted from a café. Tim and Robert seemed safe enough until the Croat commander came along, and threatened to shoot them.

They arrived in Travnik, where a number of journalists were based, to find that no one had the pictures they had, as no one had been able to get the same access, although all had heard rumours that the Croat/Muslim alliance had broken down. *Channel 4 News* took the story, embarrassing Lord Owen who was at that moment telling European Union Ministers that there was no Croat ethnic cleansing going on.

Robert now bought a second-hand camera for himself and made another trip in a hired Lada. After picking his way across the shifting patchwork of front lines one day, he was confronted with a vision from hell. It was one of those places that make you ashamed to be a human being, a home for disabled children surrounded by soldiers. The water had been cut off and they had not had access to their parents for nine months, because they were stranded on the wrong side of the front line. The scenes that Robert shot are really shocking and upsetting. After the report

was shown by the BBC a Swedish battalion which was in the region took charge of the home. As a consequence of that single report it became the best-run home for the disabled in the region for the remainder of the war.

His budget for that trip would not have been believed by conventional television journalists. He had £750 for two weeks. Once he had paid £190 for a ticket with a fixed return date, on an unfashionable and dirty Croat airline, and hired a car for less than £30 a day by chatting up the family of the man who ran the car-hire firm, that left around £200 for food. So he lived on coffee and cigarettes for breakfast and pizza and beer at night, sleeping on the floor of his translator's flat, and offering to split his takings with the translator once he sold his material. He had no insurance, and no 'plan B' if things went wrong. He was doing journalism that mattered on a budget for a fortnight that the big broadcasters were spending *on one day* just for an armoured vehicle.

This closeness to local people paid off in some of the quality of some of the work. Richard Parry in particular, and the other Frontline crews as well, saw things that people in armoured vehicles did not see. Sometimes there is a subliminal quality in their interviews of people, a sense that the interviewees are talking to someone who shares their predicament, who cares whether they live or die.

Robert spent a few days in a home for rape victims. The Serbs' use of rape as a weapon of war was one of the blackest aspects of that dark time. Robert did not even get his camera out but played with the children, chopped wood and so on, to win confidences. When he finally did do some interviews the warmth and humanity of the material did very well on German television. The home had been running out of money and was about to close, but Robert's report inspired the foundation of a charity effort which has continued to support the project to this day.

Their different way of working had other practical benefits too. In the winter of 1993 Robert Adams was working as a producer for a Scandanavian network. He and his crew left Split very early in the morning and drove through appalling snow towards Sarajevo, crossing an unpredictable patchwork of front lines as Croat and Muslim villages alternated across the landscape. The cameraman was a staffer of the old school, who was there just to take the pictures and sat in the back while the others dug their way through snowdrifts. Late in the afternoon he looked at his watch and announced that if they wanted to continue they would have to negotiate an extra-day rate with the union rep, since he was now out of working hours. So that is what they did, putting the satphone on the roof of the vehicle in the middle of a war zone for twenty minutes to call the office. The next time that company wanted to go to Bosnia they used Robert as a cameraman.

Sarajevo, Bosnia, 1992

Rory Peck did not spend much time in Bosnia. He never really committed time or effort to any country other than Afghanistan. He did not hang around. He would do the story and then move on – first in and first out. Prophetically he had been in Belgrade when Milosevic was elected. But Vaughan had fruitlessly hawked those pictures around Europe. Nobody cared then.

The BBC correspondent Kate Adie says that during a trip in 1992 Rory saved her life, driving her to Sarajevo airport. This was very rare. Adie *always* drove; she was famous for it. But that day she handed over the keys when Rory offered to drive. There was just something in his manner that inspired confidence. On an exposed flyover they were fired at by all three sides: Croats, Muslims and Serbs. Adie was hit in the toe by a bullet that penetrated the armour plating of the Land Rover. Rory took one look at it when they arrived and said, 'Congratulations. World's

smallest war wound.' In her book *The Kindness of Strangers* Adie says that 'he seemed totally unfazed by the whole episode'. While he was on his own Rory would drive around Sarajevo without any armour in a badly damaged BMW, which he called the 'ultimate war wagon', relying on speed and surprise to keep himself alive.

Gorazde, Bosnia, September 1992

Rory's one major story in Bosnia set a sort of gold standard for what was possible. When Gorazde became the first Bosnian town to be besieged, an 'enclave', in the miserable terminology of that war, Rory chatted up some Muslims who managed to get him safely in and out past the Serb snipers, riding on a donkey. His pictures were the first real insight into the horrors of the life endured by Muslims, who were corralled by the Serbs into a small country town whose population was swollen by the presence of thousands of refugees. Some of the images have a power beyond the normal reach of daily news, lingering on in the mind: an old man sucking at a bowl of thin soup, apparently oblivious to the dead man lying close to him in the schoolroom where they live, while the dead man's son weeps inconsolably; an 11-year-old girl, her face beyond tears, as doctors try to treat her wounded arm without any of the right equipment to take out the shrapnel. These scenes from the first circle of hell were accompanied on the BBC in a clear and sparse script written by Mike Donkin, who was not on the trip, but wrote it up from Rory's notes.

Gorazde. For four months a town too dangerous for the outside world to reach. From the mountains across the Drina, Serbian forces ring the changes with their heavy weapons to routinely pound the only Muslim-held town in Eastern Bosnia.

Sound of shots

Sniper fire takes most lives. Even with sights set at up to half a mile away, venturing onto certain streets and squares is potential suicide. Gorazde's population was nearly 40,000. Almost all of its 10,000 Serbs left last May. Now refugees from outside villages have swollen the numbers seeking shelter in public buildings like the Maxim Gorky School.

In a corner one old man eats soup while behind him another lies dead.

Sound of weeping man

His son is distraught. 'It's finished. I have had enough,' he says.

At Gorazde's hospital bombardment has become a constant backdrop as doctors struggle against uneven odds.

The medical director, Dr Putina, tries to explain above the gunfire.

They've asked for a surgical team but none has arrived. So 11-year-old Jenita can't have an operation to remove shrapnel from her arm. It is too close to an artery and they would risk her life.

There had been no anaesthetics and drugs and dressings had been in short supply too, until this shipment on a long-awaited UN convoy.

Man speaks in broken English: 'Convoy first time... Good... Thank you.'

Food also came with the convoy but most have it seems to have been kept in reserve for the colder days in prospect. Local people and refugees eke out the most meagre fare. They have enough to last this month. They hope.

Water in Gorazde is drawn from wells by hand and occasionally by fire appliances. Power and phone lines

don't exist. There is scarcely a window pane left intact, as householders have no building materials to make repairs, even if they dare to expose themselves to the snipers. All too many homes will never be lived in again. They have become part of the no man's land between the town's Bosnian defenders and the Serbian militia, who are just fifty yards away at some points on the front line.

Mensa Jorvic leads those guarding part of Gorazde. He is not sure how all this started. But now he can se no hopes for peace talks.

Gunman speaks in Bosnian

We have lost so many lives he says. It is either us or them, The Bosnians have driven the Serbs from the town.The UN will monitor the heavy artillery that remains

Sound of heavy artillery and gun shots

But for the moment the siege of Gorazde is unbroken.

At the time most staff cameramen came from a different culture, expecting to work with a soundman and to get a lunch break. Rory's ability to disappear on a donkey gave him an edge.

Vitez, Bosnia, 1993

During its long years of industrial isolation under its first leader Tito, Yugoslavia retained a fussy, curiously pretty air, a toytown feel. Its cars and tractors and red-tiled houses were not quite real. There were little guest houses with too much carved brown wood and overhanging eves, or there were concrete hotels, built in a particular version of communist kitsch. Their interiors were all the same, uniformly gloomy and shabby, feeling unused. But outside, the architects competed to show off, decorating the concrete with inappropriate and odd protuberances, as if someone had worked hard to make this the kingdom of bad taste.

A year into the Bosnian war many of the houses had lost their roofs. The best people had fled, as the too-pretty landscape and its kitsch houses was turned into an abattoir. Drunken louts with beer-bloated faces and large bellies would loom up to your car out of nowhere, pretending to police the road, and they would take money or cigarettes or penknives, or occasionally lives. Front lines changed with bewildering, unexpected speed, and across much of the central region there were no front lines at all but rather a constantly shifting kaleidoscope of different alliances, enclaves within enclaves, as the madness went on.

Vaughan found it constantly fascinating, dealing with the mafia and the layers of different militias and armies who emerged. And in the middle of it all, he watched as, with as much finesse as a line of redcoats in colonial Africa, the British Army began to be drawn in. Responding at last to public pressure after months of haunting TV pictures and newspaper accounts Europe woke up to the war on its doorstep, but it always lacked the military resolve to end it.

The British gave their troops only the most limited mandate. They had the unenviable task of making sense of a senseless foreign policy cobbled together by the Prime Minister, John Major, and his Foreign Secretary, Douglas Hurd. The government had begun by trying to stay out of the whole thing by claiming that all sides were as bad as each other. They talked of ancient hatreds, as if there was nothing to be done to stop people from massacring each other. And then they imposed an arms embargo that applied to all sides, although the Muslim minority were grotesquely outgunned. Douglas Hurd came up with his memorable formula, saying that if they let arms in that would not provide a level playing field, but 'a level killing field'. It condemned the Muslims to having too few weapons to defend their civilian population from their two Christian neighbours, Serbia and Croatia, and made them

dependent on countries like Saudi Arabia, who tried to radicalise their Islam while sending them rifles.

UN forces were deployed only to dampen the fighting, not to take sides or show resolve. This prolonged the conflict by keeping the Muslims too weak to achieve a stalemate or to negotiate a political settlement. The policy had the cruellest outcome, ensuring only that the Muslims lost a long war rather than a short one. To this day there are senior Bosnian Muslim politicians who refuse to meet Hurd.

Vaughan settled in with a Croat family in the middle of this mayhem, as Croats and Muslims alternately fought and allied with each other in the face of a sustained Serbian onslaught. As a freelancer he had a unique view of how different national media reported the war. Of course the best journalists stood above the stereotype, but there were strong undercurrents among all of the reporting. Some British journalism tended to be coloured by the Whitehall perspective, which dismissed the war as a hopeless, seething morass of unending tribal rivalries. Other Europeans had a more defined nationalist bias. Some Germans had a natural historical affinity with the Croats, an unsavoury alliance left over from Nazi domination of Croatia in the Second World war, while the French inherited an even older tradition, backing the descendants of the Serbs who had stood up against the Germans in 1914.

In Vitez in 1993 Vaughan was contracted to shoot for a German TV station, ZDF. He witnessed some of the nastiest fighting of the war as Croat gangs attacked a Muslim enclave while they were themselves surrounded by Muslims. He was there for three months before being relieved for a month by Peter Jouvenal, and then came back in for another spell. The correspondent, Reinhard Schlieker, was a good reporter who did not fit the crude nationalist pro-Croat characterisation that some of his countrymen shared.

But other members of his team were more biased. They had hired a ludicrously over-engineered armoured vehicle, a Pinzgauer, which looked like a weapon of war itself. The pro-Croat sympathies of the translator actually meant that Vaughan was blocked from filming one Croat atrocity. He took to going out early in the morning in a battered local car, working on his own rather than waiting to be obstructed by the team.

One day a joint aid convoy, driven by Muslims and Croats, which originated in Zagreb in Croatia, arrived in town. It was a rare bipartisan initiative, and therefore a threat to extremist Croats. As the convoy approached the village where Vaughan was staying, Gornje Vitez, it was set on by Croat forces, only about a hundred yards before the very house where he was living. First the driver of the front truck was shot by a sniper and then shooting started all around. Vaughan approached with care, crouching alongside an armoured vehicle belonging to another TV company. Local people, including the family he was staying with, began to loot the convoy. He found one Muslim truck driver hiding in a ditch, but Vaughan and other journalists agreed that it would compromise their own security if they were to put him in their armoured vehicle. So they let him walk alongside, getting protection from them, as they drove the vehicle slowly towards a British Army camp, where they handed the man over to be looked after. After that Vaughan refused to eat any food in the house where he was staying, and could not look his hosts in the eye again.

Robert Adams spent time in Vitez as well, using it as a base while he went off on his own, getting pictures from places where other journalists did not or could not go. Once he was asked to come to a secret meeting with a Bosnian Muslim general who knew his interpreter. The general was concerned because Croat soldiers had taken to firing at them from the cover of the street in front of the Dutch base. The Muslims could not fire back without hitting the

Dutch. They wanted the Croats stopped. Robert took the message to some likely-looking British soldiers in an open Land Rover, who he guessed were SAS. The action took him across that narrow dividing line between being a journalist and a spy. They do the same jobs, have the same contacts, go to the same bars and share the same information, sometimes knowingly, and sometimes not. The only difference is in what they do with the information. The whole process of journalism is only about two things: discovery and disclosure – what you find out, and what you do with it. When journalists discover things they disclose them, broadcasting them to everybody. Spies, good spies at least, keep things secret and tell only the people they think need to know.

But Robert, although not a spy, still thinks he did the right thing in contacting the SAS. At the time he was still writing for some of his 'strings', the newspapers he had serviced from Afghanistan. He did not report this for them; rather he took direct action.

If I had filed the story of the Bosnian general not wanting to fire on the Vitez base for the *South China Morning Post*, it would not have registered. If I had filed it for the *Daily Telegraph*, you would presume that it would be on a Minister's desk with a yellow highlight across it, and all the right people would have seen it in MI6. What is the major ethical difference in me bypassing the broadcasting process and going straight to the people who are going to get it anyway? By doing it, I was saying that this is a critical problem and you need to deal with it right now. I suppose I could have run back to Vitez, persuaded a BBC hack that this was an interesting story, but that I had not got any pictures to back it up, and the guy I had spoken to was someone I could not easily have found again. What are you going to do? How are you going to report it?

It worked anyway. The Croats stopped using the base as cover after getting a clear and direct message that it was not a good idea. And for Robert it was the beginning of a good relationship with British Special Forces, who have a built-in distrust of journalists. The pay off came two years later when the commander of British forces in Bosnia, General Sir Michael Rose, wanted to take two journalists with him to inspect the Muslim enclave Bihac. The aim of the mission was to see whether things were as bad in Bihac as the Muslims said they were, and he did not want the outside world to take only his word for it. To join him he chose Kurt Schork from Reuters, the leader of the pack in Sarajevo, with Robert to take the TV pictures. They flew at night in a French Special Forces Puma helicopter. Along the way they picked up the telltale 'PING' on their radar that told them they were being 'painted' by the targeting device on a surface-to-air missile, presumably one of the Croats'. General Rose got on the radio personally to tell them that shooting him down was not a good idea. In Bihac Robert was given unprecedented access to shoot SAS soldiers at work.

Frontline's Bosnian reporting was not all 'bang, bang.' There were other features as well. Robert shot a whimsical piece about Triumph-owners breaking sanctions to keep their old motorbikes going through the war. And Adam Kelliher shot a profile in Belgrade of a woman who made lots of money through an interest-rate scam. She offered 2 per cent above any other interest rate. She defied the normal laws of economics as only a war profiteer could, with a phantom monetary miracle founded on corruption, which propped up the Milosevic regime. His report said: 'Dafina Milanovic was no ordinary bank manager. The faithful call her the mother of Serbia.'

It was the kind of idea that sold well, a story outside the box, a slice of life which looked at the conflict in a different way.

Frontline had to work hard in Bosnia to keep ahead. There were a lot of other people around with a lot of cameras. A German TV producer turned down one offer like this: 'Regretting awfully our negative reply, we really hope to come together next time, in case you should have some brand new material for us.'

Getting 'brand new material' and filling the gaps was not always easy. And now the industry was changing in front of their eyes. This was not the Hindu Kush; Bosnia was an opportunist's war. Any young European could buy a Hi8 camera for a few hundred pounds and drive in. Apart from in monopoly locations like Sarajevo, it was getting harder and harder to risk your life and make a living. The days of selling the same footage to several TV companies for thousands of pounds were already coming to an end.

Maglaj, Bosnia, March 1994

Towards the end of the Bosnian conflict the main front lines had been settled for some time. The big armies were always rather unimaginative, and not very brave, so did not move much. But in between, small towns and villages were caught up in a swirling mist of changing alliances. Maglaj was a mainly Muslim town being besieged by a rare Croat–Serb alliance. It was very dangerous. The alliance was breaking down and some Croats found themselves imprisoned by their nominal allies. It was hard for reporters to make sense of this kind of thing, and harder still for the audience to keep up. Television news is an immensely intimate medium, dealing with the minutiae, focussing with that unforgiving lens on small things and trying to give them universal significance. But in Bosnia, the small image said nothing except about itself. It was a deconstructed, fractured world where nothing meant anything, except to the wretched people stuck in the middle of it all.

The Muslims were not saints and they carry their share of blame for the horror. But they were always less well organised

and almost until the end of the fighting their territorial ambitions were only ever defensive. They did not have a neighbouring state assisting them, as did Bosnia's Croats and Serbs. What they were good at was making extravagant claims for the sufferings of their people, saying that things were worse than they really were. Now the Muslim authorities were claiming that people were living in appalling conditions in the Maglaj 'pocket' – such a sweet and misleading term for an area of ordinary houses and farms being held in terror. Dozens of journalists would go off in taxis every day, probing the perimeter of the siege to try to get in, pretending to ignore each other. None succeeded. Vaughan, travelling with Richard Parry again, remembered his days as a hang-glider pilot and developed quite an advanced plan to break in to Maglaj by flying over the minefield.

'What we need are some really detailed satellite photographs. You get on to that. We should be able to buy them on the internet.'

Richard was not convinced.

'Hold on a minute. How the fuck are we going to get a powered hang-glider in? You'll get shot down by the UN. Its a no-fly zone remember. Even if you don't get shot from the ground first.'

Vaughan said, 'Yes, well, it's unlikely that the UN would pop at a hang-glider. They probably wouldn't bother.'

'But what about being shot at from the ground? We are going over Serb lines.'

'I've thought of that. If we time it right they are usually drunk by about three in the morning. Even if they could see you, they probably couldn't hit you.'

Richard knew that the idea was completely insane. But he went along with the planning anyway. Sometimes Vaughan was like that. He could not be stopped, and sometimes these mad ideas actually worked. They realised that they would not both be able to fly with TV kit, so the plan was that Vaughan would fly in with

the camera and tripod, and then fly out again to pick up Richard. Good sense prevailed somewhere along the way, and they went in by a different route – though probably about as dangerous – walking in disguised as Croat soldiers, with a guide to take them across the minefield. If the Serbs had found them they would almost certainly have been shot.

Once inside they found that things were not as bad as the Muslim leadership had made out. It was uncomfortable, certainly, but it was no Srebrenica. There was food and water, and there were men of military age around who had not been 'ethnically cleansed'.

They cast around for a story and came upon a group of SAS soldiers. The freelance photographer Gary Knight, who had come in with the Frontline cameramen, thought that they should respect the soldiers' desire to keep out of the pictures. But Vaughan did not agree and wanted to find a way to film them without showing their faces. Initial contacts with the soldiers were quite friendly. They were wearing blue berets after all, identifying them as part of the UN force. Vaughan did not take sides in the Bosnian wars, but considered that at best the British forces were there only to maintain the status quo, and the status quo now was a worsening conflict. As a journalist he felt that he had not just a right but a duty to put them on television. The soldiers said, 'If you can find a way of filming us without showing our faces, then go ahead.' But once they had checked with headquarters in Sarajevo the atmosphere changed markedly. General Rose himself ordered that there should be no co-operation with journalists in Maglaj at all. At one point the SAS threatened to shoot Vaughan, just to make the point clear.

It was not a sensible thing to do. Vaughan's warrior instincts took over, despite Gary's more cool-headed reservations. Filming the SAS in Maglai became an obsessional cause for a day or two,

before they made the long walk back across Croat lines, again in their Croat army disguise. They did get the pictures, and the SAS were shown on television, although none of their faces were identifiable. But the story itself never amounted to much; as they walked out the alliances changed back to the more natural order of Croats and Muslims against the Serbs. Maglaj was 'liberated'.

Tuzla, Bosnia, July 1995

As Bosnia's misery went on, Frontline stayed with it. The so-called 'safe havens', where Muslims were supposed to be protected by the international community, fell into Serbian hands one by one as the west lost its will to resist against Serbian duplicity and murder. General Mladic released French soldiers he had been holding hostage in return for a free hand in Srebrenica, where Dutch peacekeepers meekly handed over their guns and watched as thousands of Muslim men and boys were separated from their families. There was no attempt to stop what was about to happen, although it took place with a slow and clinical precision. Vaughan was in Tuzla and filmed the convoys of women and children, covered in blood, coming from Srebrenica. Behind them was the worst mass slaughter in Europe since the Second World War. He saw the bodies in Srebrenica later, and walked on the trails in the hills where men had run for their lives before being gunned down and bulldozed into mass graves. Perhaps 8,000 died. He came home and was surprised by a member of his family saying at dinner, 'All these bodies. It's ghastly. How can we have let this happen?' The ignorance shocked him. The story that he and others had tried to tell at considerable risk to their lives had gone over people's heads. They averted their eyes rather than facing up to the possibility that British policy had actually played a part in prolonging the agony. The experience put Vaughan off politics

for life. He felt that Britain had never owned up to the scale of the policy failure in Bosnia. In contrast a government fell in Holland after the disgrace of Srebrenica.

Back in London, Vaughan refined the skills he had used when he disguised himself as a British officer to get into the Gulf War, forging two UN identity cards for their girlfriends. He brought them out of Sarejevo, crossing hostile front lines, where fortunately the forged documents worked. Once he had got his girlfriend, Sanela, to Croatia he bought a forged Croat passport, and she came to Britain. Sanela's brother-in-law was a Serb, who was in a bad way after his shop was taken away from him at gunpoint. Once taken prisoner he also forced to dig trenches under fire. He escaped from Sarajevo and Vaughan smuggled him out of the country into Britain in the back of a car, eventually getting the whole family out like this. When they got to Britain he told them to lie and say that they had come in a truck. They all successfully claimed asylum. He has no regrets about fiddling the system like this:

> I felt very strongly that our country had behaved very badly in Bosnia by prolonging the war. If we had to pay a price by supporting these people then actually I was going to do it. They have become good citizens of Britain. It was the right thing to do after we had contributed to screwing up their country.

Perhaps the failure of the audience to understand was just a consequence of the daily news update: the brief, perfectly executed stories told by the man in the white suit. 'Bello Dello', as the Serbs called Martin Bell (it just means white suit but has a pleasing poetry to it), got frustrated himself. He famously wanted to adopt a 'journalism of attachment', which in this context meant that

he would be able to name the guilty men, taking sides instead of striving for impartiality in the traditional BBC way.

Vaughan did not see this as the right response. He had worked with all the big corporate players by now, including the two biggest beasts in the international news jungle, CNN and the BBC. And he had developed some respect for the way they engaged in Bosnia. He knew that the BBC had kept dozens of people in the country, at huge cost, and in relative safety. The BBC's final toll of two dead, although tragic, was a very low figure considering how many people it had committed to the story over the years. And yet, despite the commitment, the audience did not get it. They just did not understand what was going on. And that made it easier for the Conservative government to put about their lie about an impossible ethnic morass – 'they are all as bad as each other'.

Vaughan's response was not 'journalism of attachment' but a search for more diverse views. He blamed the pasteurising effect of the daily news feed for the failure of understanding, as if the consistent quality of the output itself acted against comprehension. The audience lost the plot because nothing appeared to have any perspective. He felt that the Martin Bell pool in Sarajevo had contributed to this. Everybody saw the same stories, witnessed the horror through the same filters. It gave him added drive to keep going with Frontline. He felt that they had something to contribute – a different way of working which might help people to understand the world better, despite the small size of the agency.

He took other lessons away from Bosnia too, about human nature itself. Milosevic, like Hitler, had actually been *voted* into office. It was quite possible for a whole country to be bitter and twisted and do obscene things. Like many journalists who spent a lot of time there, he both loved and hated Bosnia. People were so charming and hospitable, even while unspeakable things were going on. You had to listen without compromising yourself, while

drinking plum brandy at 10 o'clock in the morning; just listen and smile and never agree. It was a bit of an art and he learnt it.

He learnt the jokes too. There was no blacker humour than in this tragic war. The one people always tell, perhaps because it holds more truth than any amount of academic research, has four Bosnians – two Serbs, a Muslim and a Croat – landing on the moon. The Croat plants his flag and says, 'I claim the moon for Croatia. Look, the territory is next to ours – clearly the moon is Croatian.' The Muslim plants his flag and says, 'No no. You cannot know your history. We have been here longest. The moon is Muslim.' One Serb shoots the other and says, 'You are both wrong. The moon is clearly Serbian. Anywhere we have buried our dead is part of Serbia.'

By 1995 the whole of Bosnia had been turned into a graveyard, but the Serbs had not managed to plant their flag on as much of it as they felt was theirs. The international community saw them as the biggest villains. Vaughan witnessed a macabre last act as Serbs who could see they were no longer welcome fled from Sarajevo. They took their dead with them, in coffins, which they had dug up from the graveyard, strapped to the tops of their cars.

The Serbian nation carries a sense of grievance which cannot be compared to any other, although the petty-minded insular chippiness of some in Ulster, South Africa, or places like the Falkland Islands have some similarity. There are large-hearted, generous, intellectual Serbs with sensitive souls who care for humanity. But they had to hide away and keep silent during the Milosevic years as the barbarians took over and recast Serbian history.

Sarajevo, Bosnia, 1993

Tim Deagle, the cameraman who had spent so long in Somalia, was in Bosnia throughout, moving to room 507 of the Holiday

Inn – the longest he had ever slept in the same place since he was eleven years old – and seduced by the sheer sex appeal of the story. *Not sexy in a smooth, South-East Asian, brown-skinned smelling-nice kind of way, but more in a short skirt, long boots, I am going to fuck you blind kind of a way.*

Soon he was doing so much for NBC that he set up their bureau; few Americans were willing to risk the journey into Sarajevo. Separately Frontline helped to set up APTN, a big news agency, and Roberts Adams came in to run it, so with Richard and Vaughan running around for everyone, Frontline produced a large proportion of the television images coming out of Sarajevo at that time.

For Tim it was four years of going out of the side windows of the hotel all the time, since going out of the front door exposed you to fire; four years of hearing a Land Rover's tyres squeal on wet tarmac and tensing up, since for a split second it sounded just like an incoming shell. By the end he was doing some reporting for NBC, who loved his English accent and leather jacket, while Vaughan and others shot many of the pictures. But the Americans never called again after he had to go to London to recover from hepatitis. Vaughan only knew he was really ill when NBC phoned for Tim to do a 'stand-up', and Vaughan had to tell them, 'Actually, he can't stand up at the moment. He's flat out.' Frontline arranged proper medical treatment, finding space on an RAF flight to Britain. Anna Roberts met him off the plane.

Shortly before he fell ill, he had a string of good hits with NBC's *Nightly News*, and they asked him to join a conference call to New York. *The room at the other end was full of the type of news executives who walked to work in Reeboks and change into high heels for the office and now wanted the thrill of talking directly into a war zone.* After a few gushing comments from the other end, familiar wallpaper to anyone who has ever worked in the

States, there were veiled offers of serious work to come, and not just in Bosnia.

'So next time you're passing through New York, we'll give you a pizza.'

Tim said, 'After what I have been through, I'll want more than a fucking pizza.'

The atmosphere froze, and he never heard from them again. He had thought they were being ironic. But it was like one of those cross-cultural adverts where the golfer has to keep buying presents, or the businessman stuff himself with food because he has missed the signals. Too much was lost in translation. The executives in their air-conditioned offices suddenly came far closer to a real flesh-and-blood person with real emotions in the front line than they had expected, and did not want to be part of it.

Tim was still part of the NBC team but now things had moved on. By the spring of 1995 Sarajevo suddenly felt a much safer place, safe enough for NBC to send Americans to do stand-ups. Tim Deagle was yesterday's man. It was not yet a normal city, but a few more cafés began to open, a few less people died every day. By now every tree in the city had been chopped down for firewood and there was hardly an intact pane of glass anywhere, but suddenly tomorrow looked better than yesterday for the first time in a long time. That is why the shooting and shelling was so shocking when it started again in June. That hot summer felt like the worst because the violence came back so hard.

Fear is what grinds you down. It was very hard to stay in Sarajevo for week after week. Tim had seen more people die in Somalia, but he faced more threat to his own life on a daily basis in Sarajevo. *'You could die' is what fucks you up when it goes on week after week. You spend your whole life with the hairs slightly raised at the back of your neck.*

The cynicism behind the sudden outbreak of new violence was dazzling. The Americans had suddenly got Engaged with a capital 'E'. They wanted peace talks, but the Bosnian Muslims said that they could not go to Dayton, the Ohio air base where the talks were to take place, without the prospect of a viable state. Apart from the inevitable land-grab which always precedes a peace conference, the Muslims now had the tacit support of the USA to do what they wanted. The Serbs responded in kind. They had always been able to flatten Sarejevo with artillery if they wanted; they had only been playing all those years. Now they played in earnest.

Tim was unprepared when it came back so hard. It seemed like the bad old days all over again, but worse because there had been a lull. As well as anti-aircraft fire targeted down to the city, which would penetrate any armour available to a journalist, they were dropping more mortar rounds. The shrapnel left scars on the tarmac and buildings where they burst – 'roses on asphalt' in Sarajevo slang. On 28 August, Tim was on his way to the market to buy lighter fuel. A shell came out of nowhere, ripping people apart. Thirty-seven people died, dozens more were maimed. It was a terrible day. Tim remembers filling his car with wounded people and then driving over a wounded man who fell out of the boot of the car in front. The wounded man died. He went back to the Holiday Inn in shock and finished a bottle of whisky with friends, haunted by the images he had seen: *There was this head on a market stall, as if it was for sale.*

The next morning Tim woke up knowing that if he went out he would die. He phoned the bureau and said the kind of things you can say. 'Hi, I have some things to sort out here. I'll try and make it in later. Quiet day?' Then he went downstairs to the bar in the basement of the Holiday Inn and ordered a drink. The barman was in the strange uniform of that aesthetic travesty of a hotel,

maroon with a green shirt. Tim said to him, 'If I go outside, I am going to die.' And carrying all the wisdom of barmen handed on ever since the first corn was fermented in Mesopotamia 6,000 years ago, the barman said, 'Yeah, I know. Have another drink.'

Tim relied a lot on luck. He had a Buddha round his neck. And he and the photographer Gary Knight, who shared a car and a little knowledge of Asia, had Buddhist markings on the roof of the car in Sarajevo like those on a Thai taxi. But now Tim *knew* that his luck had run out. He did not leave the hotel that day, although he knew he would have to go out the next day and the next. He was more terrified than he had ever been. He had left Somalia when a man who he used to see in a coffee bar every morning fired at his car at point-blank range, *just because I was a white man*. It was nothing personal, but it put Tim off his espresso. He thought then that his luck had run out only in Somalia. Now he thought it had run out for good. He kept on filming for a couple of weeks, the hardest he ever faced, remembering friends who had been killed right at the end, after they had made the decision to go, when they were doing that 'one last sequence'. After the city was formally opened, following the Dayton peace talks, he drove across the bridge at eight seconds past midnight, passing the spot where the bodies of Sarajevo's 'Romeo and Juliet' lovers had been left where they fell for days, since neither side would retrieve them. The city seemed full of ghosts. The Serbs on the checkpoint said, 'You can't go.' And Tim said, 'Yes, we can.' And the next day he walked up the front line, all the way to the airport, before getting on a plane and leaving Sarajevo for ever.

Krajina, Croatia, August 1995

Adam Kelliher did not know John Schofield well, but he liked him as soon as he met him. Teams who travel together into the field are often put together randomly but develop bonds which

go beyond normal friendship. John was a radio reporter for the BBC, while Adam, a Frontline cameraman and founder member of the Club Nuko in Amman, was by then with the BBC's first attempt to run an Arabic TV channel. In the patchwork of ethnic identities in the former Yugoslavia the Krajina region of Croatia historically had a Serb majority. John and Adam, travelling in an armoured Land Rover, went to the region with two other BBC journalists to investigate claims that the Croat forces had begun a major offensive to clear out the Serbs. By the standard of these things the trip was comparatively safe; they began the day trailing the British Ambassador who would certainly not have been there if there had been a serious risk of shooting. They found an area almost completely cleared of people. The Serbs had fled or been pushed out; villages were burning as far as the horizon. It was the usual baleful Balkan scene: another complex piece of the Yugoslav jigsaw puzzle sacrificed by the ethnic cleansers. After the British Ambassador's party went back the BBC vehicle pushed on. There was nothing to suggest that anything had changed, no new border or appreciation of a different threat. They stopped to film some of the scene – Adam and the Arabic-service journalist Omar Asawi staying near the vehicle while John Schofield and Jonathan Birchall, another BBC reporter, walked a little further away to record some atmosphere and commentary for radio. Suddenly Croat soldiers who had been hiding in the grass opened fire. Adam says that they were surrounded by hundreds of bullets. 'Forget what it's like in the movies where people have time to take cover. I just flattened myself into the ground. It was horrific.' Despite being slightly injured, Omar managed to scramble into the Land Rover. Adam remembers thinking, *This is not my time. I am not going to die today*, even though a bullet gouged a furrow across his forearm, severing nerves, which have never recovered. As the firing died down he called out, 'British. Journalists. British.

Media.' The closest Croat soldier motioned to him to get up. He rose from the earth cautiously, holding up his arms, and walked slowly towards them. Blood was streaming down his left arm. The Croats were abusive, sure that he was a Serb. The vehicle, with its 'BBC' and 'TV' stickers did not convince them. By now a lot of white Land Rovers had been taken from journalists and aid organisations and were used by militias on all sides, their expensive ceramic armour making them a valuable asset. What Adam did not then know was that John Schofield was already dead, killed by a single unlucky bullet that had avoided the bullet-proof plate in his flak jacket. The Croats moved slowly, even after they realised what they had done, finally calling up an ambulance to take the journalists to hospital. Adam remembers driving back through the soft grey rain falling in the dusk light, thinking, *I am alive. I am alive. I am alive. I am alive. I am alive.*

He never went to war again.

LUST TO GO ABROAD

*Pay is the least part of the work. From time to time, God causes
men to be born — and thou art one of them — who have a lust to
go abroad at the risk of their lives and discover news – today it
may be of far-off things, tomorrow of some hidden mountain, and
the next day of some near-by men who have done a foolishness
against the state.* Rudyard Kipling, *Kim* (1901)

Moscow, 1991

When he was a young man Rory Peck tried to run away to South
America. His mother could hardly blame him for his wanderlust.
She had herself run away to join the Canadian Navy in the war.
But she wanted to get Rory back because things that mattered to
her, like honour and virtue, were at stake. Things had changed
since his first attempt at flight, when he had tried to run away to
Rhodesia to fight and ended up sailing a dhow in the Red Sea.
Now there was a girl involved.

It was like a scene from one of the Victorian or Edwardian
novels that were all Rory had to read as a child apart from *Pravda*.
Janey was the sister of a wealthy earl who lived in one of Ireland's
grandest houses on the border. She was much younger than Rory,

who was still only in his early twenties when they met at a party. Janey came to live in Rory's family home, while Rory went off to Sandhurst to try to become an army officer. When that did not last he came back to Ireland. He took Janey on holiday to the family's wooden house by the lake in Maine where he had spent so much of his childhood.

Rory's plan was that she was going to go home after the holiday while he headed for Colombia to fight drug barons for *two years*, and if Janey still loved him when he came home, then they would marry. His mother had been left a priceless collection of American original manuscripts and books, and she suggested that he should take some to New Orleans and sell them to a museum, so that he would have something to live on. That meant he had to go by sea, so naturally they went first class, on the QE2, pretending to be man and wife.

The two weeks Janey was planning to spend in Maine passed quickly, and somehow her family's plan – to send her to a 'finishing school' in France – did not appeal. They loaded up the ancient family Buick in Maine with the boxes of old books to drive south. Alarm bells rang in Ireland when she did not arrive in France. Private detectives tracked them down to a hotel in Florida, and Janey was persuaded to return home. Rory did not last two days, let alone two years, without her, and he came home to get married. After a grand London wedding, their honeymoon was on the QE2, this time genuinely as 'Mr and Mrs Peck'. He was contented for a while then in Maine, but it did not last, and after two sons were born in quick succession he and Janey parted.

His unsettled driven temperament meant that he was never really happy again until he and Juliet moved to Moscow in 1991. The coup against Gorbachev settled an argument they had been having about where to live after the Gulf War. They had their own daughter now, Lettice, as well as Fynn, Juliet's son from her

first marriage. Rory's two sons from his first marriage, Jamie and Alexander, would often come to stay too.

Juliet had long wanted to live in India. She would be able to afford to ride horses there, and India appealed for all the usual reasons too. Rory had other ideas. Now the Evil Empire was crumbling he wanted to be in Russia to witness it at first hand. Besides, Moscow had the frontier feel that they remembered from Peshawar. The old certainties of central control were breaking down. Until then journalists had to live in the same dreary apartment blocks as other licensed foreigners, like diplomats. These all had the same unloved feel, the smell of stale smoke and gravy, corridors where the lights were on all the time, as was the heating. There were no thermostats, so you had to open the window to breathe even if it was freezing outside. The same grey uniformity of communism was imposed like a blanket on all foreigners alike.

But suddenly things changed. And the Russian language had to find a new word – *biznizmen* – to describe the new breed who replaced the old *apparatchiks*. It was lawless. All of their lives Russians had recited the Marxist mantra that 'capitalism is theft'. When they became capitalists they became thieves. Now money talked. It was exactly the kind of environment where a buccaneer like Rory thrived. His upper-class drawl left little space for a Russian accent. Listening to him was rather like hearing Edward Heath speak French. But whatever the accent he made himself understood and spoke Russian better than most Englishmen in Moscow, bartering and dealing in order to fashion a life straight out of Tolstoy. He wanted to live in a dacha in the woods, away from Moscow, with a troika of horses to pull a sled in the winter. He was a pioneer in this; months before other foreigners had broken out of the capital he and Juliet had bought their way out of their assigned apartment and moved to a dacha that used to

belong to Boris Pasternak, where he hung his new collection of giant communist kitsch paintings.

To his closest friend in those days, Vladimir Snegirev, Rory was not like any the other Briton he had met. He says approvingly that Rory 'spent money like a Russian. It went on caviar, whisky, the dacha in the woods.' He was earning fistfuls of dollars, like a gold-miner who had struck a rich seam, and he spent it without caution in the land of the free-falling rouble, where dollars went a long way. Vladimir says that he became more peaceable and relaxed about the country too. 'When he arrived he thought that all Russians were feckless and lay in bed all day. He wanted to pick a fight with everybody. But then he found some friends, and found people who were straight.'

As in Peshawar, he became the centre of a circle of the like-minded, including some very young people who were travelling in and out of war zones. This was the time of *glasnost*, openness, when the shackles of the censor were lifted for the first time in memory and, in contrast to their old practice of trumpeting false successes, Russian journalists were competing to find bad news. The international TV agencies, like Reuters and APTN, relied on Russian freelancers because they could not easily get permits for their foreign staff to travel to the regions at the furthest edges of the Soviet Union. A series of nasty little conflicts erupted in remote places that had hardly intruded on the world's consciousness before – Nagorno-Karabakh, Tajikistan, and Abkhazia.

One of those freelancers, Zoya Trunova, has truly appalling stories of her treatment at the hands of the international TV agencies. They would ask her to bring along her camera, a Hi8, when she went to see them, to check that the zoom mechanism did not work. And if she had a new camera, they would take it off her and break the zoom. The aim was to stop her constantly changing the size of the shot, crashing in and out, making the

pictures difficult to cut together. But the effect was to make life much more dangerous, because she had to get closer in to shoot anything properly. Trunova had been to a Russian film school; they did not need to break her camera.

Rory was generous with his time to these young freelancers, teaching them how to shoot pictures so that they would cut together in the ways the western agencies wanted, and watching their rushes. And he gave them advice on negotiating, so that they were not ripped off because they were 'local hire'. Trunova looked very young, and traded on her little-girl looks to get her into difficult places. Soldiers took her under their wing. Nobody thought that she was a threat. Remarkably she survived. About half of her friends who were doing the same thing were killed.

During these years Juliet would sometimes travel with Rory. They had a comparatively large Russian staff to look after the house and the children, which gave her some freedom. She knew more than anyone what motivated him, and it was not primarily money. They once went to Ulan Bator to do a feature about how people were moving back into traditional Mongolian yurts, tents built around a mud wall, because the city's heating system was breaking down in more modern apartment blocks. But they did not set up the trip in order to avoid war reporting or to make money; rather they wanted the adventure, the experience of Mongolia.

Rory and all of the other Frontline cameramen were always the biggest ambulance-chasers in the business. So why do they do it? Partly it is for the sheer thrill, taking one of the few opportunities for adventure in the sanitised, globalised, packaged, risk-free, processed, health-and-safety-conscious 'developed' world we have made for ourselves. They are like men who do not want 'world-lite'; they are looking for the real thing. In one TV interview Rory said:

I think that if you ask any cameraman, he'll tell you that he films because he gets some excitement out of it. If you are in a battle and you are filming, your adrenalin rises to a very high level. You can get hooked on that. Why do I film? I suppose it's because I find it exciting. It's a tremendous challenge to find a way into any given situation. No situation is similar. You have to get in and get your pictures out. It's a wonderful challenge.

It was ironic that he had ended up in television. His eccentric father had been so opposed to television that he did not allow one in the house. When he found the children watching TV in an au pair's room, he smashed it with a hammer. But beyond the adventure there were other reasons for them to do what they did. Every journalist who goes to war, even the biggest 'bang bang' addict, says that, one way or another, they are there for the underdog. In the nineteenth century, the 'first war correspondent', the father of the tribe, William Howard Russell, made things better for the ordinary British soldier by reporting on conditions in the Crimean war. His promotion of Florence Nightingale invented modern nursing along the way. And since Martha Gellhorn's tales of civilians caught up in the Spanish Civil War in the 1930s the effects of war on its victims have driven the news agenda. The personal stories at the heart of conflict make the news. After the months of pictures of the preparation of the hardware to be dropped on Iraq in 2003, and then the extraordinary battle footage during the war itself, it was the plight of the people of Iraq that made the enduring images of that conflict.

All of the Frontline cameramen, and Rory in particular, thought that there would be less war if the real consequences of what war does were shown on television – not the images of cruise missiles

taking off to deliver anonymous death which take up so much of our TV coverage of war, but the pictures of what happens at the other end, the darker places in the world. Rory once told Vladimir Snegirev, 'My job is to finish war as soon as possible, to stop it. Because everybody can see the dark side of war.' He would search under stones, passionately committed to film what crawled out, to show the world as it really is, sometimes in the hope and expectation that the pictures could make it better. He did not shoot pretty pictures, but the cruel current of war, which is always with us, is not pretty. The Frontline cameramen walked in the footsteps of a tradition which goes back to Goya, of showing humanity its darker other side, the real image of itself. And in walking on the dark side, they had to share the risks of being over there. Their driving motivation turned the risks into a challenge not a threat.

No one was better at getting alongside the victims of war than Richard Parry. A sensitive man, who has since become an award-winning feature-film-maker, he is direct and personal about why he went to war: 'All of us have a bit of anger in us. We want to shake the world. Shooting pictures got rid of some of that anger.'

Richard still remembers one particular incident where the true nature of what was going on came home to him. He was in a hospital in Nagorno-Karabakh, the Armenian enclave in Azerbaijan. The Azeris were shelling the town with salvoes of 122mm Grad rockets, fearsome area-bombardment weapons which can send up forty rockets at a time to fall like hailstones (*grad* is Russian for hail).

A wounded man was brought into the hospital, his two sons, aged about twelve, with him. Richard watched as one of the boys died on a couch, while doctors were trying to bind up the wounds of the man and his other son in a room soaked in blood. Printed on his mind is the memory of them ladling the blood 'like soup.' The

electricity was coming and going, and Richard's small TV lights helped the doctors to work. It was the family tragedy that got to him. This man had spent twelve years bringing up his sons and now lay bleeding as they died beside him. Richard had been living in the hospital for a week or so, armed with cartons of cigarettes and whisky to lubricate his way. That is why his pictures were so good. There is no one like him for making friends and winning confidence and access.

Rory Peck arrived in the hospital as he often would, out of the blue, as if everything was normal. He was wearing a ridiculous hat as usual. He had taken some extraordinary pictures of the Grad rockets falling, calculating that the Azeris would adjust their aim slightly between salvoes, so if he stood in a new crater then he would safely get pictures of the next assault. There is not much combat footage anywhere of this quality. There are very few people who would make such a knife-edge calculation. The shots are as steady off his shoulder as if he had used a tripod; he did not flinch as the rockets fell less than fifty metres away.

An argument broke out with the Armenian doctors as they smoked Richard's cigarettes in a break from operations. Rory said, 'You're all as bad as each other', which did not make him many new friends. He had seen victims in this war too on the other side, and to him a dead Azeri child was no more nor less a victim than the dead Armenians whose corpses were piling up outside the hospital. For him, war stripped off the hypocrisy, exposing an essential truth about mankind. He liked to say, 'War is the only place where people show their true feelings', seeking out stories that might not otherwise make it on to television. He could quickly see through the small shabby compromises that make wars happen.

What did give Rory an added driving force in countries like this was that he was witnessing the collapse of communism.

He was a literate historian and liked being on the leading edge, recording history in the making. In Russia, not only was he living on history's front line, he was also killing the demon which had stalked his childhood, communism itself.

But he never stopped his practical jokes, some of them very scary. His brother, Colin, had now given up his first career as a barrister and come out to live in Moscow near Rory, shooting pictures alongside him. Colin shares Rory's temperament, and had often travelled with him since the early Afghan days, taking time off from the law. Once, when he was being guided out of Afghanistan after trying to investigate heroin-smuggling routes, he realised that the heroin he had been looking for was stitched into the saddlebags strapped to the donkey he was riding. A long-term career at the bar was perhaps never going to work.

Soon after Colin settled in Moscow, a friend of his, who worked as a banker in London, came to stay. Rory and Colin were heading off to Armenia again when he arrived. They picked up Colin's friend at the international airport, driving him straight to the domestic terminal, and told him that they were going off to the south, 'to the beach', for the weekend. At the time it would be snowing in Baku.

They took a train from Baku airport towards the front line, and then transferred to a military vehicle, although their banker friend still had no clue as to where they were. They began to see lines of refugees coming the other way. Their friend said, 'What's going on? Why are all these people coming in the other direction?'

Colin said, 'It's near the end of the season. They must be on their way home from the resort.'

They got close to the front line before the banker realised what was going on. Then a commander stopped them and said that they would not be able to go any further. There are several ways of addressing this problem, with good humour and charm

usually being the key. Some journalists try the high-handed, 'Don't you know who I am? The President will want to hear about this obstruction.' Rory's approach was unique. He fixed the commander with his large brown eyes and took a peck of snuff onto the back of his hand, snifffing it with relish, before barking out that the commander must be frightened. 'Call yourself a man. Why are you sitting back here? Too dangerous out there, I suppose.' It might have got him a bullet between the eyes; on this occasion he succeeded in making the man angry enough to say, 'OK, go where you like.' Rory grabbed a soldier by the door and said, 'Hear what he said? You're going to take us to the front.' And they went, with Colin's banker friend blinking behind them. Fortunately he was not hurt, and once he had got back he told them that it had been a great holiday. It changed his life.

Colin filmed conflict on his own as well. Once, in Dagestan, the Russians cleared a village ahead of Chechen rebels. In order to break through the cordon Colin forced his way into the back of an ambulance. The driver insisted that he pretend to be a corpse, so he lay down in the back with a sheet over his face. When they arrived in the deserted town, the driver and a 'doctor' in the back took off their white coats to reveal the cameras slung round their necks. They too were journalists.

While he was living in Moscow Rory established his reputation, and began to become known beyond the TV industry itself. He was thinking much more about the quality of the pictures, making up in experience for the training he never had, and he was now earning a lot of money. In Russia he mostly worked for the German TV station ARD, and Juliet remembers a conversation with their Moscow producer Sonia Mikich. 'She was looking at some of his footage and said, "Just compare this with what he was doing two years ago. He's really got it now." And it was a fine piece of work.'

As he grew older he became slightly less frantic. He spent more time putting the images together. He was proud of what he did and made much more knowing and ruthless calculations of risk than when he started out in Afghanistan, a decade before. In the early days he would sometimes take risks for little reward. But now he needed to know that there was a story to tell as well. He still took more risks than many did, but he was not going to sell his life cheap.

He was attracting attention too among those who lived in the places he put on television. Few other people were shining such a light on their squalid little conflicts. An Azeri TV crew wanted to know why he kept coming to cover their misery. The one surviving copy of the interview is scratched and grainy, the picture virtually washed out to black and white. But, against a background of Rory's children playing behind him in the dacha, there is a warmth and colour in his tone as he speaks about why he did what he did for a living. His easy charm and charisma come out in a voice which seems to straddle the Atlantic, as if Orson Welles had been taught elocution by Ian Fleming. He smokes ferociously throughout, admitting that he would not have minded dying for the Afghan people. He is thoughtful about the nature of war and what it does to people:

> With soldiers you get a group of men together. They are all working together and fighting for one cause. They all have something which unifies them; they are ready to lose their lives for their country, their homes. If you are a cameraman you don't have that same personal stake. You don't get so involved... In war people tend to be stripped of all the facades which they have built up in normal everyday life, so you see people much more closely... Very often people who are very strong, butch or macho in everyday life can

behave really badly in a war. They can be cowardly, selfish, hoard food if there is no food. And other people you think would be no good at all can be real heroes. And yet when they return to everyday life they are drab people. And that is one thing about war which I find very fascinating... you see people stripped down. Some of those carrying a gun with bandoliers around them, if you put them up in the front line with bullets all around them, then very often they are the first to run. Whereas the little chap who doesn't say much gets on with it.

So why do you do it?

You get paid to travel to the most interesting places at the most interesting times. What do you lose? Each time you lose a little bit of your heart I think. You see people who are suffering in the most appalling way, and every time that you see it, it affects you that little bit less the next time. You reach a point when you have seen so much suffering that it no longer personally affects you so you lose your sense of proportion I think. I used to shoot a lot of birds and deer and bears. But I can't shoot anymore. I can't kill animals. I am sure that it is the result of people I've seen being killed.

As the interview draws to the end, he is asked if he has ever been wounded. 'Nothing serious, touch wood,' he says, reaching around, but not finding any wood to touch. His hand is left in the air as the tape finishes.

Moscow, October 1993

When the tanks first surrounded the Moscow 'White House', the seat of the Russian parliament, it did not at first look as if it would come to anything much. Rory and Juliet were staying in Tbilisi in Georgia, on their way back from covering a particularly vicious

little war in the breakaway region of Abkhazia. Rory had been there for ARD, working as he most liked to, going out on his own and then calling in the correspondent to do a more-or-less safe piece to camera when the worst of the shooting was over. It was a dark time. The Abkhaz rebels were backed by Moscow and were killing a lot of Georgians, including people Rory knew well. Colin was filming on the rebel Abkhaz side, while Rory stayed with Georgian government forces, so as the two sides shelled each other, the two brothers knew what was at stake.

Back in Moscow Rory took some pictures around the White House, but then it all looked as if it was going to stay calm, although the tanks were still there. Alexander Rutskoi, the Vice-President, was staging a bid for power in an attempt to restore the old communist order, after President Yeltsin dissolved the Parliament. Some military forces backed Rutskoi's show of strength, giving an added edge, but it still might have all moved on without bloodshed. Rory was asked to stand by on Sunday, 3 October, but when he had not been called by lunchtime he and Juliet sat down to roast lamb with Colin and his wife, Rose Jane. After lunch they were just about to head out for a walk in the woods that surrounded the dacha when the phone rang. It was Thomas Roth from ARD, asking him to come in to town. 'I don't know if it will come to anything, but we had better make sure.' Colin came along to do sound and, as usual, Juliet came too. It was just another story. 'This will pay for a bit more hay for the horses,' Rory said, as he put his camera into the car.

The atmosphere at the White House had an unreal air. It was late autumn, but it was not cold by Moscow standards and curious Muscovites were out walking their dogs and gossiping amid the stand-off. There were police surrounding the White House; Rutskoi was still inside. Army tanks kept guard on the bridge over the Moscow river nearby. Rory took some pictures

and then Rutskoi's supporters, some of them armed, came out and said that they were going to try to take the television station Ostankino. This was turning into a classic coup. Whenever there is a rapid and violent change of power anywhere in the world the TV station is always a target. The Ostankino TV tower, one of the tallest buildings in the world, was more than just a landmark on the Moscow skyline. It was the key to communication with the people.

Rory always had a nose for the key players, which gave his work the sharpest focus. His charm and languid air hid a highly developed sense of what and who really mattered. He spotted General Makashov, an old communist who was backing Rutskoi. If Makashov was there, then this really was beginning to look like a bid to reclaim power by the communists who had been pushed aside by Yeltsin. With the help of Makashov's men, Rutskoi's supporters seized a military truck without much trouble and set off for the TV station. Rory jumped into the truck. It was a bumpier ride, but he knew that he would get better close-up pictures if he went in with them. Juliet followed in the ARD car.

Ostankino was built in that unlovely late-Soviet brutalist style. At one side is the TV tower, twice as high as the Eiffel Tower, set back from the road. There is a line of trees along the side. When Rory approached the trees were already bare and the muddy ground underneath on the side of the road was slippery with leaves, giving off that sweet, musty smell of autumn rot. Along the lighted plate-glass windows in the wide facade of the main TV-station building stood the silhouetted forms of several dozen Russian soldiers loyal to Yeltsin, with their rifles pointing out to the road.

Juliet arrived in the ARD car a little later to find Rory and Colin among other journalists mingled in a small group of protestors, backed by Makashov's soldiers, who had gone up to confront

the soldiers in the TV station. The atmosphere was completely different from the Sunday afternoon calm outside the White House. The journalists were right at the front, between the main body of protestors and the soldiers inside. It felt edgy and it was clear to everyone there that something was going to happen that night.

It began to get dark and Rory, who had set out rather casually, leaving his Sunday lunch unfinished several hours before, did not have any television lights. His most endearing, or infuriating, trait was never quite having the right equipment, even now, at the height of his career. Juliet drove back to the ARD office, and for whatever reason she could not find a lighting kit there either. CNN was on the TV in the corner of the office. They were broadcasting pictures live from Ostankino, and Juliet saw that shooting had started. She drove out to the dacha to collect Rory's lights and say goodnight to the children, and arrived back at the Russian TV station late at night to find complete mayhem. She got as close as she could but she could not find Rory anywhere. She could not find Colin either, who was also somewhere in the darkness. Mobile phones were not yet available in Russia then, and they had no means of communication.

Colin remembers Makashov shouting with a loudhailer at the troops inside to remember their true loyalties to the Soviet people. He threatened them, saying that if they did not lay down their guns then they would face death by hanging. Makashov's supporters, ex-communists, now numbered several hundred. There is still a dispute over who fired the first shot, but once things started they unravelled quickly. One of the ex-communists in the crowd pointed a rocket-propelled-grenade-launcher at the building, while another drove a truck at the big plate-glass windows. Rory shouted to Colin to get back towards safety, and when the RPG was fired into the building, the incident which provoked the worst

of the shooting, Colin was some twenty yards further back than his brother in the crowd. He remembers the big glass facade looking as if it was being snowed on as Yeltsin's soldiers all fired at once from inside. Colin was knocked over by a wave of people retreating from the onslaught in panic.

> As I got my senses together, everyone had gone. There were lots of bodies around me. I remember the incredible sound of fifty or sixty people groaning, wounded. And then the sound died down as they died.

The silence when they died was eerie. Colin remembered reading about how soldiers in the First World War heard the groaning of the wounded rise and fall 'like a hymn' before dipping into complete silence. He knew now what they meant. But he did not have much time to think about it.

> I stood up, just staring around, and there were bullets landing around me. It was like hundreds of little hammers on the hard pavement. I ran. Not very far; about ten yards to a car. There were a lot of other people there who had taken cover. But they were still picking people off. After about 10 minutes Rory shouted over to me quite calmly and said, 'Colin are you there?'
> I said 'Yeah'.
> 'Are you all right?'
> I said, 'Yeah. I'm fine'
> And he said, 'OK, wait for the shooting to calm down, and then make a run for it.'

The crowd of people around Colin all decided to run together, and they made it to safety. By now there were communist snipers on the

roof of the building opposite, and they seemed to be firing down onto the pavement in front of the TV station to bounce the bullets inside, since they were too high to fire directly at Yeltsin's forces. It was a very unsafe place to be. Colin went off to get another Russian cameraman and stayed working all night. He had seen his brother in bad places before. 'Living with Rory you just had to not assume the worst, otherwise you would go mad. So I was in the habit of saying, "It's OK, he's fine, he's fine, he's fine, he's fine."'

Juliet went back to the office at about midnight, and for the first time really suspected that something terrible might have happened. Rory had neither called in nor sent any pictures. He would have known the value of the footage and would have wanted to get it out on the air as soon as possible. She took the best office driver and spent hours trying to find him. They asked everybody they could, stopping ambulances and going to hospitals, asking and asking everywhere for Rory. The night was full of unknown danger. There was no front line. Power was changing hands in the largest country in the world and there was a lot of shooting.

Juliet went back to the office and stayed there all night. At dawn she started to phone hospitals. In the third hospital they said, 'Yes, we have his body.'

They went to the hospital morgue where, with that finely honed official Russian obstruction, they refused to let Juliet in because they were not open until nine o clock. Then a doctor passed.

'Is your husband Rory Peck?' He had Rory's driving licence in his pocket, so that even before he let her in to see the body she knew that he was dead. She was widowed for a second time.

They had not always had a tranquil relationship. But they had weathered the storms, and as she left the hospital, her mind went back to words he had said as he took her by the hand, only days before: 'The last two weeks have been the happiest of my life.' Rory was one of 146 people killed in the coup and counter-coup, most

dying in the shooting at the TV station. Yeltsin quickly regained control as it emerged that the coup leaders had been drawn into a trap. Despite appearances, at all material times the Yeltsin government had never really been under threat, but by provoking an insurrection they had all the excuses they needed to crack down hard, reasserting central power and dictatorial authority.

In the manner of his dying, Rory exposed the new order as just as bad as the old. A photo taken of his body appears to show him facing away from the TV station, so perhaps at least the bullet that killed him came from the communist side and not from Yeltsin's soldiers. He is lying on the ground, his distinctive balding head an immediate identifying feature. One hand still holds his camera but he appears to have his other arm around the shoulders of a dead boy lying beside him, and his mother takes comfort in the idea that he might have stayed as long as he did in order to protect the boy and get him out safely.

Even though he was not working for the BBC when he died, the BBC took over arrangements to bring back Rory's body and make sure that his family were looked after. A senior news executive, Vin Ray, one of Frontline's best supporters, came straight to Moscow to take charge.

Vaughan was in the Frontline office in Buckingham Palace Road when he read of the death on the Reuters agency wire that Monday morning. He phoned Peter immediately. They had a muscular conversation, mostly involved with practical comments about the funeral and the family. Vaughan could tell that Peter was very upset indeed. He had been as close to Rory as to anyone in the world. But he would never admit it and never shed a tear. Vaughan knew that although Peter was devastated, it was important to leave him with his dignity intact. It was a short conversation, built out of formal English phrases which would have been recognisable at the time of the empire.

Vaughan spent the evening alone, getting a little drunk, knowing the inevitable blame that people would attach to Rory – how few people shared his own views on risk. He remembered a conversation that they had once had walking home from a good dinner. *'You're going to kill yourself one day, Rory. You are not being careful enough.' And he chuckled, and I accepted that. Rory took the level of risk that I admired because it was so productive. It was completely valid that he should if he was prepared to. He wanted to do it. Why is that hard to understand? He was an example of what we had aspired to do, but that did not mean that we did it in the same way. There was an element of risk worthy of its own right with Rory. How much better we are that he lived. How lucky the world has been that he was there to do his stuff.*

Peter came into the office a few days later. The two surviving Frontline founders had another unsentimental chat: 'Bloody good man, Rory... couldn't have done it without him... tremendous contribution.'

Rory was buried in the family vault in Ireland. A fortnight before he died he had phoned his mother to say that he was thinking of becoming a Catholic, as she had been in her youth, although by now she had moved to a very traditional high-Anglican stance. Before the full Anglican funeral Russian Orthodox priests carried out their own rituals in the basement chapel in the family home, where he was laid out.

Among the mourners at his memorial service in Moscow was one of the Soviet soldiers whom he had helped to free from a prison of war camp in Afghanistan. The man had come all the way from Ukraine to remember Rory. Three months later, on a remote hilltop site in the Panjshir valley in Afghanistan, Commander Massud presided over a memorial service attended by mujaheddin who had travelled with Rory. No man can be honoured more.

XIV

A TOWN CALLED TERRIBLE

War is not a profession for Bin Laden and his people. It's a mission. Its roots lie in the faith they acquired in the closed-minded Koranic schools, and above all in their deep feelings of defeat and impotence, in the humiliation of a civilisation, Islam.

Tiziano Terzani, *Letters against the War* (2002)

Grozny, Chechnya, 1994–5

How hard are the lessons of history? Only a few years after being humiliated in Afghanistan Russia embarked on another all-out assault of a Muslim state. Again the invasion came at Christmas, in an effort to quieten the inevitable international protests, and again, as in Afghanistan twenty-five years before, Peter Jouvenal was there to report it. The difference was that this time, when Russia invaded Chechnya, he did not come in an overland bus on a one-way ticket as he had in Afghanistan, but had the resources of an agency behind him. In Chechnya Frontline deployed as never before, with more cameramen where it mattered, in the capital Grozny, than any international broadcaster.

This was where President Yeltsin tried to draw a line to prevent the further disintegration of the old Soviet Union. An independence

movement had been simmering for some years, but while other states had been allowed to secede, Chechnya was to face special treatment. The early months of that war were the most intense conflict that any journalists who went there had faced.

Yeltsin's miscalculation in Chechnya, allowing a radical Islamic independence movement to fester and then strengthening it with his ill-considered military assault, was another appalling lack of foresight ahead of the events of 9/11. The toughest of the fighters who were trained in Osama bin Laden's camps in Afghanistan in the late 1990s were Chechens. But after invading Chechnya, and stirring up the monster that he did, President Yeltsin was rewarded with full membership for Russia in the rich countries' club, the G8 group, and tea at Buckingham Palace, while his forces destroyed Chechnya, killing tens of thousands of its citizens in months and leading Russian conscripts into a mincer, ground down by the most fearsome and motivated of opponents, as well as provoking a permanent terrorist threat in Moscow. The heavy weapons – tanks, rockets and artillery – that had been developed by the Soviet Union to confront NATO in Europe were unleashed on a part of the Russian federation itself. For the first time since the Second World War thousands of shells were fired into a city in a single day. The snipers of Sarajevo seemed almost gentlemanly by comparison.

Vaughan flew down via Moscow, trying to avoid drinking too much of that curious cheap champagne which Soviet chemical factories had designed for the proletariat. The *Times* reporter Anthony Loyd, another ex-soldier who had sought out life in the front line as a journalist and was a family friend, was with him. Vaughan had tried to recruit Loyd to Frontline when he had first thought of becoming a journalist, but he had started in newspapers and stayed with them. They separated on arrival, and Vaughan headed for Grozny with Peter Jouvenal and another Frontline

cameraman, Jeff Chagrin. Their journey into the war zone was arduous, involving walking through freezing rivers and dodging the Russian patrols who were now trying to encircle Grozny.

Grozny. The very name, meaning 'terrible', conjured up a kind of hell. The reality was to be worse than anything they could imagine. A large part of the city was literally levelled, stone by stone, over those weeks, and Vaughan and his colleagues needed all of their military skills to think tactically and stay ahead of the Russian artillery. Surviving, as always, would be a matter of luck. But journalists can make their own luck, and to reduce the risk they guessed which landmarks would be targeted – government buildings, road junctions and so on – and stayed away from them. It gave Vaughan and Peter no pleasure to see other journalists being shot up when they did not make the same judgements. To make himself less conspicuous in the snow, Vaughan put white masking tape onto his camera, bought a fluffy white Chechen hat and made a white coat out of bed sheets that he found in an apartment they had commandeered. There are conflicts where it is better to be visible and to mark yourself out as a journalist. This was not one of them. There were dangers everywhere. Hardly a window pane remained intact so that if you dived into the snow on the street to avoid shellfire, it was likely to be full of broken glass. As the Russians advanced into the city at a frightening rate Chechen guerrillas put booby traps into properties they expected the Russians to enter, which made running for cover an obstacle course. Covered in dust from the constant explosions, and with their ears ringing, the Frontline crews moved on, staying just ahead of the Russian infantry.

Rory's widow, Juliet, completed the team. Her job was to drive in every day in an armoured Land Rover, bringing food and fresh batteries, and taking out their pictures to the comparative safety of an impromptu media village that had grown up around an

international satellite feed point, where she tried to sell them. They had no guarantees: their income depended on shooting combat footage every day.

Despite the Chechens' courage and ability to inflict terrible casualties on the incoming Russians, the sheer scale of the assault faced by Grozny brought its own certain logic. The guerrilla leader, General Maskhadov, retreated to a cellar as the city was pulverised over his head. He was an exacting tactician, demanding the destruction of a tank for every rocket-propelled grenade he issued and sending out his men only when they were certain of engaging the incoming Russian patrols that had been spotted by observers. They were hard men and well led, able to retake towns at will and hold them, which few modern guerrillas would have been able to do, especially against such overwhelming odds. Maskhadov's defiant stand had wide popular support. As Vaughan put it, 'If you were a fighter, you didn't get a shag from the missus that night unless you killed a Russian.' The Chechens lived on the edge. Vaughan filmed a group smoking a joint. They were 'blowbacking', getting a better high by exhaling down a tube into another man's lungs; the tube they were using to blow the cannabis smoke down was a rifle barrel.

Outside Maskhadov's bunker the streets filled with the unburied dead, and the snow was often reddened with blood. They met Anthony Loyd there, and shared the aftermath of Russian shells tearing through a bread queue – one of the worst incidents they witnessed. There were many dead, and the injured had nowhere to go. They were Russians, people who had settled here when this was a part of the Soviet Union and had nowhere else to live. Yeltsin's indifference to their fate as his shells continued to destroy their city marks him as a true descendant of 'Ivan Grozny' – Ivan the Terrible himself. The invading Russians were not stopping to pick up casualties and these wounded Russian pensioners would

hardly have been welcomed in the limited first-aid posts set up by the Chechens.

The Frontline men, with Anthony Loyd and the other photographers they were living with, Stanley Greene and Heidi Bradner, arrived at the scene of the bread queue only minutes after Russian shells hit it. Some people were already dead. But it was the sight of the living that left them arguing late into the night about why they were there. A woman had piled up parts of a corpse which she had gathered together, and was pulling it through the snow on a simple wooden sledge. When the journalists arrived she picked up one of the limbs and shook it at them, adding to their horror. Apart from her screams there was not much noise, although they were all reminded of the constant peril as shells continued to whoosh in and explode in surrounding streets.

The worst casualty was an old man who had lost both his legs and was dying in front of them. All of the journalists had jobs to do – to compose pictures, record the sounds, gather images and accounts to tell the story. But they were all human beings too. And soon an argument developed about whether there was more they could do. As the shells continued to come in they were debating the ethics of war reporting. Brutally, but realistically, Vaughan knew that there was nothing that they could do to help.

'It's not safe to stay. Come on, we have to go. There is nothing we can do. Come on Ant. They need a hospital to save them and there isn't one for us to take them to.'

But Loyd had already started to apply bandages where he could. 'We can't leave them like this. They'll die.' Some of the others tried to help, although none had the right level of medical training or any equipment. Vaughan wanted to leave, and Stanley Greene agreed with him.

'Come on. They'll die anyway. We can't save a man with no legs. If we can't properly help, then we should keep our own minimal

medical supplies in case one of us gets hurt. The only thing that is going to help him is morphine and we don't have any. We shouldn't stay out in the open if we are not working.'

The extreme cold meant that those who were wounded were not losing too much blood because it flowed slowly, but they were clearly going to die if left where they were. As they ran back to their house through the fading light all of the journalists were affected by the experience, which made them question the whole nature of their role.

Back at the house Vaughan produced a bottle of whisky that he had been keeping for emergencies. This was an emergency. Loyd said, 'What are we doing? What the hell *are* we doing here? Who gives a fuck about this anyway? Where is Peter, by the way?'

Peter had been quiet throughout. As soon as they had got back he had put his camera down and returned to the scene, carrying some food to see if he could help.

Vaughan said, 'Didn't you see him go? He told me that he was going.'

And that inspired more soul-searching for people who wanted to do more, to listen to their consciences as human beings and to behave properly, while not losing sight of the story.

'What's the point of the fucking story anyway? If we can help to save a life, then the journalism goes out of the window.'

'Ant, there wasn't anything else you could do. There really wasn't. We'd all like to get the story done, in safety, and still help individuals. But it's not that neat.'

There was no right or wrong answer. That was the problem with the dilemma, although Anthony still believes that his instincts to do everything he could to help were right. The year before he had taken two wounded children to hospital under fire in Bihac in Bosnia, saving their lives. Here, even if they had followed their best motivation as people and done all that they could to save a

life, they could not have succeeded, but Loyd thought that they should at least have provided some comfort to the dying. He wrote about the incident in his book *My War Gone By, I Miss It So*:

> I felt I was a pornographer, a voyeur come to watch… We had done nothing. All we had done was to take our photographs and leave the only survivor to die. It was one of those situations that war sometimes throws into your life. Whatever you do, you come out of it feeling degraded.
>
> Next morning the bodies were still there. Stiff and cold in the stained snow.

At the end of the assignment Vaughan and Jeff Chagrin drove out in a local taxi with no windows or doors. A shell burst over the car as they were on a bridge crossing the river.

Swerving to take evasive action the driver plunged into a deep puddle, drenching Vaughan with freezing cold water. And he still had to walk many miles in the cold before he was safe. Juliet Peck had bad news on the sales front. One of the biggest broadcasters had ripped them off and others were employing local freelancers at a fraction of the cost that they were paying Frontline professionals, without considering whether these locals had the skills to film combat footage as safely as possible. The writing was on the wall; the market was closing down. That was the last time that Frontline went into the field in force on a speculative story, to try to sell the footage as a team. They would have to find other ways to make the money. And although they never abandoned Chechnya, it was hard to make any money on reports from there. Some Frontline members, like Roddy Scott, continued to make trips into the region, but no one cared about his pictures.

Colin Peck is eloquent on the change in the market, and how it has made things worse, not just for freelance cameramen, but also

for the darker places in the world. Chechnya is still an unhealed wound, still unresolved, but it is not on television.

> There is nothing worse than what is happening now in Chechnya. They are crying in silence and no one is hearing them. In earlier days there was a camera and a microphone to cry into, and even that is important. Where people are suffering, although TV news is not going to stop them suffering, at least someone is hearing them cry.

When the refugees were crying in Goma, Elizabeth Jones was there to hear them. She later became a distinguished documentary director, but back in 1994 she spent six months after the Rwandan massacres, selling through Frontline the sort of footage which the established broadcasters could not, or would not, commit to collecting for themselves – personal stories about real people caught up in the aftermath of slaughter.

Richard Parry also continued to pursue his long-term profile of Robert King, who had grown into his chosen lifestyle, taking pictures from tough places. In one scene King got his own back on Vaughan with a quiz about Chechen political and military characters, in revenge for the mockery he had received for his ignorance when he had first arrived in Sarajevo. King was far more street-wise living under constant bombardment than he had been in Sarajevo, but there was a darker side too. He was filmed grinning maniacally as he dropped a firecracker close to two old ladies in Grozny to frighten them. He moved to Russia and the film illuminates how his mind craved a brighter high from drink, drugs and sex after the violence and fear he had been exposed to.

The most touching scene, filmed many years later, is a meeting between King and his father, who had been absent for much of his childhood. The old man admits that his son may have been a

little lost, and needed firmer ground as a child. And twelve years after the Chechen war, King speaks frankly about the effect war reporting had on him: 'Early on in my career I felt like people should feel my pain because of what I had witnessed. Funnily enough, the older you get you realise that the pain was already there, and that's what attracted me to Sarajevo, that's what brought me to Chechnya. Wars didn't fuck me up, I was fucked up before I even went. And that's why I did so well at it.'

Kandahar, Afghanistan, April 1996

John Simpson continued to make annual trips into Afghanistan during those years, and he always went with Peter. They made an epic journey on horseback to the oldest lapis lazuli mine in the world, where Leonardo da Vinci had obtained the base for his blues. And Peter filmed John clambering up a mountain of raw opium, which they uncovered in a shed during a drugs raid. But their most significant report was from Kandahar, the southern Pashtun town, while the Taliban leader, Mullah Omar, was preparing to march on Kabul.

No western reporters ever interviewed Omar. He was a simply educated country cleric who was lucky with his friends, who happened to become significant commanders in the mujaheddin. The Taliban emerged from the concern among these Pashtun commanders during the civil wars of the early 1990s that Afghanistan would never be at peace. They had fought off the Russians, and saw their success squandered by in-fighting, banditry and corruption. Even after Mullah Omar's forces had taken most of the country, he never left the south, not even to see the capital Kabul. He was always more interested in the purity of the Islamic government that he proposed than the complexities of power. At the height of his religiously inspired movement to conquer the country, he declared himself Amir al-Mu'minin, the

leader of *all* Muslims, and literally wrapped himself in the cloak of
the Prophet Mohammed, Afghanistan's most sacred relic, which
is kept in a mosque in Kandahar and is brought out very rarely.
To film Mullah Omar at all was a feat. Peter's success was to film
him in the very moment when he wrapped himself in the cloak.

Peter never had any problem dealing with the Taliban, just as he
had dealt with the communists and the parties that had come in
between. He saw all these as transient loyalties for Afghans, and
negotiated almost as if it did not matter who they were supporting
this week. He took John to stay with friends in Taliban-controlled
Kandahar at a time when almost no other western journalists
could get there at all. That report from Kandahar includes some
iconic sequences: televisions hanging from lampposts, like an
exhibit for the Turner Prize; tumescent mounds of audio tape,
ripped out of cassettes at checkpoints; a public execution, which
the Taliban badly botched, making it an unnecessary torture.
Some of this they allowed Peter to film, since the Taliban had no
problem with the portrayal of inanimate objects. Other sequences
were shot surreptitiously, with a small camera hidden in the folds
of his clothes. But it was clear that when it came to the public
exposition of the Holy Cloak he would be surrounded by more
than the usual restrictions. He and John were not allowed out of
their vehicle, the usual 'flying coach', a small minibus with curtains
on the windows, which were firmly closed while they travelled
around Kandahar as if there were women on board. Today of all
days, they were not to be allowed to film anything, especially not
Mullah Omar, and more especially not the cloak.

Through a crack in the curtain, John Simpson saw a tiny figure
on a roof a long way away, well beyond normal camera range. He
thought that their attempt was pointless and was about to call it a
day. But he noticed Peter sitting quite still, with his camera across
his knees, occasionally glancing down at the viewfinder, which

was rotated upwards. They remained sitting there quietly for half an hour or so, and, with the camera lens extended to its full length Peter shot the whole thing. The pictures have a haunting quality on television. They are usually shown in slow motion, since Mullah Omar's appearances are fleeting as he shrouds himself in the cloak. Peter's military experience, being trained to shoot through car mirrors, small holes and so on, had paid off. And his calm temperament made the pictures rock steady.

Jalalabad, Afghanistan, March 1997

Even after the fall of Afghanistan to the Taliban in 1996 the wider Islamist agenda being pursued in the mountains in the east of the country by Osama bin Laden was still not on the world's radar screen. This was before 9/11, and before even the huge bombs that Osama's agents planted in East African embassies in 1998, his first wake-up call. Back then nobody seemed to care what he was doing, least of all the Americans who had had him on their payroll until only a few years previously, during the war against the Russians in Afghanistan. He put it about that he wanted to do some interviews. There were a couple of attempts by BBC correspondents to get interest from editors, but no one wanted to know. Robert Fisk had been to his cave a couple of times to write stories for the *Independent*, but other than the rather idealised images of Osama on horseback, or firing a Kalashnikov, which were sent out on tapes to encourage his followers, he had not appeared on television at all.

It was Peter Arnett, a New Zealander who then worked for CNN, who finally bagged *the* interview. Osama refused to meet any Americans, and a non-American crew was assembled. Peter Jouvenal was the cameraman. He is convinced that Osama only wanted to speak because in his arrogance he could not bear to be ignored.

The contact for the interview came through a Syrian writer who had been a friend of Osama's since the mujaheddin days and had written an influential book about the perfect Islamic state. Despite his idealism, he chose not to live in a Muslim country but rather in Acton in West London, where his children went to school. He joined the CNN crew for the flight to Pakistan, and after crossing the border, they stayed at the Spin Boldak hotel in Jalalabad in the East of Afghanistan. The manager there was the former barman at the Intercontinental Hotel in Kabul, and he would softly bemoan his fate and the fate of his country under the Taliban to any westerner who passed by. The day after they arrived Robert Fisk turned up on his way out. He had just done his second interview with Osama. The head of the al-Qaeda public-relations unit then came and checked out Peter's camera, concerned that it might be a bomb (which was ironic considering that Osama's supporters used just this method – a bomb in a camera – to kill Massud in 2001).

They decided that they would not trust Peter's camera and said that they would supply their own. Peter waited with the crew for about ten days. One day a Taliban ammunition dump nearby exploded, killing about fifty people, after it was hit with a rocket. Afghanistan was by no means at peace. Every now and then Arabs would come and ask questions until finally they were satisfied. The day came when their guard said, 'We are leaving tonight.'

They set out at dusk in a 'flying coach'. Along with Peter Jouvenal, and the reporter Peter Arnett, was a producer, Peter Bergen. They were all given absurd sunglasses with cardboard in place of the lenses, which were supposed to mask their vision. After being driven around Jalalabad for a while to disorientate them, they found themselves being taken rather obviously through a tunnel. The air pressure changed, and the light coming in around the sides of their sunglasses altered. Peter Jouvenal knew exactly where they were – on the road to Kabul.

As the asphalt road ran out they stopped and transferred to a Toyota pick-up, and headed off into the black mountains south of the Kabul road. Peter had been there often during the mujaheddin days.

Satisfied that by now the westerners would not know where they were, their Arab guides let them take off their cardboard sunglasses and told them that if they were found with tracking devices later, the consequences would be serious. They said that Terry Waite had a tracking device on him and that is why he was kidnapped in Beirut. Suddenly there was what looked like an ambush. About fifteen Arabs jumped up from behind rocks shouting hysterically to them to stop. Peter Jouvenal felt it was just a show to test their nerve. They were searched with some kind of device that he supposed was designed to find out if they were communicating any radio or satellite signals. Soon afterwards they arrived in a village, where a stable had been swept clean, and rugs placed over plastic sheeting on the floor. This is where the interview was to be. It was all very professional. Peter had asked for a generator to power his lights, which he wanted on a long cable so it would sit far enough away not to be heard. It was all there as he had requested. He set up his lights, and found his way around the camera they had provided. While he was setting up, the Arab press officer who had come to the hotel to check his camera tried to interfere, wanting the lights turned up very bright, which is the fashion in many Asian countries. Peter had been trying to dim them to give the interview some depth and character. But he lost the argument.

Osama bin Laden appeared among a group of people who all arrived at once in a convoy of four-wheel-drive vehicles. He and his translator were the only ones who would show their faces. Osama went round all of the CNN team, shaking hands in a traditional show of courtesy. Peter remembers the hand being

rather like a wet, cold fish, similar to the hand of Gulbuddin Hekmatyar, the rival Islamic hardliner in Afghanistan. He found it hard to believe that Osama was seen as a charismatic leader, but then he remembered that charisma can be very localised. Adolf Hitler was charismatic to the Germans, but not to anybody else in the world. Osama was certainly in control, choreographing the event in minute detail. Peter filmed him sitting down and getting up and had to erase that later as the image had not been agreed beforehand. So what was he like?

> He was rather like a bank manager. What I mean is that with bank managers you go and see them and you don't quite know if they are nice , or if they are after your money or will give you a loan or what. He was aloof, so there was no idea of what he was thinking. I don't think the general public can identify with him, because he has so little emotion. He is very controlled and arrogant. There is no humour.

It was impossible to tell how much English he knew. The translations were done by a man with a British public-school accent to questions that had all been vetted beforehand. The interview lasted about half an hour, with Osama outlining his world view in poetic and religious terms.

At the time the interview was a curio, a clever piece of foreign news, recognised as such by foreign-news junkies, but not a world-shaking event. The eyes of the world were not really on Osama bin Laden or on Afghanistan at the time. One of the foreign-news junkies who congratulated Peter when he got back was Eamonn Matthews, the producer he had worked with in Afghanistan in 1989. While they were chatting Eamonn happened to mention Kosovo. In his clipped and certain way, Peter revealed some

intelligence that seemed to speak volumes: 'I wouldn't worry about it. It's not serious. Nothing is going to happen, despite appearances. Vaughan has just got some pictures back from a demonstration, and when it started to rain they all went inside.'

Six months later Eamonn got another call from Peter. He said, 'Vaughan's just been to Kosovo. He says that things are getting serious. They're demonstrating in the rain.'

XV

DEMONSTRATING IN THE RAIN

Who speaks?
Who lies?
Who says Serbia is small?
It is not small.
It is not small.
It has been to war three times.

<div align="right">Serbian nationalist song (1920s)</div>

Pristina, Kosovo, March 1998

The pain did not feel like anything to worry about, just a little discomfort at his waist. It must have been a stone kicked up by one of the thirty rounds from an AK47 that had been fired directly at him as he ran along a low ditch, crouching to try to escape detection. Or perhaps it was a ricochet at worst, a spent bullet which had bounced up at him from somewhere.

It was the least of Vaughan's problems as he lay flat on the ground wondering how to get out alive. *Damn the farmer who had led them out this way!* When they had come in earlier

Vaughan had had some control over the operation, taking time to crawl unnoticed through the curious knee-high oak trees that carpeted the Kosovar hills. The farmer guiding them had pointed out the direction they needed to go, and then Vaughan had led them slowly, evading the cordon the Serbian police had put around the area. It was not a particularly efficient cordon, and the men who were spread out in the woods were very visible in their blue uniforms. But it was a cordon nonetheless, and its aim was to stop anyone interfering with whatever the Serbs were doing on the other side of the hills.

Vaughan knew where *he* would mount a cordon, if he had been the Serbian commanding officer, and he had outguessed the Serbs to make his way slowly towards the columns of smoke that rose beyond the hills. But once he had finished filming, the farmer had headed off on a different and more direct route out. He had gone too far before Vaughan could signal to him to stop without drawing attention to himself. There was nothing for it but to follow him. And now they had been seen and shot at. Next to him, lying on the ground, was Kenny Brown, a gentle, humane and very competent Glaswegian, who had recently joined Frontline. When they waved at their guide, he slowly crawled back to them, and they successfully retraced their steps to make it out safely, running fast across the only stretch of open ground.

It was not until they arrived back at their car, some five miles away, that Vaughan realised he had been shot. He took out his mobile phone to call his wife and discovered that it was just a pile of broken metal, with the remains of a bullet embedded in the battery. The shot, a .762 round from a modified sniper version of an AK47, had been slowed down by a wad of Deutschmarks – the money now had a hole neatly drilled through the middle. The phone and money had been wrapped up tightly in a green handkerchief in a bumbag strapped around Vaughan's waist. If

he had not been carrying it, the bullet would have gone straight into his side. He lifted up his shirt and realised that he had a large bruise on his stomach, but nothing worse.

At least the risk had been worth it. The pictures he had taken were the first significant shots fired in a new Balkan war. They showed systematic destruction as men threw bottles full of petrol into houses to set them alight: the first real evidence that the Serbs had begun a major campaign in Kosovo. There were to be three big landmarks in the ratchet towards NATO bombing over the next year; this was the first of them. During the long months of the war which lay ahead no other cameraman would get as close as Vaughan had to Serb armoured vehicles in the act of knocking down houses. When the Dutch army saw the film they recognised the armoured vehicles as those that had been taken from them by the Serbian butchers at Srebrenica, the worst massacre in the Bosnian war. This evidence was a direct forensic link between the two conflicts. Despite being shot getting the pictures Vaughan was not named in the BBC report that used them that night; he was just another freelance cameraman.

I arrived in Kosovo a day later. I had bumped into Vaughan here and there, but we had never worked together before. For the next five years I would not go to war without him. I had known about Frontline for a long time and had occasionally put a voice to their pictures. It had always been a pleasure: darker, richer meat than the bland offerings from most agencies. While Bosnia was in flames I had been living in Delhi as the BBC's correspondent in South Asia, where I had met Peter Jouvenal and Roberts Adams and some of the others during long trips in and out of Afghanistan. Peter had worked with me a few times. After the Chechen trip in 1995 he came directly to southern Pakistan for a film for Newsnight. He had just been in the toughest conflict for journalists in modern times, but he looked as fresh as a man

who had been on a health farm. And when we had finished our report, a particularly grisly and tense story about a massacre in a mosque in Karachi, he set off for his house in Kabul for a break, to sit in his garden and walk his dogs, at a time when the city was under constant rocket attacks from rival mujaheddin gangs – the only man in the world who goes to Kabul for R&R.

The first time I saw Vaughan in Kosovo was the evening after he had been shot. The wound must still have been painful but he did not show that he noticed. He was sitting in a dark corner of a shabby hotel room, smoking a cheap German cigarette. The window was open but he wore only a shirt, although it was below freezing outside. He did not move much, as he watched the flickering screen in the corner, where an Australian picture editor was cutting a piece for that night's news, laying down the shots one after another in a series of fluent hand motions, with the dexterity of the disc jockey he had once been. The white electric flare from the street lights coming through the curtainless window shone on to Vaughan's bald head, which was circled by the remnants of ash-blond hair closely cropped around the edge. He rested one arm on the dusty blue Portabrace cover protecting his camera. At the other end of the bed a woman I recognised as a radio producer was curled up asleep. It had been a hard two days.

Vaughan was planning to stay and never even took time off after being shot; as a freelancer he could not afford to. He had watched the big networks closely now for several years, and he knew that however good they were at reacting to events they were reactive by instinct, rarely positioning themselves ahead of time. Frontline were small, and thrived when they predicted things. He had made contact with the leadership of the nascent Kosovo Liberation Army in London some months previously and secured the right visas and permissions to travel, so that when the time came he would be ready. Now he was going to stay as long as there was work.

At the screen a correspondent sat next to the picture editor holding a lip mike, the kind of microphone which sports commentators use, one of those pieces of technology that looked as if it had been around since the beginning of the BBC – as indeed it has.

'What do you think, can we use this sequence?'

'Those agencies can get away with so much more blood for their other European clients. How do they do it? We have to show it as if war never hurt anyone,' the picture editor complained.

The screen showed a shed full of bodies. Lots of bodies. Men, women and children, shrouded under white sheets, lined up and numbered. The adults had labels round their ankles and the children had them around their arms. The Serb killers had done a thorough job before handing them back for burial. In the background of the soundtrack was the sound of crying, then the muffled tones of people naming the dead. Through it all broke the impatient irascible tone of a cameraman, not Vaughan, asking people to lift up the shrouds so he could shoot what lay beneath. Twenty people had died a few days before as the Serbs began the final act in the destruction of Yugoslavia. The previous day more than forty had died in the village of Prekaz, mostly from the Jeshari clan, as Adam Jeshari, one of the first leaders of the Kosovo Liberation Army, tried to defend his family compound against assault by mortar fire and militia backed by armoured vehicles. It was while filming that assault that Vaughan had been shot.

'There's a wide. If I start with that, and then use the pan along the feet we should get away with it. I mean it was a massacre. We must be able to show something.'

The picture editor and correspondent engaged in a familiar ritual as they sifted through the tapes provided by different agencies. How much of what reporters see should they show on television? What right do they have to intrude into people's living rooms

with the horror they know to be out there? On the other hand, what responsibility do they owe to the dead? What right do they have *not* to show the horror if it is there – what *duty* do they owe to the dead to bear witness to their deaths so that they have not died in vain? There was the sound of more weeping, of hopeless, impotent grief. Some of the labels had names written on them. But they were sometimes wrong, adding unnecessary indignity as relatives and neighbours sought confirmation of their loss.

Vaughan did not join the discussion, but sat smoking impassively as the pictures built up. Despite the deadline, which crept remorselessly nearer, there was no panic, and all around was the usual noisy coming and going of edit suites: young local translators with their boyfriends and girlfriends, smoking furiously, producers from radio and from *Newsnight* looking for the latest pictures, or gossip, or cold beer, or just someone to talk to in a horrible hotel in a hostile town.

I found a room and put my things in it. There were no curtains, phone, TV, or hot water. Cold water came only intermittently. The single bed was small, but still they had not found a sheet to fit it. And there was only the one sheet and a thin scratchy blanket. There was snow on the ground outside, and the window did not shut. The radiator was cold. Welcome to Pristina.

The ludicrously named Grand Hotel had five meaningless stars. One of the most sadistic of the Serbian paramilitary leaders, Arkan, used to bring his victims to the basement here to be tortured. The staff worked with a studied malice against the injustices of the world. Serbs were now a tiny minority of the population of Kosovo, perhaps about 10 per cent, although no one really knew how many there were after all the chaos of recent years. The Grand was a Serb island in an Albanian sea and they never let us forget it. The food had a universal grey pallor, day and night; the bar was an uninviting dungeon; the lounge was always

full of too-fit men in tracksuits, watching people who came in and out, registering those we met.

Different nations draw on their own past to paint national myths: the French are serious about the possibilities of revolutionary change; the Americans want endless expansion, after the example of pioneers who tamed the wild west; for the British, stoicism in the face of adversity has become a defining national characteristic, turning the retreat at Dunkirk into a victory. The Serbs look back to defeat as well, but they draw a different lesson from it: not consolation but a burning sense of grievance. And the defeat that defines Serbia more than any other came at the hands of a *Muslim* army on the 'field of blackbirds' in Kosovo in 1389. Slobodan Milosevic used the 600th anniversary of the battle in 1989 to launch a new Serbian crusade, bringing down the whole house of cards that was Yugoslavia and sparking off the wars in Croatia and Bosnia. Kosovo was then singled out for special treatment. Its autonomy was revoked, and an attempt was made to absorb it fully into Serbia. The rights of the Albanian-speaking majority were drastically curtailed; they were thrown out of government jobs and refused access to schools and hospitals. A whole generation grew up in a parallel world, deprived of the normal apparatus of the state. Some of the best leaders of Albanian resistance spent most of the 1990s in jail, leaving a rather ineffectual poet, Ibrahim Rugova, free to be the public face of the Kosovar independence movement.

The first sign of armed resistance did not come until late in 1997, when uniformed men appeared with guns at the funeral of a popular teacher who had been shot out of hand by Serbian police. Vaughan made an early and correct assessment that this would be a quite different campaign from the war in Bosnia. Rugova's peaceful resistance movement had not delivered. The apartheid reality of Kosovo, which left the Albanian majority subjugated

to the Serbs, had not been dealt with in the grand peace deal at Dayton which ended the Bosnian wars at the end of 1995. The lesson for the Albanian nationalists who formed the Kosovo Liberation Army, the KLA, was that violence worked. Many of the leaders of the new army had served time on the Croat side in Bosnia, the most disciplined and ruthless force in that war.

But at the start they had no strategy for dealing with the press. Some of the KLA's leaders, particularly those in the hills, saw the future from a perspective of doomed martyrdom. They did not mind dying or piling up their own dead, thinking that it could take thirty years to shift the Serbs. They had not anticipated the appetite of the European powers, and particularly Tony Blair in Britain, to stop the violence. Vaughan believes that the Albanian fighters in the KLA were *forced* into engaging with journalists, at least with journalists that they trusted, and that that engagement shortened the war by several years. Once their war appeared on television, and particularly when his pictures exposed the Serbian treatment of Kosovar civilians, things moved quickly.

Filming it proved to be very difficult though. Adam Jeshari, whose body was laid out in that shed beside all those of his family, with numbers around their ankles, had done a British television interview only a couple of weeks before he died, and a powerful myth grew up in the KLA that if you appeared on TV, then you got killed.

We did succeed in doing one interview with a commander who we met by chance early on and, although we did not show his face but only the detail of his uniform, he got into trouble for it. Some camera crews were shot at by the KLA, others had their equipment taken. Vaughan and I met men we thought were key KLA leaders in Tirana, the capital of neighbouring Albania, but they turned out to be only logistical staff – and could not help us to secure the access we needed to film behind KLA lines. So Vaughan went back

to a contact he had first made by chance coming back in a taxi from Heathrow some months before. He had just returned from Cuba at the time, and was speaking to his wife in the language that used to be called Serbo-Croat before a civil war tore more than a hyphen out of the language. The taxi driver was immediately suspicious, thinking that Vaughan was a Serb, before he explained that his wife was a Bosnian Muslim. The taxi driver turned out to be a Kosovar Albanian, and therefore hostile to Serbs. They started to chat, and through this chance meeting Vaughan came to meet the London leader of the Kosovars, Pleurat Sejdiu, who also worked as a taxi driver (and later became a government minister in Kosovo).

It emerged that the main leaders, and bankers, of the movement were based in Switzerland. After some negotiation through Sejdiu, and two trips to meet them, Vaughan secured an agreement for us to do an interview in the field in Kosovo. He was given a password, *musteqja*, which means moustache, but there were no guarantees that it would work. It was already obvious that there were various levels of KLA leadership and that, despite the careful military strategy, many on the ground owed allegiance to local brigands, or to an increasingly assertive command structure of young officers. They really ran the war, not the men in Switzerland. Some people in KLA uniform were little more than local village militias, not part of any formal command structure at all, and once the fighting broke out they were not under the same military discipline as the main KLA. Being in charge of this organisation must have been rather like riding a tiger, unpredictable and uncontrollable as the whole countryside rose up. One of our fixers, Jeta Xharra, made her own inquiries and put the final pieces of the jigsaw into place for the interview to happen.

On the day of the interview, we got up at around 4 o'clock, much earlier than we needed to, giving ourselves time to negotiate our

way across the front lines. That early start saved the story. During the night someone had cut the tyres of every one of the armoured vehicles lined up on the pavement outside the hotel. We borrowed a car to go and buy the only Land Rover tyres available in Pristina to replace them. The delay cost us a couple of hours, and the KLA were angry when we arrived late at the agreed meeting place. Whoever had cut the tyres, presumably a Serb since Albanians could not operate freely in the capital, had unwittingly almost lost us one of the best stories we had done so far. Feeling rather ridiculous we gave them our password, *musteqja*, and the makeshift barrier of branches across a quiet country road was taken down. They revealed that they had turned back one of the biggest correspondents at CNN the day before at the same checkpoint – music to our ears.

Shooting good television sequences that can be edited into something watchable requires much more time and access than people who have not seen it done think. But even with our magic password, we were very circumscribed as to what we could film, and the KLA viewed every frame before we were allowed to leave. Initially they would let us shoot only the interview, as Vaughan had agreed in Zurich. We negotiated image by image. There was a group of armed men, with the distinctive black and red double-eagle symbol which had been adopted by the KLA on their camouflage uniforms. Perhaps we could film them walking from behind. There was an argument about that, because the KLA did not want the location of the interview to be identifiable from the pictures. Vaughan persevered, and ended up with some usable shots of feet going through the low scrubby beech bushes which covered the hillside. They had chosen a good location for the interview itself – a hollow, perhaps an old quarry, set high up on the mountain, so we could not be overlooked.

When the interviewee appeared we saw why the password had been chosen. He was a striking-looking man in his late

forties, and he sported a huge, unkempt, greying moustache, like an Albanian warrior from a picture book. He knew that his decision to appear in front of the camera meant that he would never be able to appear in public again, unless his side won the war. He said that this was a cause that he was willing to die for, and he got his wish later in the year when he and his wife were both killed as the Serbs launched a major offensive against the KLA. In the months that followed the interview Vaughan came to know him well. He was Femi Ladrovsci, who had been a university lecturer until he was arrested by the Serbs, and who joined up to fight for the Kosovar nationalist cause when he was released from prison.

We still did not have enough pictures to make a report so that afternoon we drove out of town again, meeting a mad and drunken Serbian police patrol by chance on the road. Like the vandalised tyres in the morning, it was the kind of chance coincidence that could lose us the story. One of them had lost his brother in a KLA attack that morning. He blamed the world, us, anything for his loss, putting a hand grenade down inside my shirt for the hell of it. I was not sure of the best course of action. The pin was still in, but clearly it was not sensible to drive away with it. After a minute or so he took it out himself, holding his face an inch or two away from my face and shouting insults with beer-soaked breath.

We always took out different interpreters for different stories – in the morning we had taken the Albanian Jeta with us but that afternoon we had brought along the miraculous Serbian fixer Vladimir Marjanovic, whose mannered, aristocratic air always seemed too refined for the business he had to deal with. He is easily the best interpreter I have ever worked with, speaking a number of European languages with the elegance of a poet. He had been with Martin Bell throughout the wars in Croatia and Bosnia. He

gently prised the Serbian policeman off me, whispering platitudes and making sure that the grenade was in the right hands before getting us safely into the vehicles and away.

The two worlds lived side by side in Kosovo, as if in hermetically sealed boxes, seeing the world in a completely different way. Occasionally we would go and eat in a big wooden lodge on the hill, with a blazing fire, where they served large portions of fatty veal. Here the Serbs would come and dance and drink and generally mourn the nature of being a Serb. The building was destroyed in a firestorm by the RAF a year later.

But most of the time we ate in Albanian-owned caverns in town. Once again, as so often before in the Balkans, the Kosovo story was run by very young people. None of our local fixers was much more than twenty years old. It was a miracle that they had any education at all. Excluded by Milosevic from the state system, they had been to informal schools in the back rooms of houses and then foreign-backed summer schools, meeting up with people from outside their own communities. Those schemes saved the Balkans, as did the money from people like the billionaire George Soros, which paid for computers and newspapers which otherwise would not have existed. In Pristina a stable of the brightest youngest people was put together by the journalist Veton Surroi, whose newspaper *Koha Ditore* was the most influential force in the country.

Our fixers had nationalist ideals, seeing their work with the BBC as an alternative to joining the KLA. Jeta Xharra, who would read Dickens during long journeys into the hills, had a long pedigree in the Albanian nationalist movement. Her grandfather had literally founded Albanian education in Kosovo after the Second World War, leading a group of teachers across the mountain range separating Kosovo from Albania, carrying their own textbooks. I spent an afternoon with him once, a dignified and fiercely proud

man with translucent laughing eyes, perplexed by the troubles his country was suffering. Alongside Jeta we hired Fisnik Abrashi, whose drawn, alabaster skin made his head look like a skull. He was always dressed in black and smoked as if his life depended on it. He knew everybody in town, and at the end of one trip said that he had a special treat for dinner for us on the last night. He turned up with Miss Kosovo herself, a gleaming and gorgeous model, proof that he could fix anything. We shared a large, rather bony fish in one of the basement restaurants before she drove us back to the Grand in her Mini.

Kosovo, July 1998

While I was in London for a break in July my colleague Ben Brown came out to Kosovo to work with Vaughan, and of course he needed to do his own interview with a KLA leader. By this time the KLA had taken a large part of central Kosovo, proclaiming the town of Malisevo as the capital of 'Free Kosova', changing the road signs and issuing their own car number plates. They drove around for a while, with Vaughan exploiting his considerable fame among local people who had heard the story of the cameraman who had survived being shot by the Serbs. He always carried pictures of the damaged mobile phone, and pictures too of his Muslim wife from Sarajevo, milking every opportunity to win confidence.

Vaughan came to know enough of the KLA commanders by name that he could travel almost anywhere. They adopted tough-sounding *noms de guerre*, Snake, Lion, and Tiger. Persistence paid off and Brown had his interview with Shaban Shalia, who had a remarkable resemblance to the Second World War general Montgomery, and was immediately called 'the Montgomery of the Balkans' in the TV report. An ex-political prisoner in Pristina became the 'Nelson Mandela of the Balkans' in another report, in an effort to get people to understand another foreign war.

Although Shaban Shalia was not the top commander it was a useful interview. Vaughan was making access look easy, since at the time the KLA were talking to hardly anyone else. Only the APTN cameraman Miguel Gil Moreno, who was later killed in Sierra Leone, had anything like the same access, working closely with his local girlfriend, Elida Ramadani, who had the misfortune to have two partners killed violently (one was Miguel; later her husband was blown up by a mortar shell in Macedonia).

The extent of KLA control was beginning to unnerve the Serbian leadership in Kosovo and, more importantly, President Milosevic in Belgrade, who reinforced the Yugoslav army presence. The architect of the Dayton accord, the American envoy Richard Holbrooke, flew in and held a meeting with two KLA men in an isolated farm. At the time a Serbian town called Kijevo on the main road from Pristina was cut off and surrounded by the KLA. The KLA forces in their turn were surrounded by other Serb forces. This unstable sandwich was called 'the most dangerous place in Europe' by Richard Holbrooke, and we thought we had better take a look. Working with Vaughan always made these kinds of trips more possible. The main area we travelled in, the central Drenica region, was quite small, and he was now getting to know it well. If we were turned back at one Serb checkpoint then he would usually find another way.

I have to confess that I was sometimes secretly relieved if we were turned back, thinking that we had at least tried, nobody could do more, we would live for another day. Crossing these front lines and moving around in the ulu always had an element of risk for us. The Serbs would shoot at us a lot, and the Albanians would too, if we came on them unexpectedly, because Serbian Special Forces drove around in white Land Rovers, just like ours, that they had taken off aid workers and journalists in Bosnia. But, quelling my natural cowardice, I would applaud as Vaughan

crashed through the trees, onto unmarked tracks through the woods, shouting, 'There must be a way here somewhere', and there usually was. During all the months I travelled with him, there were only two occasions when we had to be towed out by a local farmer and his tractor after being stuck in the mud.

While probing the defences of 'the most dangerous place in Europe' we came upon a KLA patrol, who showed the hostility to TV cameras which we had come to expect, but then two Yugoslav helicopters appeared, firing rockets into KLA positions not far away. Vaughan's pictures of them were the only evidence of attacks from the air during the war, and in the panic he was able to film the KLA patrol running into a trench for protection. While running for their lives they did not have time to worry about whether he was filming or not.

The next day I drove down an empty road for about half a mile from the KLA front line towards the Serb positions in Kijevo. I was frightened. We knew that our armoured Land Rover would protect us from bullets; it had already been hit several times. But it would be vulnerable to attack by rocket-propelled grenades, which were used by both sides. Nobody fired at us as we crossed the line, but the Serbian police at the outskirts of town were pretty hostile when we arrived. They felt abandoned by their government, which had not yet intervened to break the siege, although the KLA had cut off the main east–west road: Kosovo's artery, and the supply route for major Serb forces in the west. We chatted them up and shared cigarettes, trying to win their confidence. We did not have any translators with us since we were crossing too many hostile and edgy front lines, which would have exposed them to unnecessary danger. It was a sunny afternoon and we found it a rather tranquil place. Many of its citizens had fled before the fighting, and there was no movement on the roads for fear of attracting fire from the KLA side. It was the only time

in my life that I have actually put on a flak jacket just to be filmed; it would hardly look like 'the most dangerous place in Europe' if I was not wearing one.

Vaughan has always had a complex relationship with flak jackets, hardly ever wearing one. They reduce mobility and make camera work difficult, and he believes that most cameramen who wear them have no knowledge of ballistics. During all the years that we have worked together I only once *insisted* that he wore one. Our vehicle had been hit by several well-aimed rounds from a Serbian heavy machine-gun in an isolated valley one day in Kosovo. I was driving, and after executing possibly the most inelegant three-point turn in history in the narrow confines of a farm lane with the shots still hitting the armoured vehicle, we headed back up the hill and out of harm's way.

When we got back to the top, we spotted all the tell-tale signs that showed that we should not have gone down there: there were no people on that side of the hill and all of the exposed houses on the top were badly marked with bullet holes on that side. We were naturally curious to see what was down there, and local Albanians said that there was one window in an abandoned house that we could use to have a look. I reasoned that that might be exactly what the Serb gunman was expecting us to do, and would be watching that very window. Grumbling all the way, Vaughan took out his dusty flak jacket from its case and put it on – it had obviously hardly been used since he bought it for the siege of Sarajevo. He took some pictures of the man who had fired at us on the other side of the valley, sitting at his gun with a beer at his side, content in the Kosovo sunshine. On our way back to Pristina, crossing the Serbian front lines that afternoon, the guards had obviously heard what had happened to us on their two-way radios. They made a thorough inspection of where the bullets had hit, complimenting us on the armour of the vehicle. It was an insane war.

During the war in Macedonia later the following year the *Newsnight* correspondent Mark Urban was driving with Vaughan up an exposed mountain road to meet a leader of the Albanian rebels there. The road reminded Urban of the infamous Igman road, the narrow, treacherous mountain track where many died on the way into Sarajevo in 1993. He reached over and put on his flak jacket. He told me that Vaughan waited for a minute and then said conversationally, in a cool way, 'Just out of interest, Mark. Why are you putting your flak jacket on?'

He said 'I had a drink with a contact who was a senior adviser to the Macedonian army, you remember the one? I introduced you to him last week.'

And Vaughan nodded as he drove.

'He told me that these guys, his guys, are squeezing off tank and AA rounds at more or less everything they fancy. There's supposed to be a ceasefire, but we shouldn't put any faith in it.'

And Vaughan said, 'That's interesting.'

The producer, who was sitting in the back, followed Urban's lead. They were in an armoured vehicle, but they knew that it would probably not protect them from a round from an anti-aircraft gun, a favourite weapon in the Balkans against vehicles on the ground, and would certainly not stop a tank shell. If they were wearing flak jackets, they might get some protection from all of the rubbish that would fly around inside the cab if it were penetrated.

As soon as they were out of the arc of fire Urban took off the flak jacket. But he did not regret putting it on. When they stopped to film from a vantage point on the way up, he noticed that the trees on the far side of the road had been shot up and lost their tops, and that the ground in front of them was ploughed with deep furrows from heavy calibre rounds, which had been fired up the hill from Macedonian positions. He thought that he had made the right decision, but Vaughan's decision was based on a

careful assessment. Perhaps, if the armoured vehicle had been a metal one, rather than the newer glass-composite material, then he would have put on a jacket, since if a bullet penetrated a metal vehicle it might carry shards of metal with it.

Vaughan's calculation is that bullets are small; it is quite hard to hit someone with one, and anyway a number of people have been shot dead while wearing flak jackets. Not wearing one makes a cameraman carrying kit much more mobile. The jackets are certainly cumbersome, heavy and hot, although they are also some comfort, at least to those of us who do not make the military calculations that Vaughan does. The jackets are made of a thick lining which will protect the body from shrapnel and stabbing, with pockets for armoured ceramic plates that should stop bullets. During the war in Iraq in 2003 Vaughan carried just the armoured plates, not the whole protected jacket. He would hang them round his neck, suspended in what he assured me was called a 'brassiere'.

Kosovo, August 1998

The expected all-out Serb offensive in Kosovo came in August. They quickly retook the central region, pushing the KLA back. The next time we saw the pretty market town of Malisevo, the 'capital of Free Kosova', it was in ruins. Crude Serbian graffiti daubed the walls; hardly a building was unscathed. The liberation struggle was costing the Albanian people dear. We had come to negotiate another interview. The man who emerged like a shadow from a back room, amid the broken glass of the café, pretended to be just a messenger. But he seemed to be much more. Vaughan had bumped into him before and negotiated forcefully with him, calculating that he was important. He turned out to be Hashim Thaci, the leader of the KLA (and later leader of the country). The owner of the café brought some beer up from a secret hiding place in a well, where it had been keeping cool in the absence of electricity; he clearly

knew who the guest was. He pulled the crate up on a rope and as the light fell we shared the beer the Serbs had not found. After negotiating the terms of the interview by torchlight, we were taken in KLA vehicles from one house to another in the hills, to make sure we were not being followed. The standards of the soldiers we encountered noticeably improved as the night went on, until we were eventually taken through pitch darkness into a long hut for the interview itself. It must have been their main staff headquarters. Once they had sealed off the door to prevent the light leaking out. Vaughan set up the camera and lights in the corner. The barracks room did not look like a fun place to be. There was some reading matter lying around, and Fisnik confirmed that it was bloodthirsty poetry and songs of liberation.

Again we were very limited as to what we could shoot. The man we were to interview was not a soldier, although he was in uniform. He was a university professor, who had been briefed by Thaci to answer the questions we had agreed, and only those, sitting at a table decked with the red double eagle, flanked by two other soldiers. It was hardly penetrating journalism, but it was what was available and Vaughan secured what access there was.

By the end of August the Serbs had overrun the whole of the central region and retaken the major roads, and they began their assault on Drenica itself, the remote hills that were the KLA's main stronghold.

The raw visceral images Vaughan took then were powerful because they were so unusual. So often television news runs along behind events. But this was as fresh as it got. The KLA were not worried about being filmed now, they were running for their lives, escorting lines of people out onto trails through the woods. We walked to a rocky outcrop, a clearing in the woods from which we could see down into the valley. The name of the lookout point turned out to be Blood Rock.

To the west everything had been set on fire, after an artillery assault, while in front of us, coming from the east, the whole Serbian military apparatus was on the move. There were blue armoured cars driving forwards, with lines of police armed with AK47s moving along behind them for protection. And behind them were the tanks and artillery of the Yugoslav army itself. We interviewed men weeping at what they saw – there were a lot of men crying in reports we did at that time. Every minute, with a deadening certainty, tank shells were falling into the woods below us. CRASH! Looking with binoculars I found the tank, about a kilometre away, that was firing in our direction – an orange flash from its muzzle and then the crash and shaking of trees in the woods: CRASH! If I could see the tank, it could see us, and this rocky outcrop was the only target. We had to leave before it found its range. CRASH!

I told Vaughan what I could see and he shared my judgement. We made our way back to the relative safety of the lee side of the hill, where we had left the armoured vehicle. Then he went off into the woods on his own, finding the women from one family shaking and weeping in confusion and fear as the shells crashed down in the woods around them. They were clean and well dressed, refugees only for an hour so far. Bizarrely they had brought their stove from the house, along with other possessions, and sat, quivering and alone, as the roar and explosion of shells rained around them. CRASH!

My report on that night's *Ten o'Clock News* was just 167 words long. The pictures told the story:

> Pausing briefly at an outcrop they call Blood Rock, Nasmi Myloku weeps for his parents, who said they were too old to move when the village was shelled at dawn.
>
> He doesn't know what has happened to them.

Man speaks, sobbing, in Albanian

He says the world does not care, nobody cares. After tanks and heavy machine guns pounded away all day troops moved in like ants across the landscape, some columns marching for protection behind armoured vehicles.

The Kosovo Liberation Army, mostly lightly armed farmers, could do little against this onslaught but help the refugees. More than a quarter of a million people of Albanian origin have lost their homes across Kosovo since the Serb offensive began in the summer. But this is the first sustained assault into the wooded hillsides of Drenica, the region where the KLA began.

Man points, words in Albanian

He says Drenica is burning on all sides.

Savagely, systematically, but almost casually, the Serbs have entered the last stronghold of their opponents, the KLA, destroying every village and hamlet along the way.
(BBC News, 29 September 1998)

Within days pitiful refugee camps emerged, in some squalor, as it began to rain and people began to die. We found twins, just hours old, born in a shed on the run. Their mother gave them Albanian names meaning 'born strong' and 'born brave'. They would need to be. As the mayhem went on Paddy Ashdown appeared on the scene. The then-Liberal Democrat leader had kept a close watch on the region since the beginning of the conflict, and later had his ambitions fulfilled with the title of 'High Representative', the viceroy of Bosnia. We went on a tour of Drenica with him, surrounded by burning villages, and he said on camera that what we were witnessing was a war crime. Villagers were told by the Serbs that if they did not hand in their weapons their villages would be bulldozed down. It was a cruel excuse to burn the whole landscape.

People did not have any weapons to hand over. Rusty, forgotten guns were dug up from the ground and sold for huge prices just to stave off the Serbian aggression. Paddy Ashdown, who had served in the Special Boat Service himself, cast a professional eye over a cache of old guns we found in a schoolroom, confirming that none would be much good in a battle.

In the middle of the day we came upon a calf stranded in a deep, concrete irrigation channel. Clearly it would die trying to get out if it was left there. Ashdown took off his boots and jumped down, caught the calf and tied a rope around it. The British military attaché from Belgrade, who had also once been in the Special Forces, but was perhaps not now as fit as the Liberal Democrat leader, felt he had to jump down as well. And Vaughan joined in, which left only me and a couple of newspaper journalists to heave on the rope when it came to pulling out the calf. The Kosovars thought we were all mad, especially when we let the calf go rather than turning it into veal there and then.

Driving back into Pristina that night Vaughan and I were a little behind the rest of the convoy and came upon houses being burnt by Serbian irregulars on the main road, within sight of the capital itself. It was feeling more and more like Bosnia every day. But still no one really knew what the Serbs were doing in the hills. Apart from that trip with Paddy Ashdown under diplomatic protection, it became very hard to go out into Drenica. There were soldiers within sight of each other guarding the perimeter of the area. Even Vaughan's skills at getting off the beaten track were not going to help.

We needed to find out what was happening now more than ever. Vaughan remembered that in Bosnia at 3 o'clock in the morning soldiers were either drunk or asleep, so that had always been a good time to surprise people. Overnight we set out onto roads to the north where Vaughan had never been before and, looping

back, found a track by chance which was not guarded at that time. At first light we came to our first village. It was like a vision from hell, a model that was to be repeated across the region as we travelled inside the Serb cordon all day. The only sign of life was a buffalo, just alive although it had been shot. All of the other farm animals were dead, and the grain store was burning through, slowly and deliberately, with an intense heat.

The women and children had gone, and there were a few bodies, mainly of old people who had been left behind. And then men began to emerge from hiding. They had run away when they heard our vehicle, thinking that the Serb killers were returning. They were hungry and thirsty and distraught but grinning maniacally at being alive at all. Their light, brittle, fractured good humour was the mood of people who had escaped death by running away but knew in their hearts that their friends and relatives had not been so lucky. They clung desperately to life.

Behind the thin exteriors all these men had the eyes of the dead as the leaden reality of what had happened sunk in. We came across one man with his body crouched close to the earth, as if in the attitude of Muslim prayer. But he was not praying. As he got up, I realised that he had in fact been drinking from a ruptured water pipe trickling its contents into the mud. He had literally been sucking life out of the ground. And then as the men gathered together, finding the bodies, and mechanically organising parties to bury the dead, they came back from the strange light mood they had been in the moment of surprise for their own survival, and took on the full realisation of the deadened, crushed reality of what had happened to their lives – transformed in a single night.

Vaughan filmed all of this with a sensitivity and compassion which brought us the Foreign News Award at the Royal Television Society; for all that it mattered that morning. We were taken up a slope and shown the detritus of refugees scattered along the

path – best dresses packed into a briefcase in haste, a doll, family photographs, children's schoolbooks. They had fallen from a cart, which was lying on its side with the dead horse which had been pulling it suspended by its traces in a ravine. There were bodies of people lying in the undergrowth, and a uniformed KLA soldier told us that the Serbs had taken other bodies away, zipped up into bodybags which they brought with them.

Paddy Ashdown then went up to Belgrade, hoping to confront President Milosevic with his personal experiences of the killing, the burning villages and the appalling conditions of refugees. I went up with him, leaving Vaughan behind in Kosovo, hiring him for the BBC for one more day, 'just to see what he could get'. What he got was the massacre at Obrije, the next turning point, pictures that were historically even more significant than the destruction of houses he was filming when he was shot at the beginning of the conflict. And at the end as at the beginning of the Kosovo conflict, he went out and got his best material on his own without a correspondent.

He heard rumours in town that something was happening, and then had a phone call from Pleurat Sejdiu, the Albanian taxi driver in London. It emerged that the day before six Serbs had been killed by a mine laid on a road. Serbian forces then went into the nearby village of Obrije and found people from two extended families hiding in the woods. They killed them all, men, women and children. When Vaughan arrived he found people in great distress, just beginning to pull out the bodies and bury the dead. They put shoes above the graves to identify them. One baby survived under the body of her dead mother, but died soon afterwards; there were to be no good news stories coming out of Obrije that day, no miraculous stories of survival to lessen the loss of the dead.

In Belgrade I was editing our other massacre pictures, along with pictures of Paddy Ashdown. It was powerful enough piece

on its own without Vaughan's 'new' massacre. He phoned up and then assembled a few of the best pictures from Obrije – he had no time to do more – and fed them from the Serbian TV station in Pristina up the line to Belgrade. By now, we had less than an hour before the news was on. I was working with Peter Gigliotti, 'Gig', an easy and likeable Australian and, most importantly, a really quick picture editor. Gig finished the piece with seconds to spare.

I learnt later that the sound of wailing men, glad to be alive and mourning the dead, was too much, too graphic, too intrusive to the psyche; studio directors had to turn the sound down. But still the report made a difference. Eamonn Matthews, the producer who had worked with Peter Jouvenal in Afghanistan for *Panorama* in 1989, was later able to confirm the significance of the event in a history of the Kosovo crisis made for Channel 4. He interviewed the then-US Secretary of State Madeleine Albright, who said:

> When the picture showed up there was this sense that I'd had from the very beginning of the year that we shouldn't be allowing these kinds of things to happen, so I always felt terrible that we had not been able to stop something like that.

The Foreign Office had made sure that the report was seen by Madeleine Albright. In Eamonn's programme the then Foreign Secretary, Robin Cook, said about Vaughan's pictures:

> We knew Milosevic was ruthless. We knew he was brutal. We were witnessing a very deliberate and brutal repression of the Kosovo-Albanians.

That week Britain and America pushed through the UN Security Council the first resolution, condemning Milosevic over Kosovo

atrocities and threatening 'further action and additional measures to maintain or restore peace and stability in the region'. NATO was now on a ratchet towards war. It was the most influential TV report either of us had ever done, engaging diplomatic action, while at the same time informing public opinion, which was now swinging in favour of military action against the Serbs.

Tony Blair had only been in office for a year and wanted to show that he had military nerve. He saw the earlier inactivity over Bosnia as shameful and wanted to be seen to act quickly and decisively. From the beginning reports of Serb atrocities in Kosovo had quite a strong effect, perhaps disproportionate to the number of deaths, certainly compared to deaths in Africa. Even before I saw Vaughan's pictures, I first heard news of the Obrije massacre while I was waiting for Paddy Ashdown in the British Embassy in Belgrade. I was given a list of the names of the people who had been killed, only hours after it had happened. British intelligence officials were obviously on the ground, and they knew which way the political wind was blowing. This was the Big One, and they wanted to make sure we knew about it.

The KLA were immensely lucky that Tony Blair was Prime Minister. Newspaper cartoons that autumn showed him wearing a Tommy helmet, urging the reluctant leaders of France, Germany and the US 'over the top'. Blair was ready for a 'moral war', not wanting a repeat of Bosnia, and Vaughan's pictures provided him with justification. The KLA ultimately became the most successful guerrilla group since the Second World War because of his work. It took only 1 per cent of the Bosnian death toll five years before to engage NATO bombers in Kosovo.

Vaughan went back to Obrije to visit the survivors a week or so later. It was an unusual move. We are usually working too hard to commiserate. The caravan moves on to the next bazaar, leaving those behind to pick up their own lives. But he had been struck by

the dignity of one man who had survived, Umer Deliaj, and still goes to see him to this day.

Belgrade, Serbia, 24 March 1999

When the NATO bombing finally started Vaughan was in the wrong place. Three days earlier he had been in Kosovo, but the BBC said that they could not afford to keep him on so, thinking that there was still a week to go before the bombing began, he accepted a job with an old friend, Nils Brinch from Danish TV2 in Belgrade, the Serbian capital. It was a bad call. Once the bombing began Belgrade was not the place for a cameraman who had spent such a lot of time in Kosovo to be. The police rounded up all of the journalists in town, and Vaughan found himself in the lavatory of the police station, eating his KLA accreditation cards, since he did not want to be caught with them. The laminated one was the hardest to swallow. He was rehired by the BBC and tried to get into Kosovo via Croatia and Montenegro, but he was ambushed in the mountains by Serb soldiers, who took everything, including his camera and vehicle. After going back to London to re-equip he tried to get in through Albania, but ten days later, he again lost his camera at gunpoint.

He bought a third camera, but now the BBC said that it was too dangerous to try to cross the border. Vaughan was one of the few journalists alive who could have done the trip, both because of his local contacts and because of his ability to look after himself in harsh conditions. But although he appealed all the way up the chain in the BBC, the answer was the same. The Prime Minister's spokesman Alastair Campbell raised the temperature with an ill-informed, but characteristic attack on journalists, claiming that they were too frightened to go into Kosovo. He said, 'The day of the daredevil reporter who refuses to see obstacles to getting the truth, and seeing it with his or her own eyes, seems to have died.'

Much as the government had pointed to reports, including ours during the Serbian attacks the summer before, they now wanted independent reports of the conditions being faced inside Kosovo. There were conflicting accounts over what the Kosovans were fleeing from – the Serbs or the NATO bombing. What nobody doubted was that tens of thousands were running over the border to Albania in the west and Macedonia in the south. The BBC carried reports of 'alleged' massacres, which Vaughan thought was not good enough. Never had it been so important to have first-hand reporting from inside Kosovo; British troops should not be sent in to deal with 'alleged' atrocities. He pulled out of his BBC contract and went down to Macedonia to try to get in on his own.

Kosovo, April 1999

The sound Vaughan heard when he woke in his sleeping bag in a hayfield brought hairs up on the back of his neck: British helicopters. The ex-Guards officer recognised it immediately and then the sound of British voices on the ground in Kosovo. It was an emotional moment. A little over thirteen months ago he had been shot at the start of the Serbian campaign and now the army he had left to become a cameraman more than a decade before was engaged, and he knew that this was partly because of his work. Once they had got over their surprise at being met by a British cameraman the soldiers were pleased to see him too, since he could tell them what he knew about minefields and the probable locations of the KLA.

Vaughan had been escorted in by his contacts in the KLA only a few days earlier, just in time to witness the beginning of the negotiated takeover from the Serbs, after the long bombing campaign. The BBC correspondent Paul Wood, who had come in with him, walked out with those first pictures, while Vaughan

Vaughan Smith's fake army identity card, laminated (without their knowledge) in the British Embassy tennis club in Bahrain.

IDENTITY CARD

NAME	INITIALS	NUMBER	BLOOD GROUP
SMITH	HV	514640	A Pos

DATE OF ISSUE 29 Oct 82

HEIGHT

DATE OF BIRTH 22 Jul 63

514640

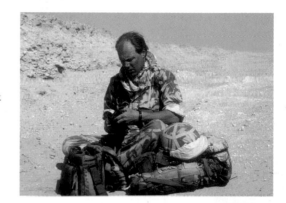

Vaughan disguised as a British Army captain in the Gulf in 1991. The scarf is not standard issue, but added an authentic touch.

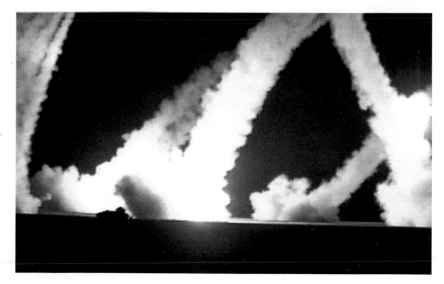

Vaughan's pictures of British rockets heading for Iraq earned more money than any others in the history of Frontline.

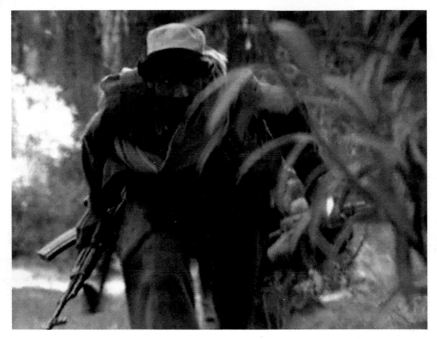

His pictures of the mujaheddin assault on Jalalabad earned Rory Peck a rare BBC credit for 'combat photography'.

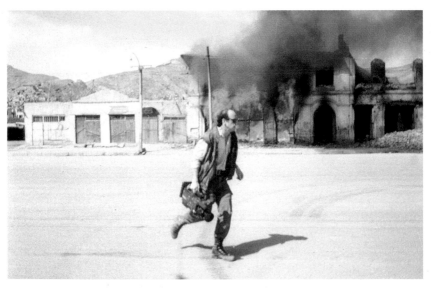

Rory in the battle for Kabul in 1992, during the worst days of fighting for control of the city.

A moment of relaxation with guerrillas in Liberia in 1991 – a story that was wiped off the news agenda by the Iraq war. Peter Jouvenal was always the best-dressed journalist in any conflict. The photographer in the picture, Patrick Robert, was seriously wounded in the fighting in Liberia in 2003.

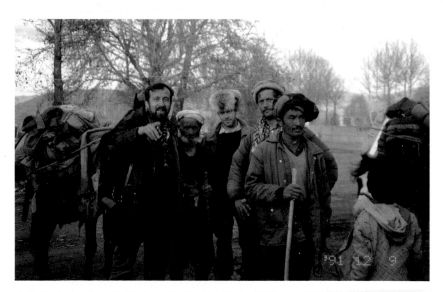

Vladimir Snegirev (*left*), Rory (*in Russian hat*) and Peter, with their Afghan guides, during their attempt to secure a prisoner-swap between the Russians and the mujaheddin. The trip led Peter to take responsibility for two Russian skeletons for several years.

Rory turned up in Sarajevo in September 1992 in what he called 'the ultimate war wagon'. He bought it in this condition from an escaping Croat refugee. Speed, rather than protective armour, was his strategy for dealing with Sniper Alley.

Rory could not take his BMW into Gorazde, but he went on a donkey to film this first glimpse of a town that had been 'too dangerous for the outside world to reach' for four months. The man eating soup is too far gone to realise that the man in the bed next to him has already died.

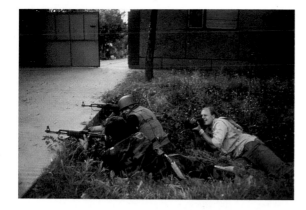

Vaughan Smith with
Croat gunmen in 1993.

Robert Adams in Bosnia
in 1992.

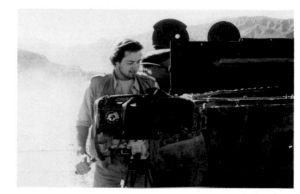

Robert and I made up a thin cover story as
an excuse to go to Bamiyan in 2000, since
we knew that the Buddhas were threatened
and we wanted to see them. This photo
was taken only a few months before the
Taliban blew them up.

Vaughan Smith showing off his wound in Kosovo.

The packet of cigarettes, mobile phone and wad of money that saved his life. The remains of the bullet can be seen embedded in the mobile.

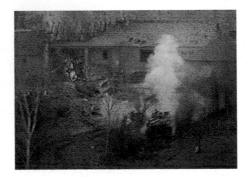

Serbian armoured vehicles in the act of destroying Kosovar houses – the pictures Vaughan was shot for. They marked a watershed, proving that a major new campaign of ethnic cleansing was under way.

A month later he returned to look at the damage.

Vaughan with Fisnik Abrashi, one of the tribe of bright, very young Kosovars who guided the BBC. (He later became a foreign correspondent himself, working for the AP agency in Baghdad.)

Vaughan putting up satphone dishes on the roof of our temporary home in a mud-walled Afghan house. The broadcasts made television history – the first news fed straight to the BBC using this lightweight technology.

Our host did not realise that history was in the making.

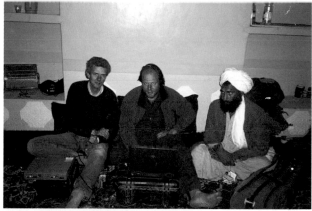

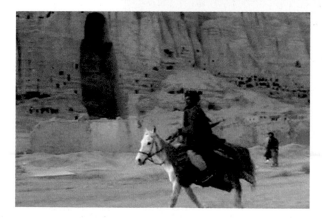

The first pictures fed using the new technology showed the fall of Bamiyan. Hazara horsemen arrived too late to save the Buddhas.

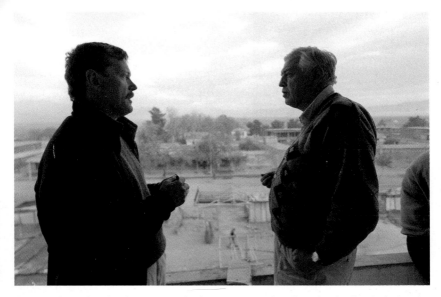

Peter Jouvenal and John Simpson looking out over the plain north of Kabul, shortly before the Taliban fell in 2001.

The day before the fall of Kabul in 2001. The mujaheddin moved fast, but John occasionally persuaded Peter to stop for long enough to do a live piece on the videophone. Jo Phua is dialling up London.

put his pack on his back and started to walk north to Pristina, the Kosovar capital, ahead of the advancing British and American forces, in that most dangerous of times, as power was handed over and the countryside was full of people who did not know who to trust.

The Serbian armed forces had not been badly damaged in the weeks of bombing; they had been too good at hiding. But now they had agreed to withdraw and were abandoning Kosovo methodically, just ahead of the advancing forces. Vaughan hitched a ride in a vehicle festooned with signs saying 'TV' and 'Press'. It was full of German journalists, whose translator, another of Pristina's tribe of young female fixers, had recognised Vaughan. They were not heading for Pristina, rather they were aiming to go to Prizren, a once-pretty wooden town in the west, much of it now burnt down in the war. Vaughan was grateful for the lift. *Why not? It's another story. I will still get there ahead of any other cameraman and be able to sell the pictures to the BBC.* They turned off the main road heading towards the west, and were unlucky enough to meet Serbs manning a Yugoslav army checkpoint, who were packing up and were about to leave; twenty minutes later they would have gone. They were angry, confused and very surprised to see the press, who were not part of their plan at all. The journalists were 'too early'. The officer commanding the unit thrust his heavy drunken face into the back window of the vehicle, leering at the Albanian threateningly. He said that they could not go any further. The fixer began to try to translate, but it did not make much sense. Vaughan understood some Serbian, and hearing the soldier say something about 'singing', suddenly he began to sing a well-known Serb nationalist song from the 1920s. '*Ko to kaze, Ko to Laze Serbija ye mala. Ni je mala...*[Who speaks, who lies? Who says Serbia is small?...]' The translator joined in with Vaughan, and some of the Germans

did too, not knowing the words but singing for their lives. It broke the ice and they were allowed to leave, heading north-east now, in the direction of Pristina itself.

It was a strange unnerving incident, made even more so when they arrived in the capital to discover that two German journalists had been killed by Serbs on that same road shortly after they had been there.

Obrije, Kosovo, 10 June 1999

Once the Serb forces withdrew fully, Vaughan found himself wading in the horror of what they had left behind. The next day he headed west towards Drenica, where he saw people emerging from their hideouts in the hills, grey-faced and sick after weeks running from the Serbs and NATO's bombers. Old men were being pushed in wheelbarrows, thin children carried on the shoulders of their parents, malnourished and weak. Near Obrije, where he had filmed the massacre in September, he came across a man who was returning to his house having been with the insurgents in the woods, to see if his family had survived. He had still not been inside, and they persuaded the man to let them come with him, so that the camera would see what he saw at the same time as he did.

The house was full of charred bodies and skeletons, and the smell was appalling. Vaughan was concentrating on what he saw down that tiny tunnel into reality, the viewfinder of the camera. There was bright sunlight outside but it was quite dark inside, so he was worried about his colour balance, wondering whether to turn on his top light and looking for any light source out of his spare eye, while still focussing on the reactions of the man who had lost his family. He was suddenly aware that he was stepping on something squidgy, which cracked softly under his boot. He looked down to see that it was the backbone of a woman. She looked as if she had been in her mid twenties. He immediately left

the house and refused to film anything else. He had crossed a line, taking away the ordinary humanity of the occasion, stripping the event of dignity. In another house nearby it looked as if a whole family had been taking refuge upstairs when somebody threw a grenade in. He could see where one young woman, who was wounded, had jumped from a window to save herself. Blood had flowed through the floorboards into the room below. He saw lots of this, small nasty local tragedies, some of which could not really be filmed, even if an editor would transmit it. There was no way to film it in a way which could be used, although as a Frontline cameraman Vaughan wanted to show as much of the underside as possible.

At the appalling Grand Hotel, the BBC had rather incongruously set up a bureau in a gift shop in the foyer, pushing the kitsch carved wooden knick-knacks to one side to make way for TV equipment. The following day a fixer called Pranvera Shema came in. She had not worked for the BBC before, but she had news that the Albanian guerrilla army, the KLA, had arrived in Pristina, and were shortly to hold a press conference. A BBC producer assigned Vaughan to go and take a look. Pranvera was surprised to find that he knew all of the key KLA leaders, who had now swapped their military fatigues for suits, dropping their *noms de guerre* along the way. Snake, Tiger, Wolf and the rest of them wanted to campaign for votes now. It emerged that Pranvera had been into the offices of ITN first to try to find work, bringing the offer of news of the press conference. If they had accepted her services, then Vaughan might never have met the woman who would later become his wife.

XVI

GOING FORWARD

At Chitral I fraternized with fratricides, parricides, murderers,
adulterers and sodomites... I start tomorrow for Kabul where a
female donkey is the object of favourite solicitude.

Lord Curzon, Viceroy of India, in a letter to a friend, 1901

Pakistan, September 2001

On 11 September 2001 Peter Jouvenal was in the Pearl Continental
in Peshawar, sorting some kit before a trip up the Khyber Pass
into Afghanistan, his second home. The 'PC' would look like any
other five-star chain hotel anywhere if it were not for the sign
on the door asking guests to hand in their guns to reception. To
Peter it was a place to see and be seen, a trading post for gossip,
information and influence-peddling – the threads that make up
the tapestry of a life lived on the road.

It was early evening in Peshawar, and the sun was setting, with
its last rays obscured by the smoke and dust from the thousands
of cars, bikes, scooters and giant, gaudily decorated trucks, with
their decorations fringed with strings of metal tassles, fighting for
space on the teeming streets outside.

Peter had just finished a trip into Afghanistan with John

Simpson, and while Simpson was planning to go home, Peter was heading back to Kabul for his side business in old military kit. There was a consignment of British-era rifles that he had his eye on, and he wanted to check up on a rare early Renault tank, which had been mouldering on a hillside in Kabul since the 1920s. He thought he had a buyer for it, if it could be moved. Sorting the kind of logistical problem which would seem mad to the rest of the world was how Peter filled his mind.

He kept half an eye on the television in the corner as he packed.

They had been in Afghanistan to report on the effects of a serious drought and to film the Taliban's efforts to stop the growing of opium poppies – both stories that Peter knew the Taliban wanted covered, which would give them a reason to probe at other stories that the Taliban were less keen on. Simpson had a diplomatic mission too: to persuade the Taliban to let the BBC reopen its office in Kabul. The BBC had been the last international news organisation to keep a foreign correspondent there. But earlier in the year their correspondent had been expelled and was now reduced, rather unsatisfactorily, to reporting on events in Afghanistan from across the border in Pakistan. The excuse the Taliban used was one report aired on the Pashtu service. By now the Taliban had tried to end all pleasure as well as ending normal life for women. Singing, dancing, painting, film-making, even kite-flying were all forcefully suppressed by young zealots carrying rubber whips in the streets. All of this was reported on the BBC. But when the Persian service chose a particularly harsh term for 'barbaric savages' in translating comments about the destruction of the Buddhas of Bamiyan the BBC were out. John Simpson had been trying to pour oil on the murky depths of the Taliban psyche. When he left for the mission no one could then know how important it was going to be in the next few months to have reliable reporting from inside Afghanistan. He went into

Peter's room only to say goodbye, but quickly became silently transfixed. With hundreds of millions of people around the world, they watched the live drama of mass murder in New York. First one plane and then the second hit the twin towers of the World Trade Centre as if guided by remote control.

'I don't suppose I'll be going home' was all that Simpson said.

The two of them moved to the capital, Islamabad, and then for some weeks they went on a bewildering kaleidoscope of a journey trying to find their way back to Afghanistan, where they knew the story was going to be. It was immediately obvious that Afghanistan was going to be the focus of whatever happened next. Osama bin Laden was based there: American retaliation was inevitable.

Peter found himself deluged by offers from American networks to go in with them. He wanted to go with the BBC but he was wary of getting stuck on the way. He knew that if Simpson was drawn by the magnet of live television onto the roof of the Islamabad Marriott, then he might never get off; he might as well have been set in concrete. They had to get out before the cement set hard. Peter's mind went back ten years to another international hotel, another war, another reporter: the time when he tried to go to Baghdad before the American attacks in the Gulf War in 1991. They only made it as far as Amman in Jordan, where the US reporter unpacked the edit pack, did some live pieces and suggested they stayed 'to see how things developed'. Peter had had to detach himself forcefully then to go forward to Baghdad alone, and ever since he had tuned his antennae to screen out journalists who found excuses to stop, reasons not to head for danger. He had also had it written into his contract since the incident in Amman, that he would go forward, into the front line. If the BBC did not get him into Afghanistan, they were breaching his contract, and with his highly personal and idiosyncratic view of what was right

and what was wrong he insisted on them sticking to it, even if it looked impossible. He was sometimes not the easiest man to manage, but managing mavericks is part of the job description for foreign editors, or should be.

John Simpson was just as keen as Peter to get to where the story was. But not everybody in the BBC had the same idea. As a large BBC operation landed in Islamabad, Peter talked to local contacts about ways into Afghanistan while producers engaged Simpson in daily coverage from the hotel roof.

During the days when the mujaheddin were fighting the Russians Peter had made seven trips in with them across the high mountain passes to the north from Chitral, and Rory had set off from here for most of his epic trips into Afghanistan. This is a place where the world seems to be at your feet – the scene of an epic late-Victorian adventure when British soldiers relieved the siege of Chitral in 1895, carrying their field guns up the side of a mountain. Peter's information now was that although it was late in the year, and snow would soon close the passes, it was still possible to go along the smugglers' routes from Chitral into the Panjshir valley in Afghanistan, although nobody quite knew where the Taliban were and there might be some pockets of Taliban fighters along the way.

It was clearly a hazardous journey and in the days that followed a classic dialogue developed over the plan. It never became an argument, because Simpson is too good a diplomat. But there were clear differences in approach, which were hard to resolve.

More money is now spent on safety of crews in the field than any other single area. The BBC is acknowledged as the industry leader in this and their training, equipment and backup is impressive. But no one has yet been able to put a price on experience. It must be worth something but there is no box for it on a risk-assessment form. Many of the producers in charge of large overseas operations

have considerably less experience in the field than some of the reporters and crews over whom they assume a legal responsibility. The best producers draw on that experience and add it to what they have learnt in training in order to make collaborative plans – a grown-up, common-sense, decision-making process. But sometimes tensions over safety in the field can make the situation more dangerous, where decisions made for safety reasons *create* hazards, especially if those with less experience try to impose their will over more experienced people. The military experts who are responsible for our training courses are always shocked by the difference between our culture and theirs. Like soldiers we are going into harm's way, but unlike soldiers we do not have a rigid command structure; we are not trained to be obedient, in fact quite the opposite. In the field journalists put a high value on general bloody-mindedness, quoting approvingly the definition coined by the late Nicholas Tomalin about the key qualities needed to be a reporter: 'ratlike cunning, a plausible manner, and a little literary ability'. Reporters like to think that they are not easy to order around.

The formal BBC guidance, that 'no story is worth a life' is, by common consent to most people in the field, banal beyond the point of value. The safety forms that foreign teams have to fill in before embarking on anything are much the same as a producer for *Blue Peter* might fill in, where the expectations are rather different. Almost all worthwhile journalism in areas of conflict involves some element of risk. Managing that risk is a complex process which cannot easily be picked up by reading a manual. For Peter Jouvenal there is a certain amount of mysticism involved – not mocking the gods – and he does not talk much about the safety side of the work. He has been shot at more times than most people but he is never foolhardy and has a finely tuned sense of risk, taking sensible precautions. He draws on statistics

about Spitfire pilots in the Second World War. Although their life expectancy was short, the longer they flew the safer they became.

The problem is that this intuitive safety, based on years of experience, can sound like incredible arrogance, and to outsiders Peter's attitude is genuinely frightening. During the discussions in Islamabad the consistent question, directed from London, was 'What's the exit strategy?' It was a proper question of course, straight out of the training manual. But it was not going to get them into Afghanistan.

Simpson did not need much persuading when Peter suggested to London that they should at least look at the mountain routes across from Chitral in the north. They made the 14-hour car journey, but after only one night it became obvious that they were not going to be able to cross. The Pakistani army was now patrolling the border, with orders to shoot anyone on sight. Peter's old smuggling contacts could not help. He wanted to stay up there, probing, drinking tea, paying court to whoever he could in the Pashtun way. It had worked for him before, and he later learnt that an Italian had got safely in by that route. But he lost the argument.

They drove back south again, although not, this time, to Islamabad. They made their way instead back to Peshawar, the frontier town, which felt closer to Afghanistan. Already there were hundreds of other journalists there too, and the machinery for 24-hour live television, a snare that Simpson knew would not attract Peter. In his book *News From No Man's Land* he writes: 'Watching him as he came into the lobby of a hotel filled with journalists reminded me of introducing a free-range chicken into a battery farm.'

Then CNN came on the air live from Kabul, with a report that the American bombing had started. The report turned out to be wrong. What they had heard was an isolated attack on the

Taliban by a stray Northern Alliance helicopter, but that did not matter. Suddenly the imperative to report from inside Afghanistan, matching the reports by the CNN crew who had just happened to be there on 11 September, overwhelmed everything else. After talking to old mujaheddin friends Peter calculated that the only way they could get in was in coffins or disguised as women. They did not fancy the pine boxes, so they went into the bazaar in the old town and kitted themselves out in the largest burqas available. Simpson chose powder blue, the standard colour for the all-enveloping tents which Afghan society imposes on its women, while Peter went in yellow.

Neither of them embarked on this jaunt with much conviction that they were going to get away with it for long, and they did not plan to stay inside Afghanistan, especially because the only areas they could get to quickly were all in the hands of the Taliban. But they needed to match CNN and do it quickly. And they wanted to test the smugglers' ability. Perhaps they could deliver them all the way to Kabul.

On their way to the border they raised suspicions only when they sat in the front of the vehicle, since women are confined to the back seats at best or even left squatting in their burqas in open car boots, carried like so much baggage alongside the potatoes or live sheep. The cross-dressing crew found their way over the porous border and although they were not far away from a Taliban checkpoint, they set up the videophone for a live piece. But the fates were not with them. The equipment must have been damaged by the journey, some of it on horseback. Their pictures could not be seen in London. Simpson did some radio pieces, so that they could say that they had reported from inside the country. But they had very little to show on television for their journey into Taliban-held Afghanistan. They had never intended to film the burqas, but now they felt that they should use the

journey as part of the story. The decision to reveal how they had crossed the border became the instant stuff of journalistic legend, and was to cause them no end of trouble in the days to come. The pictures of the World Affairs Editor of the BBC dressed as a woman were used in every Pakistani newspaper and were seen to have crossed some imaginary line, showing disrespect. And every police officer on the North-West Frontier knew it.

Simpson went back to the hotel rooftop to pay his dues to the 24-hour news beast. In corporate terms of course it was worth it, bowing to modern reality. As the figures for news bulletins on BBC1 inevitably decline in a multi-channel environment, live news is taking a bigger share of the money and influence. The Afghan war was to give the BBC a new audience, just as the first Gulf War had made CNN in 1991. This was particularly true in America, where people tuned in to find out what had hit them on 11 September. The BBC is big enough to have some reporters who can make their own stories, off the leash and away from the roof, but now as literally thousands of journalists were heading for Islamabad John Simpson was lured back there to the centre of the vortex. Pakistan, or 'Hackistan' as it came to be known, was the story, as feature articles appeared in glossy magazines that were about the journalists and not about the war. The reality inside Afghanistan itself became secondary in this self-referential loop, especially once the Taliban had thrown CNN out of Kabul. The rooftop became the place to be. The medium swallowed the message like a whale as the critical mass of journalists in Islamabad took on its own momentum.

The news agenda is a mystical thing, and sometimes works against independent initiative. Curiously some major exclusive news reports from faraway places have no impact precisely because of their exclusive nature; they come from outside the machine. Simpson was chained up to feed the beast.

Then Peter's contact came back to him to say that the northern route might be open; he had found a way. Lifting their feet out of the setting concrete once again, they headed back up to Chitral. But it was hopeless. The governor of the province had lost his job because of the burqa incident. Within a couple of days they were in Peshawar again, where a police guard lined the streets to prevent them from trying again. They were not going to be able to smuggle themselves in. They would have to try a legal way.

Tajikistan, 3 October 2001

The transport plane, an old Russian Ilyushin, smelt of horses, its last cargo. But after weeks on a fruitless odyssey around Afghanistan's neighbours Peter was past caring. The BBC had chartered the plane to go to Tajikistan, a country which had suddenly achieved significant strategic importance for journalists, since at the time it had the only border with Afghanistan not in Taliban hands. To get there Peter and John Simpson had been on an unscheduled Central Asian tour via Delhi, where they tried to get Uzbek visas, back to Pakistan, before meeting up with another group of BBC journalists in Dubai in the Gulf to join the charter to the Tajik capital, Dushanbe. Peter had one more technical obstacle to overcome. Somewhere along the line he had managed to forget to get a Tajik visa, so when they arrived he had to walk forwards and shin down the ladder designed as an escape route for pilots while the others climbed out the main doors. He met up with them in the darkness, out of sight of the Tajik police.

Tajikistan's unique geographical position meant that for a few months its charming but unbelievably poor capital city had a sudden injection of foreign currency as thousands of foreign correspondents arrived on their way to the war. The wide avenues of Dushanbe still have a pre-revolutionary elegance. And a display of flowers in parks and along the wide boulevards, marking the

tenth anniversary since the collapse of communism, freshened it up. But behind this facade Tajikistan is a desperately poor place. Like the other ex-Soviet satellite states in Central Asia it is a neglected backwater, marking time somewhere off the edge of the planet.

There are two hotels in town. One is called the Hotel Tajikistan, and the other the Hotel Dushanbe. And when you consider that *Dushanbe* just means 'Monday' you get some idea of the lack of imagination of the place. The BBC had set up in the Dushanbe, a formerly grand establishment, resonant with dry, faded echoes from the past.

The Tajik border, for a variety of reasons connected with drugs and politics, is one of the most heavily fortified in the world, in places more comprehensive than the Iron Curtain that used to divide Europe. Border security is still the responsibility of Moscow, although the Russian government has long since ditched all other liabilities in these countries on the outer fringes of the former Soviet Union. The only safe tracks wind through a patchwork of minefields and barbed wire fences, and in 2001 the government erected an expensive, bureaucratic and time-consuming obstacle course to slow down the progress of journalists through it.

Using his Cornish wit and elegant command of Russian, the BBC's then Moscow Bureau Chief, Kevin Bishop, found his way into a Russian Army camp close to the border, and arranged for BBC staff to stay there on the way through, persuading the Tajik government that there was no need for an escort. The best field producers are like conjurors, using sleight of hand to pull rabbits from unlikely hats. Kevin is one of the best. The price agreed with the Russian soldiers was a satellite dish, so that they could watch international television. It was an entirely appropriate payment in kind, allowing the BBC to travel independently from the government convoys for journalists, which were irregular and slow.

As they crossed the narrow Amu Darya, the Oxus River, on a flat car ferry Peter heard the distant rolling sound of artillery fire. He was back in Afghanistan.

But he was still a long way from the war. The sounds he was hearing turned out to be gunfire set up for the cameras. The front line up here in the north had not changed for years, and most of the military manoeuvres and artillery exchanges on the Northern Alliance side were put on for the benefit of western photographers. Khoja Bahauddin or 'Hodge' as it came to be known without affection, the first town in Afghanistan, became a hellish place packed with journalists with no real story to cover, who were only there for the dateline – so that they could say '...for XBC News [fill in name of station], Afghanistan'. There was the occasional government briefing, but most of what they reported came from the agency wires which they accessed on expensive satellite connections to the internet, so that all they knew went round and round in a little loop, with the occasional injection of a fact from a reporter who had made it further south. Vaughan and I spent less than two hours in Hodge before securing a vehicle to take us towards the war, when we arrived a few days later.

Peter was concerned about getting stuck. Here was another gathering of journalists, another dateline on the news diary for foreign desks across the planet, another siren call to wreck their attempts to travel towards the war itself. There would not be any real military action in 'Hodge' for several weeks more, and then with tragic consequences. Once the front lines did move four journalists would die. But that all looked a long way away in the stage-set in the desert.

Panjshir Valley, Afghanistan, 6 October 2001

Finally John Simpson led his team south along mountain tracks that were often just ditches running along sheer hillsides made of

loose scree. All who made the journey agreed that it was the worst in the world. Their Russian jeeps, hardy but not built for comfort, would slip often on the loose stones, and another freelancer, Jo Phua, who was part of the BBC crew, was badly hurt when he had to jump out of a jeep before it crashed. The jeeps broke down often. They started in a convoy of four, getting through ten vehicles altogether during the week-long journey. Only one of the original four vehicles made it all the way up to top of the 14,000-foot Anjuman Pass and then down the length of the Panjshir Valley itself. Along the way they kept in touch by listening to the BBC World Service on a radio with its own mini satellite dish. It was not designed to be mobile but another BBC magician, Peter Emmerson, turned it into a car radio by moving the dish around by hand in the freezing air above the vehicle. That was how they heard that the American bombing of Kabul had started. They unloaded the videophone in the middle of nowhere to do a live report, although they knew that any delay now might cost them the story. They had to get there in time, before Kabul fell.

And then the road levelled out at the bottom end of the valley, and they made it through the narrow, twisting choke at the bottom, a piece of geography that, above all else, determined who controlled the Panjshir. High mountain walls on either side of the narrow river, twisting and turning for a mile, offer fixed firing positions from which to repel any attackers. They passed the burnt-out Taliban tank that marked the most northerly point the Taliban had reached in their attempt to drive out the last of the mujaheddin in 1996, and then they were out onto the Shomali Plain at last.

Kabul was just a couple of hours' drive away now, down the only surviving tarmac road in Afghanistan, if the Taliban had not been in the way. But the Taliban front line was in front of them – blocking the gates to the city.

They paused, staying a night in the first town on the plain, Jabul-es-Saraj, a curious place with a Wild West feel. We once met a man there whose party trick was to swallow bullets. Vaughan filmed him, and I am ashamed to say I asked him to do it again so that we could take another shot from a different angle, to make the sequence easier to edit. His mad, staring eyes, as he took another bullet from a passing soldier and swallowed it, seemed to symbolise something about Afghanistan, although I was not quite sure what.

The sudden influx of westerners provoked a rash of signs among the wooden shacks that raggedly lined the market streets on the hillside of the town, beneath the shattered ruins of a former royal palace. The signs advertised 'Room with hot bath – foreigner welcome'. The natural tendency of journalists, even from rival news organisations, to stick together was on display again in Jabul. There were several journalists there already, clustered around the Northern Alliance foreign ministry, some sleeping on a concrete floor in a dormitory in the foreign ministry, the more adventurous in 'room with hot bath', while one American network, grandstanding the rest, had set up in the foreign ministry guest house itself.

Peter was suspicious of all this. There was an element of control among the Northern Alliance bureaucrats which did not ring true to his Afghan experience. Like all who travelled down the Panjshir valley his convoy had to pay 'tolls' at unofficial checkpoints. It shocked him, and now the Northern Alliance, with its eye on the thousands of dollars available, tried to control access to translators, vehicles and housing too. It was understandable profiteering but the openness of the demands surprised Peter. These were not the mujaheddin with whom he had travelled for long years in the 1980s, when they were fighting against the Russians. In selling their services, the Northern Alliance found

willing buyers. The BBC machine began to negotiate; some of those in Simpson's team were drawn to the security of the herd. But then Peter found some old friends. He had known the local police chief, Awar Gul, for twenty years; another commander, Anwari, had assisted him and John Simpson on their epic walk into Kabul during the Russian era; and the area was under the control of one of his oldest contacts in the mujaheddin, Gul Haider himself.

The journalists who had been rounded up in the Northern Alliance corral needed official permission to head south from Jabul. But with Gul Haider's protection, Peter moved off to the last town in northern hands, Charikar. It was from here that Alexander the Great had regrouped to launch his invasion of India, after taking Afghanistan in the spring of 329 BC. In the winter of 2001 it was to be the springboard for the key battle to end Taliban control. The long war, beginning with the Russian invasion of 1979 and chronicled by Peter Jouvenal ever since, was about to come to a decisive climax.

The Afghan guidebook I always travel with, if only to mourn what has been lost, was written just a couple of years before the Russian invasion by the extraordinary Nancy Hatch Dupree, a chainsmoking American academic, still living in the region. With her husband, Louis, Nancy had done more to put Afghanistan's archaeology on the map than anyone. Nearly all of their discoveries have now been destroyed, or looted and uselessly scattered into illegal sales worldwide. Her description of Charikar is heartbreaking:

> Because of its central position in this fertile valley it has an air of busy prosperity... If this is to be your only visit to a provincial town, you will find the bazaar a fascinating adventure.

Nobody much lived in the abandoned bazaar now. Peter looked out over the desolate mud roofs from a large open window of a ruined concrete office block, the only two-storey building on that side of town. Beyond what had been the bazaar the front line was in sight over the Shomali Plain. On his right there were Taliban rocket positions on the hill. The only use for the building recently appeared to have been as a public toilet. Its roof was cracked by a direct hit from a mortar shell, its windows blown out. This was to be home for the BBC's most forward position in Afghanistan for the next month. That night Simpson did his first live videophone piece through the large opening at the end facing the front line – the night sky behind him lit by distant flashes which were bombs falling on Kabul.

They had beaten the cement mixer.

THE LAST CASUALTY

*It is a source of deep regret that this beautiful country should
be inhabited by a race of men so turbulent and vindictive as the
Tajiks have here proved themselves to be... 'Blood for blood' is
their motto and their rule.*

Lt. Col. Sir Alexander 'Cabool' Burnes, *Cabool – a Personal Narrative
of a Journey to and Residence in That City* (1841)

Charikar, Afghanistan, October 2001

The last casualty inflicted by the Taliban before they fell was a
canary, killed by a mortar shell which tore over the BBC 'house'
in Charikar with a searing whine, exploding in an alley next
to a mosque in the centre of town with a heart-stopping crash.
Vaughan and I arrived a few days after Peter had led his team to
Charikar. On the floor below, at the other end of the building, a
school still functioned after a fashion, only for boys of course.

After the first shell fell I ran down to the boys' end to see
where it had fallen, passing an absurd painted sign advertising
bodybuilding classes – an Afghan obsession. Bodybuilding is one
of Afghanistan's stranger subcultures. Afghan refugees are now
even beginning to dominate Britain's bodybuilding competitions.

As a second shell whined over our heads, the schoolboys all smiled in that annoying Afghan way, which seems to sneer, 'Ha, ha! We're not scared and we know you are.'

Damn right I was scared. It was not consoling to be told later by our ex-army experts that this was almost certainly an unaimed random discharge by Taliban artillery clearing their weapons to withdraw. The explosions were enough of a reminder of mortality. Jo Phua, the cameraman who had been hurt on the journey down, now had his second brush with death. He was only yards away from the shell when it exploded, and he filmed the chaos as the injured were taken away from the narrow market street. In the market an old man who had been selling caged birds showed off the tiny dead canary killed by a piece of shrapnel, its yellow feathers stained with blood. But it was an isolated attack from the Taliban side in those weeks. Otherwise, we had a ringside seat for the most extraordinary daily air show, as American F/A-18s carried out air raids on the Taliban front lines and on convoys moving through the desert.

Daily, from our balcony, we watched as the planes lined up over the snow-covered mountains, then dived in steep hostile raids through the achingly blue sky. I was always taken aback by the speed of the dive, as if it wasn't enough to point the bomb in the right direction, knowing it would steer itself; it had to be released with maximum ferocity like a knockout punch. There was never much opposition, although one day an agency cameraman was lucky enough to take pictures of American planes wheeling around like angry seagulls, taking evasive action as the silver shaft of a missile, fired by the Taliban from the ground, went harmlessly past them. And over it all, night and day, was the constant sound of long-range B-52 bombers high in the Afghan sky, just like the familiar rumble of airliners over a city, but bringing a much deadlier load. The B-52s were dropping cruise missiles onto selected targets in

Kabul, and the innocuous-sounding 'daisy-cutter' bombs onto the convoys moving on the plain beneath us.

The bombing was accurate, which gave us the confidence to stand on the balcony while the bombardment went on just a couple of miles away, drinking small rationed glasses of whisky and smoking even more carefully rationed cigars.

John Simpson's restless intellect makes him absorbing company. While we watched the air show he would wander out and open a conversation about something like Elizabethan poetry as the American bombs continued to fall. One lunchtime, in the café on the crossroads in Charikar where they used a particularly acrid oil as if designed to destroy the taste of any kebab, he asked those around the table what they planned to do in retirement. Some present were less than half his age and had not given it any thought. Simpson revealed that he planned to be the first BBC reporter to work on the air in daily news for fifty years. At that time he had only a decade or so to go.

For a while it was like living in a mad English country house, where Peter played host. Afghanistan was, after all, the closest thing to home for him. When they first set up in the ruins Peter slept in a room on his own. As the BBC machine rolled in with security men and satellite engineers and producers it became a dormitory. But the close proximity of people, the inevitable tensions and petty politics like those in a small office, never phased him. He is unruffled by anything, even gunfire. With his tiny ex-army haversack as his only luggage, Peter lived lightly off the land and more casually than most people do in a modern city. He had his hair cut in the market, oblivious to the threats of Taliban shells, and put the house under the control of Rahman Beg, an ancient retainer with the usual Afghan wounds, a glass eye and a false leg, who had travelled with Peter in Afghanistan since the days of the mujaheddin. Once hired as a horseman, Rahman Beg now sorted out the building and ran

the kitchen. Like Long John Silver, his venerable beard and his limp made him look as if he was no threat. He was the ideal person to cross the front lines to bring us information from the other side of the lines in occupied Kabul.

There was some complaining among those who pay the bills at the BBC about the rate Peter charged for this trip. Perhaps he makes what he does look too effortless – the establishment of an exclusive facility, where no other journalists were allowed to live, and penetration of hostile front lines to bring back information. It was certainly beyond the scope of any BBC staff producer. Peter had turned down higher offers from American networks to work for the BBC.

His modest haversack must have had a magic bottom, for he seemed to have an endless supply of cigars. Days ended in a comforting fug of smoke, green tea, whisky and dreadful imported Iranian biscuits with unlikely names – Strawberry Mange, Banana Mange, and my personal favourite, Kustard Sandvig. And the next morning, under the mile-high blue skies of an Afghan dawn, you would hear Peter's cut-glass voice, as good-humoured as ever, in one of the abandoned offices, which we used as a kitchen.

'Excellent, Rahman Beg. Fried eggs today? Goody! Glad your chaps can do them at last. Any chance of one of those turkeys for dinner?'

'Sir. Turkeys very quick. Too quick.' Rahman Beg rose from the broken-backed chair where he always sat, limping on the rubber foot at the end of his too-short artificial leg, while flicking hopelessly at flies with a filthy dish cloth.

'Get Andy to kill one. That's what these Special Forces blokes are here for, isn't it?'

The presence of security officers with BBC crews in war zones is a new phenomenon, part of a response to the dangers inherent in the fractured world of modern conflict. More than 1,200

journalists have died violently since the Berlin Wall came down in 1989. Our guards in Charikar were mostly ex-Special Boat Service types who wore terrifying T-shirts taut across their ox-shaped chests advertising their achievement of some difficult feat – like diving to record depths into the nuclear testing site at Bikini Atoll. As well as slaughtering the odd turkey, which did not bring us much pleasure since the meat was extraordinarily tough, their main contribution was personal hygiene. Swimming under the Atoll may have made them slightly over-qualified for the job, but they dug latrines, and arranged clean water and laundry, giving us a unique competitive advantage, since staff for every other TV company in the area were getting sick in the impossible living conditions and were hard to replace.

Peter moved around the area easily, talking to commanders who he had known since they were young recruits in the early days of the mujaheddin, rebuilding confidences, making new friends, until one day he emerged with a beautifully drawn full-colour map of the battle plans of the Northern Alliance, detailing how they planned to punch through the Taliban and retake Kabul. Now that the Taliban had been 'softened up' by US bombing, the Northern Alliance, in their antiquated tanks, or in saloon cars, were going to attempt what they had failed to do all these years and retake the capital.

The plan was that Northern Alliance elite troops would move down the mountains at the western flank, finishing off any Taliban rocket positions that had not already been vacated, while the armour, a few dozen workable tanks, raced down the plain to the east. In between, the BBC's landlord, Haji Bari, and a neighbouring Hazara commander would move their infantry forward, mainly by road to avoid the inevitable minefields.

The signs of new Russian money were everywhere as the Northern Alliance put on new uniforms, and now they had

enough fuel to bring their armour out of the Panjshir valley for manoeuvres in the dry dust at the top of the plain against the sheer wall of the Hindu Kush. For the first half of the 20-year war, resistance had been against the Russians, but now, in one of the more remarkable ironies of the post-9/11 era, the Russians were backing the very forces who had given them most trouble during their long ordeal in Afghanistan. The Russians were playing the same game the British had played in Afghanistan throughout the nineteenth century, making alliances without principle to win power and influence. Dr Abdullah, the brains behind the Northern Alliance, firmed up the new deal in a meeting with the Russian leader, President Putin, at 3 o'clock in the morning in Dushanbe. Abdullah was another old friend of Frontline. He used to stay in Peter's house in Wimbledon on visits to London in the early 1980s.

The Northern Alliance stronghold in the Panjshir valley was a military society, which Vaughan filmed for a profile we made for *Newsnight*. The people who lived there were mostly Tajiks, who could justly claim that this was the only region never to have been occupied in modern times. The Tajiks gave all the credit for their success in defending this place of Afghan legend to Peter Jouvenal's old friend Ahmed Shah Massud. The 'Lion of Panjshir', as they called him, who had courted the western press so well for so long, had been killed by a bomb in a TV camera, carried by an Arabic TV crew, just days before 9/11. Vaughan filmed the building of an elaborate mausoleum to house Massud's coffin on a high point in the middle of the valley, close to the place where Massud himself had presided over a memorial service for Rory Peck. There is a view on all sides into the distance over that small slice of Afghanistan which Massud never surrendered. His charisma outlived him. I noticed our own driver and translator paying their silent respects with tears in their eyes.

Under Massud the Panjshir valley was fuelled by drug money and subsidies from whichever passing country wanted to play, and bandits extorted what they could from travellers at will. The whole economy was geared to war even in the absence of invaders: society stood still here, and people were as poor as anywhere in Afghanistan. Apart from heroin-refining factories hidden in the hills, the only industry was a remarkable armour-repairing workshop.

When Massud saw that Kabul was threatened by the Taliban in 1996 he moved the whole of the factory – lathes, steel presses, spare parts – from Kabul into the valley. Vaughan filmed an ancient armourer turning out a new rifle barrel with the help of an apprentice, aged about thirteen. I asked the boy if he went to school. Before he could answer for himself our escort broke in with the obvious lie that he had school lessons on the premises.

The factory was a remarkable place of human ingenuity directed to desperate ends – keeping museum pieces maintained at war-readiness. There were Russian field guns that could have been at the Battle of Stalingrad, since they bore dates going back to the 1940s. Artillery that had been used to fight the Nazis had found its way into another war, another age, another front line. And now it was all being polished up in readiness to trundle towards Kabul once American air power had done its work.

One Sunday morning, a whole line of American bombs fell well onto the northern side, 'our' side of the front line. One very narrowly missed a group of western photographers; another hit a house, killing several people from two families. When I went to cover this incident in the village where the bombs had fallen, I was robbed at gunpoint and lost a mobile satphone. America's allies, the mainly Tajik 'soldiers' who came to be known as the Northern Alliance, owed allegiance only to local warlords; their petty crime, corruption and endless in-fighting had led to the

formation of the Taliban in the first place. I never got the phone back.

The front line snaked across the Shomali Plain between large farmhouse compounds, surrounded by high mud walls, which gave a certain amount of protection against the small mortars and rifle fire that were the only military exchanges. An elaborate irrigation system had once channelled fast-flowing waters from the snow-covered peaks of the Hindu Kush to turn Shomali into the most fertile region of Afghanistan. But the Taliban had wrecked it in military reprisals against the civilian population, leaving wasted fields linked by very narrow dusty tracks carved through the broken walls of neglected and abandoned villages. The front line here had been static for almost five years. There was never any real fighting after these positions were fixed, back in 1996. The Taliban could not push further north and Massud's men, defending the Shomali plain, could never push south to Kabul until the Americans came to bomb the Taliban. Instead, the commanders of each side would taunt their opponents by two-way radio across the dead vines and fruit trees in the untended fields in no man's land.

In the weeks before the push on Kabul we filmed and recorded conversations between the two sides, as their insults filled the air waves through the long, still evenings after the American bombing raids. It was mostly childish stuff about the length of the Taliban beards or their style of turban. You knew when there were Arabs around on the other side as the air waves went silent.

During this period Peter would go to a house as near to the front line as he could get during the day to film the destruction. His background as an artillery officer meant that he understood arcane things like targeting sequences and the effect of the wind on the planes and the bombs. Vaughan went up occasionally too and, using the longest lens used by any journalist on the front line,

he took the best pictures that exist of Arabs wandering through the defended farms on the other side.

The operation was a typical contribution from this tiny news agency. At the sharp point of the BBC, the largest news operation in the field with crews on both sides of the front line, the two cameramen in the assault from the north who made a real difference were from Frontline.

But Vaughan and I had not come to report on the fall of Kabul. That was John Simpson's job. I had seen Kabul fall before, as the only reporter with the Taliban when they took it in 1996. This time I was heading north. We were travelling light to take advantage of an offer from General Dostam of a helicopter to carry us to join him in his attempt to recapture his home town, Mazar-e-Sharif, in the north.

General Dostam, a round-faced man with a moustache and close-cropped silver hair, put on a suit after the fall of Kabul and tried to get close to the centre of power at the right hand of Afghanistan's dapper but ineffectual leader, Hamid Karzai. But he retreated again to his natural home in the north-west when it was clear that Afghanistan was not going to be united by the fall of the Taliban. His career had begun in the Russian-backed Afghan army, until he turned on them and joined in the murderous fight for Kabul that broke out between the various factions in the early 1990s, after the Russians had left. His swift changes of alliance protected his home town. Hardly a shell ever fell on Mazar in the fifteen years or so of war before the Taliban came, and because of that Dostam was popular. But if the Taliban had caught him, they would have hanged him instantly and he knew it.

Northern Afghanistan in the late 1990s was a wild, complex, colourful, secular, human place – a buffer between the rather sombre, grey, post-communist uniformity of the former Soviet

republics to the north and the clerical austerity imposed by the Taliban on the conservative south of Afghanistan. There was money in Mazar, some from drugs and guns of course, but enough from the most verdant fruit-growing region in central Asia to mean that there was an economy outside the war.

When I used to go to the north in the days before the Taliban came, Dostam liked to show off the differences between him and the Taliban, making sure that we talked to women's organisations and filmed mixed classes of male and female students. If you could leave aside his wilful shelling of civilians during the murderous fights for Kabul in 1992, he was a likeable man. Back then we sat for long evenings in his vulgar palace at Shebargan, near Mazar, drinking that ludicrously expensive Johnny Walker in the blue bottles that only dictators and footballers can afford. Outside in the garden there was a swimming pool, surrounded by rather curious concrete deer. At one point he insisted on hiring English air hostesses, when he seized half of the Afghan national airline, Ariana, and they would adorn his pool between flights, before the Taliban arrived of course.

In those days before the Taliban Dostam needed little persuasion to arrange a *buzkashi* match. And with an imperial flourish he went to one game on top of a tank, leading a column of armoured vehicles after a dawn inspection of his troops. The *buz*, the carcass of a small calf with a hole cut between the bones of its rear leg, lay in the middle of a large area, the size of about two football pitches but still not quite large enough to hem in the teams of horsemen, each about twenty strong, who fought for control of the carcass. On one occasion the horsemen careered around the car park and damaged the little taxi I had brought all the way up from Kabul – sometimes there are items on expenses claims that are hard to explain. General Dostam had just one phrase to explain the difference between his forces and the Taliban: 'The Taliban don't play *buzkashi*.'

In 2001 Vaughan and I had been talking to General Dostam since the summer, well before 9/11. He had landed in the centre of the country by helicopter in the spring, in a rather courageous move to try to fight his way back home, and as keen on publicity as ever, he had wanted us along. Dostam put together a force of those same horsemen who I had seen playing *buzkashi*, and they took some ground from the Taliban. But they would only make real headway and their struggle only become international news once the Americans were on their side after the attack on the World Trade Center.

Our plan to join Dostam was a hard one to realise. I suspect that the Americans never wanted us to get there. Their Special Forces were too deeply involved on the ground to welcome intrusive British journalists. There was certainly a blanket ban on any helicopter rides whenever I tried to make a request through official channels, travelling up from Charikar to sit cross-legged on exquisite rugs with America's Afghan friends in the Northern Alliance headquarters, drinking endless glasses of green tea and eating sugared almonds, while listening to their honeyed excuses as to why we could not fly.

Peter Jouvenal, with his decades of Afghan experience, was contemptuous of Dostam. By now Peter had stripped the country down to a list of known rules, which he would bark out in terse sentences of few words. By abandoning Mazar to the Taliban in 1997 Dostam had broken one of the rules.

'Beaten commander. Never get back. They won't stand for it.' (In the end of course Peter would prove to be right. Dostam did retake part of the north but was never again the undisputed king of the region.)

In the first week of November tanks rumbled through Charikar at night, their lights sweeping the dark town, where there had been

no power for ten years. The tanks were a precious asset harvested from the Russians in the 1980s or bought on the black market and smuggled across the river from Tajikistan. They could not stay in the field for long. The assault on Kabul must now be imminent. There was money around; soldiers were paid and given rations for four days. And then the final clinching sign: the BBC's landlord, Haji Bari, became more insistent for advance payments of rent to cover a period when he knew we wouldn't be there. He deserved our nickname for him – 'Haji Dollar'.

There is nothing as intimidating as a tank in a village. The proportions are all wrong. The sheer walls of green armour squeezing between market stalls and the big barrel sticking out the front seem menacing enough. But it is not just the size of the leviathan that makes an impact; its sound is terrifying too. Black diesel smoke replaces the air, and wood and mud buildings fill with dust shaken out by vibrations that seem to presage the end of the world. The tanks sent a powerful message to Vaughan and me. We had to move north or we were going to miss the war.

Day after day helicopters came and went from the flat lawns near the bottom of the Panjshir valley, an airstrip surrounded by the rusting archaeology of quarter of a century of war – the chassis of an armoured personnel carrier had been thrown across the river as a bridge to the landing site. But the helicopters that emerged out of the low clouds of autumn were not going into the war. They were bringing in supplies and people for the assault on Kabul itself. We had been talking on the phone to General Dostam for a couple of weeks, and to another general in Tashkent, Dostam's personal pilot no less, who was going to fly us in. Or was he in Dushanbe? You never know with a satphone. All we knew for sure was that to get to General Dostam helicopters had to come down to the bottom of the Panjshir valley to refuel before flying over Taliban territory to get to the north. Other journalists

hung around at the helicopter pad too. But they were not looking to go further into the war. They were on their way out, hoping to hitch a ride rather than make the most punishing car journey in the world again, up through the Panjshir valley.

Despite the hopes and promises, no helicopters came for us. And then on the satphone I heard the news that meant we would have to make new plans.

'Mazar has fallen.'

'Is it certain, how do you know?'

'I just spoke to General Dostam himself. He is inside the city. He has been on CNN.'

CNN were not there. I knew they weren't. Dostam must have talked to them on the phone. No journalists were there for the key battles of the north of Afghanistan, and we had tried harder than most.

I put down the satphone and went along the corridor, my headlamp torch illuminating the sullen soldier who always sat outside the makeshift wooden partition we had put up, in a vain attempt to secure the BBC's end of the bomb-damaged building. The soldier smiled a big, toothless, mirthless grin as he always did and made the rustling sign with his fingers that means money. They were all on the take here. And now, as I walked on through the dark building after hearing the news on the satphone from Najibullah, the fixer working for me in London, I knew that we had missed it.

Najibullah could not be wrong. He had grown up over the road from General Dostam in Mazar, had known him all his life. I walked past the 'kitchen' of the small garrison 'Haji Dollar' kept around his quarters. The soldiers were cooking over an open fire in a small room that must originally have been built as a toilet. To let out the smoke they had knocked out the wall and part of the roof too, revealing a large patch of starlit sky. It was the only

way they knew. There is a primitive barbarity to most people in Afghanistan. The country was less sophisticated in 2001 than it was a thousand years ago. Except for the guns. The white teeth of smiles shone at me through the smoky gloom as I muttered a greeting.

'*Salaam a lekum!*'

Muffled '*salaams*' came back at me.

I knocked next door, and the bolt was drawn back to allow access to a gothic grotto built by Vaughan's old friend Anthony Loyd of *The Times* and the photographer Seamus Murphy, the only other journalists permitted by Peter to share the building. A landscape of blue candles grew out of a mess of solid wax moulded to the top of a sort of sideboard, like skyscrapers emerging out of a mountain. Other hillocks of candles revealed some flat red cotton-covered bedrolls covering most of the floor. Loyd, by now acknowledged as one of the finest war correspondents of this generation, sat at a table made from a board resting on bricks, his long blond hair flowing forwards, writing on a laptop powered by a car battery. He was close to a deadline.

'What do you know? Has it fallen?'

I wondered again at the strange language we use. Fallen. As if Mazar-e-Sharif, that beautiful city built around a shimmering blue mosque where a thousand white pigeons soar in a pack like moving silk, had stumbled and lost its footing in the desert.

'Yes. It's fallen. I have just spoken to Najibullah, who spoke to Dostam himself. He says he's in the city. They claim to have cleared out the Taliban all the way to the border.'

But I hadn't come to confirm the story for the front page of tomorrow's *Times*, though it would not have been the first time that we had swapped information. I had come to look for the third person in the room. Peering into the dark, I saw Vaughan's bearded face hanging in space, lit only by the line of candles.

His bald head was covered with a *pakhool*, one of those rolled woollen Panjshiri hats that can too easily look like a fried egg, and he wore a new dark blue *shalwar kameez*, loose trousers and long shirt, the normal dress in most of Pakistan and Afghanistan. He was smoking the inevitable roll-up and drinking local alcohol. Despite being one of the driest of dry countries, you could get pretty well anything you wanted in Charikar for the right money.

'Shit! So that means we won't get the pictures of the assault on Mazar.'

'That's what it means,' I confirmed.

It meant a lot to Vaughan. His whole career has been based on combat footage, and Dostam's cavalry backed by American air power would have delivered the most extraordinary images: twenty-first-century precision warfare from the air and the tactics of the stone age on the ground, with added Kalashnikovs, as horsemen fought their way down from the mountains.

Vaughan would not easily have been recognised that night by those who had trained him to stand in front of Buckingham Palace, guarding the Queen. He always tries to blend in with the local scenery, partly for safety and partly because clothes designed for the conditions feel more comfortable. We had been in Afghanistan for a month, and although blond, he had grown a decent beard. Every soldier on both sides of the front line had one. A Frontline cameraman had to follow suit. With the enthusiasm of a fetishist he buys new local scarves wherever he goes so he can blend in as a local, and now he wore a grey cotton scarf around his neck above the *kameez*, which he could quickly turn into a turban. He claims to be the only Englishman of his age who can tie both a bow tie and a turban. But none of that had any value if he was not taking pictures. Combat footage is the lifeblood of Frontline TV and if we were not going to get to the front, nothing else mattered.

And then things changed. Three days before the fall of Kabul, our helicopters came. WHAP, WHAP, WHAP, WHAP, WHAP. The long rotor blades beat against the thin mountain air as two big, Russian-built Hips clattered along the narrow choke in the mountains near the bottom of the Panjshir valley, only just fitting between the sheer rock faces on either side. Najibullah had called at dawn. He was still coordinating our entire operation from his flat in West Ham. General Dostam was now expecting us. There were helicopters on the way and a senior official in the Northern Alliance forces was going to give us clearance to get on them.

When we arrived on the ground, of course, it was not like that. Checking in on these flights was never going to be a routine affair. We still had to get onto the narrow bridge across the river, where a guard told us that it was completely impossible for any western journalist to join the flights. It always started like that. It was just a question of how much we could get away with before producing a bribe, who to pay and when. The young local interpreter with us was friendly enough but slightly out of his depth. But we also had a new secret weapon – a mobile satphone. I worked away with different officials keeping the line open to Najibullah in London, and handing the phone to these bemused men.

Afghans, particularly in the north, behave with formal politeness. Almost any chance conversation needs to go through a routine of asking about health and the state of the family before they get down to business. Listening to the guards on the bridge talking to Najibullah in West Ham, I recognised the routine – the pleasantries of the tea shop smoothing our way into the war. The stream of Persian words mattered. They would lubricate the journey as much as dollars.

'Greetings, How are you? I wish you peace and happiness, and how is your family? Where are you from?'

'Of course, I know your father, and how is he. I hope he is well.'

After the helicopter engines were turned off, the pilots appeared, walking in rather dainty shoes across the narrow bridge. They had the air of men who knew they had the most glamorous job in the country. They were generals of course, and we shook their manicured hands. Their moustaches were well trimmed, and they wore one-piece cotton flying suits as if they were a fashion item. One had a leather flying jacket hanging loosely over his shoulders. They smoked as though their helicopters were not being refuelled only yards away.

The pilots could not have been more polite. If it had been up to them they would have taken us anywhere. Nothing was too much trouble. And then they were off in a Russian jeep to a cafe nearby for lunch, bringing an unmistakable whiff of another world to the pinched poverty of the Panjshir. We were left with the rather less accommodating guards on the bridge who were still adamant that we were not going to the landing site. By now Najibullah had got a senior Northern Alliance military official on the phone – the one who'd given his permission for us to fly in the first place. The complication was that these were not General Dostam's helicopters. They had been requisitioned for a secret flight. We did not know where they were going but suddenly that sounded even more interesting. And for the first time we were able to take up an offer like that because we were carrying technology that would allow us to broadcast high-quality pictures from wherever we ended up.

Until then sending television pictures needed equipment weighing more than 200 kg that would fill a jeep. That's progress. Only a few years ago the kit filled a transit van, with a separate dish the size of a room. They were called 'flyaways', rather misleadingly, since they were so heavy. But they were a huge advance on the previous generation of equipment the size of a bus, which could certainly not be flown anywhere. Now Vaughan had put together pioneering lightweight editing and transmission technology, and

besides the lightweight digital camera, we needed only a laptop and a satphone about the same size. On top of that we each had about 30 kg of personal kit, dried food, a stove and sleeping bags, which gave us unprecedented ability to travel flexibly anywhere and broadcast at the same time.

Some money changed hands and suddenly it all moved quickly. We carried our packs across the bridge. The pilots returned; more money would change hands before we could take off. And then the big rotor blades were spinning again, and the helicopters rose and flew back up the valley for a while, before turning left and heading up the saddle at one end of the Hindu Kush, straight up to about 14,000 feet above sea level, the limits of height for such a large craft. The ground less than a hundred feet below was still in the hands of the Taliban and I said my prayers as never before as we made our way steadily across one of the most barren mountain ranges in the world.

We were the only passengers on the Hip, a helicopter built to take thirty soldiers. The rest of the space inside this big workhorse of war was taken up by big white bales. We edged back a corner of one of the bales with a knife. The cargo was money, billions of freshly minted Afghanis going to lubricate the conflict.

We did not know exactly where it was going, or which army it was to fund, since we had to leave our local interpreter on the ground. What we did know was that this flight was not going all the way to the north to meet General Dostam, but crucially it was getting us across the Taliban front lines into the area outside their control in the north and west. Once we were behind Taliban lines we could make our own decisions about where to go. During the long morning of negotiations it had quickly become clear that this was one of the first flights to make it out across the mountains because the pilots had been concerned about being shot down by the Taliban.

As the helicopters laboured in the high, thin air, we looked down at our shadows passing over occasional small huts close by below, searching for signs of life – fresh footprints in the snow, or any other Taliban activity in the high mountain wastes they still controlled.

Charikar, Afghanistan, 12 November 2001

They drove cautiously at first through the darkness before the dawn. Alongside Peter Jouvenal and John Simpson in the lead vehicle in a little BBC convoy was John Jennings, an old friend of Frontline who had been in and out of Afghanistan since the Russian invasion. Jennings had emerged from the dust one day, after taking a holiday from his job in the casualty department of a New York hospital to see Kabul fall.

He was a former US Marine, and besides his medical and military skills, he spoke Dari, the Afghan Persian dialect, with the same exact precision as he did everything else. He was very carefully spoken in any language, as if every word was being selected for its linguistic origin and relative value before being given a final polish and placed in the intellectual jigsaw puzzle that was his every sentence. He carried a righteous anger about the Taliban, remembering what he called 'all those Ally Mcbeals' who came to work in the World Trade Center on 11 September, and remembering too the long days and nights waiting in his hospital for the injured who never came, because they were all dead. He was tall and had a remarkable constitution which meant that he remained very, very thin whatever he ate. A memory that stays with me is of shaving in the ruin in Charikar very early, and suddenly noticed his pencil-thin form out on the balcony, carefully flossing his teeth with the focus of a Buddha.

Peter became impatient of the convoy very soon. There were too many vehicles. If they went the wrong way through the maze of

narrow dust tracks carved through the parched vineyards, it would be hard to turn round. And they were kicking up too much dust, attracting attention from enemy artillery, who might presume that the long convoy held senior commanders. If the BBC knew that the offensive was under way, then surely the Taliban did too. The Northern Alliance could not expect a walkover. There were other journalists around too, clustered together on a rooftop. This was no place for a Frontline cameraman.

The live news machine followed them now into the field. As a freelancer, Peter's ultimate objective was to get his correspondent into Kabul first. But the news beast needed feeding too. As another cameraman set up the videophone Peter began to look for the way out. His calculating and cautious exterior disguises a decisive temperament. Without any discussion he went forward on his own, carefully following fresh tank tracks, since the tanks would have detonated any mines. He disappeared for a few hours before returning with some pictures. When he came back John Simpson was live on the air with Jo Phua on the camera. Peter deposited his pictures and then sped off in his grey jeep again, leaving Simpson visibly mouthing obscenities at the departing vehicle while waiting for the next question from the studio in London.

Peter could not get stuck back here in the convoy. If he did, he would not get his pictures. He had seen the battle plans, but he knew that once the shooting started anything could happen. This was outside the realms of theory. It was the real thing, and in the fog of war it could all move very fast and unpredictably once things broke down. At that point he was still probing forward, searching for what the army calls the FEBA, the Forward Edge of the Battle Area. He knew that it might still be four miles away, and he had to get ahead to find it. He was being paid to be in the front line and he knew that if he got the pictures, any irritation provoked by how he had got them would soon be forgotten.

It was worth it. By the time he met the rest of the BBC again the Taliban had crumbled. In the middle of the afternoon, the Northern Alliance broke through and seized all of the Bagram air base. Peter had the pictures. There had not been much fighting and he had seen few bodies, except where the Afghans encountered foreign fighters. While he was crossing one part of the Taliban front line, three Pakistanis lifted up their heads. Their attempt to surrender was ignored, and they were shot at and set on from all sides: their uniforms ripped to shreds, their ammunition and personal effects stolen. In contrast there was not much retribution against captured Afghan opponents. The commanders and many soldiers knew each other well across the front line, as they had fought alongside each other during the shifting alliances of Afghanistan's long war. Providing the Arabs were out of the way, pro-Taliban commanders tried to change sides ahead of the advancing troops.

At nightfall the front-line troops stopped in a hospital by the side of the main road and called for food. It was clear they were not going any further that night. The BBC team headed back to Charikar to spend their last few hours in the ruined office block that had been home for a month. Retreating towards safety followed another of Peter's rules about Afghan wars. When they have momentum Afghans are good to work with, but if they have lost the initiative or are on the defensive, then it can get very dangerous. Peter did not want to be around if the Taliban mounted a counter-attack since he knew that the mood of the Northern Alliance troops could deteriorate quickly if they started to lose. They might even turn on journalists.

Kabul, Afghanistan, 13 November 2001

But the Taliban were finished. When John Simpson's team came down the same road again before daybreak they found they could drive straight through to the top of the hill above Kabul. They

could see the capital below them, nestling on the wide river at the strategic crossing point joining two mountain ranges.

The soldiers at the checkpoint were nervous and restless. Many had families and property in Kabul, which they were keen to protect, knowing that the changeover of power would probably be followed by looting, as had always happened before. There was tension and violence crackling in the air. A man who was mentally ill came up the hill and was mocked for a while, then savagely beaten by the victorious Tajik army.

There were two armoured vehicles across the road, parked on the express orders of the overall military commander of the assault, Peter's old friend Gul Haider. He came up for a friendly chat. But he had been told to stop anyone going in. His men were restless. And they wanted to get in quickly for another reason too. They had heard a rumour that the Americans were offering $3,000 for a captured Arab. Local commanders were offering side deals, bartering over wholesale prices for Arabs, fixing the market. But the Arabs were a risk as well. There had been reports for days of Arabs strapping explosives under their robes ready for a suicide attack as soon as they saw any journalist or American who came in. Peter was nervous.

The BBC's Charikar landlord, Haji Bari, was the first to try to drive down the hill, but returned quickly when he was shot at. His motivations for getting in first were not entirely connected to security. He had his eye on several houses he wanted to secure, to let to the foreigners who would undoubtedly flood in once the Taliban had gone. But then a taxi driver Peter knew emerged from the market and drove up the hill. If he could make it up and down, perhaps they all could. The BBC journalists were as restless as the Northern Alliance soldiers. No other journalists had arrived yet, but it was only a matter of time. They had invested a lot in this story. They were clearly not going to be able to drive in. The

suggestion that they should walk became more attractive as the minutes passed.

They decided to walk through the barricade one by one. John Simpson went first, then Peter, followed by the others – threading through at different points along the wide road. Peter bumped into another commander, who said that he had been shot at. But they carried on in a gathering wave of optimism that they were going to make it. Simpson sped up, walking faster than any time since a rudimentary operation in a Belgrade hospital during the NATO bombing three years before had left him with a limp. Peter had to run to get the shots he needed – from the back and crucially from the front. The images shot by him and Jo Phua, of Simpson striding down the hill became world famous.

As Peter ran backwards through the throng of people who began to be aware of what was going on he saw (out of the corner of his eye) a minibus, which had been driving up the hill, now reversing *down* the hill to keep up with their progress. He knew it would look odd. Uppermost in his mind now was cameraman's pride in the perfect shot. *The bloody thing's going the wrong way in the picture. Got to get it out of shot. John's motoring in. The liberation's good for him.* They were carried down the hill on a rising wave of emotion. People from the city came to meet them, shaking every hand. They must have been confused as anyone about who was actually in control. If the *BBC* were here, with *cameras*, then that meant the Taliban must have gone for good. *God, thank heavens we moved when we did. Any delay and there would have been a thousand journalists on the pass waiting for the signal from Gul Haider.*

And then they were split up as Peter crashed over a bicycle a bemused bystander was holding across the road. He dropped his camera, which was damaged as the flood of people swept past him.

Peter's taxi driver friend picked him up and they headed for the Intercontinental Hotel. On the way they saw a jeep full of Arab prisoners and Peter filmed their still-defiant expressions, pulling a mask down from the face of one man who had tried to hide his identity.

The hotel was quiet, its dusty 1970s-kitsch concrete reception area hardly living up to the magic of the liberation going on all around. Peter went upstairs to find John Simpson lying on the floor holding a phone. He said, 'Get down, there are Arabs outside.' Peter abandoned his damaged camera and borrowed another one. He went out to the hotel garden, where he witnessed the last act of Taliban defiance in Kabul, which, in a moment of Waugh-ish irony, took place in an abandoned wine cellar under the hotel grounds. The Taliban had seized all the alcohol they could find here when they took the city in 1996. Broken glass left by the temperance zealots still littered the ground. It was here that three Arab fighters had gone to ground and were to make their last stand.

It was potentially a very dangerous event to film. Anything could happen and Peter kept his distance, always making sure that he was close to cover as mujaheddin fighters fired down the glass-strewn steps into the wine cellar. They found another Arab and forced him to shout to those inside to give themselves up. The Arabs came out one by one, throwing guns and grenades on the ground as they surrendered. Then their captors began to fight each other for the spoils. Three Arabs were worth $9,000. It was a demeaning spectacle.

When he had finished filming Peter looked up to the top of the hotel. The Taliban had let a few journalists in before the end of the regime, and they stood now on the roof, setting up live camera positions but missing the gun battle which was going on under their noses.

He remembers that they were wearing yellow flak jackets.

XVIII

BUSH'S BEST

*There is nothing like the dawn. The quarter of an hour before
the curtain is lifted upon an unknowable situation is an intense
experience of war... Every step might be deadly; yet there was no
time for over-much precaution.*

Winston Churchill describing the battle of Omdurman,
2 September 1898

Hazarajat, Afghanistan, November 2001

For most of our short helicopter journey into the unknown nothing
grew on the ground below. There were the tracks of vehicles, and
the marks of horses' hooves on the high snow-covered plateau,
but we saw no people. Beyond the plateau the landscape gave way
to deep grooves into the softer red stone at the western end of the
Hindu Kush, leaving strange sculptures like chimneys above the
dark valleys cut into the mountains. Then the red turned to green.

After half an hour or so, we saw our first life, trees struggling
to grow at the higher end of a mountain stream that coursed out
of the startling green rock. It was a mysterious, wondrous place,
with the kind of scenery that is the stuff of myth and fantasy. A
waterfall spouted from the top of a mountain, giving life to a vivid

green river. In happier times this had been a place of pilgrimage, the site of a local version of the St George legend. The mountain is shaped like a dragon, who once demanded the life of a maiden every day until it was killed. The sound of the springs bubbling through the rock is said to be the groaning of the dragon.

The helicopters followed the surprising green river through the sparse elemental landscape until it levelled off to a flat plain, maybe half a mile wide, the first level ground we had seen, although it would take the hardiest crops imaginable to grow up here, since we were still around 8,000 feet above sea level.

We landed at the end of a valley beside a small hillock flanked by a guard of armed horsemen. They were alert, since the region was still surrounded on four sides by the Taliban. We had arrived unexpected, with neither interpreter nor transport, into the middle of an army at war. Through the windows, I recognised them to be from the Hazara tribe, Genghis Khan's descendants. As the doors opened and we jumped out I caught a glimpse of a decidedly non-Mongol figure: a tall, well-built white man wearing jeans and a T-shirt, outside a house on the side of the valley. He pulled down his binoculars, turned quickly and walked up the steep track out of sight, revealing the matt-black stock of a rifle which was certainly more advanced than the AK47s being carried by the Hazaras around him.

Later, in Vaughan's footage, I could see that he had seen more Americans. Vaughan had disappeared as soon as we landed, melting into the landscape, but had enough time for a steady and usable shot of a line of US Special Forces soldiers moving sharply back under cover as soon as they saw us step down from the helicopter.

We each played our roles – Vaughan's to film what he could as discreetly as possible, mine to do my impression of Stanley meeting Livingstone, and confirm my suspicions of where we were. It was not quite 'Dr Khalili I presume?' but it was close to it, as I walked over

towards a distinguished figure with a white beard and a western-style tweed jacket, standing head and shoulders above the other Hazaras around him. This was the man who was being most closely watched by the silent warriors mounted on horseback holding all of the high positions around us. I recognised him, although we had never met – Ustav Karim Khalili, the most prominent Hazara leader, backed and financed partly by Iran, but not under their control. The Hazaras are a tribe with a fiercely independent tradition, who have often faced persecution. Now they were going to fight their way home. We did not have five words in any shared language, but he seemed happy enough to see the BBC.

He and the Americans left on the helicopters loaded with money, while we took over their one-room house on the side of the hill. And if proof of the nationality of the men who had just left were needed, I found an empty tin in the kitchen advertising its contents as 'fat-free, low sodium baked beans' – which would not have been the choice of the British Army. The name of the manufacturer of the baked beans that fuelled the advance of America's elite troops was 'Bush's Best'.

This was the headquarters of Afghanistan's poorest army. With a 16-year-old boy who spoke a little English as our guide, we took one of their three vehicles, an ancient Russian jeep, into the nearby town, Yakovlang. Armed horsemen easily kept up with us for the short journey along the neglected dust track, which was the only road into the major town of the region.

In Yakovlang there was evidence of ethnic cleansing against the Hazaras on a Bosnian scale. The town had been put to the torch. There were stories of mass graves, of hundreds killed in Taliban reprisal raids. One of the strangest images Vaughan caught on tape was the remains of a shop that must have belonged to a money changer. It is hard to burn money when it is tightly packed together, and charred scraps of notes floated around the

ruins above a floor of solid charred cash. The pictures had an unmistakable echo of another fanatical experiment, 'Year Zero' in Cambodia under Pol Pot.

In their mountain fastness the Hazaras have suffered persecution from all of Afghanistan's rulers, but never as badly as from the Taliban. The Taliban found any number of reasons to hate them. As Shias they were the wrong kind of Muslims, and spoke a Persian dialect, unlike the Pashtu-speaking Taliban. The accident of history that left the finest large Buddhas from the ancient world in the hands of the Hazaras was another reason for Taliban contempt.

The following day we witnessed Hazara jubilation, mixed by bitterness of what had been lost, as they advanced into Bamiyan, the town where the Buddhas had stood for a thousand years until they were blown up by order of the Arabs in the Taliban high command, earlier that year. Their destruction had shocked every Afghan. Vaughan filmed the empty holes in the Hindu Kush and the piles of rubble where the Buddhas had stood. After the battle for Bamiyan, the Hazara commanders ordered that we should be taken away for safety, in case of a Taliban counter-attack.

Working in a village high up in the mountains, about seven miles from Bamiyan, we used our new lightweight transmission technology, the first time it had been used for any BBC report. We were put into what we later discovered was the women's quarters of a farm, and we loaded up the pictures we would need from a DV camera onto a laptop with the entire population of the tiny mountain village looking in at the window. They did not know that they were watching a little piece of television history; we must have seemed like aliens from another planet, as we sat for hours at a flickering screen, while warming food as if by magic in a silver bag without a fire.

The discovery of a chemical that heats water to boiling point on contact has really made a difference for this kind of travel.

Whoever makes them, I suppose we will always now call them MREs – Meals Ready to Eat – after the US army's habit of turning words round, mangling the language in that special way they have. We could not carry too many of them because they were heavy. But we had brought just enough to keep us warm on nights like this, when morale could be boosted enormously with a hot chicken tikka. While Vaughan loaded up the pictures into his laptop I tore off the top of a couple of plastic bags, filling them from the stream that ran through the compound, which activated the magical chemical and warmed up the meal in its silver bag.

Once I had written the script and we had edited the piece, Vaughan compressed it into a usable-size file, and pressed 'Enter'. It was a cold but clear night, and the two satphones we had put on the flat mud roof above our heads should have no trouble finding a signal. The risky helicopter ride across the Taliban front lines had paid off. In the liberation of Bamiyan we had a genuine exclusive, days ahead of anybody else, and for the first time we could carry the technology to tell the story.

> What we found was a scene of complete devastation. After retaking their home town, the Hazaras rushed to the place where their Buddhas, the largest in the ancient world had stood before they were destroyed by the Taliban... Although President Bush is fighting what he calls the first war of the twenty-first century with high-technology bombing from the air, on the ground nothing has changed much here since Genghis Khan. Apart from the Kalashnikovs. (*BBC News*, 13 November 2001)

Vaughan put a Mozart CD into the laptop, *Così fan tutte* if memory serves me well, and smoked some of the finest cannabis known in the world. A few days before he had sent a driver out

with just ten dollars to buy some in Charikar, and the man had come back with such a large brick that he had to leave most of it behind with Loyd and Murphy in their gothic grotto.

The following morning we realised the extreme vulnerability of our situation. We woke to find that the vehicle that had brought us up the mountain had left to rejoin the war effort. They had taken us to a place of safety but not bothered to take us out again. Vaughan spent the morning juggling to entertain the children, and played them the piece we had transmitted of the fall of Bamiyan. Even the women in the family came from the room we had exiled them to for the night, dropping their veils long enough to view the film, giggling and flapping like a flock of birds at so many strange men inside the compound. But there was still no vehicle in sight. It was a beautiful place, with a timeless charm and a view that took your breath away. A mountain stream ran under the whole line of houses, supplying clean water, at least to the house at the top. The scenes around us, of men sitting on their haunches in the sunshine chatting, women carrying firewood, cooking and keeping the children in order, could not have changed much in the thousand years since the Buddhas themselves were carved from the rocks of the Hindu Kush,

We had lost our 16-year-old English speaker by now, and the Hazara army had sent another 'translator' with us. But his English was worse than my Persian, i.e. non-existent, and to spare his embarrassment we never exposed him. In the middle of the morning, with a lot of sign language, we sent him off to see what had happened to the vehicle, and we never saw him again. Clearly if we were ever going to leave we would have to arrange it ourselves. We could have walked, but the packs were heavy to go very far at this altitude, especially since we had picked up a car battery along the way, so we found a couple of mules to carry our kit back down to Bamiyan while we walked behind them in the

mountain sunshine. Our host, who had never left my side even when I had walked off for a shave and those other things you need to do in the morning, insisted on escorting us back to town with the mule-owner. I gave him a hundred dollars for his hospitality, less than half the price of a night in a European business hotel. It was a ridiculous amount of money here – enough for everything he would need to buy for a year in a subsistence society where there is little to buy anyway.

When we got back into Bamiyan we had one of those chance meetings which can make or break a story. As we arrived a line of army trucks had just pulled up outside the school, which was one of the few buildings left standing after the Taliban holocaust had passed. It was a temporary forward headquarters for Khalili. But we did not go in to see him. We were interested in the soldiers who were now climbing aboard. The commander in charge of the front truck was a teenage wide boy with a ready smile and some English. In this Dickensian scene of squalor and poverty he was the Artful Dodger, a thin boy with a curtain of long black hair, painted fingernails and a few gold teeth, dressed in a long black cloak like a medieval scholar. He had joined up to fight when he was a small boy after both his parents were killed by the Russians – or was it the Tajiks or the Uzbeks or the Taliban who had killed them? It did not matter. War had never left Bamiyan alone for long. It turned out that the trucks were heading for Kabul, loaded with a thousand soldiers in order to defend the Hazara community. The memory of the massacres they had suffered in 1992, the last time the city was taken by the Tajik-dominated army, were still fresh. The very name 'Hazara' means a thousand, and is a reminder of their warrior past, like calling a tribe 'battalion' or 'division'. This was too good a story to miss. The Northern Alliance had just pushed out the Taliban with American air support, and now another army was heading for the capital.

While I squeezed into the cabin Vaughan climbed up into the back with the backpacks and satphones and the car battery, enduring a long, cold, bumpy ride. As the trucks wound down from the Hindu Kush towards the capital he filmed the Hazaras singing and chatting and cleaning their weapons until it was too dark to film any more. Some of the soldiers were just boys, nine or ten years old, the age the Artful Dodger had been when he first joined up. One carried a large gun on a tripod, as big as himself, just like the gun I had once heard Peter Jouvenal describe as a 'BFMG Mark I', when he was asked to identify it using his military judgement, by an earnest young producer: a 'Big Fucking Machine Gun'.

In the cabin there were absurd shining glittery pink hearts stuck to the brutally utilitarian olive-green sheet-metal dashboard. A postcard from London had been glued on by somebody, its edges smoothed by a thousand greasy hands clutching at Big Ben as the unyielding steel leaves in the suspension failed to soften the crushing impact of the roads. Who had stuck on the postcard and the hearts? A Russian soldier, frightened and alone in Afghanistan, who had had his throat cut at night a generation ago, while sleeping in his cab? Or had the hulking Kamaz been given as military aid by Uzbekistan, or Tajikistan, as Central Asia tried to influence its troublesome southern neighbour? The truck was a timeless ancient beast, one of thousands that were rolled out – the same for half a century – sculpted from too-thick steel in huge belching factories somewhere in Russia, at the heart of the former colossus of the Soviet military-industrial complex. Communism may not have lasted, but the reliability of its over-engineered trucks and jeeps meant that they would go on in places like this after the end of the world.

As we set off the driver gestured at the glare coming through the scratched windscreen and pointed to my sunglasses. He was a

tough-looking Hazara in his forties, old for this army, his round face and oriental eyes framed by a filthy sand-coloured turban. Dressed in a series of layers of similar-coloured faded jackets and shirts, with a faded padded jacket on top, he seemed to be moulded from the same material as the truck. The sunglasses seemed a small price to pay for the story.

'So. Mister David. You get me passport to England. You big man. British BBC yeah?'

The Artful Dodger never let up during the days we travelled together. The driver had wanted only my sunglasses. He wanted a letter to the Queen. Big Ben was inches away, bobbing up and down on the dashboard as the Kamaz crashed along the cratered sandy track. It seemed a world away for this boy who knew only war. But he was certain that I was going to get him there.

'Here, my name Kamal. You take it and give to Embassy. I come London and see you. You my friend?'

All this with a gold-toothed smile under a wispy down moustache on a lip which had never known a razor. I asked him how he had come to fight. He gave the same answer I have heard from boy soldiers elsewhere, the same pitiless intent, the same naïve charm.

'I joined up to kill. Once my parents killed I kill often. Afghans fight. I fight. Now I come to London, yes?'

He could write in English, and the men under his command, some twice his age, called him 'Doctor' because he had once worked in a pharmacy. A little learning goes a long way in a society where most sign their names with a thumbprint.

The Hazaras were in a hurry. We stopped at about eleven at night, and most of them crammed together into a large room in a health centre while Vaughan and I opted for sleeping bags on the frozen ground outside. We knew that the kit we had would keep us warm, although the ten minutes or so before we got into our sleeping bags were painful. It was well below freezing, and we

were now back above 10,000 feet since we had been labouring up switch-backed passes to cross the last mountain range before Kabul. We moved off again at first light, around 5 o'clock, just giving me time to file a short piece for radio news on the mobile satphone.

We stopped a couple of hours later in a small mountain village, which was quickly taken over by the army of a thousand. In a café we caught up with our money, the billions of Afghanis that had arrived on our helicopters. Vaughan filmed a circle of commanders through the woodsmoke, dividing the money to pay the men to garrison the Hazara areas of Kabul. The Artful Dodger took his sackful of money with the other commanders, and then went out to supervise the refuelling of the truck from an underground diesel reservoir left by the Taliban. He ignored the bodies of dead Taliban soldiers, already swarming with flies. The Hazaras had extended their transport. As well as the trucks they had now taken a tank, one of the small T-62s that had been originally been taken from the Russians.

By the time we stopped again, in the early afternoon, just a couple of hours from Kabul, I realised again the awesome reach of the BBC in that part of the world, which is often underestimated. The shortwave local-language bulletins remain the single most potent force of the BBC, even in the internet age, particularly in trouble spots, and nowhere more than in Afghanistan.

Now the army of a thousand Hazaras had been stalled on its advance to Kabul because the Northern Alliance had heard my report and wanted to talk to them. A short radio piece about another army heading for the capital had set alarm bells ringing. We needed to find the Hazara leader Khalili, who was by now in a village ahead of us. Our army trucks had stopped in a remote village, so we had to walk several miles carrying our packs, leaving the Artful Dodger and his men behind. On the way we

bumped into a group of Taliban stranded by the side of the road. They were mending a puncture in one of their trademark Toyota 'Hilux' four-wheel-drive vehicles, the key weapon that had won them Afghanistan in the mid 1990s.

In that register of weapons which have defined conflicts – the longbow at Agincourt, the Spitfire in the Battle of Britain, the Huey helicopter in Vietnam – the Hilux was the secret weapon for the Taliban in Afghanistan. During their years of ascendancy they owed the speed and mobility of all of their swift advances to the Hilux. They would not have taken Herat in the west or Kabul itself in 1996 without it. We walked forward cautiously since the eight men in two vehicles were still armed, but we found them friendly enough. They were even happy to be filmed – the strictures of their leader Mullah Omar against cameras were never popular among his soldiers, who wanted to be on TV just like anyone else. Vaughan's pictures show men who look as though they are auditioning as extras for a romantic film set on a pirate ship – big handsome Pashtuns with ludicrously long, black, flowing beards, heads swathed in black turbans. As usual some were without eyes or legs. Their leader turned out to be a Vicar of Bray character who was the living definition of one of those 'rules' about Afghanistan: 'You can never own an Afghan, you can only rent one for a while.' He was the Mayor of the next town, halfway between here and Kabul. It was a Pashtun community, sandwiched now between the unyielding Tajiks who had taken the capital and the Hazara army of a thousand. He had seen the Hazara advance, and wanted them to know that he was happy to make peace. That night, his nephew, a Talib who spoke good English, came to see us to borrow our satphone to make what he said was a call to a relative in Saudi Arabia.

When we met up with Ustav Khalili, who we had last seen in that magical highland valley before the fall of Bamiyan, his story

had changed. He made out that the soldiers we were with were his bodyguards, although I pointed out most world leaders did not need a thousand men for close protection to guarantee their security.

And we *knew* why the Hazara army had been sent to Kabul. Vaughan had shot vivid pictures of a dawn briefing on a high mountain ridge as the general in command of the army had told his men exactly why they were going, reminding them not to commit abuses against non-Hazara Kabul residents as they protected their own. But my radio broadcast had stirred up the Northern Alliance high command, who now knew they were coming. It was going to take a while for them to negotiate their way in.

We settled into the oily back room of a garage, miraculously finding an old tractor battery under a sheet in the corner, which gave us just enough power hooked up alongside our nearly dead car battery to send another TV report, before rolling out our sleeping bags on the dusty floor. We had not seen any clean water for several days but could still transmit television pictures. And that's progress?

The next day Vaughan filmed the first Friday prayers in the Shia mosque since the Hazaras had pushed the Taliban out, liberating their mountains again. Khalili rose to the occasion, speaking for about an hour about the past and future of his nation. Watching Moses must have been something like this. There was no room inside but Vaughan found a vantage point at an open window to film the speech. Many of the soldiers who filled the square outside the mosque could not fight back their tears.

Kabul was still half a day away, and *Newsnight* wanted the Hazara story on that night. It would be hard to edit a whole *Newsnight* in the back room of the garage, so we left the army of a thousand and drove into the capital in a borrowed aid-worker's vehicle through the area still nominally in Taliban hands.

Suspicious Talibs, frightened now, scurried along the roads. They had nowhere left to run. After dark a gang of thieves loomed out of the darkness forcing us to stop. They were operating in the brief envelope of chaos between the enforced stability of the Taliban and the *pax Americana* they thought was to come. There were half a dozen of them, and from their dress they seemed to be a mixed group from different armies. They claimed to be police and tried to extort money. These situations can go well or they can go very badly. You can pay up, or bargain, or get shot. But we had found a giant of a driver, who bellowed at them and drove on. Their rifle barrels clattered against the windows and bodywork of the car as he accelerated and I tensed up, waiting for the shots. But no shots came. Only a few minutes later we came to the first street lights of the outskirts of Kabul, the first electricity we had seen for a month.

The BBC had taken over most of a floor of the dusty, abandoned Intercontinental Hotel. The sheer scale of the machine needed to service the 24-hour news networks that now drive all our coverage never ceases to surprise me. But Peter Jouvenal was not among the army of crews and producers and engineers. On the first day of the liberation he had found Osama bin Laden's house. He wanted to find out more about him and his plans. Six months earlier Peter had helped an American TV crew to track down an al-Qaeda sympathiser in Malaysia. That gave him access to pictures which showed all of Osama's properties in Kabul.

In one of the houses Peter found a book with advanced plans for an al-Qaeda Stealth bomber, which concluded that it could easily be built in the valleys of Afghanistan because labour costs were so much lower than in America. This bizarre reasoning, ignoring the billions of dollars needed for research and development, was an extraordinary insight into the zealots' fragile hold on reality, and their continued obsession with planes, demonstrated with such

shocking effect on 9/11. On the one hand they could successfully knock down skyscrapers, on the other they were fantasising about supersonic Stealth planes to fly their agents around the world, while they could not even mend the roads or provide clean water in Afghanistan.

Peter took with him the newspaper reporter he trusted most, Anthony Loyd – a Frontline member in all but name, and Loyd took these documents and others he found back to *The Times* in London. Once they were translated he turned in a characteristic scoop that proved Osama's fascination with nuclear weapons.

Peter was now negotiating to clear the house of the remnants of military planning left over once American agents had rifled through the material for themselves. He paid off Osama bin Laden's outstanding rent and ended up living there, renting rooms to journalists. He could offer the best dateline there was. For months afterwards, stories from Kabul in newspapers across the world would begin with the line: 'I woke up in Osama bin Laden's bed...' After setting up his hotel, Peter did not set foot in England again for another year.

One of the first residents, at a time when guests had to decorate and furnish their own rooms, was Barbara Jones from the *Mail on Sunday*, who stayed on for a while. Her first exploit after the fall of Kabul had been like something from Fleet Street folklore. She had bought up the single surviving lion in Kabul Zoo and used the newspaper to launch an appeal to save it. Before she headed for Peter's hotel she had turned a ghastly abandoned room in the Intercontinental Hotel into a kind of salon, with rugs on the floor and candles, where we spent a few evenings drinking the last vodka and eating the last bits of Italian sausage anyone had, cut into tiny squares on bits of Ritz biscuit. After a month sleeping in a shed it felt pretty sophisticated. In a ridiculous drunken argument the thin American doctor John Jennings said that Saddam Hussein

should be the next target of American wrath. It seemed black and white to him: Saddam should be toppled. The world was feeling a far less safe place.

Peter was at home now. The Taliban had gone; he could operate more freely in Kabul again. He had played host to the BBC for a month, now he was going to stay in Kabul to live. But for Vaughan and me it felt like time to go. Being in the right place at the right time is not just about knowing when to arrive but when to leave. The day after we arrived in Kabul, and after just a few hours' sleep since we had been up half the night putting together the Hazara story for *Newsnight*, I was asked to put together a routine short news piece on the situation in the capital. I was startled when the picture editor went off on a meal break in the middle of the edit. No one could deny it him, but after living and working in some of the most arduous conditions imaginable for a month the culture shock to me was something of a surprise – an intrusion of normality. I remember his reaction too when he saw Peter's pictures of the damage inflicted by American bombs on Taliban convoys.

'Huh! Can't use those. I don't know why he bothers. When will he ever learn?' It was the comfortable contempt of the staff man for the freelancer.

The shots were certainly grisly. Remembering where he had seen American bombs and missiles landing from the other side, Peter had spent a day filming the effects of targeted high explosive dropped from 15,000 feet. There was the occasional tank, but the pictures were mostly of convoys of Hilux four-wheel drives and trucks. The men who had been in those convoys had been vaporised in the intense heat of the fires, although here and there something of them remained and the pictures showed congealed masses of melted cartilage shrunk tight on to blackened skeletons. Next to the burnt remains of one Hilux was the melted shadow of

a man, blackening the dust, after his form had all burnt away at unimaginable temperatures. The shots reminded me of Hiroshima and were certainly as macabre as the famous newspaper pictures of dead Iraqis welded to their steering wheels in the 'turkey shoot' on the Mutla Ridge at the end of the Gulf War in 1991.

Peter knew that most of these images could not be shown on British television in the uncompromising way that he had shot them. But he did it that way, true to the last to his view of his craft. He does it as a witness, out of respect for the individuals, and a wider cause – for humanity itself. He believes that if there had been good cameramen in the trenches in the First World War, that slaughter would not have gone on for as long as it did. His pictures of the blackened remains of Taliban drivers grilled by American bombs were shot just for the picture editor who turned his face away from them. For Peter, war cannot be sanitised or there will be more war.

As he boxes up and trades the arms sold by the British to both sides in earlier Afghan wars Peter becomes more confirmed in his own mind of the wrongs of the modern arms trade. He sees it as hypocritical that Britain sells arms to both sides in the conflict between India and Pakistan and then complains when tensions increase in the region. To him it is a key function of democracy that these things are filmed and reported.

Before we left Vaughan and I had one appointment to keep, and a couple of days after arriving in Kabul we set out again in the direction of our 'army of a thousand'. We had persuaded the Taliban we had met repairing their puncture to do an interview, in exchange for borrowing our satphone. No one else had talked to any Taliban since their government had collapsed; it seemed to be a pretty good story. But we never made it.

The Northern Alliance had heard that they were still there too, and they were not planning to negotiate. When we arrived on

the road out to their village, a legendary mujaheddin commander, dressed in long, flowing white robes, was surrounded by a delegation of old men who had come to try to prevent any more destruction. But he was not listening to them; he did not really want to talk peace. He was more interested in ensuring that his tanks were digging into the right positions to fire soon. Since the shooting had not actually started yet, we talked to the elders about going back with them. And I asked our driver, the big man who had saved us from the gang of bandits, what were the chances of us being held as hostages if we went into the Taliban area that lay between us and the Hazara army.

'About ninety per cent,' he said, without smiling.

It was time to go. As we got back into the centre of Kabul, driving at about forty miles an hour along a mercifully straight road, one of the front wheels came off and bounded off into the distance while the vehicle ground to an ungainly halt on the exposed axle. We walked hopelessly back along the road, searching for wheelnuts, until we hit on the idea of paying for them. The price was set at 25,000 Afghanis, about £1, for a nut. In less than five minutes we had eight nuts, three more than we needed to secure the wheel. Only in Afghanistan.

We planned to drive out at dawn to the Torkham border, the gateway to the Khyber Pass. The night before we left another of the Frontline cameramen, Robert Adams, had arrived in Kabul along the road we planned to use. It crossed the area where Osama bin Laden had had his headquarters and most of his training camps, until the bombing started. There was no confirmation that it was safe, but Robert had not faced any problems. I remembered his words the next day: 'It's fine, quite safe in Afghan terms,' adding, 'as long as you don't upset anyone.' Mark Urban, who came at the same time, expressed some concern about the road, urging caution in the town of Sarobi in particular.

We had a different vehicle but the big driver came along as a passenger. He was going to see his family, who lived across the border as refugees in Pakistan. He carried a small electric keyboard, a present for his daughter. As soon as the Taliban had gone, formerly forbidden items were already appearing in the shops in Kabul.

Vaughan and I were extremely cautious about this journey, wrapping ourselves in Afghan scarves and blankets, making some attempt at disguise. Following Urban's warning, we were most concerned about the town of Sarobi, about a third of the way to the border. But our new driver, a voluble and rather stupid man who talked all the way, did not seem to realise the potential danger we were in. There was a problem with the vehicle, as always in this land of second-hand cars and bad roads. The driver stopped at a garage actually in Sarobi, gossiping loudly with the mechanic and anyone who passed, smoking a cigarette in the street, although the holy month Ramadan had just begun, when smoking, drinking and eating during the day are banned. We sat firmly in the back in our disguises, avoiding the gaze of people who passed.

Once the vehicle was fixed we drove on again, and going through Jalalabad, the last town before the border, we picked up the first whispers of a rumour that something terrible had happened. We did not know what it was; the people who told us did not know. We drove on. Thinking ourselves reasonably safe beyond Jalalabad, we stopped for a pee and I began to make a phone call on our mobile satphone. But the big man, whose judgement we had trusted for several days now, was agitated. He wanted to move onto the border as fast as we could. The leaves on the trees shook above our heads in the wind that carried the news of the horror.

When we arrived we found the border closed to people trying to get into Afghanistan from the other side. We could get out though,

and after I made a personal appeal to the head of the Pakistani border police, I was allowed to go back and call the big man out across the barbed wire, carrying his keyboard for his daughter. Although he did not have the right papers, we argued his case for him and got him through. And then we were surrounded by journalists who had been blocked from getting into Afghanistan. They were mostly women and mostly Americans. They were in quite a state of outrage because their 'rights' to cross the border were being infringed. Even getting as far as they had from the Pakistani side had taken them all a lot of time and effort. To cross the so-called tribal areas to get to the border needed written permission and an approved guard. Now they had got this far they had been blocked from going into Afghanistan. They shook with righteous indignation. There was much talk of free speech, of ambassadors getting involved. To those of us who had been through the war for more than a month it all sounded rather petty.

And there were rumours of journalists being hurt. 'What do you know? What did you hear? What did you see?' We knew nothing, we had heard nothing, we had seen nothing. A taxi driver I knew was driving one of the frustrated journalists back into town, and I managed to hitch a lift. She stopped at the home of a Pashtun tribal leader to see if he could help to get her into Afghanistan. But as the hours passed it emerged that closing the border was exactly the right thing to do.

Four journalists had been shot dead while driving through Sarobi towards Kabul. Our caution had been appropriate, although I do not know if it would have made any difference if we had bumped into that gang. The killers were probably rogue ex-Taliban, still carrying out the requirement of their leadership to kill foreigners. Piecing it together later, I think that the incident happened about half an hour after we stopped in Sarobi.

We must have passed their convoy on the road.

XIX

WORTH A LIFE

A people without fortified towns, living, as the Scythians do, in wagons which they take with them wherever they go, accustomed, one and all, to fight on horseback with bows and arrows, and dependent for their food not upon agriculture but on their cattle: how can such a people fail?

Herodotus, *The Histories* (490 BC)

Ingushetia, September 2002

The pictures Roddy Scott took while travelling with Chechen rebels, crossing neighbouring Ingushetia on their way to join the fight for their homeland, were a remarkable insight into a secretive group who had taken on the Russian army. He filmed them training, then travelling with horses through the green hills of the Caucasus, from their camps in Georgia towards the war in their homeland.

There had been Chechens in the Pankisi Gorge on the other side of the border in Georgia for generations, and their numbers were now swollen by thousands of refugees from the long brutal Russian campaigns against their country. Roddy came to know them well. Before he set out for the Pankisi Gorge he emailed a freelance

journalist who lived there: 'I personally think Pankisi is a great story; it's about the first time I have ever seen the possibility for someone to really lift the lid on everything, rather than the usual journo-grasping-at-straws-with-no-good-sources which seems to emanate from that region.' He walked for a month with the rebels through tough terrain. Five hundred set out in his group; by the time they reached the Chechen border only around 200 remained. Two German mercenaries had set out with the expedition but turned back when the going got too tough. They ran out of food and water, eating only grass and berries for some days before they came upon a herder and bought a cow from him.

The Chechens soon realised that the Russians knew where they were. Their aim had been to join other companies of rebels to carry out a new assault on the Chechen capital, Grozny, but now they found themselves surrounded and fighting for their lives. Roddy died in the village of Galashki on the border. He was with an advance guard, but then remained back with their commander while five men went ahead using the cover provided by a drainage pipe, trying to find their way through the village and evade the Russian cordon.

Roddy must have known that he was in trouble; he wrote a last letter home. Afterwards the Russians said that he was a mercenary or a spy, and claimed that he was wearing military clothing. This was a lie. Roddy had never worn a uniform; he was a true freelance adventurer, with a passionate belief that the story should be told at a point when no mainstream broadcasters could take the time or the risk to tell it. Survivors from the group of Chechens who were with him say that he was targeted by a sniper and was waving a white cloth when he was shot. A Chechen who came to his aid was shot too.

Roddy had always said that he would give himself up to the Russians if things became too dangerous, but he did not have the

chance. His parents, Robin and Stina, later travelled to a refugee hostel in Vienna to meet Chechen rebel fighters who were with Roddy when he died. They slaughtered a sheep in his memory, and sang a long and sombre song honouring the Scotts and remembering Roddy as a martyr.

Like so many of the Frontline cameramen, Roddy never became rich. It was an industry where you could make a lot of money quickly or none at all. He had to wait for a broadcaster to pay £500 owing from an earlier Afghan trip before he had the money he needed to set out, joking to Vaughan that he wanted to make enough from this Chechen trip to 'at least buy a new pair of boots'. He tried to persuade me to join him, when I bumped into him the day before he left, in the tiny mews office that now housed Frontline, in Paddington. I could not spare the time; only a committed freelancer could.

Roddy was a remarkable man, a relative of the late C. P. Scott, legendary editor of the *Manchester Guardian*. He had always been a traveller, learning Arabic along the way. Even while he was still a student he spent one university vacation in a Kurdish refugee camp in northern Iraq. (They gave him a rifle, after asking him to hit a distant rock to make sure that he could shoot.) After he died, the best tributes came from people he had met in unusual places. He was 'a silent man with a love for his work', according to a freelance journalist, Nathaniel Abrio, who was planning a project with him in the Philippines, where more local journalists are killed than any other country in the world. Nathaniel emailed Roddy's parents after he heard that Roddy had been shot, one of a number of unlikely contacts Roddy had made around the world during his career who emerged after he died to tell how he had touched their lives. Abrio said that Roddy had lived 'to bring into the world what his eyes have seen and make us understand the real story' – perhaps the most lyrical description of the work

of the freelance cameraman ever written. Another friend wrote to say that despite the suffering he saw Roddy always remained kind-hearted. 'He was so modest, he didn't have a sense for what a larger-than-life and interesting person he was.'

In that year's edition of a specialist travel guide book, *The World's Most Dangerous Places,* Chechnya was 'the world's *most* dangerous place'. Roddy knew where he was going; to make a bit of money, he had helped to write the guide. He had been to Georgia before, knew and trusted the men he was with, and had tried to make the same journey during the previous winter in extreme weather conditions. His family and friends supported his decision to make the trip. In a letter to *The Times* his father called him 'extremely brave':

> He was totally alert to all the risks and had indeed met most at first hand. It was only this proof of physical and professional calibre that made him acceptable on a mission that included the possibility of heavy losses.

Robin Scott wrote his letter after his son's name and reputation were sneered at in a really unpleasant piece in *The Times*. Roddy was described as 'naïve', in a report that quoted unnamed journalists as saying that his trip had been 'practically suicidal and really crazy'. The anonymity of the attack made it even more cowardly. There has always been whispering, when Frontline cameramen have died, about how unsafe they are, and pieces written with the perfect clarity of hindsight, from the security of a pensionable job, on a state-of-the-art computer in an air-conditioned office, about how the Frontline men should not have been where they were when they died. But this article in *The Times* was the worst, sinking to new depths of contempt, saying that Roddy had 'no right' to be where he was. It prompted Vaughan to urge several

friends in broadcasting and journalism to protest. He wrote in graphic terms: 'We have every right to spill our own blood if we want to and have never held broadcasters responsible for it in the absence of a contract.'

There is something deeply embedded in human psychology that should be examined, to explain this lack of respect for journalists who die in conflict. It is becoming a very dangerous job. There were more journalists killed in a shorter period of time in the second Iraq war than at any time since the most intense periods of the Second World War. Many of them were killed by the Americans, and yet the Pentagon has not apologised. Somehow they are to blame for their own deaths. You hear people say things like, 'He brought it on himself, he shouldn't have been there', and so on. You do not hear that said about soldiers who die in conflict. Their decision to risk their lives is ritualised, ours can be derided.

Given the importance of the work of journalists, it is surprising perhaps that remembrance is so rare. The lens on a TV camera is a window on the world, which plays a central role in informing democracy, in shaping our common understanding of the human condition. Every image of violence shown on television is taken at some risk, since at any moment the situation could change and become lethal to the person holding the camera. To make those judgements, on how to operate and stay alive, when to remain and when to run, people need a most refined sense of risk-taking. Living with the stark daily possibility of death immediately sets them apart, and perhaps the blame which journalists, especially freelance journalists, face when they die comes from being set apart.

Bruce Chatwin wrote compellingly about the way that nomads have always been outcasts. Even when they were organised and sophisticated they were seen as dangerous to people who lived in cities, because they were different. They did not plant crops

or move inside the safety of the city wall, even when it became possible. Their *decision* to remain free was profoundly threatening to the psychology of the herd. Europe's disgraceful treatment of Roma people, who continue to face oppression in many places, is out of all proportion to their relative threat to land or property. They are outsiders, wanderers, and therefore dangerous to the soul of the settler – a threat to civilisation.

In his *Anatomy of Restlessness* Bruce Chatwin quotes Herodotus' classic account of the military tactics used by nomad cavalry to defeat the Persian King Darius, more than 2,500 years ago. Darius controlled much of the known world, and with his huge superiority in conventional forces he moved east to extend his Empire into the lands controlled by wandering nomad horsemen. But he could not find anyone to fight. He wrote a letter, taunting the nomad chief, Idanthyrsus, and asking him why he would not come out and fight. Idanthyrsus wrote back, 'I have never yet run from any man in fear; and I am not doing so now from you. This is precisely the sort of life I always lead, even in times of peace.' And the nomad cavalry remained just a day's march ahead of the Persians, out of sight, staying on the move and harrying the invaders until finally they withdrew after sustaining heavy losses, without a formal battle. The psyche of civilisation was seared by nomads.

The pressure of live television today means that dozens of people need to go out for every major network to feed the beast, perhaps not unlike the deployment of traditional military units like King Darius' army. And the belief is growing that the networks can go out and set up their dishes at relatively little risk, as if taking the safety of the city walls out into the ulu with them. That does not leave much space for the freelance crews, still operating outside the box like nomad cavalry. In this new environment, even if there were still a proper market for freelance footage in news, which

there is not, it would be very hard for crews like Frontline's to operate in the way that they did.

The safety spending is well-intentioned, but sometimes no more than a comfort blanket. The death of the BBC correspondent John Schofield in Croatia in 1995 was the spur for a huge expansion of spending on safety. The provision of 'hostile environment' courses is now big business, and at their best they do of course give people tools to cope in difficult situations. But at their worst they are merely an insurance policy for management and can give journalists the illusion that war can be reported at no risk, with no personal cost. And alongside the training, a new army of ex-soldiers has grown up to escort journalists into war. Their presence again freezes out independent initiative, since the required guards and armoured vehicles are much too expensive for many freelancers to contemplate.

The use of ex-military minders in the field is comforting to managers, who do not themselves ever go outside the 'city wall'. The reasoning is that if journalists are going out to the ulu, surely it is better to send people sanctified as warriors to look after them. The almost mystical belief in the quality of British soldiers, shared in newsrooms nowadays, means that it has taken a long time to sort out which ones are any good at the highly specialised task of guiding TV crews. The ancient nomad chief would not be able to make much use of the modern British soldier. (Roddy Scott, the quintessential Frontline 'nomad', was turned down by the British Army, who saw him as too independent of mind.)

The ex-soldiers who become minders for journalists sometimes think in the wrong way, as they try to move from the military mindset, where some casualties are inevitable, towards the new management mantra that 'no story is worth a life'. Some of the ex-soldiers I have seen protecting journalists are outstanding, but some are worse than useless, taking the BBC for what they can

make out of it, unable to believe that anyone would pay them hundreds of pounds a day for what they do.

The difference between a soldier and a journalist going to war is not just that we go into harm's way without a weapon. Our whole relationship to the physical environment has to be different from that of soldiers. There can be times for a journalist when having the highest profile, bumbling around in a Hawaiian shirt and flip-flops, can actually be the *safest* course to take. How could he be a threat if he looks such a fool? Those people with military knowledge who *do* successfully develop journalistic instincts, like the ones who ended up in Frontline, always offer a unique perspective. Once in Kosovo, when we were filming in the late afternoon, I saw some movement in the low brush oaks on a hill about a mile away. I tapped on Vaughan's shoulder, and he took his eye from the camera pointing down the valley to look up the hill through my binoculars. He said, 'That's just a forward OP [observation post] setting up. They won't have any weapons which need to worry us for now, we're out of effective range. They might be able to bring down mortar fire, so listen for it. It does look as if the Serbs are moving over to this side of the hill though. We have probably got about half an hour.' And he carried on filming to finish the sequence we were doing, before packing up unhurriedly and driving away.

But journalists, even Frontline journalists, are not perfect (nor indeed are they shadowy mythical nomadic horsemen). You meet different sorts of people in a war zone. No one leaves it unaffected. Apart from the dead and wounded, some of the survivors are damaged and continue to carry with them the horror they have seen or the threats they have faced. In a bar in Kosovo one night a very prominent news agency journalist, who was later killed, suddenly got up and walked out, to return with a tape recorder and play a tape of a shooting incident when he had been chased

around a house by a gunman in Africa. You could hear the shots and the sounds of others dying. Playing the tape was a disturbing, dysfunctional thing to do, which did not have much to do with the conversation, but everything to do with him coming to terms with the daily risk he was facing. In his towering book on the Vietnam war, *The Cat from Hué*, Jack Laurence has written compellingly of what it is like when it stops – how you miss it. He was with CBS and had spent more time in Vietnam than virtually any other reporter. And he wanted to go back:

> Some of my colleagues at CBS whispered that I had a death wish, that eventually I was going to kill myself and whomever I was working with, but I didn't believe that... To me it was a matter of calculating the risks. My deeper impulses may have been reckless and self-destructive but my conscious motives were less complicated... Life was brighter, more intense, more enjoyable when you took the risk of losing it and then nearly lost it and then survived to have it back.

Deprived of Vietnam, Laurence sought solace for a while in drink and drugs, to fill the gap. And more recently the *Times* reporter who spent so much time with Frontline journalists, Anthony Loyd, has written candidly of his own struggles with heroin – the very title of his book expressing the longing for war that can itself resemble an addiction: *My War Gone By, I Miss It So*. A Canadian psychiatrist, Anthony Feinstein, has done the most research on this, comparing a group of journalists who have covered conflict with a control group of deskbound Canadian journalists – his 'nomads' and 'settlers'. He found rates of post-traumatic stress disorder among journalists who go to war similar to those among military combat veterans, with a high incidence of depression, marriage breakdown and recourse to drugs and alcohol to cope.

The arrival of academic research into how conflict can scramble the mind of the journalist has been followed with a plodding inevitability by the growth of an army of counsellors who want to help to repair the damage. But most have no idea what they are doing. The whole nature of the life of 'nomadic' risk-takers is so alien to these 'city-dwellers' that they too often address the reason why people go there at all rather than trying to fix the specific problem. The trauma-related stress faced by some journalists who cover wars can only be treated by fellow nomads, at least in the first instance. People who take 'abnormal' risks need to have that acknowledged by their peers.

Frontline cameramen are not suicidal. Being prepared to risk their lives does not mean that they do not value them highly. They wanted to show that the job could be done professionally and safely, and that, with a bit of luck, people would survive. And they tried to limit their risks by broadening their range of stories, finding new markets so that they did not go only to war. Carlos Mavroleon, the half-Mexican, half-Greek shipping heir, shot a whimsical piece about the Frankincense industry gearing up for Christmas, as well as the wars he covered for Frontline. Of all of the mavericks who were drawn to the Frontline banner, balancing adventure and journalism in different parts, Carlos was the one for whom it was almost all pure adventure. His unlikely background – dropping out of Eton, spending time in a London comprehensive, dating a Kennedy and Fawn Hall (the secretary in the Iran/Contra scandal) while at Harvard, *joining* the mujaheddin – made him one of the most colourful people ever to work for Frontline. But he never really gelled, because he never really stuck with anything. Both Peter and Vaughan had quiet words with him about his habit of carrying guns. They disapproved, but it did not make much difference. Carlos drifted out of Frontline as he had drifted in, with huge charm

and no hard feelings. He was ultimately found dead in a hotel room in Peshawar in 1998, apparently after a drug overdose, in circumstances that have still not been explained. Another photo went up on the wall in Southwick Mews.

Vaughan has spent his life fighting against the clichés written about his colleagues when they died: 'they had it coming to them', they were 'naïve' or 'practically suicidal and really crazy'. Vaughan says that they knew that death was a possible outcome of their work, and they accepted it:

> We had a certain élan, or panache. Why should we want to die old in our beds? To die young and in style has an eternal quality and is beyond everyday life. It is much more meaningful than the mediocrity of many of our critics, often managers too afraid to take decisions, or insecure reporters only interested in stardom. There's a culture nowadays that says we are not really free to risk our lives, but societies have always progressed through the actions of risk-takers. It is a sad reflection on British society today that risk-takers are viewed with such suspicion. We never expected support from any quarter and rarely got it. Rory Peck understood the risks that he was taking. He thought that courage was a virtue, in a way that people don't seem to any more. Rory understood about living for the moment in a way that very few of us do. He was free.

That is so frightening to the normal impulses of the civilised world that the only response of the world's messengers, newspaper writers, is to scorn the dead. But it is not just a matter of luck that two of the key founders of Frontline, Peter Jouvenal and Vaughan Smith, who have experienced as much threat to their lives as anyone in journalism during the last quarter of a century,

remain alive. Herodotus would have approved. It is the quality he most admired in the nomad cavalry of the Scythians: 'They have managed one thing better than anyone else on the face of the earth: their own preservation.'

Vaughan recognised that since some in the industry saw them as cowboys, mocking their little cameras and their pretensions, they would need to be really professional, turning their military experience to their advantage. From early on he was the one who wanted to push them from being 'gentleman amateurs' to people who were regarded, celebrated for filling a niche. And he thinks that they have something to contribute, showing how it is possible to go out into a war zone and come back, time after time. Many of the Frontline cameramen were onto the safety agenda at the beginning: for example, promoting flak jackets in Bosnia before many other media organisations and renting out armoured Land Rovers. Vaughan himself was prominent in encouraging the creation of safety training, advising some of the early courses and writing a paper that tried to engage the industry in taking a radical new approach on the issue.

The other main nomad chief outside the city walls of broadcasting was Ron McCullagh, who worked for the BBC before he set up his own company, Insight News Television. He uses the metaphor of television news as a giant lumbering dinosaur, with a little head at the end of a long neck and the whole body moving slowly and ponderously behind as the head grazes from one story to another. In that image Ron feels that he and other freelancers are like a rats running ahead on the ground. There is no point being where the dinosaur is; all his clients are there already, eating at the same trough, engaging in what we inelegantly call a 'cluster fuck'. I bumped into him at Heathrow in 2003 when I was on my way to the war in Iraq with, seemingly, every other foreign correspondent on the planet, except for Ron. He was going to Liberia, which

was not then on anybody's radar screen. It was a few months later though.

Ron shares Vaughan's frustration, feeling that the industry does not realise what freelancers contribute to TV news. He feels that independent journalists are treated like pariahs by most broadcasters, tolerated rather than welcomed, and grudgingly accepted only when they have something special to offer, as in 'Are we going to have to use the footage from that fucking independent to cover the story?'

After a couple of huge rows with *Newsnight*, he did not sell anything to the BBC for more than ten years. One of the rows was over a proposal he made to go to Somalia for *Newsnight*. He was commissioned after he gave them a lot of information about the story, but they then pulled out. He found another client and went anyway, only to bump into a *Newsnight* correspondent on the ground doing *his* story. On another occasion he had to rattle the bars hard just to get them to look at pictures that they had sent him to Africa to do. Considering Insight's track record, picking up dozens of awards, the BBC's failure to use him for many years was their loss. In contrast, Channel 4 now have money set aside for independents, which keeps some of his people alive, and he works a lot for broadcasters abroad.

In its peak years Frontline made most of its money from, and certainly put most of its effort into, complete news features, becoming the second-largest supplier of features to a major Dutch network. The BBC was the biggest supplier, but made material available at prices that did not reflect the real cost of newsgathering, squeezing genuinely commercial operators like Frontline very hard. It became harder and harder to make money. The key niche for Frontline, selling rushes from war zones, dwindled too, as budgets went down and the industry changed. There was more competition about, and fewer people who were

prepared to look at the relative value of freelance offerings. The bottom line counted too much.

By the turn of the century crewing was their main way of making money, working alongside staff reporters, commissioned to shoot by the day. At the high end, like walking into Kabul with John Simpson, it could be both satisfying and financially rewarding. But there was not enough of that. And broadcasters tended to go behind their back to do their own deals with the cameramen they liked, treating Frontline like an introduction agency, without any regard for quite how hard it was to make money out there. The way the broadcasters wanted to use them as crews rather than making space for them to sell their own footage, was all about *power* as well. Despite the expansion into 24-hour news channels, there was to be little room for divergent views, uncomfortable images from unfashionable places in the world. The rolling news channels all grew to look the same. The head of the dinosaur was going to decide what mattered. That was a bad thing for diversity and for the under-reported areas of the world, and it squeezed Frontline out of business.

So should the broadcasters have cherished what they had, rather than let Frontline television wither? There was some support. Ironically, just as it became harder to make money at all as a freelancer, the BBC, Reuters, CNN and others were persuaded to pay money into a fund to subsidise safety training for freelancers and provide affordable insurance. The BBC's Head of News, Richard Sambrook, was crucial in providing a link between the broadcasters and groups outside, like the Rory Peck Trust, which had been set up to remember Rory's name by supporting freelance operators.

The Trust was set up at the instigation of Rory Peck's wife Juliet, who knew the isolation of bereavement. But despite these initiatives, independents still felt as if they were seen as a

competitive threat rather than suppliers who should be valued. In the increasingly homogenised management structures that have squeezed most of the last nomads out of television editorial floors it was hard to put a *value* on what Vaughan and his colleagues were offering.

Like one of the nomad horsemen, Peter in particular had a habit of disappearing for months at a time and then infuriatingly emerging with something that was hard to place. As safety became institutionalised their unique skills looked strange, hard to quantify on balance sheets; their competence was misunderstood. The repetition of the policy that no story is worth the life of a journalist tends to put the blame for those who die onto them. Since there is a large component of luck in any tragedy, this approach can mean that thinking on safety is determined too much by the most recent terrible loss.

One senior BBC news manager told me of the dilemmas. '*No story is worth a life* has to be a management mantra. You can't *send* someone to their death. Using the Frontline men felt scary. Some took sensible risks, while others had bloodlust, living on the edge. Are they risky and could they cost you? Yes. From a management point of view, do you need them? Yes, we always knew that. Both are right.'

But as the years passed, the first element of that dilemma became all-important: risk outweighed need. And the broadcasters' growing aversion to danger coincided with the news environment becoming much more hostile, as journalists were increasingly seen as fair game by guerrillas everywhere, particularly in Islamic conflict. The gap was filled by locals, with little training, using later versions of the 'holiday cameras' that Frontline had pioneered in the 1980s.

Now small cameras are everywhere, and their technical quality is remarkable. All of the spending on safety training for crews from

Britain is wasted if some of the key news footage on the ground is taken by young locals. They can be paid far less, although no one asks any questions about their training or integrity. Some of their material is excellent, but there is a tendency towards a kind of war-porn, images unrelated to journalistic investigation. It began in Iraq. Some of the most compelling footage was shot by doctors and lawyers and other local witnesses, sometimes just boys, in towns that briefly became household names – Fallujah, Tikrit, Al-Amarah – where it was too dangerous for non-Iraqi crews to travel around. The world of the Hindu Kush twenty years before suddenly felt like an age of lost innocence.

XX

LIBERATED BY MISSIONARIES

O people of Baghdad… your city and your lands have been subject to the tyranny of strangers, your palaces have fallen into ruins, your gardens have sunk in desolation and your forefathers and yourselves have groaned in bondage. Your sons have been carried off to wars not of your seeking, your wealth has been stripped from you by unjust men and squandered in distant places… Therefore I am commanded to invite you, through your nobles and elders and representatives, to participate in the management of your own civil affairs in collaboration with the political representatives of Great Britain.

> General Stanley Maude, proclamation to Iraq after Britain took Baghdad, March 1917. (Three years later the 'liberators' faced a rebellion that cost 10,000 lives)

London, October 2002

We spread out maps of the Gulf region on an Afghan rug on the floor of Vaughan's flat above the office in Southwick Mews, surrounded by memories of other campaigns. In a cabinet stood the Royal Television Society award for his Kosovo coverage alongside the damaged mobile phone, still with the bullet that had almost killed him inside. The walls were covered with Afghan saddlebags,

and muskets picked up in the markets on the North-West Frontier leaned up against walking sticks in the corner. The shelves above the television set were lined with ethnic hats – a harmless enough object to collect – including the ridiculous fluffy white one from Chechnya, which he had worn to camouflage himself in the snow in Grozny. Among the hats was a baseball cap from an American press institution with the legend 'Trust me, I'm a reporter'. His old British Army helmet with the desert camouflage cover he had 'procured' as part of his disguise when he walked to the front line in 1991 sat at the end of the row. That had been the action of a jungle animal, like a tiger, who needed space to operate. But he was not going to be able to repeat his exploits in the next war in the Gulf. Call it globalisation, or what you will. Things were different now. There was no room for the big cats.

By the autumn of 2002, a year after 9/11, war with Iraq was inevitable, whatever the UN said. As Tony Blair went through the motions of trying to get someone else in the world to sign up to the US/British invasion of Iraq, we weighed up the options. But the TV environment had changed a lot since Vaughan, Peter, Rory, Nick and the others in Frontline had gone out to make their mark in it. They had carved out a distinctive space for themselves, partly because they had succeeded in doing things on their terms. But the news machine had moved on, squeezing out independent enterprise. There was the strong sense of the end of an era. They could not work now as they had before.

It had been the beginning of the end in Afghanistan in 2001; Peter and Vaughan had just managed to stay ahead in the war, but only because they were working for good friends – John Simpson and myself – who both shared their restless desire to get away from the pack. And even that was different from the early days on the North-West Frontier, when they went out to get the story for themselves. At best now they were hired hands working for

reporters; their only choice was in which reporters they travelled with.

It was not only the news industry that had changed. The battlefield had changed too. This was a different war and there were to be different rules for reporting it. Vaughan had taken a principled stance in 1991, when he decided to deceive the military. He believed that they were wrong to restrict access to the battlefield. Censorship and the pool system were unreasonable obstacles to freelancers, justifying his deception. Witnessing the war should not be restricted to those who had Pentagon approval. But for the Second Gulf War the US military brought a new word into journalistic usage – 'embedding'. There was nothing new about the principle of course. The 'first war correspondent', the *Times* reporter William Howard Russell, was 'embedded' with the British Army when he witnessed the Charge of the Light Brigade.

Embedding always involved a compromise between freedom and access. In the most extreme case, the First World War, reporters gave up all freedom of movement in return for officer status, a comfortable billet in chateaux set back from the front line, and safe, escorted day-trips up to see the troops. There were hardly any casualties among reporters in this most bloody of European wars, and half a dozen of the British correspondents won knighthoods for the patriotic tripe they wrote throughout. At the other extreme, the Vietnam war, reporters could go pretty well wherever they liked, using American helicopters to move them around. Iraq was not to be like Vietnam. The idea was that embedded reporters would be attached to individual units, dependent on them for food and transport, seeing a tiny part of the war. It would be a question of luck whether they saw any action at all.

As we planned our operation, with the maps spread out on the floor, surrounded by memories of earlier campaigns, embedding did not look like a very attractive option.

'No one serious is going to be an embed, are they? I mean clearly there are ethical issues against it. It's not independent journalism. They're bound to control access. You're not going to be able to do what you want.'

'There has certainly been a gap between what the Americans have promised and what they have delivered in recent conflicts. Anyway, we might get stuck in the wrong embed,' I said. We were then still a rarity in being comfortable with laptop editing and feeding on collapsible satphones in the field, having used the equipment on a couple of trips to Africa since the Afghan war. Most other crews remained wedded to much heavier technology and conventional satellite dishes. 'We need to exploit our flexibility with the lightweight kit and keep our competitive advantage.'

'What do the BBC want to do with us anyway?' he said.

'They are hoping we'll do what we did in Afghanistan – stay out of the machine and find our own stories,' I said. 'If we're not going to be embedded, then there are several options, other than Baghdad, which is already too crowded. We could go to Jordan in the west, although it's a hell of a long drive across the desert from there. We could go to Kuwait in the south and try our luck as you did last time. Although perhaps not in disguise.'

Weighing up the options, Vaughan said, 'I think it's going to be much harder than last time. The Americans are entering a hostile country not liberating one from a defeated army, as they were in Kuwait. And the chemical and biological threat does make this the most dangerous war zone we might ever face. What about the north? All of our friends, the serious players – Anthony [Loyd], Seamus [Murphy], Julius [Strauss], and so on – look as if they're going there.'

There is really no such thing as a 'war correspondent' or 'war journalist' and Vaughan has always avoided people who call

themselves that anyway. It is a very strong part of his nature. It matters as much to him *how* he behaved in the field, *how* he shot pictures, as *what* he shot. And talking about it was, well, a little vulgar. He once told me that he is not drawn to the flashy men dressed in pseudo-combat clothes or a photographer's waistcoat:

> The journalists that I respect are not the 'wannabes' holding up the bar, showing off and telling war stories. The ones I admire are sitting quietly in the corner eating their mouldy bread and jam which they might have brought in, and getting on with it. They may have done amazing things, but they are not desperate to tell you about them. You know because you have heard it from somebody else. The wannabes are dangerous to themselves and others. They're too distracted trying to prove something.

Although few of the serious players like the title 'war correspondent', there is nevertheless a recognised fraternity of people from many countries who meet in conflicts across the world. It is a constantly shifting network but often the core contains the same faces, who share information through formal and informal channels at times of war. In the days before the Iraq war, after going through the same processes we had, our friends were mostly heading for the north.

'The biggest problem with the north is that John Simpson is going there. And the Turks aren't sympathetic to letting in anyone else,' I said.

We looked at the maps. There were problems to the north, south and west.

'What about Iran then?'

'It's almost impossible to get a visa to Iran as a BBC journalist at the moment.'

It felt like a challenge. In Iran we expected to see hundreds of thousands of refugees fleeing Saddam's chemical weapons, and if we were lucky, we might be able to break out across the border into Iraq ahead of the American advance. It would also give us a possible route into the Kurdish areas in the north, if that became more interesting, now that the Turkish route which other reporters had taken into northern Iraq was closed. Through a roundabout route we got visas and headed for Tehran.

Tehran, Iran, March 2003

American television crews travel abroad with the same amount of kit as a major imperial expedition of the nineteenth century or indeed the ancient army of King Darius. There was an American crew on the flight to Tehran with us, and Iranian customs official had put all of our suspect kit together when we arrived in the middle of the night. At one end was a single trolley carrying the equipment for the nomad cavalry: a couple of rucksacks, two flak jackets and three other small boxes, everything that Vaughan and I would need to live in the field for months and transmit television. More than a dozen other luggage trolleys were overloaded with small mountains of American gear: a full size satellite dish, several boxes of pre-cooked American food and countless other unidentified items. The American network had a five-man team, but they were not planning any more journalism than we were. In fact, in the end, they did nothing at all in Iran.

The two-man camera crew, wearing impeccable white trainers, disappeared into their hotel rooms. The picture editor, a well-preserved veteran who was a dead ringer for Truman Capote, sat in the hotel lounge throughout their stay, watching the world go past, while the correspondent fretted and the producer ran around getting mobile phones and transport and permits, but all without

much effect. They never unpacked any of their mountains of kit in Iran, never rolled the camera once.

The weather was foul, and the slate-grey skies of Tehran matched our mood. We dodged through showers of sleet into interminable meetings to try to win permission to move around and report from the Iranian side of the border. But from day one it was clear that we were missing the war. All of the clever second-guessing about the intentions of the American military had been wrong. For the first time in a generation they let journalists film and report real action as it was happening. 'Embedding' did what it said on the tin. We were in the wrong place. The American network NBC even had a live camera mounted on a tank racing north towards Baghdad. The technology for this was awesomely complicated; it was a remarkable scoop. It did not make us feel any better.

It also became quickly apparent that any idea we had of crossing the border into southern Iraq was fantasy. Hardly surprisingly the Iranians were obsessed about the threat the war posed to them. President Bush's inept and meaningless linkage between Iran, Iraq and North Korea as the 'Axis of Evil' had upset them. They already had American bases to the east of them in Afghanistan. American successes in Iraq would leave Iran surrounded. They were not going to let the BBC anywhere near the border. And our second idea for a story was not going to happen either. Like all other predictions about the Gulf war, the prediction that thousands of refugees would flood into Iran to escape the fighting turned out to be wrong. Nothing turned out as was generally expected. There were no weapons of mass destruction and not even much fighting between conventional forces. Instead, the Americans faced guerrilla warfare from the start, as suicide bombers and other fighters harried isolated convoys along their extended supply routes.

We did some desultory filming of 12-year-old refugee camps filled with Marsh Arabs from the *last* war, waiting for our luck to change. During that trip we had a curious conversation with a senior government official that spoke volumes about the all-seeing eye of Iranian security. Vaughan and I found ourselves sharing a three-room apartment in a hotel in the south with this official, who was a sort of top minder. While I wrote a radio piece the two of them sat in T-shirts, chatting over the sticky orange drink Mirinda, which was all we were permitted to drink.

The official asked Vaughan if he had ever interviewed an Iranian singer. It was a strangely specific question. Vaughan remembered that a few years ago he had done a day crewing for the BBC in London, filming an interview with a woman described as Iran's most famous singer.

'That's right. Her name was Marzieh. Plump, motherly, nice voice. Wasn't she connected to some political group?'

'The MKO. Yes. She usually lives in Paris. But your interview was in London, I think?'

The official knew all about it. The Iranian government has an obsession with the MKO – the Mujaheddin-e-Khalq Organisation – a formerly communist opposition movement dedicated to bringing down the Islamic regime in Tehran. Vaughan had never applied for an Iranian visa or been there before. But they obviously had a file on him as a cameraman who had done a suspect interview several years ago. We understood then quite how much everything that we were doing in Iran was orchestrated. Not because they suspected Vaughan but because that is how things were. If we still harboured any lingering ideas of slipping to the border on our own, we ditched them then.

We urgently reviewed our options, and we were not the only ones. I made calls to the office in London and to friends based across the region. Few journalists were having a really 'good'

war. And the most frustrated ones were in the north. Living up there was arduous; it was cold, and there were too many journalists around with too little to report. The Americans had failed to persuade Turkey to let their forces through that way. Apart from a few Special Forces raids in support of the Kurdish forces, there was little military action. Worst of all, the north was where the BBC would suffer its worst casualties of the war. An Iranian cameraman, Kaveh Golestan, was killed and a London-based producer, Stuart Hughes, lost his foot in a landmine incident, while John Simpson's translator, Mohammed Kamaran Abdurazzaq, was killed by a bomb dropped from an American plane. We were one of the few crews in the world who could have gone into northern Iraq at that time. But nobody wanted us to go.

We headed south towards Kuwait with no great hopes. By now there was very little appetite for independent operators such as ourselves. Embedding was working well, while 'unilaterals' were getting killed, among them ITN's longest-serving reporter Terry Lloyd. The bodies of two of his crew, Hussein Othman and Fred Nerac, were never found. After they were shot by American troops, there was virtually a ban on anyone else trying to go into Iraq without military support. Being a unilateral was not the obvious thing to do.

And then our luck changed. Forty-eight hours after arriving in Kuwait we joined the US 24th Marine Expeditionary Unit, which had been called up late to fight the war when the Pentagon realised that they needed more forces to do the job. The 24th MEU were looking for journalists to come with them; we were looking for a war to cover. It was a perfect match, made by a BBC producer whose job it was to hang around the US forces and who knew that we were coming into town.

The producer was perhaps the most bored journalist in the Gulf, since waiting at the US Army press centre was not much

of a challenge, but her little-girl looks and piercing green eyes disguised a tough and experienced operator. One Marine press officer had rather taken a fancy to her, which is why we had such a soft landing into an embed with the 24th MEU. It was only after she had secured it that she sweetly told him that her tour of duty was over and she was leaving Kuwait the following day. By one of those accidents of history in the small tribe who live in the foreign news world, the woman with the green eyes who got us our embed was the very same Zoya Trunova who Rory had helped eleven years before, when she was a struggling freelancer going into war zones with the zoom mechanism on her camera broken by news agencies. She is now a BBC producer in Moscow.

We signed up for the embed with none of the normal preliminaries. Some reporters had had to undergo special military training on chemical and biological warfare, or go to boot camp in the States, training with the units that they were to join in the Gulf. All we did was to sign a form agreeing that we would not take pornography or drugs into the war zone, not show faces of US casualties in certain circumstances and, more controversially, that we would not sue the US military if they got us killed. And then we were in.

Southern Iraq, 2 April 2003

On the first day in Iraq we had our best story of the whole trip. We set out on what was billed as a confidence-building exercise. In a town called Qalat Saki the marines made a show of dragging out pictures of Saddam Hussein from the Ba'ath party headquarters and burning them, seizing a large quantity of arms and ammunition at the same time. They stuck a line of detonator cord on the front of the standard larger-than-life painting of Saddam at the entrance and blew it up with a satisfyingly loud bang. Then Vaughan shouted for me to join him. He had gone

into the Ba'ath party building with the American Army translator, a former Iraqi citizen called Khuder al-Emiri, and smelt a story.

Khuder had fled from this town in 1991 during Saddam's repression after the failed uprising which followed the first Gulf war. We filmed him leafing through files, looking for the evidence of what had happened to his two brothers. By the time he went out into the high street some of the other embedded journalists were on the trail of the story too, but Vaughan already had the best pictures. Khuder's sons appeared, having not seen their father for twelve years, and there were emotional scenes as he was embraced by old friends. He ended up being carried shoulder-high through the streets in his American army uniform.

Most of the Americans did not move beyond their vehicles, keeping people away behind a line of rifles. Vaughan went up onto the roof to get wider shots, and took some telling pictures of a man with a garland of faded plastic flowers trying to put it round the neck of a marine. This was what was supposed to happen: once Saddam was deposed the Americans would be garlanded with flowers and everybody would live happily ever after. But Iraq was not a fairy story. Suicide bombers had already made the Americans wary of close physical contact. It was only on his third attempt that the man succeeded in getting his wretched garland round the neck of a reluctant marine.

When we got back to the base the commanding officer, Colonel Richard Mills, wanted to know what Vaughan, as an ex-British Guards officer had made of the operation. 'So what would the Guards give that – B Plus?'

'Definitely an A, sir. No doubt about it!'

I had made sure that Vaughan travelled in the Colonel's Humvee to the operation by asking the Colonel for access early in the morning. The pictures would be useful, certainly more useful than we would get travelling on the back of the open truck, baked

by the sun, with the rest of the press. But more important than that, I knew that it was essential that Vaughan established his credentials early on. He has a knack of getting on with fighting men, in whatever situation. That morning it worked in spades. He had chatted up everyone in the vehicle, from the driver to the colonel himself, and it turned out that not only had the colonel's grandfather been a British soldier but, by an absurd coincidence, he had fought in the First World War in the same infantry regiment, the East Surreys, that Vaughan's great-grandfather had served in. We were in. For the rest of the trip they swapped stories about what they knew of the East Surreys and arranged to meet at regimental reunions.

In truth, Vaughan's view of the operation we had witnessed that morning was that it had a different style to what he was familiar with in the British Army. The marines went in with some force, loudspeakers blaring a repeated message. The loudspeaker said something like 'We come in peace', while the outward message of a large body of heavily armed and armoured troops was just the opposite. It was just like Bosnia and Kosovo, where the US military had always seemed to be far too concerned with their own safety, putting too much distance between them and the local population. All of the seeds of America's later problems in Iraq were sown in those early days, as they failed to acknowledge the culture. Their message seemed to be: 'We have come from another planet. Don't touch us. One of us is worth a thousand of you.' To Vaughan it lacked the élan that gives the British Army an edge. He reminded me of the time when he was commanding a half-company in control of a small town, Keady in South Armagh, in Northern Ireland. With the twin aims of being constantly unpredictable and showing no fear, he arranged for the annual regimental photograph to be done in the town square at 5.30 in the morning. Perhaps the IRA were simply asleep at that time, but

it was the kind of mad gesture that kept them guessing. That is what he meant by élan.

Some of the American journalists embedded with us could not understand Vaughan's access to the Colonel, as if it was an underhand trick played by typically arrogant Brits. One of them in particular, from *The New York Times*, never stopped running down Britain or getting in our way. He was a highly strung reporter whose regular beat was to write on Hollywood, and he had the email address 'MyPulitzer', just in case you did not know. After the war I looked up what he had written, and it was rather good. But he was extraordinarily annoying company, with an obsessional Anglophobia that would have been racist if expressed in the way it was about any other nation. The others were a mixed bunch; this was after all a late embed. They ranged from some good reporters at the top end, who were reconfiguring for a second shot at the war after accidents early on, all the way down to two elderly Germans who had no interest in war reporting at all.

And then there was a crew from Abu Dhabi TV. Their invitation was in response to the Pentagon's late realisation that they were losing the propaganda war in the Arab world. If you looked at TV coverage across the piste, there were really two wars being reported. At one end were the American networks, focussed on the American advance, and at the other end were Arabic cable stations, equally obsessed with Iraqi casualties. The Abu Dhabi crew with the 24th MEU was one of only a very few Arabic teams reporting from the US side of the war. The correspondent, Anas Bouslamti, was a good journalist, whose judgement we came to value. Vaughan and I stuck close to them whenever we went near any Iraqis, because we had no other translator. The worst thing about being embedded was the lack of access to independent translators or transport, the lifeblood of foreign reporting. Abu Dhabi TV helped us out.

Most embedded journalists in Iraq did not travel in a pack like this. They lived with individual military units. But the war was moving so fast that no one had time to split us up. And we all wanted to stay close to the marines' command HQ to keep on top of the story. As the days went on the thing that most surprised me was how much in tune we felt with the Arabic TV crew and how little we had in common with most of the American journalists.

One benefit of 9/11 has been that there are far more US journalists in the field, since foreign news has suddenly taken on an urgent priority at home. In the past, in conflicts like Bosnia, American networks tended to use Europeans to provide their coverage. But few of the new American generation now on the road had the objectivity that would normally be expected of journalists. Most had an unquestioning belief in the rightness of America's projection of military power.

Sitting on the back of the truck one afternoon, waiting, as you do a lot in wartime, Vaughan engaged the American journalists on how they saw the world.

'Maybe the Afghan war was right,' he said. 'Certainly, most people in the world understood that America was going to strike back after 9/11 and that was the obvious target. But they've gone about it all wrong – it is not at peace. They're only interested in hunting down Osama. And now they've got stuck in here with no clear way out, and are even talking about taking on Iran and Syria as well. It's not doable.'

The Americans all had a startling belief in the ability of American military power to 'prevail', as they put it. They were mostly younger than us, and not as experienced, apart from an old CNN warhorse, Bob Franken, a big cheese on national TV back home, who had nagged his office to send him out to one last conflict. Bob was one of a handful of correspondents in the Iraq war who had been in Vietnam. He kept quiet as Vaughan

expressed his strong scepticism for America's desire and ability to wage war. Only one of the Americans, a photographer, Chris Hondros, had anything sensible to say:

'You can't say that Afghanistan isn't a much better place now. There's a mobile-phone system in Kabul now. That would have been unthinkable under the Taliban.'

It was a fair indicator of progress. But they all wanted America to do more, much more.

One said, 'The world is such a different place since 9/11. We've woken up to what we need to do and we are doing it. Gaddafi has got the point, and dropped his nuclear weapons plan before we bombed him. If Iran and Syria don't get the hint, we'll go for them too.'

It was always 'we'. Whatever happened to the notion of journalistic detachment?

Vaughan turned the conversation back to Afghanistan. We had nearly been killed there a year or so before, by an mob armed with stones who destroyed our vehicles and nearly got to us. It did not feel then as if *pax Americana* was delivering the goods.

'You're all ignoring the real issues. The Americans are promoting the same people they promoted in the past. Afghanistan feels much less safe than it did, even under the Taliban.'

We got the impression that some of the journalists were emphasising their patriotism to impress the marines who were listening in. They so wanted to be part of the show. By now some had taken to wearing US military clothing much of the time.

Vaughan said, 'Your feet have gone down in this region with no delicacy at all. There has been no attempt to sort out Israel and Palestine first. What does this look like to the young man in a slum in Cairo with no job, no prospect of a job. That's where democracy could emerge, not through an invasion. This is what America is missing. Where America excels is in giving people the

hope of a better economic future, through being innovative and go-getting, setting an example for the world. Instead it remains in a bubble, bringing a 300-year-old civilisation up against one that goes back 6,000 years. There's tremendous suspicion, and your forces lack panache. They don't understand the relationship that's required, the need to know your enemy better than he knows himself. It goes back to Sun Tzu, and the British Army aims to do it naturally. As for the idea that other dictators in the region would get the message from US threats, like Gaddafi, it's not going to happen. We've just come from Iran. It's a big, proud mountainous country with a functioning army. It's no pushover. There's no way that the Americans are going to be able to take it without major casualties. Just because the Iranians might not want the mullahs hardly means they will want the Americans.'

They did not understand that. Some of the marines began to join in now, to say that Vaughan knew nothing. They thought America could do what it liked, and would be happy to attack any other countries in the region when the time came.

'There's no one else. Your British Empire has gone. And the superpower combat in the Cold War is over too. We have to take the responsibility. You watch. After we bring democracy here, Syria and Iran will be next.'

'It's not as easy as that,' Vaughan said.

'So are you for or against the war?' they wanted to know.

'I'm in favour if the war has the limited aim of freeing the Iraqi people. But the Americans have come for themselves, not for Iraq. And lumping it all together with the war on terrorism has been America's big mistake.'

The extent to which American journalists across the world have an uncritical belief in the infinite ability of military power to solve everything, and a sense that their country can do no wrong, is quite frightening. The kind of inquiring journalism pioneered by people

such as Frontline Television is beyond them. I have a good friend who was producing for an American network in Afghanistan. His correspondent was a very young whizz-kid, who made sure that he reminded my friend every day which top Ivy League college he had been to. One day an American plane bombed a wedding party, killing around two dozen people. My friend tried to get the young college graduate to write the story. But he stayed in his tent. He would not file, saying only, 'It can't be true. The American forces don't do that kind of thing.'

Despite our heretical objectivity, we were never censored, and in fact our material was never previewed by Dan McSweeney, the public affairs officer who was our formal link with the marines. He was far too busy keeping an eye on what Abu Dhabi TV were saying, somewhat hampered by the fact that he did not speak Arabic.

One night we were told that there was going to be a major push on the following day, towards Al-Amarah, a strategic town on the main eastern route linking the north and south of the country, along the banks of the Tigris River. Ever since we had become embedded with the marines Vaughan and I had been pushing to go forward on a military operation. We stressed his combat experience, but in the end they never let us break out of the pack. For the assault on what we were told was a Republican Guard Division defending the city we were put with the marine artillery, which we knew would be about 7 miles back from the front line.

We had a good day with them though, profiling the team who were working together on one gun. It was the kind of feature I liked doing with Vaughan, similar to our profile of the military society behind Massud in the Panjshir Valley in Afghanistan. He is convinced that people always want to see the context behind the news footage. We try to bring the audience over with us and ask their questions. Filming the gun crew, led by a staff sergeant with

the unforgettable name of Shad Moon, we wanted to answer the question 'Who are these Americans who have come to bomb one of the oldest civilisations in the world?'

> Staff Sergeant Shad Moon lines up No.1 Gun of Fox Battery of the 24th MEU. After the unconventional guerrilla tactics of the early days of this war, he has been told that now a regular army division is holding out in Eastern Iraq.
>
> Shad Moon: 'This is what we thought we would hit when we came ashore. We were briefed on totally something different, and had to learn how to fight guerrilla warfare in populated areas.'
>
> David Loyn: 'I guess you prefer this kind of warfare.'
>
> Shad Moon: 'Yes, I like to fight them from a distance. I don't like 'em where they can reach out and touch me. When we get a chance with this fine piece of equipment we're going to tear up an Iraqi force today. They don't really stand a chance. They are just not as good as we are. They should have really surrendered a couple of days ago when they had the chance, but that's their own fault.'
>
> (*Newsnight*, March 2003)

The battle was a walkover; Shad Moon's big guns never fired. That night we slept in the buildings that they had been aiming at in the Al-Amarah air base, one of Saddam's extravagantly big military installations. The Republican Guard had gone home, dematerialising behind the palm trees into the dusty air. A few uniforms lying around suggested that they had changed into civilian clothes first. But there was little sign of recent human habitation. The satellite-reconnaissance pictures, which showed dozens of armoured vehicles dug in, were misleading. The vehicles were rusting museum pieces. There was no fuel in their tanks;

none of them had moved for years. As the light faded Vaughan used the flat tones to shoot a classic series of images of US marines at war, their uniforms and helmets and equipment all coming out the same colour as the sand around them. Their Abrams tanks dwarfed the small Russian-made Iraqi BMP armoured vehicles which were dug into berms at the airbase.

Al-Amarah became briefly famous as the town that liberated itself. A small deputation of elders came out the following morning to report to the Americans that it was all under control, and handed over the keys of the city. American military intelligence officers told me that they knew it already because they had unmanned drones taking pictures of the scenes of jubilation in the streets of Al-Amarah, as the town fell to anti-Saddam forces overnight without a shot being fired. But we could not have gone to report that, since the Americans were not going. I missed the independence of being a reporter, living outside the embed.

The following day the overall commander of the task force, General Rich Nathonski, went to inspect things. Al-Amarah welcomed him but people were worried. A shopkeeper called Ashraf, who had fled from Baghdad, spoke in fractured English but with an extraordinary clarity, considering what was to happen in the weeks and months ahead:

> We don't want any tanks, any pistols or guns. There is not war, no fight here. We want some requirements, electrical, food. We don't understand you, nor you us. We don't need peace. This town was very peaceful already. We want the basic requirements. Food is the very basic; water is the very basic requirement.

The Americans were nervous, concerned about people milling around their vehicles, unwilling to shake hands with an inquisitive

and friendly crowd. We walked past a new checkpoint controlling a main bridge over the Tigris. Lines of traffic tailed off for several hundred yards in each direction. One of the marines at the checkpoint politely asked me, 'Sir, can you tell us where we are?'

'You're in Amarah,' I called back.

'Thank you sir, and what river is this?'

And then there was another sign of how things were changing in this previously secular society. Vaughan set up the tripod to film a line of tanks parking by the Tigris. At the water's edge three women were washing clothes. Some local men passed us and aggressively made sure that we were not filming the women. They were fired up because one of them had seen some kind of picture of a woman stuck inside the cabin of a marine vehicle. The rumour spread that the Americans were giving out pornography.

Looting had already begun. A line of cars waited to take their turn to rob a military fuel dump, while other people waved looted pipework and wiring at the Americans. But the Americans were not taking on the looters. General Nathonski was a large and imposing man, who spoke as if everything was in block capitals. When I asked him to outline his responsibilities he said, 'I RUN EVERYTHING BETWEEN THE TIGRIS AND EUPHRATES.'

He strode around dispensing wisdom borrowed from Buzz Lightyear, the spaceman in *Toy Story,* 'I COME IN PEACE. GO BACK TO YOUR HOMES.' In a meeting local elders told him that they had water for only two hours a day. His main public response was 'WE ARE VERY GLAD TO HAVE LIBERATED YOUR PEOPLE FROM THE OPPRESSOR.'

We went back to our base camp for the last time. It was Palm Sunday, a week before Easter, and we got talking to the marines' chaplain as he made his way over towards a tent for a service. I am a Christian, but I could not defend his fundamentalist approach to Vaughan, who was already angry about the many marines who

wore or carried very visible Christian symbols. You would see many of them in the pale light of dawn reading their bibles, and a good proportion had 'Psalm 91' written on their helmets, which promises protection in battle:

> Thou shalt not be afraid for the terror by night; nor for the arrow that flieth by day... A thousand shall fall at thy side, and ten thousand at thy right hand; but it shall not come nigh thee.

Then Vaughan saw a huge silver cross hanging off the barrel of a .50 calibre machine gun mounted on the back of a Humvee. To him it was like a red rag to a bull, and would certainly not have been allowed in the British Army, where a discreet cross around your neck is the largest religious symbol allowed. When we pressed the fundamentalist chaplain on Palm Sunday he took a very firm line on the limits of salvation. He had no sympathy with any other faith. I quoted a conversation we had had with a Shia cleric who had spoken approvingly about the faith of the Americans, comparing it favourably with the godlessness of Europeans. The compliment was not paid back by the US Marine chaplain.

I said, 'When we were talking to the Shia leader he said that there can be only one God. You and he must be praying to the same one.'

The Marine Chaplain looked at me over his glasses and clasped my shoulder as if to say that I would never understand. 'I don't think I could agree with him, son. That is certainly not the way we see it where I come from. There is only one God, and only one way to Him.'

To Vaughan it all fitted with the simplistic approach to the process of freedom from oppression in Iraq: liberation at the

hands of missionaries. American leaders in Washington spoke of a crusade, seeing democracy as a Christian ideal, promoted to the status of a universal truth. One evening Vaughan asked a marine if he was tired. He said he was, 'But the Lord gives me strength'. Of course the ordinary marine saw the local culture and its faith as inferior. That is what they were taught by their officers and priests.

US base near Qalat Saki, Southern Iraq, 15 April 2003

The day before the 24th MEU's last battle, their intelligence officer Major Jo Paschall, went to assess the state of surrounding villages. And for once the rest of the embedded press pack were off doing something else, giving Vaughan more room to work. He filmed a snapshot of life behind the war, uncovering a deep, grinding level of poverty in the Iraqi countryside which was shocking: large families; a lot of disabled people receiving no help; green unmoving lakes of sewage festering in the middle of unpaved streets. Iraq had been pushed beyond the reach of ordinary health care and education by the savagery of western sanctions and the wilful negligence of Saddam Hussein. It was like a place in suspended animation, all creativity drained away. Major Paschall was a good-looking man and he knew it, and he performed for the camera. He had a carefully honed soundbite: 'The time has come to move on from killing to kissing.'

The piece finished with a classic wartime image of two helicopters parked in the sand with a single US flag hanging out of a window, silhouetted against a giant red sky as the sun set. Vaughan had sat for an hour with the camera on a tripod waiting for the right moment for the shot.

But before they moved from 'killing to kissing' the marines still had to secure the town of Kut. It lay on a crucial crossroads. There are only three major routes in southern Iraq: one broadly

following the line of the Euphrates river up the west side, the route the Americans took on their advance up to Baghdad; the second up the eastern side, along the Tigris. The space between these is shaped like a lemon. The third key road crosses from Nasiriyah at the bottom left-hand end to the top right-hand end of the lemon, where it joins the Tigris road at Kut. Now that Baghdad had fallen, Kut was the last town in the south the Americans had still not entered.

Jo Paschall was in a sombre mood at his intelligence briefing that evening.

'There's been evidence of some kind of gathering at the football stadium in Kut. Our drones have pictures of lots of men there with guns. We know that hundreds of foreign fighters and pro-Saddam fedayeen ran away from the war in Baghdad, and we have reason to believe that they may now be holed up in Kut. It's the last place they could be, and they could be wanting to make a last stand. Our estimates are that there could be 200 al-Qaeda there, with another 5,000 assorted Syrian, Jordanians, Chechens and Yemenis loose in the town outside the stadium. We're preparing for unconventional warfare – suicide bombers, hit-and-run attacks – the whole thing. We can't bomb the stadium from the air; they're all civilians.'

He looked around, playing to the gallery.

'Maybe it's a 200-person boy-scout troop having a jamboree. Certainly it is a situation which we haven't faced before in Iraq.'

And he pointed on the map to a location about five miles from the centre of the city. The laminated map was overlaid with criss-crossing and numbers, drawn on in felt-tip as the Americans had advanced through the countryside. Only the area around Kut itself remained blank, uncharted territory.

'We're not out to fight Ba'ath party officials. The conventional war is over. The message from Nasiriyah was that if you block the

exits for a couple of days, then things ease up. That's what we've been doing. But now we have to go in and see what's there.

'Our LAVs will go in overnight to probe the area and then we will make an assessment. The rest of the force will be ready to go in at dawn, depending on what they find. But the main battle, if there is to be one, is more likely to be on the following day. Questions?'

The LAVs were an awesome piece of marine equipment – eight-wheel leviathans as happy underwater as they were roaming around the countryside in a potential chemical-warfare environment. Like all US military kit, they looked bigger and meaner than anything else on the battlefield. They cost almost a million dollars each.

After the briefing Vaughan and I made our usual bid to go and actually film something in the front line, and some promises were made for us to go with the LAVs, but not until the following day. We knew that the first probes were happening while we were still sitting in our base camp. So near and yet so far: being embedded could be a frustrating business.

We were feeding a *Newsnight* film that night, and as we sat in the contemplative darkness under camouflage netting watching the tiny flickering lights on the modem lying in the sand that meant that the material was still going to London, we talked of the dangers of war. The Americans were observing strict light-discipline to conceal the size of the camp from passing Iraqis. So the dark was total. Vaughan was in a reflective mood, although the dark meant that he could not smoke. He had just heard that he had received planning permission to convert a building he had bought in London into a new club for journalists.

'So we might go in with the LAVs. So we have to prepare what we need. I'm unusually apprehensive. I suppose it's because this is the first time in my life where I can see a future, particularly after

this awful divorce, which has just about ruined me. Now things might get better. You know I'm soon moving into my parents' farm in Norfolk and then there's the club. It has always been a bit of a struggle financially since I left the army.'

'This does not feel that dangerous, compared to some places we've been in the past,' I said. 'Those LAVs look well-armoured, certainly against any weapons which can be hand-carried. The Americans have been very keen to keep us out of harm's way so far.'

'Yes, I don't think they've appreciated what I have to offer in terms of looking after myself. But in fairness they haven't faced anything yet. The Iraqis they've met so far have folded their tents and gone home. But what we are looking at now is not all that safe. At some point I have to put my head out of the roof to get some pictures. And if the Americans are going to secure the town, they'll have to walk around too. Still. I have always had this thought that Churchill had, that if it's not supposed to happen then it won't. It's linked to destiny I suppose, although it's not really a religious idea.'

Like many people who put themselves in harm's way, Vaughan has certain small rituals. He always carries a small black cat from a Christmas cracker, which his grandfather carried before him. He is not a superstitious man; but when he remembers the grandfather, he feels less alone. And he also carries a tiny compass, which was supplied to him in the army. It has a cracked face, and I have never actually seen him take it out to find the direction, but it has a talismanic value.

'I've never felt myself standing out from the crowd. But I've had opportunities that others have not had. Bugger. Look at that.'

And he broke off to restart the *Newsnight* feed, activating the screen on the laptop, which had gone dark, and trying to refeed on two satphones to halve the time it took. We never succeeded with two. There was just too much congestion on the circuits as

journalists competed for the scarce satellite circuits that were left once the military had taken their share. It was a very different environment from the one he faced on his lone walk to the front line in the first Gulf War, twelve years before.

With one phone restored Vaughan went on: 'Curiously I'm not so optimistic as I was. I simply don't have a good feeling today, about tomorrow. This sometimes happens, as you know. I'll be a little more worried now about security. I'll do the job to the best of my ability. But I am cautious. A bit low on inner optimism. We have so little control here. The filming, editing and transmitting is all really hard because of the dust and the lack of space and power, which our hosts do not really understand. Just being a cameraman is hard. Anyway, nowadays I don't really feel that I am working for a machine that thanks you and values you but rather an office that prices you. Incredibly I don't think they really understand field work, and they should. You're just a commercial beast, dots on an accounts sheet. It's becoming cappuccino television. Missionless entertainment.'

'So is the story worth dying for?' I asked.

'Yes. YES. Absolutely. I think if human lives are lost then you are already in a position where the situation could be worth dying for. Once you take a risk, then there is a mathematical probability that you're going to die.'

'How do you measure the probability?' I probed. It was something we had talked about sometimes before. But not often. It was taken as read that death was a possible outcome of some of the decisions we took.

'What if you knew that the probability of dying was as high as 1 per cent' I said, 'that there was a *likelihood* that if you did the same thing a hundred times, then you would die?'

'Fine men and women, Rory, Nick, Rosanna and Charlie, Carlos, Roddy have died knowing that risk,' Vaughan said. 'Although I do

have a problem with people outside who don't take an interest. They're not worth dying for. I do this for people who do want to know, the interested ones. I want them to be accountable for what's done in places like this. If they're not informed, then they can say, "I didn't know what was being done in my name." Their freedoms come with a responsibility which few take on board, and that must involve making the effort to keep informed. They should *want* to engage in it. Those are the people we do this for. And ultimately we do it for the people we film. Is that idealistic? Friends of mine have died for it.'

The following morning the American journalists went off on another facility, while we headed for Kut. Our friends from Abu Dhabi TV came too. But Major Paschall's briefing had succeeded in scaring the Germans, now the only journalists left behind in our original camp.

We were not in our usual seven-ton truck. The driver of that, Joshua, a young mountain boy with an accent straight out of that Boorman film *Deliverance*, had gone off with the American journalists. I once asked Joshua why he had joined the marines, and he said laconically, 'Well it was either that or jail.' He had some terribly tangled relationship with a girl he feared was now going out with his brother. We heard him pining on a satphone he borrowed from one of the journalists one night: 'But I love you, Jolene. You know that. Kiss me, pretty please.' The 24th MEU had been away from home for nine months. Iraq was their eleventh country in that time. Jolene's patience had worn thin.

The whole atmosphere was different on our drive towards Kut. The floor of the truck we were in was covered with heavy sandbags, an anti-mine measure, and we were with about a dozen marines, all pointing their rifles outwards. The thought of hundreds of 'foreign fighters', i.e. al-Qaeda-inspired Islamists, was on all of our minds. We arrived in the outskirts of the

town in the early afternoon, and shortly afterwards Colonel Mills himself appeared by chance in a helicopter. He brought news. The LAVs had faced no opposition overnight, and by dawn marines were out on the streets of the town. The 'foreign fighters', if they had ever existed, had melted away. We did a short interview with Colonel Mills, and then prepared to file a live piece. This was significant news and it was all ours, since the embedded Americans were elsewhere. The fall of Kut meant that the Americans and British now had control of the whole of southern Iraq and another route from Basra to Baghdad. The college where we ended up, remarkably, had power, and even a single working tap in a bathroom at the back.

After we had filed, Vaughan walked around with Anas, the Abu Dhabi TV reporter. The college was all nearly intact apart from a few broken windows, but we knew that the looters would soon be in it, which was heartbreaking. There was even a photographic department where cameras were just lying around. Anas was an intelligent man, very opposed to the war and its effects on the Arab world. He was morose and did not say much as they walked around looking for posters of Saddam Hussein to take as souvenirs. Finding those was the only thing Anas was enthusiastic about. He was gloomy about the prospects of anything else turning out right.

'War can never be good. Look at the destruction of this college. The war did not mean to destroy this. It was not on any target list. But it has been destroyed all the same.'

They came upon some biographies of Saddam and a novel which everybody knew he had written, although on the cover it just said 'by a writer.'

'Some of this is as bad as Afghanistan, except that there they did not have this appalling personality cult,' Vaughan said, balancing the large, garishly decorated paperback in his hand. 'As far as

whether the war is good or bad, I think the jury is still out. The war has led to circumstances in which the college was damaged, and is now very vulnerable. But that's not just the result of the bombing. It's also caused by Saddam's appalling regime. He's mostly responsible for what has happened. This is potentially a very rich country.'

Anas remained sceptical. 'You will see. There is nowhere in the Arab world where wealth is shared out. Saddam will be replaced by somebody else.'

'I think we can really only make proper judgements when we see the state of Iraqi people in five years' time. But I agree with you that I don't think democracy will be easy,' Vaughan said.

A marine came over carrying a small, flat, round stone, about the size of a large coin, and a green cloth.

'Hey! D'you know what this is?'

Anas told him it was a prayer stone and the marine said 'Gee!', and put it in his pocket. It was not valuable in a financial sense. The stones come from the main Shia mosques in Karbala nearby. It could be replaced. But the petty theft of this personal item made Anas even more morose.

Vaughan said, 'You have to look at the best intentions of the Americans. If they have come in to help the Iraqi people, then surely it would be justified.'

But Anas was sure of his ground. 'Anything would have been better than this. It's the job of the Iraqis to do it. When did we invade America? The Americans have come in heavy-handed, but even this college is not important to them at all. It's just a source of souvenirs, picked up by people who do not even know what they are.'

American marines were already swarming around the rooms behind them. Downstairs the colonel had set up in an office, near the front door. In the classroom next door someone had taken

a skeleton from its stand in the corner and sat it up in a desk facing the empty blackboard. The floor was littered with broken glass.

Kut, Southern Iraq, 18 April 2003

The following night we slept in a bed for the first time in a long time. It was not much of a hotel. Like everything in this Shia-dominated region of Iraq, it had been deliberately run down by Saddam. But even though poorly built and maintained, it was a hotel.

The 24th MEU had done their job, and could not offer us any more, but we were invited to stay with the main Task Force, led by the General we called Buzz Lightyear, while they began the process of nation-building. They initially wanted us to stay in a tent at the air base. But we found a hotel in town, which gave us independence, power and water. We negotiated a sort of 'semi-embedded' status which I am sure broke all kinds of rules in the Pentagon but enabled us to do our job, and kept the marines on television.

Kut offered an opportunity to do the kind of journalism that most appeals, getting behind the instant headlines to try to tell what is really going on. A year or so before, when we had set up for more than a month in Herat in western Afghanistan, we found the first real evidence of starvation in the mountains, filmed the widespread planting of opium poppies that followed the relaxation of Taliban control and reported on Iranian influence. Now we were on the other side of Iran, and we were surprised at how little interest the Americans took in the border with a country which was their sworn enemy, part of the 'Axis of Evil'.

A group of journalists made the half-day journey from Kut out to the border before the US forces did. They reported back that the border was open and that a lot of people were coming towards

Kut. The Americans had taken Iraq but did not seem concerned with its regional security. Leaving the border unmanned looked rather careless, and had immediate consequences. The problems the Americans faced in Kut in those early days were only the precursor to the problems which worsened and intensified for them across Iraq later.

Every time the Americans stopped in town a small crowd would appear, armed with posters that had been freshly printed in Iran, showing the faces of various Shia political heroes. They chanted, 'YES, YES FREEDOM!' and 'NO, NO, CHALABI!', a reference to the urbane, US-educated banker America was then grooming to take over as Iraqi leader. The Americans did not really seem to know who they were dealing with. One of the early arrivals on the road from Iran was Abdelaziz al-Hakim, the brother of one of the most prominent Iraqi ayatollahs and the commander of an Iranian-backed Iraqi revolutionary force, the Badr Brigade. The Hakim family had been trying to paint it as a version of the Northern Alliance, the rebel forces that the Americans had deployed against the Taliban in Afghanistan. We had a civilised conversation with him, although he was certainly someone who the Americans would categorise as a fundamentalist. I deliberately opened a conversation about God, and Vaughan was impressed that he seemed to be much more liberal than the marine chaplain we had met a couple of days before. Who was the fundamentalist now? The Americans did not even know he was in town; the complexity of the country they had occupied did not seem to register.

A little-known Shia cleric, Syed Abbas, had taken over the town hall. At least he *was* little known, until the Americans failed to deal with him. When he began he had a few hundred of the 'NO, NO CHALABI!' brigade camping in the grounds to keep the Americans away but that was all. He had no real political base. A week later he had successfully become the focal point of

everyone in the town with a grievance against the Americans. We interviewed him, after a bit of a tussle in an outer office, one of his aides putting his hand over the lens. Later we were forcibly excluded by marines, again with a hand over the lens, when we tried to film a meeting they had called with other local leaders to try to sideline the mullah in the town hall. The two hands over lenses made a pleasing symmetry in our report on the situation in Kut for *Newsnight*. As Vaughan drily remarked while editing the pictures, 'When will people ever learn? I don't know why they don't grab you in the nuts instead. Much more effective way of stopping the pictures without the drama.'

In fairness to the marines, they were configured for war-fighting and they had done that quickly. They were not nation-builders, and it soon became obvious that they had no tactics to deal with what they were facing. There were protest demonstrations as things went from bad to worse. All that the Americans had to counter them with were low-flying helicopter gunships – intimidating but entirely useless at crowd control. Were they really going to shoot? After one particularly hot morning, when the marines had to wear riot gear to stop a protest march from cutting off the narrow bridge across the Tigris, they lined up some people kneeling on the ground at the back of our hotel. The prisoners were handcuffed and had bags over their heads. Vaughan discreetly filmed from an upstairs balcony until he was seen. A marine captain bellowed at him to come down and bring his camera.

He went down without the camera. It is a matter of the highest principle to Vaughan that he never hands over a tape. The two men stood chest to chest, about six inches apart and bellowed at each other for a while, Vaughan's Guards experience just giving him the edge. The marine made serious physical threats about what would happen if we did not hand over the tape, including the memorable warning, 'If you don't give it to me, I will cut you.'

That made Vaughan march into their headquarters next-door and demand an apology. We had never got to know the colonel in charge there very well, and in fact he had been the man whose hand had covered the lens, which had rather soured any thought of a good relationship on either side. Boxes of ammunition surrounded the walls in his office on the first floor. The only furniture was a trestle table with his military-issue laptop on it, the screensaver showing constantly changing poses of Liz Hurley in various states of undress – every few seconds another picture, another angle, another piece of lace. The colonel had no sympathy for Vaughan's complaints about the threats we had faced.

'I'm removing your embedded status. Consider yourselves disembedded.'

It was all rather petty. A friendly public affairs officer, Mike Dougherty, who had been with us throughout, came round to the hotel in the evening to apologise and restore our status, although by this time we had no idea whether we were embedded or not, or whether it mattered.

By now we had done all that we could do. The Americans were not going to bring peace to Kut quickly. They had succeeded in antagonising the local tribal leadership and the professional middle class, doctors, lawyers and university professors, without getting rid of the mullah in town hall. A year later western journalists could not walk around in Kut at all and could only travel to the town with an armed escort.

On the last night we got some bottles of 'Baghdad Gin', flavoured with plums or cherries. Bizarrely it was on sale for half the price of a can of imported lager. One of the Americans, whose girlfriend came from California, had an iPod, loaded up *only* with songs with 'California' in them.

Still we had something of a party, with 'Welcome to the Hotel California, California Dreamin'', etc. rigged up to BBC speakers,

until the marines in a machine- gun position mounted on the roof over our heads put a stop to it with a volley of bullets across the river.

Early the following morning we were flown out to Kuwait in the belly of a cargo plane, an awesome beast carrying a generator the size of an express train, which needed to be taken out of the war for repair, as well as several US soldiers, striking poses. The pilot insisted on tactical flying, taking an erratic course with the plane near the ground, although by now there was now no risk of anti-aircraft fire. The generator lurched and strained on its chains as we swooped around over the desert. It stirred up the Baghdad Gin somewhat.

Basra, Southern Iraq, April 2003

We drove back into southern Iraq, now finally in our own vehicle, and already, just a few weeks after the end of the Saddam regime, there was a markedly more relaxed atmosphere in the area patrolled by British forces. We came upon an unarmed Geordie soldier, who cannot have been more than nineteen years old, wearing a beret and no body armour. He cheerily gave us directions to the British base at Basra Airport while directing six lanes of traffic around a tank that had broken down at the side of the road. On the road to the airport we passed the decomposing carcasses of a line of camels unlucky enough to have been targeted in the war.

During our first conversation with a British officer, who gave us tea as soon as we arrived, he used the word 'Hobbesian'. We were with a different army. It was more than the familiar comforting clatter of Land Rovers, the toytown proportions of things against the behemoths we had been living among, or even the fact that soldiers complained about everything, in a cheery grumbling way, which lubricated their every conversation. They were just more comfortable with Iraq than their American cousins.

Basra International Airport was one of Saddam's biggest follies, unused until now, with a full-length runway and a terminal about the size of Stansted, all built to high international specifications at a time when sanctions prevented any flights in or out of Iraq, and a no-fly zone meant that anything in the air over Basra would have been shot down by the US and British planes that had been patrolling the skies continually since 1991. Journalists were not officially allowed to stay at the airport, but there were enough Guards officers around who recognised Vaughan that we were treated as 'family' and taken in. We lived lightly on their hospitality, sleeping outside in the car park, and set up to edit at the check-in counter.

It was there that Vaughan heard that James Miller had been shot in Gaza. It was devastating – the death affected Vaughan more than the others had before, even though James had not been working as a Frontline cameraman by the time he died. Vaughan could not bear another press release, another picture on the wall. In Kosovo Vaughan had given James one of his first commissions to shoot a documentary, and he had been in and out of the Southwick Mews offices for a while before leaving quite amicably to work for himself. After travelling to places like Lebanon, Sudan and Algeria for short news features with Frontline this quintessentially cool and professional Englishman naturally progressed to making documentaries. He had found his niche, and he was lucky to meet Saira Shah, going on to shoot the award-winning documentary about life for women in Afghanistan, *Behind the Veil*. The two then moved on to Gaza, and were working on a report on life for ordinary Palestinian families under permanent siege by the Israeli armed forces. James was targeted by an Israeli soldier as he walked at night towards an Israeli armoured vehicle in Rafah, carrying a flag and shining a torch onto himself to identify himself as a journalist. Seven shots were fired at 13-second intervals; the

second shot went over the top armoured plate of his flak jacket, killing him.

In the fading light of Saddam's airport in the late afternoon, Vaughan would break off often as he put pictures onto his laptop, interrupting the story of the Marsh Arabs he was editing to remember another thing about James – a confident likeable man. He remembered that he had never emphasised the risks he faced, pointing not to the action in his footage, but to the *journalism*. He was one of the best, seeing danger as a distraction from the business of telling people's stories. Vaughan continues to take personal responsibility to remember fallen colleagues. James's death left another widow, another orphan, another unfinished life.

Brixton to Baghdad, April 2003

When the Gulf War began Pranvera Shema, now running the office at Frontline, was surprised to get a phone call from Richard Parry. After doing his time in Bosnia, Chechnya, Armenia and so on he had successfully launched a career as a feature-film producer. His drama *South West Nine,* set in his home area Brixton, achieved cult status in independent cinemas.

He is a brilliant man, who puts his ability to film fiction in a documentary way on the streets of London down to the knowledge he gained in conflict as a cameraman for Frontline. Although he had loved the life in the front line, and learnt things from it, it had given him panic attacks. He developed an awareness of reality that made life tougher, and made him insecure. He stopped in order to stop the slide down the path towards becoming a war junkie. But it never left him. He had found out things about humanity that that could not now be neatly filed away in the way that normal life is processed. Like all who travel into conflict he was changed for ever, left with a knowledge that there are some things that do not make sense. In many ways his film *South West Nine* was

a response to this. He says: 'It is about these things which don't make sense. When you see it you can't say that this is a good guy and that one's bad. It looks more like the world really is.'

When the first images of the Gulf war came in, the live shots from the top of tanks on their way to Baghdad, he thought, *I have to be there.* He went for a run and the feeling had not gone away, so he made the call.

'Do you need a cameraman?'

'I thought you'd given it up,' said Pranvera.

'Yeah, I had. But d'you need a cameraman?'

Frontline had been inundated with offers of work from companies for months before the fighting actually began. I knew, because he made sure I knew, that Vaughan had been offered much more money to work with an American news network than the BBC were offering. But he came with us for the journalism. Pranvera managed to fix Richard up to shoot a documentary for the American A&E cable network. 'Arts and Entertainment' – everyone had to get into the Gulf War. It turned out to be a documentary about the journalists who were covering the war, which suited Richard fine. He wanted to be back among them. And when he was not shooting in Baghdad he went and sat with American soldiers, drinking in dialogue for another film he was planning – his own take on war. He was loving the life again, shooting pictures, talking, drinking, having sex, and writing in the corner of a shared hotel room with his computer resting on a pile of books because otherwise it would overheat in the already warm Baghdad spring. And then he heard the news of James's death. He said:

> It was funny because we were having a lot of fun. There was a party atmosphere. We were drinking too much and sleeping with each other. And then James Miller died. It

brought it all home. It's about life and death. Bullets kill people.

He returned to London, and was not even paid for the job. The production company reneged on their contract.

XXI

TIMES OF WAR

In times of war, television journalism comes into its own. It allows us an immediate sense that we are seeing an accurate depiction of the front line. Richard Wild, *The Observer*, 6 April 2003

In the spring of 2003, shortly before America and Britain invaded Iraq, Richard Wild walked through the door at Southwick Mews to see Vaughan. It was a common event. Every week or so, another aspiring freelancer would ring up or come through the door to ask for advice. Vaughan had not made the appointment himself, and tried to cancel it, knowing that he could not offer Richard anything. But he was already on his way, and Vaughan liked him immediately, saying that of all the hopefuls who had come through the door, 'he was easily the most interesting that I remember for a very long while', although he tried to put Richard off, as he always did, telling him that it was very dangerous and he would not become rich selling freelance TV pictures.

Richard was bright; he had been through Cambridge and the army, and after various short-lived career attempts he wanted to try journalism. Vaughan agreed that Frontline would try to sell his pictures, while warning him in the usual way that times were hard

436

and he should not expect much. Richard shot some distinctive material, off-piste stories from around Baghdad, including a profile of a Palestinian refugee camp. He also wrote some pieces for British newspapers, questioning the aims of the war and the civilian casualties. And then he was singled out one day by an unknown killer, who came up behind him and shot him in the head. The killer was smartly dressed and had been waiting for some time outside Baghdad's museum, in a car, while Richard was inside. All of this information has come from journalists who investigated the incident; Richard's parents remain angry that the British government made no effort at all to trace the killer. His father, Robin, says, 'All we've had are excuses from the government about why it did nothing. The silence is a disgrace.'

Robin Wild is an unusual conspiracy theorist. He is the most senior Scottish Justice of the Peace, but he believes that the evidence points to a contract killing and even to the possibility that the British and American governments may have known much more than they are prepared to say. There is no decisive proof, but rather a number of small circumstantial details that point him towards this unnerving conclusion: the British government's too-ready (and inaccurate) story that Richard had been killed while surrounded by an angry mob; the arrest of two Arabic journalists who wrote about the killing and ended up in Abu Ghraib prison; and the theft of Richard's laptop from his sister's flat in Aberdeen, just after she had emailed articles Richard had written that questioned the war. Nothing else was stolen from her flat in the burglary, and the laptop case but not the laptop itself was returned by the police a couple of weeks later. Robin Wild does not think that TV news is worth dying for.

Vaughan could not take any more. The business was not functioning and yet he was dealing with the deaths of people he hardly knew. It had always been hard, and only a handful of

Frontline cameramen ever made a living out of it, of whom he had been financially the most successful, even while shouldering the responsibility of running the company. But he could not just shut up shop. Too many had died, and he could not just forget them. By the end of the year he had finished the building work on the old industrial building he bought in Paddington and opened a club for journalists, where photos of his dead colleagues are on the wall by the bar, suitably remembered. Now he could close the books of the company; Frontline Television News in its old form was no more, while now, through the club, he can offer support to journalists who risk their lives for their work (frontlineclub.com).

The Frontline Club emerged out of the solid Victorian brick origins of the building, reworked by a gang led by Vaughan's Serbian brother-in-law, one of the relatives he smuggled out of Sarajevo and brought to Britain. The leather sofas, which give it the air of an Edwardian club, were upholstered in Belgrade. Pranvera Shema, now Vaughan's wife, is the club manager. It is a place for those with a nomadic temperament to gather and *not* tell war stories, patiently observed by the barman JJ – already a London legend. The walls are covered with flags from past conflicts: a bullet-scarred Yugoslav flag taken from a tank, and other flags from Saddam's palace, the Taliban, Kosovo, and one from Romania with the communist symbol torn out of the centre. The cabinets lining the walls are full of curios from other wars. The silk map of Iraq issued by the SAS to Andy Mcnab for the 'Bravo Two Zero' expedition is in a frame on one wall, while pride of place goes to photographs of a bleak hotel room in the Holiday Inn, Sarajevo. Within months of the club opening, it had the feeling of a place that had been open for years. And when a major press award went to journalists killed in Iraq, the industry naturally said the award should sit at Frontline. The meeting room upstairs has emerged as one of the most important public

spaces in London for discussion – a forum with no big sponsor, and no agenda. It is not run by a corporation, or a union, or a guild. Nobody has an axe to grind.

Peter Jouvenal still shoots pictures sometimes, when he can be persuaded out of his hotel in Kabul. After beginning with Osama bin Laden's old house, Peter moved to a bigger property in the centre of town, where the bar has quickly become the main meeting place for journalists in Kabul, as the Frontline Club is in London. There is now a two-month waiting list for rooms as diplomats, security officers, power workers, journalists and others head for Kabul on short-term contracts. Peter named it Gandamack Lodge, after Harry Flashman's country home in Britain, which the swaggering swordsman himself named after one of the most famous of Victorian epics. The fictional story of Flashman's 'survival' at the last stand at Gandamack, which followed the slaughter of the whole of the British Kabul garrison in 1842, suits Peter's nineteenth-century temperament. He has furnished the hotel with foreign linen and prints and china, putting guns and swords on the wall, samples from his other business, dealing in antique weaponry, found in Afghanistan, but much of it originating in Britain more than a century ago (gandamacklodge. co.uk). His first manager was an old Army friend who trained the Afghan staff in western ways, for this has been declared a 'rice-free zone'. He has also made himself entirely respectable in Afghan society, marrying an Afghan woman, Hasina, herself a formidable businesswoman. Peter has come a long way from the days when he crossed the Khyber Pass along smugglers' trails to take pictures of the war. But the company he founded to take care of him and other freelancers has gone.

The whole business had changed dramatically in the years they had been operating. In the early days the strength of the trade unions meant that freelance footage faced significant obstacles.

When the BBC first tried to hire a freelance cameraman to work in a foreign bureau in the 1970s his work was blacked for a while by the union. Frontline and others forced their way in. The technology and the people and the stories came together through a unique window of time. But the window closed again. Nowadays anyone can go to Dixons and pick up the equipment needed to shoot and edit TV news packages cheaply. Properly supported freelancers can not compete.

Apart from the loss of his company, and with it another layer of support for freelancers, Vaughan Smith thinks the industry is in danger of losing something else – a diversity of ideas and images on the screen. Organisations with big staff commitments often cannot afford to take a different view from the establishment. Frontline might, for example, be able to expose something in China where a larger organisation could not risk its Beijing bureau. He says:

> I think we are valuable for that. But we have never been valued nor even encouraged to do it. Nowadays we are not even paid properly for such work. So we don't do it and journalism is weaker.

Vaughan continues to work as a cameraman on selected projects, but mostly he puts his energies into the club. He came into journalism as a thrill-seeker, taking risks to prove himself, and seeking escape from a more routine life. Once he had got that out of his system, he might have moved out of it into something else, but found himself drawn to something deeper by the suffering he witnessed. Beginning in Bosnia, he found that journalism made a difference and wanted to continue that work. The club is the fulfilment of his belief that there is nothing more important to society than good information – challenging the drift towards

more politicised broadcasting led by Fox News with its bizarre claim that it alone is 'fair and balanced'.

Towards the end of 2010, Vaughan found a new cause. He threw himself publicly behind Julian Assange, as the Wikileaks campaigner battled to keep out of jail. Assange, who had never had a permanent home, rented rooms in the Frontline club for several months, during the time he was planning his largest publication of documents – a leak of hundreds of thousands of US diplomatic cables. Vaughan quickly grasped the scale of what was happening, and felt that Assange was not being given fair treatment either in the courts or the British press.

He sought to put Frontline at the centre of public debate about the significance of the Wikileaks phenomenon, at the same time as giving Assange a bail address at his home in Norfolk, while Swedish prosecutors pursued an extradition case in connection with charges alleging sexual misconduct with two women. It gave Vaughan a high public profile, as one of the few people prepared to defend Assange, indeed one of the few people who knew the elusive free speech activist well.

Vaughan knew there was some risk in his stand, both to the reputation of the club and himself. Some club members, a small minority, disagreed with what he was doing. But most backed him, and he thought back to what the Frontline founders who had died – Rory and Nicholas – would have made of it. He thought that they would have approved. He said, 'I'm lucky to be alive. My friends aren't.' He emphasised the difference between his personal support for Julian Assange's court case, which he did not expect Frontline members to back, and the wider public issues around press, secrecy and government behaviour that came out of the Wikileaks affair. Once again he found that Frontline was on the fringes of the British press, familiar territory from the days when it had been a struggling freelance agency, punching above its weight.

Vaughan criticised much of the British coverage of Wikileaks for focussing on the man, Julian Assange, and not the issues that his leaks exposed. To Vaughan it seemed as if the press were doing the government's bidding without even being asked. He compared what was happening with the treatment of Daniel Ellsberg – 'the most dangerous man in America' – who had leaked what became known as the Pentagon Papers in 1971, concerning US policy in Vietnam. Vaughan said, 'Nixon got people to steal Daniel Ellsberg's medical records to try to damage him. You don't have to do that now. Now the press are doing it for you. The press do their own hatchet job.'

As the story grew, the *Guardian*, who had benefited from preferential treatment by Assange, being shown the Wikileaks material several weeks before other media outlets, turned on him, publishing the prosecution evidence against him in the Swedish case.

The full implications of the Wikileaks affair will not be known for some years. But it felt like a game-changing moment, concerning the ownership of information, and control of the internet. Vaughan is not naïve and understands the need for the government to keep some things secret, but backs Wikileaks in shining a light on western foreign policy failings, after a decade in which none of the wars initiated by the US have turned out as expected. The issues of transparency and democratic accountability that the affair brings to light are at one with the more democratic and diverse news industry always sought by Frontline TV. Perhaps independent freelancers will have more of a role in this future.

The fact that Frontline cameramen were never credited on the air for their work perhaps played some role in their invisibility, and ultimately to their inability to establish themselves as a permanent presence, but their ideals live on in the club. To Vaughan it is the fruition of the awareness that had first awakened in him in Bosnia,

when he saw the suffering of war. 'In Bosnia I saw that we could make a difference and were obliged to do so. With the club I have come to realise that there is nothing more important to society than good information. That conviction gives one tremendous security. I have learned that there are no good institutions, only good people.' There is already a programme of Frontline events in Russia, and a club in Tbilisi, with plans to open elsewhere.

More than the building, the BBC correspondent Allan Little says that the Frontline Club has become:

> a community of values, a place you come to remember what you stand for, the sorts of values you are meant to uphold. It's a place where you come to reconnect with the idea of open exchange, free discourse, freedom of expression and all the complicated things those things mean.

Even without these continuing projects which have grown out of Frontline, the self-starting, bloody-minded, competent operators from this company left an indelible mark on British broadcasting. Eamonn Matthews, the producer who had such epic adventures in Afghanistan in 1989 and then later in Baghdad with Frontline crews, began the series *Unreported World* for Channel 4. He says that Frontline changed the way that cameramen worked:

> They have influenced people. Their tentacles have spread out a long way. When we started *Unreported World*, I was hugely influenced by them. *Unreported World* is modelled on my memories of Frontline.
>
> Now we have much more hand-held material in documentaries, because we realise that the most beautiful and artful shot might be rather dull if there is nothing happening in it. It was quite a pragmatic approach. They

influenced a whole generation of news cameramen. Their footage had inherent vigour.

When they first walked into Lime Grove [the former HQ of BBC Current Affairs] and said, 'We'll buy a Land Rover and a couple of mules, and it will take six months', no one else was thinking like that.

Eamonn also pays tribute to their skills in the field. He says that they never made exaggerated claims as to what they might get, because they were the ones who were going to have to go out there and get it – a quality that makes them the direct spiritual descendants of the understated English explorers of the past and sets them apart from the normal world of modern TV news, which tends to make rather inflated claims for itself. When I was doing the interviews for this book, it was sometimes difficult to get people to tell their war stories, because of an inbred diffidence and innate humility.

At the very time that Vaughan took down the 'Frontline' sign, television news seemed to need specialists in conflict camera work more than ever. The murder of Simon Cumbers, the freelance cameraman shot alongside BBC correspondent Frank Gardner in Saudi Arabia, marked another watershed in the increasingly dangerous business of being on the road. It had been getting bad for a while. Adam Kelliher, who never went to another war after he was injured when John Schofield was shot dead in Croatia, saw the industry change in front of his eyes. He remembers a time when journalists were not usually targeted because their neutral stance as observers was respected by fighters in most conflicts. Bosnia changed that. It was as if scales had fallen from the eyes of soldiers everywhere. Suddenly everybody was literate in the effects of the media, believing that journalists were *players* even if they were not actively biased. And America's wars since 9/11

marked another ratchet downwards. Journalists are now seen as targets as much as any other westerner straying into the wrong place.

All his life Adam Kelliher had thought that he was bullet-proof. But when he saw the pain that was caused to John Schofield's family it profoundly affected him. He had recently got married himself, and his wife was expecting their first child. The BBC was sympathetic – it has never been compulsory to risk your life – and he kept working for a while, shooting non-conflict stories. But his heart was not in it, and soon he put his camera down for the last time, going into business on his own selling dietary supplements. His own safety suddenly mattered a lot to him and he wanted to reduce the odds of dying.

Richard Parry continues to tell stories on film, including a well-received TV documentary series about gypsies – nomads again. And he and Vaughan finally completed their profile of the photographer Robert King. One of the last scenes is in 2005 in Baghdad where King is embedded with US forces. Frustrated by their unwillingness to take him out on operations, he is reduced to taking pictures of soldiers stirrring giant oil drums full of burning excrement to dispose of it. This highly restricted access was the fitting end to an era that had begun in the freelancers' war of Sarajevo. King says that the US forces were unwilling to take him out on that day because they had taken casualties:

> They didn't greet them with flowers, they greeted them with bullets. All we can do it to sit on our arse, lay on the cot, not cover the story, wait for them to organise some press event where they hand out cookies or blankets or soccer balls to the kids. The best we have got of the day is soldiers burning shit. It's human shit, the great old media embed.

Shooting Robert King was shown in cinemas to critical acclaim and on BBC Four (www.shootingrobertking.com). Richard is now working on a feature film based on the Frontline story itself.

In another sign of the end of an era Juliet Crawley Peck, who had seen two husbands shot dead, and seemed indestructible, was finally defeated by cancer in 2007. A huntsman blew the call 'gone away' at the end of her funeral on a freezing January day in Yorkshire.

Susannah Nicol became a BBC producer, doing distinguished work in the hardest times in Baghdad, before leaving TV news. Anna Roberts became a schoolteacher. Tony Smith is a 'video-producer' at the BBC, as cameramen who can write are now called. Sophia Swire, the once-ditzy blonde whose carelessness in leaving Vaughan's microlight bolts at Heathrow indirectly pushed him into television, stayed in the North-West Frontier and founded a schools charity and a business importing Pashmina shawls. She was last seen in Kabul heading a project aimed at helping Afghanistan exploit its enormous wealth in gemstones. Fisnik Abrashi, the Kosovo fixer with 'alabaster skin and a head like a skull', is now an experienced AP news-agency correspondent, who has worked both in Baghdad and Kabul. Jeta Xharra went back to Kosovo, working as a film-producer, TV presenter and playwright. Tim Deagle headed to Asia in the late 90s, finished with Frontline, and worked initially with the APTN agency, before joining a partnership with other freelancers called Asiaworks. I remember seeing him very early in the morning in Banda Aceh after the tsunami in 2004, silhouetted against the rising sun, standing motionless on the pavement, with a cigarette in one hand, his camera swinging from a strap on his shoulder, waiting for the Japanese correspondent he was working with – just waiting.

Tim told me that he sometimes sees young cameramen coming through Jakarta where he lives, with inexpensive cameras that

are ten times as good as the Hi8s Frontline started with. And remembering his own past, he helps them if he can.

> But too often they seem to be activists with a camera, wanting to change the world. Frontline never had an agenda. We were people with different political outlooks. I never knew how the others voted. We were in it for the sheer unbelievable adventure of it all, idealistic only about journalism.

Robert Adams stopped doing war camera work for a while when it became much less fun. After the Bosnian war, he worked mostly as a cameraman for other people, rather than going out to find his own stories. He did his time for the 24-hour news beast on the rooftops of Peshawar, and then in Kabul after the Taliban fell, and in 2003 he spent a couple of months in Baghdad, before the US-led invasion of Iraq. But he had lost his interest in it and left before the American troops arrived. When the fighting started in Iraq, he was in the bush in Africa, taking wildlife pictures, and found himself with days of skull-numbing depression at missing it. Then as the death toll of journalists rose and rose, he remembered his children, gave up smoking, and came home 'cured'. In an epic adventure he drove a Land Rover with his family down the length of Africa.

Since the first edition of this book came out, there has been some sign of a shift in public remembrance of dead journalists. Until then the only focal point was a shrine to fallen journalists in St Bride's Church in Fleet Street. But we are getting better at remembering our own. The new Broadcasting House building at the BBC is topped by a glass sculpture like a beacon, lit up at 10 o'clock every night – the time the main news comes on the air – in memory of dead journalists. Many of those bereaved in incidents

connected to Frontline were at a moving ceremony when the memorial was unveiled by the UN Secretary-General.

The Rory Peck Trust, set up after Rory's death, has developed into a charity helping journalists and their families from across the world. I saw their work at first hand one night in the Frontline Club when I bumped into two Palestinian cameramen, both from Gaza, who the Trust had brought to London for treatment to their arms. They were both injured when they were carrying cameras too close to Israeli forces.

So was there anything special about the Frontline cameramen? There are many other cameramen who go to dangerous places, as there have always been soldiers who have become journalists. But in a world after National Service, where fewer people have any experience of the military, they stood out. Tim Weaver, who now works in the City, has such a particular sense of risk that he will put on a seatbelt in the back of a London taxi. But he says that he does not remember feeling fear when he was shot at: 'A little trepidation beforehand perhaps, but if you were to think all the time that you might lose a leg, then it would be impossible to do the job. There is too much going on.' Alex Maxwell, who lost both her brother Nicholas and husband, Charlie, in northern Iraq, would agree. She compares the Frontline cameramen to ballet dancers, who love the dancing and do not notice the pain. Ask a dancer if her feet hurt and she would hardly know what you are talking about, even if you could see the blood. Ask a cameraman if he felt fear and you might get the same response.

Nicholas della Casa and Rory Peck seemed to go through life unburdened by the normal world. The two key founders who survived, Peter Jouvenal and Vaughan Smith, perhaps made a contribution to journalism that was more methodical. And Vaughan in particular had the vision to found the first TV news agency to deliver independent freelance television news

journalism of integrity and diversity – no mean feat given the fierce independence of the mavericks who came through his door. He championed the freelance principle and built an agency that drove a wedge into traditional broadcasting practices, so that the impact of each of the Frontline freelancers was far more than they could have achieved on their own.

But they found themselves in a society which did not value their skills. They were individualists in a world of conformity. Instead of heroes nowadays we end up with health and safety officers. The big networks are at the centre of an infrastructure that appears to have little interest in seeing the emergence of a successful independent fringe, preferring a monopoly. The effect of this is to encourage homogenised TV output that manufactures ordinariness and correctness rather than promoting diversity. Such output is a long way from the world view of the Frontline men and women, who had an eye for the sheer drama of war, and knew the way it could make heroes of quiet men, and fools of the loud. Rory once wrote:

What is it that is so fascinating about human conflict? It's not the spectacle of death, which is ultimately tragic, but more that one sees people bored of pretence and all the evolved masks which society has developed to protect itself from men's basic instincts. Yes, you see man in his natural, savage (and Afghans are particularly savage) form, at the same time you see nobility of spirit, courage, heroism, fear and cowardice all in varying shades in different men.

Lord Richard Cecil's brother Robert, now the Marquess of Salisbury, said this about Lord Richard. 'What would he have done as he got older? I suspect that a lot of these chaps don't know that. And I think that rather worried my brother when he

thought about it. He was not stupid; he thought about things beyond the next bang. But he had this sense that the world was going to hell in a handcart and at least he was going to have a bit of sport along the way.'

ACKNOWLEDGEMENTS AND PERMISSIONS

This book could not have been written without the continued and active support of the surviving members of Frontline, in particular Vaughan Smith, who has been a loyal friend throughout the process. Peter Jouvenal was concise in his account of the past. Thanks are due too to Tim Weaver, Richard Parry, Robert Adams, Tim Deagle and Adam Kelliher and Tony Smith. Among other journalists, I should thank Eamonn Matthews, the first producer to realise the potential of what these cameramen had to offer, Mark Urban and John Simpson in particular. The Marquess of Salisbury, for a long time a promoter of freelancers, has also been a great support. Peter Allegretti and Tira Shubart provided valuable insights into the early days of Frontline.

I developed great respect for the relatives of those who died as I prodded at difficult memories. Juliet Crawley Peck was more help than she knew as we looked at family photographs sitting in front of Rory's giant Russian canvases in her Yorkshire cottage, remembering this complex and charismatic man. Colin Peck too has been a key source about his brother, as well as about his own significant contribution to the Frontline story. And I have Carola Peck to thank for the title to Chapter XI,

referring to Mark Antony's sterling quality of a 'quick spirit'. Late one night in their Northern Ireland mansion, perhaps after we had opened the second bottle of Rioja in order to stimulate the flow of memories about Rory, she turned to me in a very conspiratorial way, confiding, 'He was Mark Anthony, you know.' Rory's first wife, Janey Alexander, was also a hospitable hostess and fund of personal stories, as I put her through the mill of difficult memories. Other friends who shared their thoughts on Rory include Bruce Clark, Charlie McGrath and Tony Davis.

I am particularly grateful to Marigold Curling for giving me unprecedented access to Rosanna's diary, while Andrew della Casa was meticulous in ensuring his brother's story was told properly. Alex Maxwell deserves more thanks than anyone, not only for reliving the horror again but for agreeing to draw the maps for the book, including the one showing the last walk of her brother Nicholas and her husband, Charlie, with Rosanna. I tentatively made the suggestion that she might want to draw them as we sat in her Fulham home, surrounded by other beautiful and creative work of hers, and she took on the project with great style and care.

The families of both Roddy Scott and Richard Wild have also been supportive. Robin and Stina Scott have set up a charity in Roddy's name to assist people in the Pankisi Gorge in northern Georgia, where Roddy was staying before he was killed (www.roddyscott.co.uk).

Those who took the trouble to make useful suggestions on the text as it developed include Paul Iredale, Vin Ray, Anna Roberts, John Owen, Anthony Loyd, Julius Strauss, Mark Brayne, Graham Greene and Pranvera Shema. Pranvera also helped to lead me through the thicket of Balkan languages when I needed a guide. And I have special thanks for my old boss Chris Cramer for saving me from embarrassment for a couple of errors about American terms.

ACKNOWLEDGEMENTS AND PERMISSIONS

Picture acknowledgements:

Seamus Murphy: Jouvenal with battle map; Simpson and Jouvenal in Charikar; Simpson and Jouvenal on front line.

Peter Jouvenal: passport photo; antique-weapons store.

Vaughan Smith: Smith in the Gulf; Jouvenal and Smith in Kandahar; Smith in Kurdish mountains; Smith wounded.

David Loyn: Jouvenal and Smith on front line; Adams and Loyn in Bamiyan; Smith in Prekaz; Smith putting up satphone dishes; Smith and Loyn editing.

Rory Peck: Rory Peck and Davis.

Tony Davis: Rory Peck and Massud.

Juliet Crawley Peck: family holiday.

Robert Nickelsberg: Rory Peck in Kabul.

Colin Peck: portrait in Afghanistan.

Ali Akhmadov: Scott with Chechen guerrillas.

Vladimir Snegirev: Snegirev, Rory Peck and Jouvenal in Afghanistan.

Anthony Massey: Rory Peck with BMW; Smith and Abrashi in Kosovo.

Frontline Television News Ltd: screen grabs ex-TV (Gulf rockets, Gorazde, Jalalabad, Prekaz, Bamiyan).

Tony Davis let us use his photo for the price of a lunch. Special thanks are due to Seamus Murphy for access to his intimate portraits of Peter Jouvenal for not much more, to Vladimir Snegirev for his unique pictures of Peter and Rory together in the Hindu Kush and to Anthony Massey, whose extensive slide collection yielded the image of Rory with 'the ultimate war wagon', among others. Every effort has been made to contact copyright holders, although some pictures, particularly those from the archives of dead cameramen, remain without attribution. The author and publisher would be happy to correct any errors or omissions in future printings.

Extract from 'Taking a Chance on Love' words by John LaTouche and Ted Fetter, music by Vernon Duke copyright © 1940 EMI Catalogue Partnership, EMI Feist Catalog Inc. and EMI United Partnership Ltd, USA. Worldwide print rights controlled by Warner Bros. Publications Inc/ IMP Ltd. Lyrics reproduced by permission of IMP Ltd.

INDEX